PICASSO

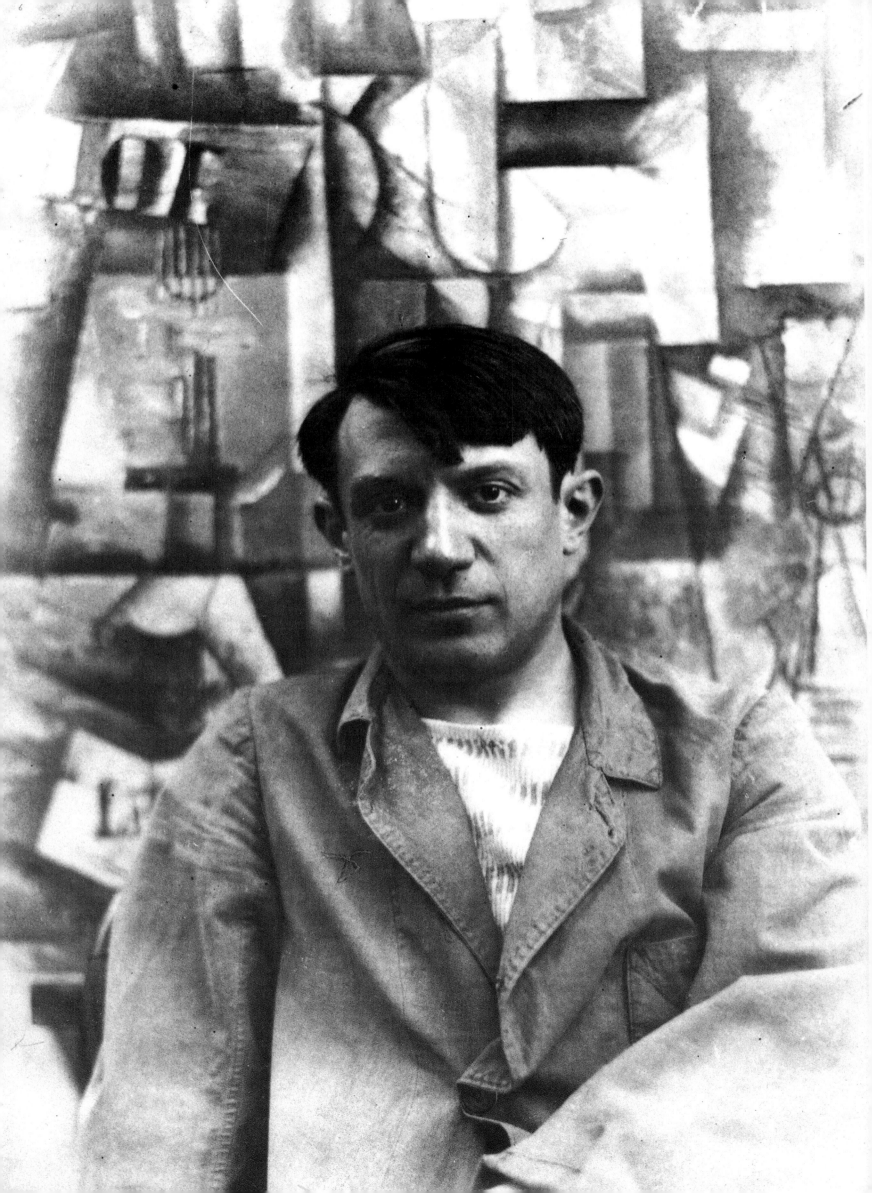

LORRAINE LÉVY

Introduction by
Pierre Daix

PICASSO

Translated from the French by Barbara Beaumont

KONECKY&KONECKY

Konecky & Konecky
150 Fifth Ave.
New York, NY 10010

ISBN: 1-56852-172-3

Printed in Italy.

Picasso
Painter of the twentieth century

It is increasingly acknowledged that Picasso, whose active career stretched from 1895 till 1972, encompassed the whole range of twentieth-century art. His prodigious ingenuity and skill in the handling of form have endlessly haunted the imagination of artists, spanning whole generations from Surrealists to Abstract Expressionists, to Pop Art and the last decades of the century. He created a whole host of prototypes that were the product of his Cubist experimentation and renewed the language of all the visual arts, from advertising posters and cartoons, to television and video graphics. He left no area of plastic expression untouched. Beginning with his achievements in academic art, he sought to generalise the expressiveness of the nature of materials and contrasts in texture. He knew how to combine the shock originating from the botching of traditional painting with collage, assemblage, the celebration of industry's cast-offs, haphazard or automatic processes. Picasso, whose first efforts rivalled Rodin's, revolutionised both sculpture with his assemblages and, later on, ceramics where he extended Gauguin's inventiveness. Finally, he widened the scope of engraving techniques and produced work embracing the eternal themes of the human comedy on a par with Rembrandt and Goya.

Indeed his breaking with tradition and his innovations have always sought to increase the power of art over the world. His masterpieces include both portraits, the successes of his private life, denunciations of injustice, and the most lyrical outbursts of the period, images of women that range from im-

placable cruelty and eroticism to the full flowering of grace, the most refined miniatures, the transformation of the most vulgar of materials and the most monumental compositions. He established a channel of communication between the perspective of the twentieth century and the art of the Cyclades or Mycenae, the work of unknown Negro artists as well as that of El Greco, Poussin, Velázquez, Ingres, Delacroix or Corot. With *Guernica* he gave a reminder that contemporary events can be subjects for a painter. Constantly denounced by some critics as a destructive and corrupting force, he showed that modern art could take on the humanist functions of Renaissance art for the generation that had experienced Auschwitz and barbarism elsewhere.

He was a natural virtuoso – did he not claim, in truth, at the age of twelve to draw like Raphael? – but he was not born into the modern style. He discovered it on arrival in Madrid when he was fifteen, and more especially later on in Barcelona. This probably explains why more than any of his precursors (apart from Gauguin) and more than any of his contemporaries (except Miró, twelve years his junior) Picasso had a sense of an artistic tradition reaching back to the Renaissance, an enclosed world of its own from which it was not enough merely to depart but from which it was imperative to burst forth into an all-embracing modernity and make a fresh start animated by the work of primitive artists remote from Western civilisation.

That was his principal intellectual discovery between 1906 and 1908. And it was undoubtedly this

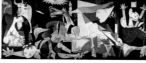

Guernica

that also made it possible for him to preserve to the end a symbiotic relationship with his own century. The only place where he could make that discovery was Paris, where the sheer technological verve of the Eiffel Tower, or that magic wand, Electricity, mingled with an arid cultural wilderness like parts of Africa or unexplored Pacific islands. While Italy, and, above all, Spain were living out the nineteenth century on the strength of their past, in Paris painting after Delacroix and Manet had become caught up in a wave of revolutionary fervour. By the end of 1906, encounters with Gertrude Stein and her brother Leo, Matisse and Derain, retrospectives of Manet, Gauguin and Cézanne, changed Picasso's outlook. The revolutionary masterpiece he produced received its consecration from art historians some thirty to fifty years later when *Les Demoiselles d'Avignon* was recognised as the decisive first step towards modern painting.

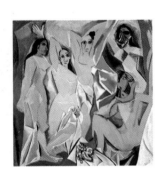

Les Demoiselles d'Avignon

In 1907, no one, not even Picasso, knew anything of this. Almost all of those close to him saw in this painting nothing but a tragic blind alley. At that time there was none of those theoretical points of reference that have become so familiar to us. Moving away from classical perspective seemed, like Einstein's Theory of Relativity, an aberration or a joke. It was only in 1923 that Lévy-Bruhl lent humanity to the 'primitive mentality' and in 1961 that Claude Lévi-Strauss published *La Pensée sauvage*. In this way, he endowed the rough-and-ready intellectual and practical skills, which Picasso had instinctively practised with the adroitness of a fabulously powerful artisan, with their cachet of respectability bringing out their implications in the field of human knowledge and experience. In his early days in Paris Picasso worked in a studio in the squalid building known as the 'Bateau-Lavoir'. Here he strove to liberate artistic creativity from what he regarded as the dead hand of the long-established tradition of Western art and from the nineteenth-century Grundyism which had sought to curb and stifle painters and poets such as Gauguin and Rimbaud, van Gogh and Toulouse-Lautrec. As an artist himself, Picasso never forgot the fate of his predecessors who had been condemned by society and he avoided it by becoming self-taught in what, although as yet unrecognised, was to

The 'Bateau-Lavoir'

emerge as the cultural hallmark of the twentieth century. His longevity did not extend to that exceptional ability to question apparent success – his own included. It took ten or fifteen years for the public to grasp the full significance of his last paintings completed about 1970.

Though mastering for himself the ways of the new century which dawned as he reached manhood, Picasso was always in conflict with it and even when eventually there was widespread recognition of his role as artistic standard-bearer, it was always against a background of protest and incomprehension. For him, as for the heralds of his generation of artists – Gertrude Stein, Apollinaire, Matisse – the twentieth century stood for the ideal of unlimited access to all the resources of the human spirit, the advent of a completely new era. They were the avant-garde, even if they did not use that term themselves, and André Breton could say, 'that one cannot fail to acknowledge an enormous debt to Picasso. If this one man had lost his nerve, this whole business with which we are concerned would have been delayed, if not lost altogether.' And so to follow Picasso as he wrestles with this vision of the future is the best means of deciphering the adventurous course of his painting.

Training for revolution

The child born in Malaga, southern Spain, on 25 October 1881 seemed destined to be an artist. His father painted and taught drawing in order to meet his family's needs; Pablo was their first-born son, and his innate gifts soon revealed themselves. There was only one handicap, but an enormous one: Malaga was still living in pre-industrial revolution times. Paris was far away; and so everything should have conspired to make of Pablo Ruiz Picasso a precociously talented artist in the academic style. This he achieved with breathtaking verve. He made a game of the exams he passed at the art schools in Madrid and Barcelona, mastering at the age of fifteen portrait and genre painting. In February 1900, when he was eighteen, his painting *Derniers Moments* was shown at the café Els Quatre Gats in Barcelona and, later that year, represented Spain at the decennial retrospective at the Exposition Universelle, Paris, in 1900.

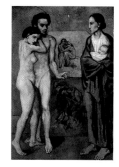

La Vie

But a well-mapped-out itinerary can spark off only anxiety and revolt. In the meantime, he had resolutely thrown in his lot with the new century in Barcelona, still a melting pot after its own Exposición Universal of 1888, and where Catalan nationalism had broken out, where Nietzsche had been discussed, El Greco rehabilitated, where Gaudí's inspired architecture aroused passionate interest, and painters who were launching forth into Modernismo dreamt of Parisian innovations from Impressionism to Pointillism. The most striking feature of this adolescent who was already shocking people and getting the upper hand on his elders stems from the scope of his curiosity, his capacity for assimilation, and his determined spirit that made him shake off all family and social restraints, in the same way that he overcame fashion.

In the autumn of 1900, very shortly after his arrival in Paris, he tackled a painting of *Le Moulin de la Galette* by night, which has none of the gaiety of Renoir's treatment of the same subject, but would lead one to think that he was familiar with van Gogh's *Le Café de nuit*, as he recorded in minute detail the poverty of Montmartre, adding, for local colour, a fairground stall on the boulevards. He returned to Malaga, via Madrid where he co-founded the short-lived journal, *Arte Joven*. On his return to Paris, he jumped at the chance of an exhibition in June 1901 at Vollard's gallery, and invented a style of painting characterised by vivid, even strident, colours. He produced sixty pictures in under three months, depicting Parisian life in a virtuoso pre-Fauve style. It was a success, but was not to be repeated until the 1960s, when the popularity of coloured reproductions brought out their originality once more. By the time summer came, Picasso had effected a 180-degree turn towards the ferociously cool limpidity of Toulouse-Lautrec, who had recently died. Memories of his friend Casagemas's suicide brought him back to Zurbarán and El Greco, leading him into monotint blues, with which he expressed the hopeless wretchedness of the venereal disease-ridden prostitutes in the St Lazare gaol, produced several portrayals of *Motherhood*; then, back in Barcelona it was *Les Deux Soeurs*, such a bitter and profane version of the Visitation.

Nobody wanted these paintings of the dregs of *belle époque* society. But he did not give up, he painted even poorer people, following up his *Derniers Moments* with a questioning of fate featuring Casagemas again: *La Vie*. This work was immediately sold for a good price, so much so that a newspaper wrote about it. 1903 saw a flowering of masterpieces: *The Blind Man, The Blind Man's Meal, The Old Guitar Player*, leading to *Célestine* in early 1904, marking the end of the Blue Period.

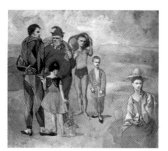

Family of Saltimbanques

Picasso was anxious about this return to success and was keen to test it in Paris. He installed himself at the 'Bateau-Lavoir' in Montmartre and experienced poverty once again, but a young woman called Madeleine came into his life, and his painting became cheerful in a pink romantic portrayal of *The Harlequin's Family*. He was invited to the Venice Biennale and sent a large gouache *Acrobat and the Young Harlequin*, which was rejected. (It fetched a record price in New York in 1988.) This did not prevent him from embarking on a major picture, *Family of Saltimbanques*.

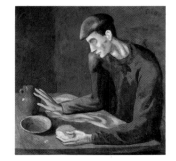

The Blind Man's Meal

A trip to Holland, a new female companion, Fernande Olivier, moving into his studio were all less significant than the discoveries Picasso made at the Autumn Salon in 1905, which was marked by the scandal of the 'Cage of Wild Beasts' – the single room given over to those painters labelled pejoratively as Fauves. The retrospective Manet exhibition made him modify his *Family of Saltimbanques*. He was particularly overwhelmed by Ingres's *Turkish Bath* displaying unexpected modernity. At about the same time, a young American, Leo Stein, enthused over one of Picasso's sentimental gouaches and introduced him to his sister Gertrude.

Their purchases (including Blue Period pictures) changed Picasso's life. The previous year he had met Apollinaire, who had begun to bring him out of the Spanish artists' colony in Montmartre. The Steins introduced him to Matisse. And so he suddenly found himself in the midst of the avant-garde, in which Cézanne, whom he barely knew, occupied an exalted rank. Picasso embarked on a portrait of Gertrude Stein after the manner of Ingres, whose achievement he hoped to surpass. This kept him busy until the Indépendants' Exhibition in 1960, at which Matisse triumphed with his pastoral scene

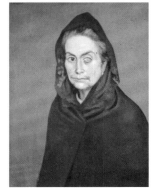

Célestine

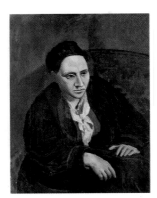

*Portrait
of Gertrude Stein*

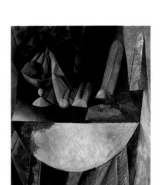

*Bread and
Bowl of Fruit
on a Table*

Bonheur de vivre. For the first time, Picasso found himself up against a rival.

He became worried about the possibility that his talent was making him too facile. Perhaps he was only skimming the surface of art, mastering too easily such a long tradition? Matisse's boldness obliged him to take stock of himself. A new departure was called for, working up from the very foundations of art, rediscovering the primal sources of its origin. At that very moment there were on show in the Louvre sculptures that had recently been excavated, work by untrained craftsmen in the Iberian peninsula; his own part of the world. He soaked them up, abandoned the *Portrait of Gertrude Stein* and set off with Fernande to immerse himself once more in Upper Catalonia, at Gosol. There he painted first of all classical nude studies of his companion, outdoing Ingres; then he broke with this harmony by transforming an old peasant's face into a mask. Because this decisive period took on the ochre tints of the Gosol clay, for nearly sixty years it was confused with the 1905 sentimental Rose Period, which was to render the transition to Primitivism incomprehensible.

Once back in Paris, Picasso experimented with this Primitivism by finishing the *Portrait of Gertrude Stein* and producing a number of extremely simplified nudes. He renewed his acquaintance with Matisse, who was back from the south with similar problems, like Derain, who had fallen madly in love with one of his women friends. Both of them were full of enthusiasm for Negro masks. At the Autumn Salon in 1906, his first and really complete retrospective, Gauguin set the seal of approval on Primitivism. Picasso felt himself to be at the heart of the avant-garde movement.

He had come a long way since *Family of Saltimbanques*. He decided to make a significant gesture, a painting set in the present, as opposed to the pastoral escapism so dear to his new friends. Naked women where they might be expected to be found: a brothel scene. He set out to paint a manifesto combining Primitivist simplification with the sculptural solidity of Gauguin's Tahitian women and the contrasting rhythms of Cézanne's women bathing, fusing together the various avant-garde trends.

By the time his plan was worked out, he discovered, as a result of the double scandal at the Indépendants' Exhibition in 1907 centred on Matisse's *Blue Nude* and Derain's *Women Bathing*, that they had gone further than he in the direction of Primitivist provocation. He gave up his original plan, moving on to *Les Demoiselles d'Avignon*, the picture we know, with its demonstrative barbarity, both a violent destruction of traditional objectives, and, above all, a new beginning, the liberation of a new painterly craft.

It is only in the last few years that it has been possible to piece together what happened next. During the summer of 1907 – while he was going through a crisis in his private life, which led to his separation from Fernande – until the autumn, Picasso carried on with his Primitivist campaign, fiercely engrossed in his work and reflecting anew on the Negro masks and on Cézanne, all of which led to a large picture, *Three Nude Women*. It was at this point that his friends came back to Paris. Gertrude Stein was the only one to defend him. Neither Apollinaire, Matisse nor Derain understood the work. A newcomer, Braque, was struck by it but protested: 'We've heard from Fernande, who came back to the studio, that this is a picture by a flame-thrower.' He reworked the theme of the *Three Women* in his Cézanne-like manner, but without trace of Primitivism, and got out of it a picture, now lost, which was exhibited at the Indépendants' Exhibition in 1908. Derain did the same with a large painting, *La Toilette*, also lost. Gertrude Stein observed that they were, in spite of everything, lining up on Picasso's side, and that it was Matisse who was isolated, turning his back, as he now was, on Primitivism, by returning to outpourings of colour.

Picasso then set about a systematic exploration of Cézanne (the retrospectives that followed his death in 1906 gave him the opportunity for study) and African and Pacific art. He reached the point where he gave up barbaric deformation in favour of rhythmic reconstruction, powerfully composed. Braque, returning from l'Estaque in September 1908, brought back with him pictures born of the same geometric constructivism (there was to be talk of 'little cubes'), but quivering with vibrations, transitions à la Cézanne. When Picasso had seen how successful these were, he reworked the *Three Women*, which he had already purified of all savagery, creat-

ing atmosphere. He and Braque were to go on to create, so they thought, what death had prevented Cézanne from achieving: painting that made an abstraction of forms, reinventing the world of the senses in all its fullness, and affirming the presence of objects. Inversions of perspective pushed the shapes out to meet the viewer. Picasso began to cut up the background, in order to emphasise their rhythm, notably in his monumental nude studies, and a *Woman Bathing*, a rival for Matisse's *Blue Nude*. He transformed a group of figures into the large still life *Bread and Bowl of Fruit on a Table*, and measured up to Cézanne in his portrait of the shopkeeper Clovis Sagot. Braque, who saw him every day from now on, was to speak of their 'mountaineering expedition' scaling the heights with ropes.

The summer parted them. At Horta de Ebro on the borders of Aragon, Picasso created landscapes with crystalline geometry. He cut out the face or head and shoulders of Fernande in ever more elongated diamond shapes. When they came back, Gertrude Stein, as she compared these pictures with photographs of Picasso's subjects, declared that Cubism was born. According to the young German dealer, Daniel-Henry Kahnweiler, Louis Vauxcelles was the first to write publicly of 'cubes' in his review of Braque's exhibition held at Kahnweiler's gallery in the rue Vignon in November 1908. Picasso, for his part, never took part in the Salons.

The revolution was under way. Picasso was living more comfortably, thanks to the Steins, to the arrival of Kahnweiler, and the purchases of the Russian collector Sergei Shchukin brought along by Matisse. He left the 'Bateau-Lavoir' for a studio closer to Pigalle. While Braque was building up space with the presence of objects in large still lifes, Picasso was moving on to every imaginable way of cutting up the background, creating women who leap out at our eyes, thanks to variations and modulations in geometrically structured space. Then suddenly there was a *Girl with a Mandolin* (Fanny Tellier), dazzlingly graceful, who stood out, like something by Corot, in spite of discontinuities that the eye could not line up. Picasso conducted controlled experiments by way of two masterly achievements, the *Portrait of Uhde* and *Portrait of Vollard*, which was not to be completed until the autumn of 1910.

It was during the summer of 1910, spent with Fernande, Derain and Alice Toklas at Cadaqués, that Picasso pushed discontinuity to the point where, to use Kahnweiler's phrase, 'homogeneous form exploded'. That is to say, he recomposed the discontinuous elements of objects and figures outside of their structures in order to construct pure abstract rhythms that some title or constant detail would make it possible to identify. He would never eliminate the relationship with the model, wishing his shapes to remain a diagram, the transmutation of exterior reality. He executed his paintings with uncommon vigour, *The Rower*, and *The Guitarist*, for example, or the large still life, *Glass and Lemon*. And yet he was anxious about so much abstraction and brought a number of uncompleted pictures back to Paris, where he finished the *Portrait of Vollard*, a masterpiece of cutting into elongated facets, and embarked on the *Portrait of Kahnweiler*, which was the fruit of the abstractions and discontinuities of Cadaqués.

There then followed a period of uncertainty in which he was alone, Braque following only at a distance his abstract recompositions. In early summer 1911, he achieved equilibrium in a truly diagrammatic picture: *The End of the Ile de la Cité*. He set off alone for Céret, in the eastern Pyrenees, where his friend the sculptor Manolo was living. His palette paled under the impact of the Mediterranean sun, and it was here that he invented pyramid-shaped architectural forms, here too that objects imagined on a bistro table contributed their structural form: the verticality of a bottle, the oblique angle of a clarinet, the openness of a fan. He discovered that by isolating a fragment of a painted headline from a newspaper, he could create an autonomous space with a conceptual allusion. When Braque arrived with Fernande in mid-August, he was in the process of succeeding in recomposing people in the same way, whilst remaining intelligible: *The Poet, The Man with a Pipe, The Woman Accordionist*.

There followed a period of enthusiastic reunion with Braque. It was unfortunately very brief, as Picasso had to rush back to Paris urgently, through

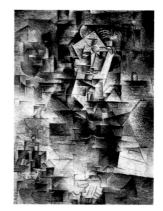

Portrait of Kahnweiler

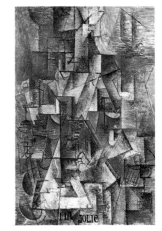

Ma Jolie

fear of being implicated in the theft of the *Mona Lisa* by a Belgian adventurer who had been hanging around Apollinaire, from whom he had purchased in 1907 two Spanish statuettes, both stolen property. After being interrogated, Picasso was dismissed, but Apollinaire spent three days in prison. These alarming events did not stop him painting and he completed some magnificent pictures under the impetus of Céret: *Man with a Mandolin* and *Man with a Clarinet*. These brought to an unprecedented climax the discontinuity in pictorial fabric tentatively begun by Manet, and are the visual equivalent of the syncopated rhythms of jazz, as compared to classical music. A far cry from the applied geometry of the 'Cubists' that caused a scandal at the Indépendants' Exhibition in 1911, and started up again at the Autumn Salon. Yet American and European newspapers, who, unlike the French, were familiar with Picasso's work from exhibitions, accredited him with fathering this new form of painting.

*Still life
with a Cane Chair*

Entry into the twentieth century

The affair of the statuettes sparked off the crisis that had been brewing between him and Fernande. Picasso celebrated in the autumn in the studio at the 'Bateau-Lavoir' that he had taken on again by painting *Ma Jolie*, the title of a popular song, and which was a reference to Eva Gouel, who had become his mistress. Braque, who had stayed behind at Céret, came back in January 1912 with a masterpiece, *The Portuguese Man*, very close to Picasso's Céret figures. Yet it contained one major innovation, stencilled letters. Proof that the new painting could take on board forms that owed nothing to the hand of the artist, introducing external, objective signs. Picasso, who was making more and more clear-cut the shapes emanating from objects, absorbed this novelty immediately, treating it quite simply as a sign, thinking to profit from it in order to introduce, as another outside element, bold colour, which until now had destroyed the balance of their compositions. In order to make the foreign intrusion split off even more effectively from the rest of the paint, he had the idea of using colour in its pure unmixed state, industrial paint from Ripolin's. The picture was becoming a true domain for visual experiment.

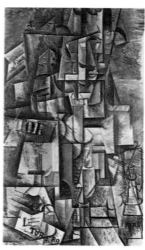

The Aficionado

He now began with amazing fervour to incorporate all sorts of elements gleaned from objects; from a journey with Braque he produced two large oval still lifes on the theme *Souvenir du Havre*; he painted over with Ripolin paint the entry ticket to the bullfight in his *Spanish Still Life*. This was where he got the idea of sticking a piece of linoleum with the pattern of the cane seat of a chair in his *Still life with a Cane Chair*. This was his first collage, but, more importantly, a breaking away from the 'noble' medium in art and a manifesto for the new craft, in which the optical effects of painting were to gain strength from a range of contrasting materials and textures.

The crisis with Fernande blew up suddenly, and he had to leave Paris in a hurry, going off to hide at Céret with Eva. But there were yet more troubles to flee from and he eventually settled in Sorgues, on the outskirts of Avignon, Braque and Kahnweiler having undertaken to move his studios for him. The most notable thing in all this is that these upheavals in no way interrupted the dazzling advance in the exploration of new painting. Picasso was experiencing an unprecedented freedom that illuminated his still lifes. A *Landscape with Posters* made the objects flaunted in the advertisements stand out in Ripolin paint. Braque, who had joined him in Sorgues, was his equal in inventiveness. He was creating paper sculptures, modulating optical differentials in his paintings, adding sand to his glazes, then inventing the first papier collé picture where a wood-effect wallpaper border transformed the drawing into an assemblage, the contrasting textures creating conceptual and optical effects hitherto unheard of. At the same time, however, Picasso was completing in painting a splendidly re-assembled character, *The Aficionado*.

Hardly had he returned to Paris, than he left Montmartre for Montparnasse on account of Fernande; at the time this was like emigrating, yet he experienced an upsurge of creativity. He created in cartoon form a composition based on a guitar, an open sculpture, breaking away from the body of the instrument and bringing out new reflections on the plastic potency of Negro masks. He transposed the effects into paintings, then into assembled collages, and then he, in his turn, took up papier collé, but using cut-outs from newspapers instead of Braque's wallpaper borders. He immediately began playing about with

the meanings of the headlines, in order to intensify the conceptual dimension, as if he wanted to confront abstract signs with the concrete material reality that emanated from the collage. In the studio, this culminated in an assemblage of a purely conceptual drawing of a guitarist, holding by means of his newspaper arms the addition of a real guitar – proof that his abstractions could function within the space of everyday life.

It could be said that it was from this point on that Picasso's Cubism assumed its own autonomy, as regards the products of his 'mountaineering expedition' with Braque, and it was at that precise moment that he truly entered the twentieth century. The first collage, papier collé, the first assemblage with the guitar not only abolished the frontiers between art and industry, which had been a stumbling block for individuals such as Baudelaire, but what is more, they tackled the transfiguration of popular, mass-produced matter, such as advertisements and headlines from the gutter press. The nobility of art does not reside in its subject-matter or the medium, which the nineteenth century, after Courbet, had set out to demonstrate, but, rather it is within the artist himself, inside his creative idea, his ability to transform, to produce art from a basis of non-art. Never had the fact been demonstrated so exhaustively.

But, as with the new ground broken with *Les Demoiselles d'Avignon*, all of this remained generally unknown, except to a few friends, only Apollinaire and Braque being sufficiently perceptive, until it was rediscovered between 1920 and 1930 by Aragon, Tzara and the Surrealists. And it was not to be appreciated at its full worth until the late 1950s, when twentieth-century art caught up with that decisive breakthrough, and not until 1989 and the 'Braque and Picasso pioneering Cubism' exhibition in New York, that the role played by Picasso and Braque was firmly established.

Picasso set off for Céret again with Eva in early March 1913, and there was to be no slowing down in his creativity until May, when his father died, and this was followed by an attack of typhoid, which obliged him to return to Paris at the end of June. In the autumn, when he had settled into his new studio at 5 rue Schoelcher, he created assemblages out of scrap wood, which filled the Russian Constructivist Tatlin with enthusiasm. Then he launched into an entirely new kind of painting where he used his imaginative potential liberally, in works such as *Woman in an Armchair*, a figure that Surrealists, ten years later, would see as heralding the surprise effects and state of disorder that they were aiming for.

Braque came back from Sorgues in late autumn with large papier collé works of an admirable musical composition. They had not seen each other since March and their work was diverging. Braque's success, however, spurred Picasso on to make some more papier collé pictures, but using the extraordinary range of their assemblages as a 'machine for seeing' the potential of the new pictorial space. With this laboratory, Picasso would carry out experiments to test what was haunting him: could the graphic and pictorial freedom that he had acquired stand up to classical painting? Did the space of composite pictures, built up as it was on split levels, the effect of collage and optical contrasts, that is to say his Cubism in its most evolved form, remain valid, when confronted with the illusionism of perspective? Could they co-exist? Could the one overtake the other?

Forty papier collé pictures with sand effects, sawdust, still lifes painted in homage to *Ma Jolie*, the open-work sculpture of *A Glass of Absinthe* of which he painted six different versions, led Picasso, during a summer spent in Avignon, to a feeling of fulfilment and happiness in his painting, with the freedom of colour and the achievement of a pre-Surrealist baroque. In secret he continued his confrontations with the illusionism of perspective, having shown Kahnweiler in the spring his attempts to return to portrait painting. He gathered them together in *The Artist and his Model*, a nude, undoubtedly the only portrait of Eva, the existence of which was made known only after her death.

He was evidently afraid that such experiments, incomprehensible to everybody, including Braque, would be seen as a form of regression away from his revolutionary painting, whereas they were, in effect, the opposite. Picasso wanted to prove that his freedom as a Cubist encompassed in some way the achievements of classical painting, bringing with it

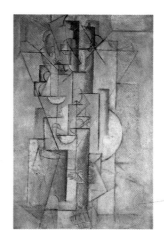

Nude,
'I love Eva'

an extra, something that was 'better than before', to quote what he told Kahnweiler. What stopped everything, finally spoiling the spirit of enterprise, was that unforeseen bolt from the blue, the First World War. Braque and Derain, who had been called up, left Avignon. Picasso, as a Spaniard, was neutral. He went with them to the station. He would note later, sadly, 'they never came back'. Their avant-garde would never recover. He was alone from then on. The deaths of his companion, Eva, and of Apollinaire, his separation from Kahnweiler deprived him of any witness. Here, the history of art was to take more than half a century to catch up with what had been lost.

Even today we have difficulty in assessing the situation. Overnight, Kahnweiler was unable to leave Italy; not only did his painters, Picasso, Braque, Gris, Derain, Léger and others, find themselves without further resources, but hundreds of their works, the heart of modern painting, except for those by Matisse, became inaccessible, even to themselves, because they were sequestrated as enemy property until 1921-2, when they emerged in massive sales. If one adds to this the fact that these hundreds of works had practically never been exhibited in Paris, that they had not been reproduced anywhere, other than in photographs that were also sequestrated, one realises that twentieth-century painting was virtually stifled at birth and conjured away by the folly of the French state. Instead of being able to take its place within a tradition, it would have to be painfully reconstructed from the 1930s onward, in France initially by individuals such as Christian Zervos, and at the Museum of Modern Art in New York. This is the explanation for the fact that Picasso's relationship with the twentieth century is still a new subject.

Advent of Surrealism and Second World War

Eva had died of tuberculosis at the end of 1915, and the declaration of peace in 1918 found Picasso recently married to Olga Koklova, a dancer with the

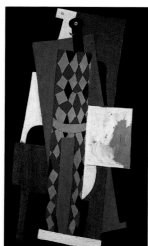

Harlequin

Ballets Russes. His sets and costumes for the ballet *Parade*, with an unusual score by Erik Satie, had created an uproar the previous year. Although he had shared an exhibition with Matisse, showing his Cubist works, despite a fine, almost entirely abstract, *Harlequin* dating from 1915, and the fact that *Les Demoiselles d'Avignon*, shown at the Salon d'Antin in 1916, passed by almost unnoticed, people seemed only to take note of his 1914 reflections which seemed like a return to apparently traditional portraits and paintings such as *Small Tables before a Window*, shown at his new dealer, Rosenberg's, in 1919. In the eyes of the Cubists, it was a betrayal, as if Picasso were caught up in the need for social consolidation after the slaughter, the 'return to order' as Cocteau would put it later.

This was the misunderstanding that Picasso had feared. It is still in force, although as facts subsequently demonstrated, Picasso continued to advance equally on two fronts, Cubism on the one hand and revising illusionism on the other. Before the catastrophe of war, he had already perceived that the modern spirit did not consist exclusively in burning the bridges with conventional art, but in reaching an understanding of the meaning and conditions in which it was to be superseded.

This involved intellectual courage and solitude. Picasso faced the lack of comprehension as he had done unceasingly since his Blue Period. He painted a most Ingrèsque portrait of Olga, he had photographed her, in order to measure the transformation, and produced for himself a manifesto-painting, *Studies*, which he was never to let out of his possession, and in which he mingled his recent Cubist abstractions with his classicist revisings. In February 1921 their son Paulo was born, for Picasso a miracle. In the summer of that year he painted simultaneously the double Cubist version of *The Three Musicians* and the classicist double version of *Three Women at a Fountain*, but in 1923, after the masterpiece of this backward-looking vein, *The Pan-pipes*, he moved on to still lifes where haphazard effects and sand-blasting led to a 'fluid' abstraction, an automatic composition technique that was an anticipation of Surrealism.

If Cubist exploration was still producing masterpieces (*Still life with a Plaster Head*, 1925) it was this new painting, outside any norms, that was getting the upper hand and veering towards an unprecedented

exploration of cruelty. As in 1907, there was a personal crisis, his marriage with Olga, underlying it all, but Surrealism in the meantime had become the latest movement. Picasso recognised himself in this youthful revolt against a society that had produced the worst of wars, and the attention they were paying to the subconscious was a comfort to him in his off-beat researches. In 1925, *The Dance* and *The Kiss* were two manifestos of the new unleashing of pictorial violence, now directly accompanied by sexual aggression. The whole of this period until 1931 was to be dominated by it, despite the arrival of the young and carefree Marie-Thérèse Walter in Picasso's life. Primitivist reworkings linked to abstract breakthroughs (*The Studio*, 1927-8; *The Artist and his Model*, 1928), aggressive assemblages of a guitar (one of which had a floor cloth and nails with their points sticking out, 1926), 'metamorphoses' all charged with sexual connotations, open-work sculptures and his first iron assemblages in collaboration with González from 1928 onwards, *The Crucifixion* and *The Seated Bather*, a praying mantis of 1930, all of these were as many piercing expressions of his personal crisis in the context of the moral and cultural crisis of the post-war world. Not only did Picasso anticipate the financial crash of 1929, but he was also equipping himself with the means of expressing violence in the plastic arts that were a preparation for confrontation with the period beginning with Hitler's rise to power.

Picasso had never played an active role in politics, even if, when he was very young, he had sympathised with the Spanish anarchists and approved of the pacifist demonstrations of the French socialists in 1912-13. The Surrealists, who made their protestations more radical in 1927 by going as far as joining forces with communism, contributed to his recognition of a certain correspondence between the revolution in painting of which he saw himself as the incarnation, and revolution proper. The Spanish Civil War would reinforce him in that conviction.

In the meantime, his secret love for Marie-Thérèse stimulated him to produce a lively series of engravings and more especially to a form of painting in which sensual liberation of rhythm and colour reached a modern form of lyricism, one of the high peaks of his work (*Girl in front of a Mirror, Le Rêve,* 1932). This was brought out of hiding at the first retrospective exhibition of his work in Paris, and

later in Zurich in 1932. All the heart-searching of his fortieth year was past. Picasso was also celebrating Marie-Thérèse in sculpture in which Surrealist reworkings became admirably purified; he made the series of engravings *The Sculptor and his Model* from them, and these led on to the *Suite Vollard*, an extraordinary romance in one hundred episodes, covering everything that was haunting Picasso's life and art at that period.

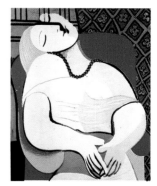

Le Rêve

The break with Olga, occasioned by the birth of Maya, his daughter by Marie-Thérèse in 1935, interrupted the flow of his work, but his painting came alive again to celebrate mother and child, as well as the arrival on the scene of Dora Maar, who was to be his companion during the war years. This new season of portraits and lyricism would give way only under pressure from the rising tide of danger brought about by the scale of the Civil War in Spain. Picasso accepted the commission of the Republican Government for its pavilion at the Exposition Universelle in Paris in 1937. From all this he produced *Guernica*, into which he cast the entire experience of those last ten years of painting, submitting it to the test of the terror and murder with which his country was beleaguered.

If until this point the violence unleashed in his pictures and his assemblages had its origins in his own inner revolt, from now on it was to show itself to be one with the tragedy that was spreading across Europe, heralding a devastating war. Art must stand up, Picasso thought, 'to the ocean of pain and death'. Even more so as Hitler taxed art with being 'degenerate' in all its modern forms. He accepted the symbolic appointment by the Republican Government as Director of the Prado. He did not, in his painting, forget his female companions, nor little Maya, but over the years they were to become mirrors contrasting with the boundless anguish and misfortune which he felt to be imminent. A large picture, *Fishing by Night at Antibes*, painted on the very eve of war, is filled with the ferocity of the harpoon. No one was to be spared the terror.

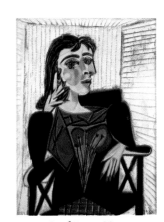

Portrait of Dora Maar

French defeat in the spring of 1940 found Picasso in the act of painting a monster, *Nude Woman,* doing her hair. Meeting Matisse in Paris at the end of May, he declared that the fleeing generals were the 'Ecole des Beaux-Arts', and in September, Matisse, who had remained in France, wrote to his son Pierre in New York: 'If everyone had carried on his business as Picasso and I have done, it wouldn't have happened.' Indeed, it seemed to both of them at that disastrous time that the lies of official art, which they had been demolishing unceasingly ever since 1906, corresponded to the lies and illusions of the established order which had just collapsed. And in consequence, those of their own explorations that seemed the most abhorrent, the craziest of their attacks on form, were indeed in touch with profound truths concerning contemporary society. Both of them refused to leave France at this time.

Even if Picasso was forbidden by the Nazis from exhibiting in Paris under the occupation, he never ceased painting. At the time of the death of his old friend González in 1942, when confronted with the unleashing of terror in the occupied zone, he reached tragic heights (*Still life with the Skull of a Bull, Aubade, Portrait of Dora Maar*). He then launched into new explorations in the domain of sculpture (*Bull's Head* made from handlebars and a bicycle saddle, *Death's Head, Man with a Sheep*), all of them affirmations of the continuity of his art and its validity as a form of resistance in the face of the destruction that was overtaking civilisation. War had not become a subject. The questions he was asking himself had, in fact, been the same since the turning point of 1906: what are the means by which art can be enabled to give expression to the twentieth century? The century was turning out to be less than ever just one of promises of science and wisdom but also of frightful and savage massacres, and unpardonable crimes. He had encountered this century as early as 1907 when Clemenceau's repression had led to the death of strikers and in 1909 when Ferrer had been shot in Barcelona. That was a factor in his opting for communism.

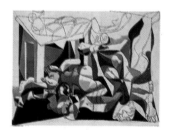

The Charnel House

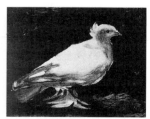

Dove of Peace

From 1943 onwards, the return of hope brought light to his painting and the liberation of Paris on 23-25 August 1944 found him ready to join forces with his friend the poet Paul Eluard in the Communist Party. He was to see himself treated as a symbol of art's resistance to the Nazis, and the Autumn Salon, which for a long time had been academic, opted for a retrospective of his recent works in order to pay homage to him. The public had previously known only *Guernica*, since his paintings had been shown, not in the large official galleries, but in smaller ones known only to discerning art-lovers. The Nazi occupation had banned them. Incomprehension turned to scandal, which was no surprise but rather delighted him.

His still lifes at this time continued to bear the mark of tragedy, for the war was not over. Perhaps the painful experience of the 'return to order' after 1918 was a factor, but significantly Picasso at this point embarked on a large, austere picture which is a pendant to *Guernica, The Charnel House* (not the title given to the painting by Picasso himself but by those who wrongly attributed its origin to the discovery of the mass graves of the Nazis' victims). It is a requiem for massacred innocents. Whenever Picasso painted death, his purpose was always to understand its meaning. *The Charnel House* denounces a world unhinged in which murder came down on innocent people; as in Guernica, it fell from the sky, but the picture is a direct question to us: what kind of victory is this that we are living out? As yet nothing has been achieved.

In this way he was taking up a position in contradiction to that of his communist friends. Now he was to spend eight years in difficulty over his idealistic adherence to communism, in which he saw the best guarantee of real peace, but also the tendency towards official illusions in socialist realism. His artistic problems were elsewhere, however. The arrival of a young painter, Françoise Gilot, in his life led to a new explosion of lyricism which found expression at the Château d'Antibes, which was to become a museum devoted to him. This group of paintings on fibrous cement conveys both the exaltation of new love (*La Joie de Vivre*), as well as the perception that the pictorial environment is no longer the same. Surrealist surprises and reconstructions were giving way to a return to abstraction, which was tending to free itself from the cold, geometric corset it had worn in the pre-war years. Questions such as: 'How can one paint after Ausch-

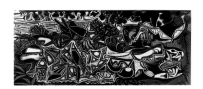

*Les Demoiselles
des bords de la Seine*

witz? After Hiroshima?' were in the air. It is notable that the paintings on fibrous cement of 1946 display once more the constructive abstract strength of the Cadaquès period. Picasso was to take abstraction even further in the two versions of *The Kitchen* in 1948. He did not bother about being fashionable. He questioned his own painting on the basis of various problems posed by the new generation of painters.

All the more so as it was a period of great uncertainty. After this war, there was no experience of a new beginning with a clean slate, like the Dadaist movement, no return to classicism. The newness of lyrical abstraction would only achieve respectability in 1949-50, when Picasso and Matisse were discovering the Abstract Expressionism of New York painting, and Moscow denounced them as apostles of decadence. One thing was certain: the twentieth century would never be the same again.

P icasso embarked on new techniques that he suddenly found at his disposal, lithography at Mourlot's in Paris, ceramics at the village of Vallauris. He threw himself into them wholeheartedly at what was turning out to be a period of transition, in which he worked actively as a militant for peace, taking part in the Peace Congress at Wroclaw in Poland (where he visited Auschwitz). Aragon used one of his lithographs of doves, *Dove of Peace,* as the poster for the Peace Congress in Paris, 1949. It was circulated throughout the whole world, spreading a virtuoso image of Picasso's art. His painting would reflect his militant preoccupations (*Massacre in Korea,* 1951; *War and Peace,* 1954). His *Portrait of Stalin* at the time of the latter's death in 1953 earned him the Communist Party's incomprehension and reproach. He painted Françoise Gilot (*La Femme Fleur,* 1946) and their two children, Claude and Paloma, but soon there was another personal crisis and the separation coincided with the political questionings that arose following the death of Stalin. Alone, at the age of seventy-two, Picasso took stock of himself. He drew, in 180 sketches of magical verve, everything than can happen between painters of all kinds and their models, be they young girls or old women. His art had changed course. He no longer summoned up the inhumanities of history to check his powers, but

went ahead with a self-analysis that was as far-reaching as that of the great turning point in 1906-7. Picasso then realised that his painting had already embarked on this different path, without his really being aware of it, on account of his twofold crisis, with communism and with Françoise. This was a path that would open up to him vast territory that had been left virtually untouched, and to which younger artists did not have access. After all, the twentieth century was only half-way through and, as he told Kahnweiler, he felt quite fit and still able to 'climb ladders'.

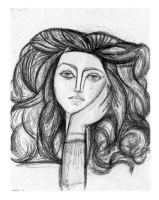

Portrait of Françoise

*'Painting is something
I cannot resist'*

U ntil this period, each time he had questioned or summoned up a great painter of the past, it had been in order to appropriate him as validation, and to prove to himself that he could equal him in giving expression to the twentieth century. How could the passing of centuries mean that we knew more about their art than Raphael or Velázquez did themselves? How could one check, other than by transposing them, as he had done with Ingres and Poussin, into Cubism's own language, or by taking Le Nain to visit Seurat? From now on the problem was different. It was no longer a question of checking on innovations in pictorial language or some aspect of the craft. The twentieth century had not only transformed the optical expression of painting, changed the relationship with physical reality by bringing in speeds hitherto unknown, instant communication or indeed the cinema's transformation of images, but around about 1950, it was becoming evident that a different vision of the world and of mankind was involved, and hence of art. And so transposing works of art from the past into the twentieth century no longer had the same significance. After Auschwitz, and other death-camps, what else could he make them say that was valid? That was new by stripping them of the bric-à-brac of dead painting? What had happened to the eternal nature of painting?

Portrait of Sylvette

Picasso had begun with an engraving of *David and Bathsheba,* after Cranach the Elder. Then, in February 1950, one after the other, *Portrait of a*

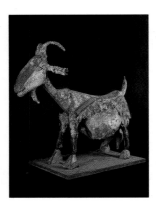

The Goat

Las Meninas
(after Velázquez)

Painter after El Greco, and *Les Demoiselles des bords de la Seine* after Courbet, with shapes that were not only dislocated but overlapping in a space defined by their rhythm, bringing up once more the thorny problem of the relationship between the figures and the spatial framework. But it was transformation in portrait painting that had the edge in the forty versions of *Portrait of Sylvette*, a girl with an unexpected hair-style for that period, a pony-tail. It was at this point that Jacqueline Roque, closer to Sylvette's generation than Françoise's, erupted into his life, and she was to become the companion of the eighteen dazzlingly productive years that remained to him.

1954 brought the sudden disappearance of those who had been his accomplices at the great turning point of 1906; Derain died of the consequences of a car accident at the end of the summer, Matisse, *the* rival, in November. Each time that a master of painting died, Picasso considered it incumbent on him to take up the mantle. It had happened with Toulouse-Lautrec in 1901, and Cézanne in 1906. When Gauguin's death had been announced in 1903, had he not drawn a *Tahitian Woman* and signed it *Paul* Picasso? If Derain had disappeared from modern art after 1920, Matisse had gone on producing masterpieces until the end. His last cut-out gouaches produced coloured rhythms in exploded compositions, the like of which had never been seen, and never painted. Matisse left him his odalisques . . .

All of this took on the form of a dialogue in fourteen pictures with Delacroix's *Women of Algiers*. It turned out that Jacqueline strikingly resembled the woman holding the hookah in the version in the Louvre. Picasso pursued, by means of Delacroix as an intermediary, his exploration of the woman who was to become his tireless model, but at the same time he was confronting Delacroix's composition with the language of Matisse. He would continue this undertaking at his new villa near Cannes, La Californie, which had Moorish fanlights. This latest series continued the dialogue with Matisse's plastic signs. Jacqueline's presence, and that of the studio, became abstracted into lines, flat tints merging with the whiteness of the light. From what point does a pure abstract form become the sign of something else, an object or a figure? What gives non-figurative composition this swing towards analysis of the outside world? From which deviation in the outline, which touch of colour, is representation present?

At the time of the 1912-13 breakthroughs, Picasso had already faced similar problems, experimenting, for example, with the minimum collage sufficient to make a drawing into a papier collé picture; stencil work relief creating deceptive collage effect in painting, and reducing objects like figures to the simplest ideograms possible. This investigation into pictorial language and the language of image would be endless. It was evidently a part of the contemporary inquiry into structural linguistics, because Picasso was in intellectual symbiosis with his age, but without feeling the need to consult specialists. From now on this was to be found in all of his conversations with predecessors, who, henceforth, were to be considered as external raw material, such as Velázquez's *Las Meninas*, which was dissected and reconstructed in fifty-eight paintings (1957), and variations on Manet's *Le Dejeuner sur l'Herbe*, which occupied the whole of 1960-1. These would be followed by sequences on the artist and his model from 1963 onwards, the proliferation of 'Jacquelines' in which Picasso questioned the signs and compositions of Picasso.

But that was only a small part of the debate with abstraction in art. The contradiction between the figure and the spatial framework became transformed into a contradiction between the signs and the space of the painting. *Les Demoiselles des bords de la Seine*, in the manner of Courbet, had already treated figures and space uniformly as interlocking signs, exactly as in 1909-10. Picasso had cut everything up into geometricised surfaces. From now on, the problem was elevated to its ultimate generalisation, authorising all contrasts of form, the most stupefying cutting out and remodelling in works full of vibrant rhythm, with that peremptory force of expression which may be considered the very hallmark of Picasso.

There was no slowing down in the volume of production, for Picasso was more and more haunted, as he turned eighty, by the idea that he might die 'without having said everything'. Since 1949, the upsurge in his painting had gone hand in hand with a return to sculpture. The initial stimulus came from ceramics, moving on to modelling: *The Pregnant Woman* (1949), assemblages that transfigured scrap items: *The Woman with a Pushchair, Girl Skipping, The Goat* (1950), *Female Monkey* (1951), *Woman Reading* (1952), in order to inaugurate a three-way

dialogue with painting: *Skull of a Goat, Bottle and Candle* (1951-3) which would continue until the monumental *Woman's Head* (1964). In the meantime, the series of geometric assemblages of *The Bathers* (1956), an intensely aggressive packing-case *Head* (1958) a *Gas Venus*, made from a burner, a flowering of painted canvases cut up and destined for monumental enlargements, went way beyond all previous experiments.

P icasso was at the height of his creative powers, not only because his eye and his hand, still unimpaired despite his advanced years, permitted him every feat of prowess on the practical level, but also because intellectually he dominated his own century. Through his paintings and his sculptures, he was becoming more aware of the meaning of his Cubism, his Surrealism, and was able to integrate them into syntheses with complete freedom.

Even if he no longer viewed history as a determining factor, he remained in touch with it. He was among those intellectuals who asked for an extraordinary congress of the Communist Party after the invasion of Hungary in 1956. A bull's head, painted in May 1958, seemed to have risen from the ashes of 1938, expressing his anxiety at De Gaulle's return to power. The Cuban missile crisis in 1962 provoked him into a discussion of Poussin's *Massacre of the Innocents* and David's *Rape of the Sabine Women*. But the essential lay well and truly with investigation into the meaning of painting. And if he referred, when some idea summoned them up, to his great precursors, it was his own painting that served more and more as the material for experimentation.

Forced to leave La Californie on account of excessive speculative building, he acquired the Château de Vauvenargues, that is the Mont Sainte-Victoire. His arrival in Cézanne's Provence brought him back to an active questioning of what his way of looking at things had been inherited from his origins, from what Maurice Jardot was to call 'an inner Spain, ardent, grave and simple, strong and frank; a Spain of great depth'; that from which he had been exiled by the survival of Franco. He pursued these considerations further at the Mas de Notre-Dame de Vie at Mougins and they were one of the keys to what he was to entrust to the sketch pad that opened the

series *The Artist and his Model* in 1963: 'Painting is stronger willed than I; she makes me do what she wants.'

This was not a last will and testament, but a manifesto of an eighty-two-year-old who felt himself to be on the verge of boundless conquests. He was going to tackle them head on, relentlessly, and through drawing, engraving and painting simultaneously. The revolt of his youthful years with its impetus towards a clean sweep in art, which had not come about in 1945, was let loose in the early 1960s on an international scale, with Pop Art's 'demolition' of Abstract Expressionism, the 'new realists', support-surface or minimalists ranged against formal painting.

If Picasso found it only normal that he should be a target for the younger generation, he had after all been trained against the background of the death of academic art, and for this reason he had always been alert to the idea that the death of art was something that could happen; an idea that Nazi and Stalinist attacks on modern art had reinforced. He felt himself at a loss in a situation where derision and the challenging of all craftsmanship by young people, gathered together beneath the banners of anti-art, seemed to be going so far as to worship the everyday commonplace and the cult of the 'happening'. He who had known how to raise industry's cast-offs to the level of art, saw the late twentieth century extract from them the very negation of the meaning of his own efforts, a giving way to material appearances, a cult of shoddy goods, a new academism of non-art. He had already experienced the anxiety that the unleashing of abstraction might go hand in hand with the loss of the painter's craft. He saw the spread of this in the facile statement 'everything is art', Dada re-run and in earnest under the fifty-year-old banner of Duchamp! At the same period, the critics, if they greeted his exhibitions too respectfully, relegated him to the sidelines with the comment 'Picasso is having fun'.

For his eighty-fifth birthday, Paris was preparing a complete retrospective of his painting at the Grand Palais. He decided out of the blue to parallel it, by revealing for the first time the existence of his laboratory, the whole of his sculpture, which was practically unknown, assemblages that had never been shown, the whole of that area of his activity that was outside the usual parameters and filled the Petit

*Degas
at the Maison Tellier*

Palais. It was virtually in vain. Outside his circle of friends, no one in France was ready to assess the significance of it, toppling as it did what had been written of the history of modern art until that point. Things would not be the same at the Museum of Modern Art in New York, which already possessed a fine collection of his sculpture. William Rubin acquired the gift for it of *Guitar* (1912-13), the first open-formed sculpture and its unknown archetype in cartoon.

This was the moment when engraving took on a significant role in Picasso's activity. After having undergone a major operation, he entrusted to this genre the task of confirming that he had lost none of his masterly touch. Yet at the same time he defied its centuries-old rules: he combined in series of breathtaking richness, boldness and beauty, erotic exploration – still subject to censorship in France – with an immense Commedia dell'Arte of the Spanish picaresque in 347 engravings exhibited in 1968. And this was to be only the first phase of a venture that continued relentlessly with hundreds of items until 1971, culminating in the sequence *Degas at the Maison Tellier*, unsurpassable in its virtuosity as it questioned mercilessly the relationship between art and sexuality.

Such challenges would have sufficed to use up all the creative energy of a young man. As his ninetieth birthday drew near, Picasso was to contradict this modern overtaking of the heritage of illusionism from the past by devoting himself to the most formidable demolition and questioning of painting. It is probable that the fact that the language of television developed its own autonomy in France during the 1960s, with specifically composed images, outside broadcasts with telephoto lens effects, urged Picasso into these reconsiderations. While he went rarely to the cinema, he had become an assiduous television viewer, and everything conspired to make him take up through painting the new, typically twentieth-century challenge, which reached out to him in those very restructurings of the image, to which his life as a painter had been devoted.

At all events, as in the days of *Les Demoiselles d'Avignon* he was once more systematically breaking down his craft, but it was no longer, as it had been then, to escape from the craft of tradition in order to effect his own coming of age as a twentieth-century artist. Now it was his own craft in twentieth-century painting that he was to overturn. Contrary to appearances, it was not an exercise in iconoclasm – moreover it embraced on the way the dazzling freedom of masterpieces such as the series of *Large Figures* or *The Matador* of 1970 – but rather a cleaning up and stripping down of short-cuts in graphic expression, fussiness and overworked abstraction, effects with materials that had simply become routine. It was indeed his own art that he was levelling out, that he dismantled as none of those younger than him would have been capable of doing, and not only to make it confess all of its secrets, but at last to discover what it was that made him unable to resist painting. It was almost as if he was turning his back on the completion of his art, leaving it under construction for his successors.

There was also a gigantic battle going on with the little time that was left to him. Here he was, launching forth into 'badly done things', the most summary of outlines, the most indefensible of mistakes of composition, vulgarity of execution, as if old age had made it impossible for him to concentrate, only to redeem all at the very last moment, imposing his indelible imprint on various versions of *Embrace, Couple, Kisses* that would frighten fashionable critics away when they were exhibited in Avignon in 1970 and 1973. There would also emerge from the domain of the impossible in painting a *Bather Standing,* a *Child with a Spade,* a *Motherhood,* nudes seated or lying down, musicians whose bold expressiveness was all the more striking as it was perched on the edge of the abyss: the final silence of the paint-brush at the end of 1972. Beforehand, Picasso had produced, as if playfully, with the simplest of means, a *Young Painter* before whom the whole of the future was opening up.

Hence the extraordinary intensity of this end of the journey with hundreds of paintings, making no concessions to anybody or anything, pushing to the very limits of creation and ending with the drawings of his own death. Since *Derniers Moments* of his early days, he had never ceased grappling with death, and so, feeling his end to be near, must have

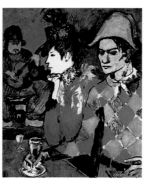

At the Lapin Agile

demanded from his art that it focus its gaze on his own death, on the irremediable defeat of his being, to which, as ever an atheist, he conceded no after-life, except that of his works. In this he undoubtedly showed himself to be, until the last, the man who had looked the twentieth century straight in the eyes, as Gertrude Stein had predicted.

French museums, which had never bought a work from Picasso, let the *Self-Portrait When Facing Death* of 30 June 1972 go off to Japan. But in any case they did not deserve it.

Triumph after death

In his lifetime, Picasso to all intents and purposes was not familiar with the learned reconstructions of his creative career. He had on the other hand already seen his *Self-Portrait* of 1901 beat price records for a modern painting, which left him with mixed feelings about a virtuoso work, completed when he was nineteen. He was not sure that the fuss about this picture did not stem from the fact that it had originally been bought by Hugo von Hofmannsthal in 1911 at Tannhauser's. What would he have said if he had known that the same self-portrait would beat the record again in 1981, for about ten times as many dollars, 5.83 million to be exact, and that its price would subsequently be multiplied by eight for a new record of 47.85 million dollars in 1989? He would doubtless have experienced the same surprise, mingled with confusion, at the announcement that *The Marriage of Pierrette* at 300 million francs had broken this record. He would probably have paid more attention to the fact that *At the Lapin Agile*, a more difficult, stronger picture, fetched 40.7 million dollars, and especially that his *Mirror* of 1932, one of the finest pictures of the Marie-Thérèse cycle, fetched 26.4 million dollars. Whatever the causes of this frenzied speculation in modern art, it is significant that its scale of values depends more on the taste and above all on the powers of discernment of the purchasers or the institutions capable of spending such sums, than on the objective significance of the works. He would have been comforted by the idea that there had been a similar craze for the hapless Vincent van Gogh, with equally irrational fluctuations in price, with *La Promenade de Manet* fetching only 14 million dollars for example.

I am still convinced that Picasso would not have seen in all this any triumph for his ideas or his art. After all, his Parisian museum is made up of works that his dealers refused or that he never wanted to sell, and before receiving the museum's stamp of approval, it is doubtful whether the market would have had much of a fate in store for most of them. If he lived from the art market all his life, if he was attentive to the prices he received, he nevertheless held it in a reasoned disdain. 'What is a painter basically?' he asked his dealer Kahnweiler one day. 'He's a collector who wants to build up a collection by painting himself the pictures that he likes in other people's houses. That's how I start off, then it turns into something else.'

It was this 'something else' that made Picasso's art inseparable from the twentieth century.

PIERRE DAIX

The documentary sources of this essay are to be found in my biography Picasso créateur, *Paris, 1987, and in particular in the American edition which was completely revised.*

A Spanish childhood

Pablo Picasso was born in Malaga on 25 October 1881; his father's origins were in the Basque country, and his mother was Andalusian. He was the family's first-born child, inheriting his mother's black eyes and jet-black hair. Maria Picasso had sent for her mother and two unmarried sisters to be with her in the comfortable apartment on the Plaza de la Merced as she kept an eagle-eyed watch over the small boy.

Pablo's exceptional giftedness at drawing became evident very early. Even before he knew how to read, to the amazement of his playmates, he would cut out all kinds of animal shapes from large sheets of paper.

Don José Ruiz Blasco saw in his son's precociousness compensation for what had been his own fate. He was a gentle man, conscientious in his work, combining the offices of drawing teacher, picture restorer and curator of the municipal museum in Malaga.

Don José, whose blond hair, fair complexion and pale eyes set him apart from the rest of the family, used to spend his leisure hours painting. Birds were his favourite subject, and he would often ask Pablo to finish his canvases for him, especially the birds' claws, the most difficult part to get right. The child went into action and the results were disturbingly perfect. But simply helping his father with what he later called his 'dining-room pictures' did not satisfy him. He had his own albums for personal work. At the age of eight, Pablo completed his first painting, oil on wood, and proudly entitled *The Picador*, which he kept all his life.

In 1891, the municipal museum at Malaga closed down. Don José, having thus lost his job as curator, was obliged to take up duties as drawing master at the Guarda Institute at Corogna. But before leaving, he solemnly gave up all his painting materials, with the clear-sightedness of a man who realises that his son is a much better painter than himself.

'Then much later on,' Picasso recounts, 'he gave me his paints and brushes and he never painted again.'

Aware that powers were being handed on, Pablo from now on gave up signing his works with his full name, Pablo Ruiz Picasso, preferring to use just his father's surname, Pablo Ruiz.

The family was growing in size, and Pablo now had two sisters, Lola and Concepcion, the latter of whom died of diphtheria just a couple of months after their arrival at Corogna.

In the early summer of 1895, Don José took his son to the Prado Museum in Madrid. The child was full of wonder as he discovered the great masters of Spanish painting.

1
The Plaza de la Merced at Malaga where the Ruiz family lived until 1891.

'I never did childish drawings. At the age of twelve, I was painting like Raphael.'

2
A study in the classical style. Picasso would say later: 'I'm not in favour of following any particular school, for that brings with it nothing but the mannerism of those who follow it.'

2 *Torso*, 1892-3
Charcoal & Conté pencil on paper, 52.4 × 36.7 cm
Picasso Museum, Barcelona

3 *Portrait of the Artist's Mother*, 1896
Pastel on paper, 49.8 × 39 cm
Picasso Museum, Barcelona

3
Picasso was fourteen, when he did this portrait of his mother, a pastel painted at Barcelona.

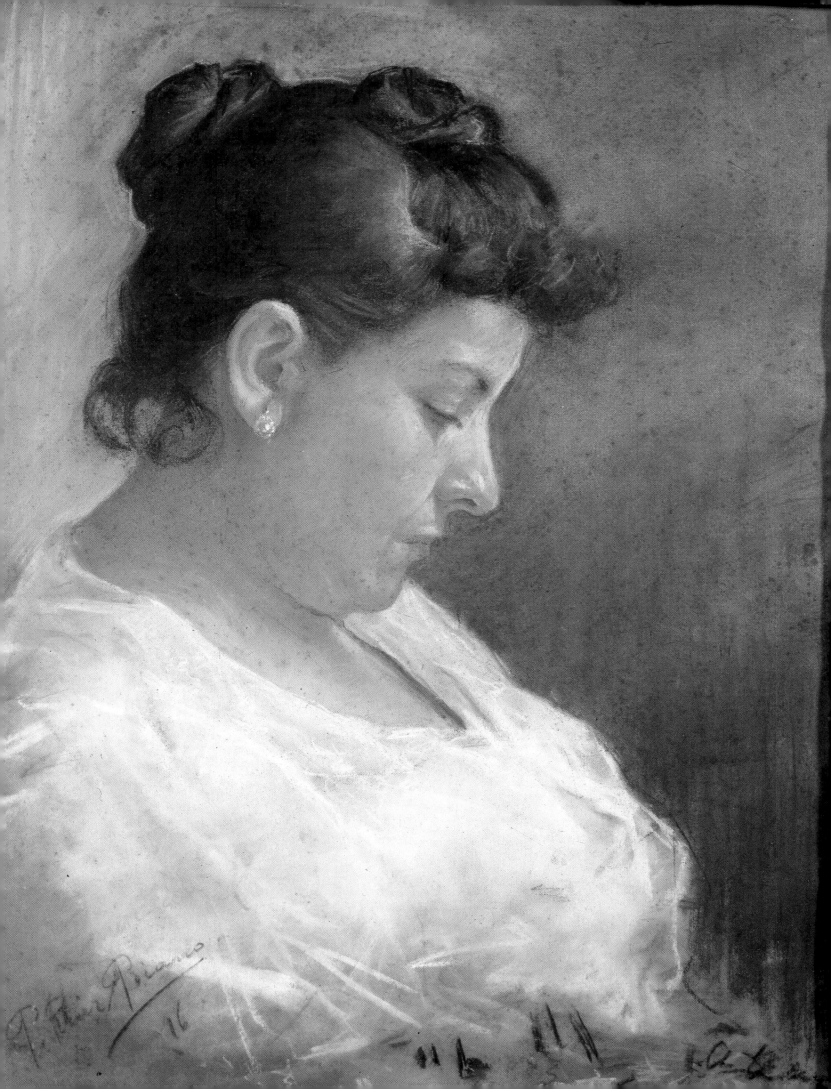

In 1895, Picasso's father was appointed to a teaching post at the Academy of Fine Art in Barcelona.

Picasso took straight away to this city, teeming with life and turned towards Europe. At fourteen, he was too young to take the entrance exam to the Academy, but his father pulled strings with the board of examiners and eventually obtained the necessary dispensation. The syllabus for the entrance exam comprised a classical study, still life, life and painting. Legend has it that Picasso completed in one day a subject for which a month was allocated. Two of the drawings that he presented for the examination have been found and they are dated 25 and 30 September respectively. The lecturers were amazed at the skill of the young artist. He passed brilliantly and was admitted to the senior section of the Academy. Don José was delighted.

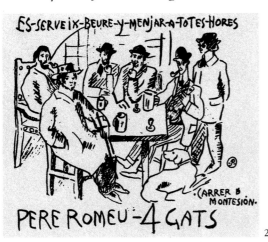

Emboldened by his success, Pablo got his father to agree to rent for him a small studio, where he would have more room to work. This was the period of the two great academic masterpieces painted when he was fifteen: *First Communion* and *Science and Charity*. This latter picture, in which Picasso painted his father at the bedside of a sick woman – which is bound to recall his younger sister Concepcion and her premature death – was awarded an honourable mention at the Academy of Fine Arts exhibition in Madrid, and the gold medal at Malaga. For his family, this was a first endorsement of his talent. And so Picasso was sent to Madrid, but an attack of scarlet fever soon hastened his return.

From now on Pablo had his own studio and became a regular at the Els Quatre Gats bar where all the members of the literary and artistic avant-garde of Barcelona society gathered. The bar, which he decorated with twenty-five full-length portraits, became one of his favourite places for exhibiting. Picasso worked, celebrated friendship, got involved with the prostitutes of a neighbouring brothel: he was eighteen and relishing life.

'Els Quatre Gats . . . it was already Montmartre, on the plaza di Cataluña.'

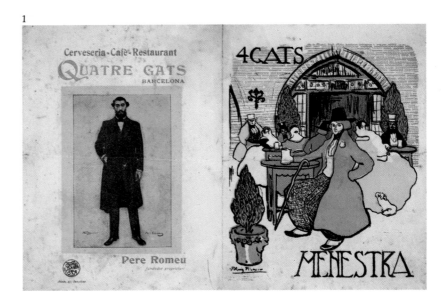

2
This poster by Picasso features portraits (*l-r*) of Romeu, Picasso, Roquerol, Fontbona, Angel, F. de Soto and Sabartès.

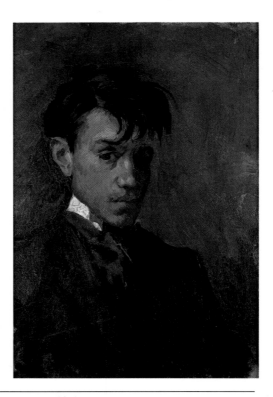

1
The menu cover of Els Quatre Gats was designed by Picasso in 1899. He amused himself by giving an English touch in the style of Aubrey Beardsley. On the back of the menu, old Romeu, proprietor of the bar, painter, poet, dreamer, madly in love with Paris, Aristide Bruant and *Le Chat Noir*.

3
The marked romanticism of this self-portrait, painted when he was fifteen, contrasts with the academic portraits that the artist was producing to satisfy his teachers.

1 *Menu cover of Els Quatre Gats*, 1899-1900
Printed, 21.8 × 32.8 cm
Picasso Museum, Barcelona

2 *Poster for Els Quatre Gats*, 1902
Pen & ink drawing, 31 × 34 cm
Private collection, Ontario

3 *Self-Portrait with a Wayward Lock of Hair*, 1896
Oil on canvas, 32.7 × 23.6 cm
Picasso Museum, Barcelona

4 *Science and Charity*, 1897
Oil on canvas, 197 × 249.5 cm
Picasso Museum, Barcelona

4
This picture, with its rigorous composition, bears testimony to the virtuosity of its young creator, despite the academic nature of the subject and its execution. Don José, Picasso's father, can be recognised in the features of the doctor at the sick woman's beside.

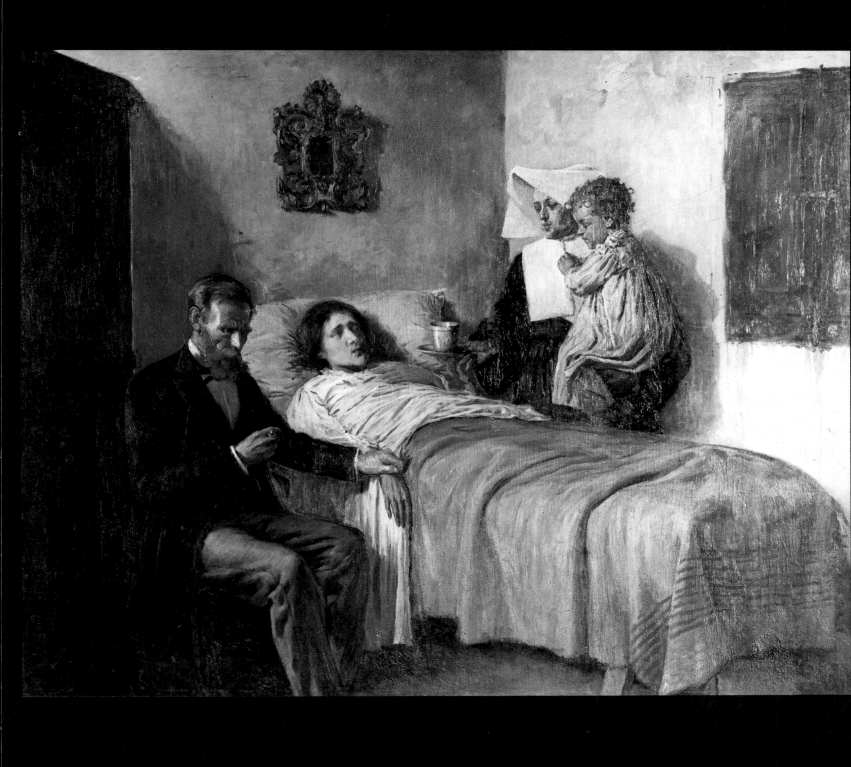

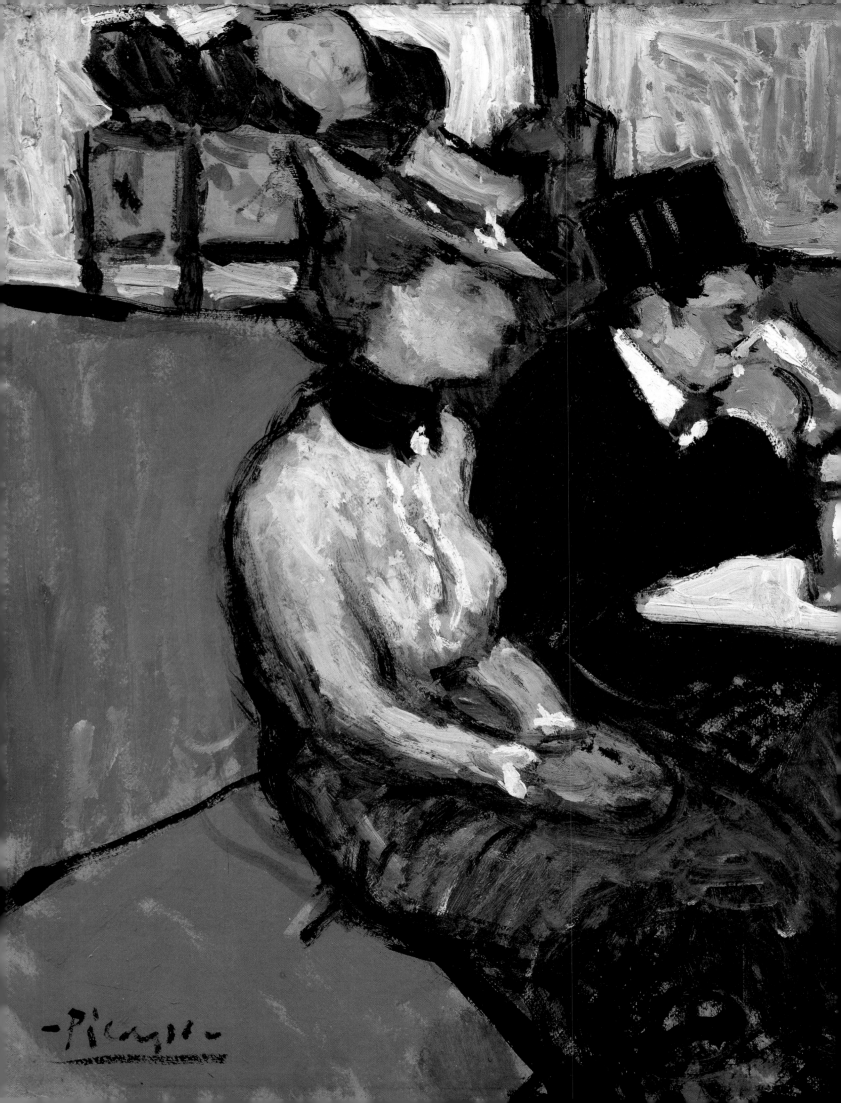

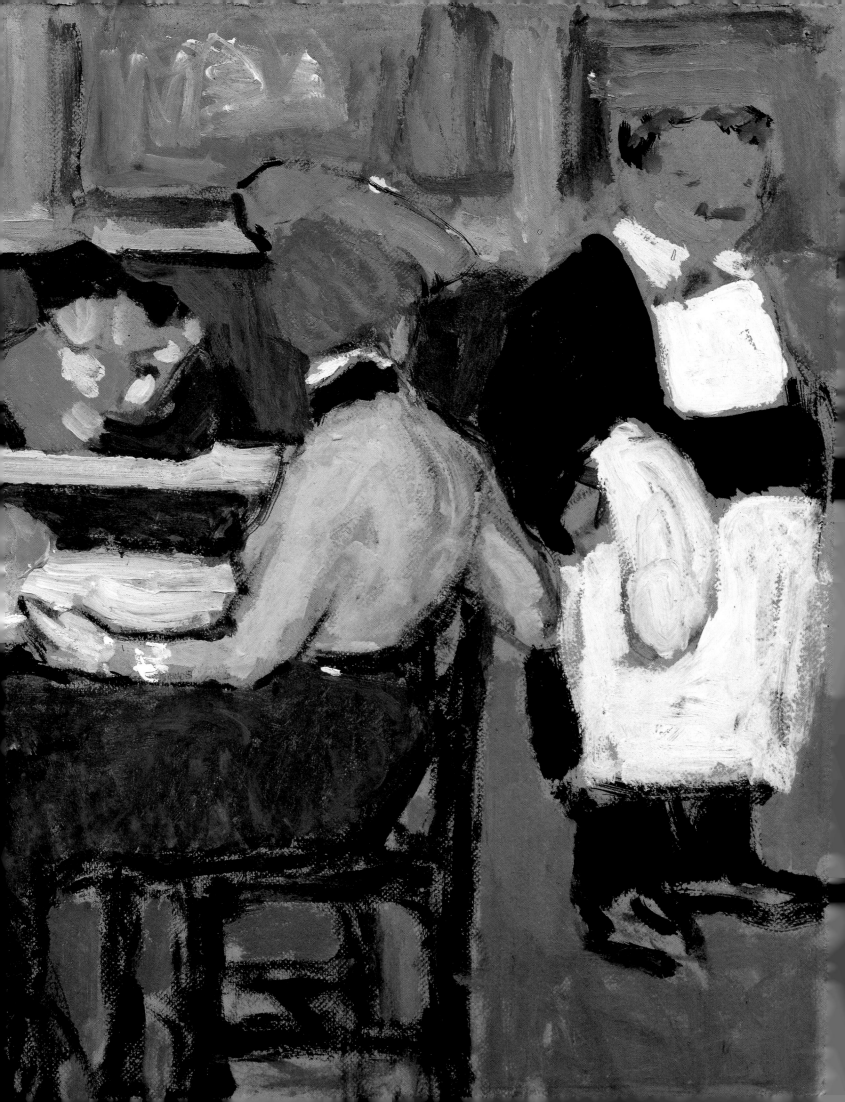

Paris

'If I had a son who
wanted to be a painter,
I wouldn't keep him in
Spain for a minute.'

The year 1900 posed problems for Picasso. The young man was scarcely well off and family disagreements the previous year had considerably reduced his income.

And so he made up his mind to share a studio with his friend Carlos Casagemas at 17 St Joan Street. The studio was unfurnished, minute and badly heated. But what did it matter! As they had no funds for furniture, Picasso decorated the walls and painted on them the table, cupboard and chest of drawers that they were short of. And after all, Picasso had work to do: he was getting ready for a big exhibition of drawings and paintings for the Els Quatre Gats. They were mostly portraits, in pencil, charcoal or watercolour, of Barcelona personalities, such as the painter Joaquin Mir. It occasionally happened that the drawings were bought by the models themselves for two or three pesetas; enough to have a real feast with, and to which all the regulars of the bar would be invited. Then, in October, Picasso, Casagemas and Manuel Pallarès left

1

1
Montmartre at the time of Picasso's arrival in Paris. In the background, to the right, the 'Bateau-Lavoir', where Picasso lived from 1904 to 1909.

2
The Bullfight, pastel, 1900, probably part of a series on this theme bought by Berthe Weill.

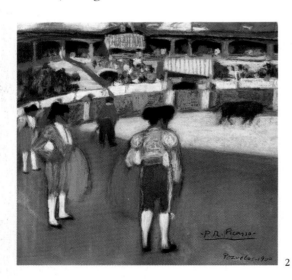

2

3
Studies dating from 1899. The portrait in profile on the left and the person in the middle wearing a hat are representations of Picasso himself, with the permanently wayward lock of hair and the Bohemian style of dress that he affected.

Spain for the first time.

Picasso had for a long time been dreaming about Paris, the capital of the arts and of love, home of Toulouse-Lautrec, Steinlen, Cézanne, Degas, Bonnard and many other painters admired by the young Spaniard.

In Paris, the three friends stayed at the studio of their fellow countryman, the painter Nonell, at 49 rue Gabrielle in Montmartre. Nonell showed them around, and introduced them to three ravishing models: Antoinette, Odette and Germaine, who was the most fetching and the prettiest. Casagemas fell desperately in love with her. Picasso would then set about courting Odette.

Preceding pages:
At the Restaurant
Oil on canvas, 33.7 × 52 cm
Private collection

2 *Bullfight*, 1900
Pastel, 36 × 38 cm
Private collection

3 *Studies*, 1899
Picasso Museum, Paris (RMN)

4 *Spanish Couple in front of an Inn*, 1900
Pastel on cardboard, 40 × 50 cm
Private collection

4
This picture, classical in its execution, is a reminder of Picasso's studies at the Academy of Fine Art and its formal teaching. But the intensity of colour and the perfection of the drawing make this work stand out, and evoke the flair of Steinlen or Toulouse-Lautrec.

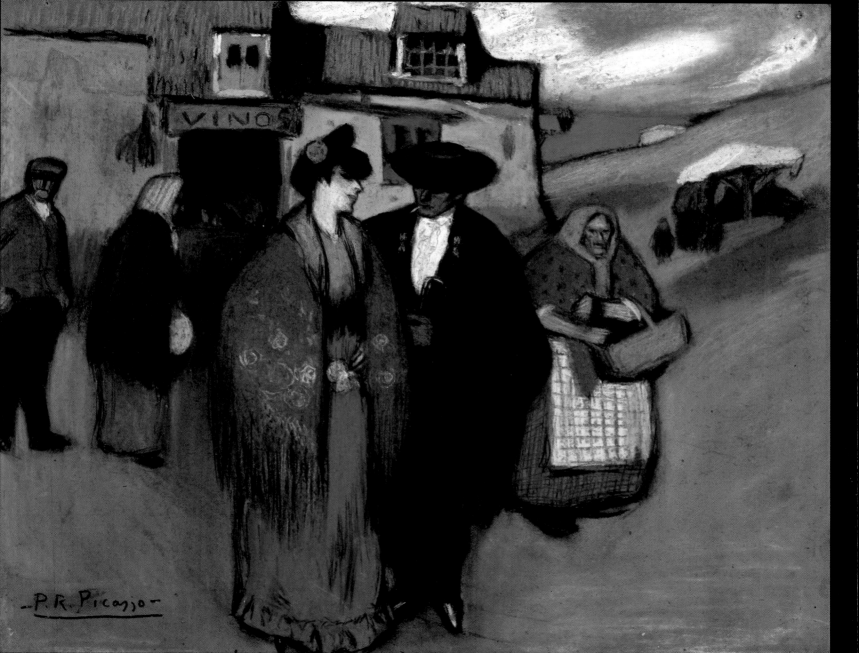

'I hate copying, but when somebody shows me a folder of old drawings, for example, I don't hesitate to assimilate everything I can from it.'

1
Picasso recognised in Cézanne one of his masters, long before the latter's triumph at the Autumn Salon of 1904. Cézanne, who painted a number of pictures on the theme of the *Montagne Sainte-Victoire*, was the first 'to approach nature through the cylinder, the sphere and the cone'.

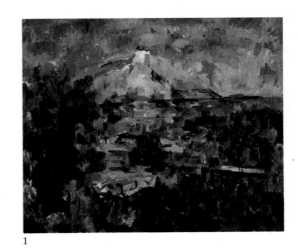

1

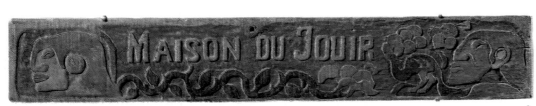

2

2
This panel was sculpted by Gauguin over the lintel of his house on the island of Hiva Oa, built on stilts and roofed with coconut palms. Picasso was as fond of Gauguin's painting as he was of the man himself, since he read his fascinating autobiography, *Noa Noa*. When he learnt of the painter's death in December 1903, Picasso signed the nude he was painting *Paul* Picasso.

3
Picasso lived on the top floor at 130 boulevard de Clichy. He portrays his bedroom with the realistic technique as practised at Barcelona. The influence of Degas, Vuillard and Toulouse-Lautrec can also be detected. The latter's poster of the dancer May Milton is pinned to the wall, and Picasso maintained that he had removed it from a wall in the street.

3

4
The hair is shorter, carefully combed on each side of a parting, the suit elegant. Picasso the dandy is even wearing gaiters!

Picasso discovered the museums of which he had dreamt. He studied Degas, Ingres and Delacroix in the Louvre, admired the Gothic sculpture in the Musée de Cluny, and discovered the Impressionists. He was filling notebooks with sketches, and from now on signed himself Pablo R. Picasso.

Then he made two decisive encounters: Mañach, a Catalan industrialist who was sufficiently interested in his painting to offer him 150 francs a month for a regular delivery of a few attractive paintings or drawings, and Berthe Weill, a young woman, passionately interested in modern painting, who bought three paintings from him and became his first dealer. She recounts: 'A young Spaniard, Mañach, brings us works by Nonell, a Catalan painter . . . Mañach never ceases to look after his compatriots. I bought from him the first three pictures sold by Picasso in Paris, a series of bullfights, at 100 francs for the three. To Monsieur Huc, a large picture *Le Moulin de la Galette* was sold for 250 francs.'

1 *La Montagne Sainte-Victoire*, 1904-6. Paul Cézanne
Oil on canvas, 60 × 72 cm
Kunstmuseum, Basle

2 *Maison du Jouir*. 1903, Paul Gauguin
Panel of sculpted wood (lintel), 40 × 244 × 2.5 cm
Musée d'Orsay, Paris (RMN)

3 *Woman Washing* (or *The Blue Bedroom*), 1901
Oil on canvas, 50.4 × 61.5 cm
Philipps Collection, Washington

4 *Picasso in the Madrid Style*, 1901
Wax crayon, 46 × 16.5 cm
Private collection

5 *Harlequin Leaning on an Elbow*, 1901
Oil on canvas, 80 × 60.5 cm
Metropolitan Museum of Art
(donated by Mr & Mrs John L. Loeb), New York

4

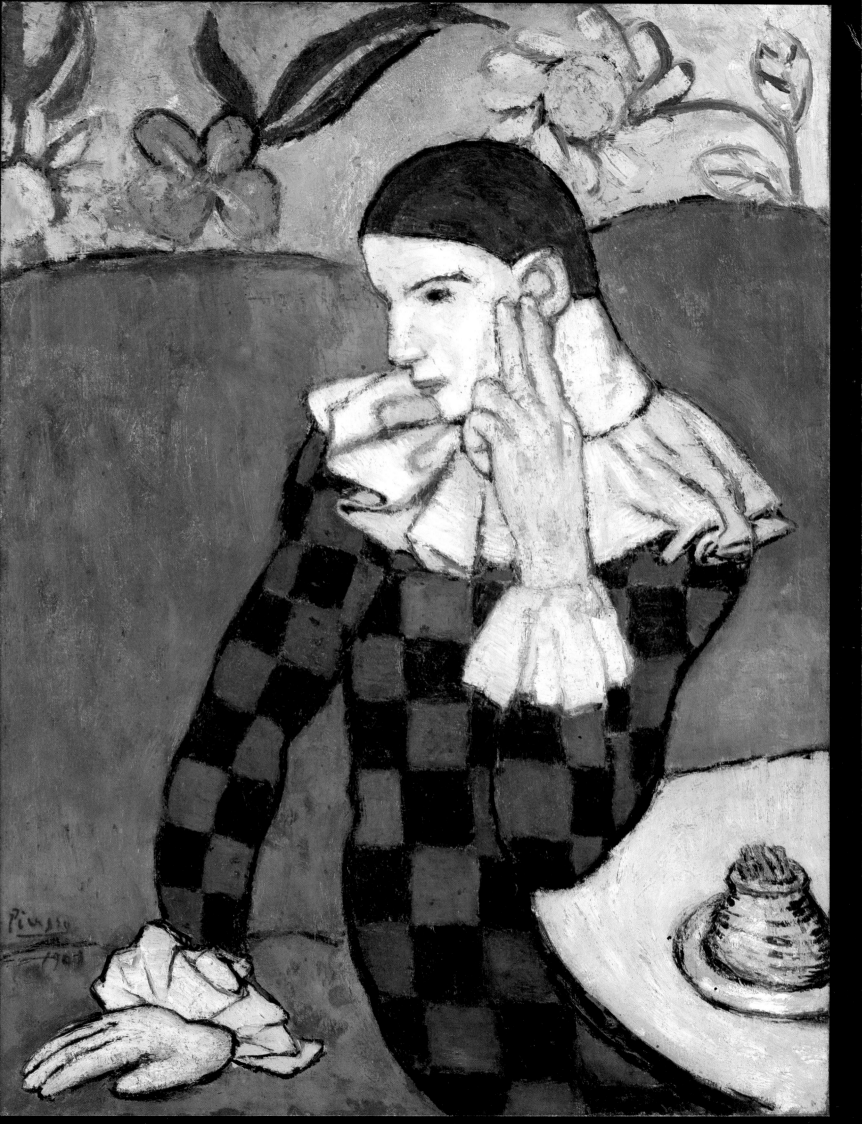

icasso and Casagemas left Paris for Barcelona, but his rows with his family rapidly got worse. His parents did not care for his Bohemian appearance and were wary of his audacious painting. They dreamt of the glorious career of an academic painter for him, whereas he aspired to be 'more modernist than the modernists'.

Picasso fled quickly from Barcelona where he was no longer understood.

Compounding this disappointment was Casagemas's brief sadness at being separated from Germaine, whose affections he had not succeeded in winning. The two friends escaped for a few days to Malaga, hoping to restore their courage and vigour.

A week later, the young men went their separate ways, strengthened by the new re-

1

solutions they had made, their new plans: Casagemas headed back to Paris to see Germaine once more, this time in the hope of becoming her lover. Picasso set off for Madrid to edit and illustrate an ambitious magazine, *Art, Joven*, co-founded and produced by the Catalan writer Francisco de Asis Soler. The first four issues came out, but despite the magazine's intellectual and artistic qualities, it was a failure. This was a hard blow for Picasso. His distress was all the greater as he had just received some tragic news: the suicide in Paris of his friend Casagemas.

Pablo was in a daze, crushed with grief. He sank gradually into melancholy which, a few months later, would give birth to a phase of exceptional creativity that he would nurture for more than four years.

'The drawing should not be to one side and the colour to the other . . . When one finally looks at the drawing and the colour, they should be one and the same thing.'

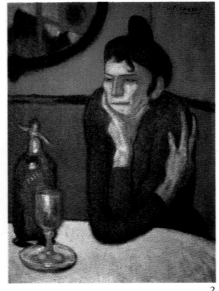

1/2/3
Paris at the turn of the century offered a freedom of spirit and morals that was unthinkable in Spain at that time: lovers kissing in public, women alone in cafés . . . To the avenues frequented by the smart set and garden parties, Picasso preferred the narrow streets where workers, artists and rogues rubbed shoulders, cafés where people spoke in loud voices, where one might meet a woman with a vacant look over a glass of absinthe.

2

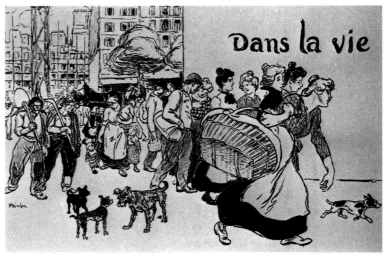

3

2 *Woman Drinking Absinthe*, 1901
Oil on canvas, 73 × 54 cm
Hermitage Museum, Leningrad

3 *Dans la vie*, 1900. Steinlen
Ink & pastel

4 *Woman with a Chignon*, 1901
Oil on canvas, 75 × 51cm
Harvard University Art Museum
(donated by Maurice Wertheim), Cambridge

4
The face of Germaine can be recognised in *Woman with a Chignon*, painted in 1901.

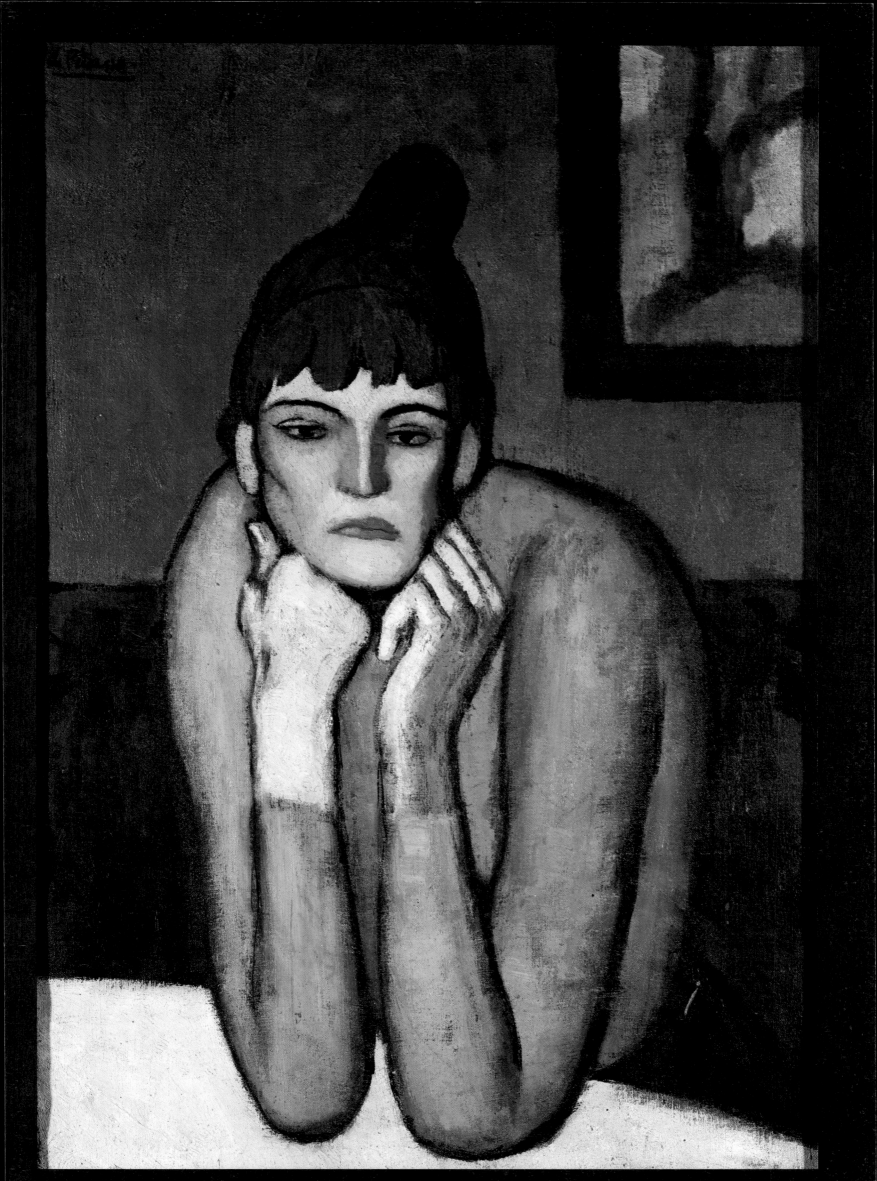

Friendship and death

Casagemas, his companion during bad days as well as the good times, was dead. He fired a bullet at his temple after having threatened Germaine at the Hippodrome café at 128 boulevard de Clichy. He was twenty, the same age as Picasso. Pablo was distraught. Urged by the Catalan painter Mañach who wanted to organise an exhibition for him at the famous dealer Ambroise Vollard's, Picasso returned to Paris and moved into Casagemas's studio at 130 boulevard de Clichy.

In the autumn, Picasso embarked on one of the most outstanding periods of his life as a painter: the Blue Period. From now on he painted solitude, poverty, grief, the coldness of the world and its indifference to the despair of simple people. The artists around Picasso welcomed these new pictures enthusiastically. For Sabartès, Picasso 'was himself again . . . one might say that this painting in blue bears witness to his conscience'. A return to himself and to life as it really was; without glamour, without cheating. It took a degree of courage to paint in a single colour at a time

1

1/4
Two studies for *La Vie* have been discovered, in one of which Picasso gave the man his own features. In the final version, it is against Casagemas's shoulder that a woman with a sad, downcast look is leaning. The couple are naked, or almost, as Casagemas is wearing a white loincloth, symbol of a sexuality that proved impossible. They will remain infertile. That is why there is no response to the gesture of the man towards the clothed woman, who is carrying a child in her arms. In the middle, two sketches express pain and solitude. *La Vie* is one of the key works of the Blue Period.

'It was while thinking of Casagemas that I began painting in blue.'

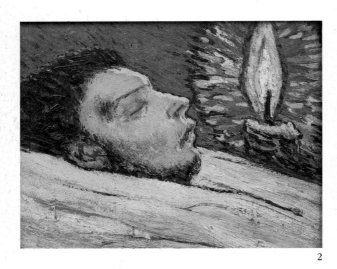

2

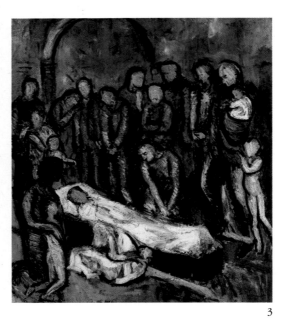

3

2/3
In order to exorcise that memory with which he was obsessed, Picasso painted a number of portraits of his dead friend. In *The Death of Casagemas*, the bloody mark made by the bullet can be clearly made out on the suicide's temple. From memory, Picasso painted Casagemas in his shroud, lit by a candle, the strange light of which is reminiscent of van Gogh's technique.

when Fauvism was making its appearance. But if this boldness delighted the painter's friends, it displeased the dealers and the public. Mañach broke the contract by which he had agreed to pay Picasso 150 francs a month. Berthe Weill was no longer able to cope: 'I don't mind taking a few of Picasso's drawings and paintings here and there, but I can't manage to support him, and I'm upset about it, because he's cross with me. His eyes frighten me, he knows it and takes advantage.'

1 Study for *La Vie*, 1903
Pen, 15.9 × 11 cm. Picasso Museum, Paris (RMN)

2 *The Death of Casagemas*, 1901
Oil on wood, 27 × 35 cm
Picasso Museum, Paris (RMN)

3 *The Corpse, The Burial*, 1901
Oil on canvas, 100 × 90.2 cm
Private collection, USA

4 *La Vie,* 1903
Oil on canvas, 196.5 × 128.5cm
Museum of Art (Hanna bequest), Cleveland

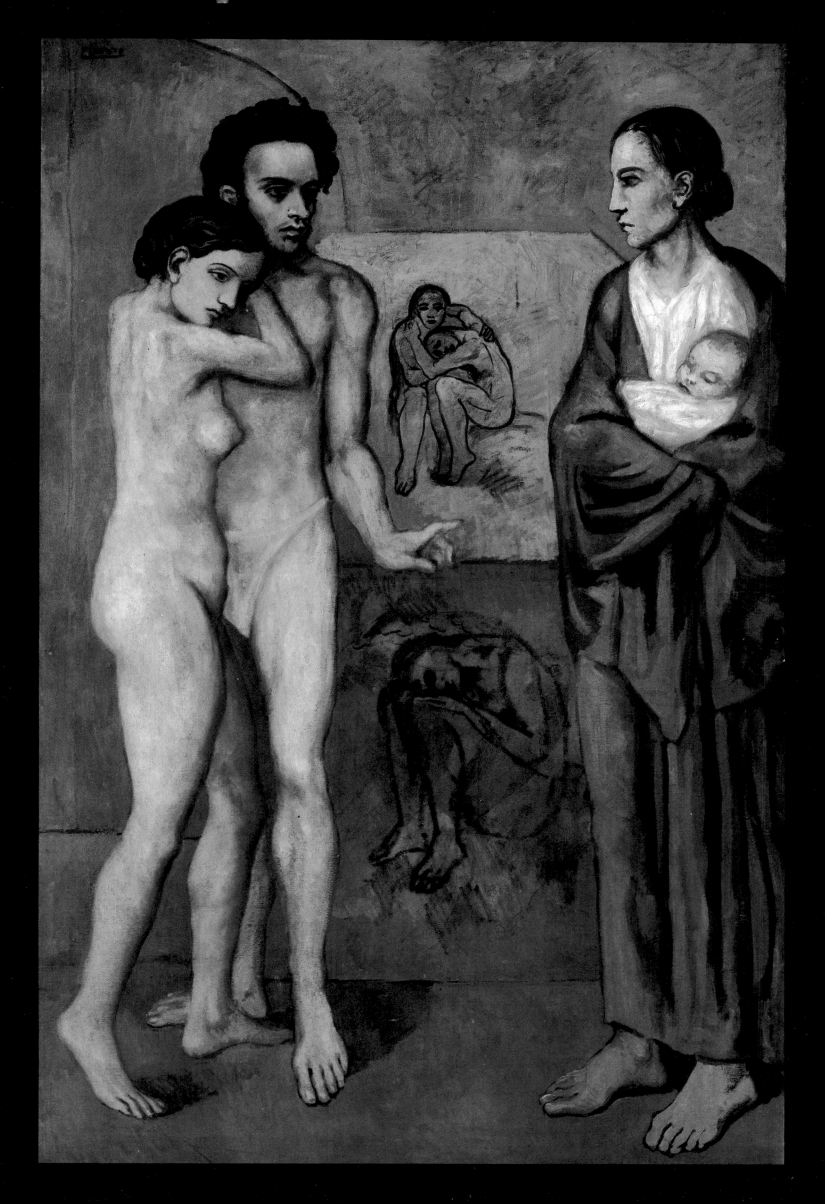

Max Jacob in front of the 'Bateau-Lavoir'

'It is the colour to beat all colours,
the bluest of all the blues.'

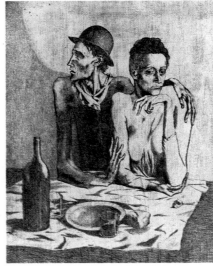

2 3 3/5

The Frugal Meal, second
engraving on zinc by
Picasso, is a masterpiece of
this technique. The thinness
of the characters, the
slenderness of the hands
and their extreme mobility
are reminiscent of *The
Blind Man's Meal*, painted
the previous year. To his
friend Sabartès who used to
say, 'Picasso thinks that art is
the child of sadness and
pain,' Picasso would answer,
'I'm only painting the age in
which I live.'

Picasso would remember later: 'When I
started to paint blue pictures . . . people didn't
like it at all. It went on for years. That's the way
it's always been for me. Fine, and then, all of a
sudden, very bad.'

It was at this point that Picasso met Max
Jacob, a penniless poet and art critic. The two
men very quickly took a liking to each other,
and Jacob became the painter's first French
friend and one of his most fervent admirers: 'I
had been so filled with a sense of wonder at
what he was producing . . . that I had dropped
in a note of admiration at Ambroise Vollard's.
And the same day, I received from Mañach an
invitation to visit. From the very first we felt a
great deal of empathy for each other. He was
surrounded by a bunch of impoverished
Spanish painters, who used to sit on the
ground to eat and chat. He was doing one or
two pictures a day, wore a top hat like me and
spent his evenings in the wings of music halls
. . . sketching portraits of the stars.'

Picasso and Max Jacob decided to pool
what little money they had and share a room
on the boulevard Voltaire. As the room had
only one small bed, the two men took it in
turns to sleep: Picasso would paint at night
and go to bed at first light when Jacob went off
to work. It was a life of great poverty, ex-
hausting and distressing. Worn out by tired-
ness, malnutrition and the cold (he admitted
to Sabartès that he had to burn paintings and
drawings to try to warm the room), Picasso
went back to Spain. He would return to Paris
the following year, moving in to a great ram-
shackle building occupied by painters at 13
rue de Ravignan in Montmartre, that Max
Jacob nicknamed the 'Bateau-Lavoir'.

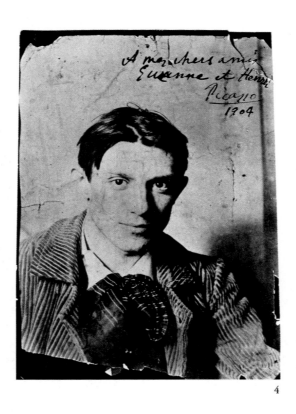

4
This photograph, taken by
the painter Ricardo Casals
in 1904 bears a dedication
to the violinist Henri Bloch
and his sister Suzanne, the
highly talented singer of
Wagner and whose portrait
Picasso painted the same
year.

4

2 *The Bistro*, 1900. Steinlen
Poster

3 *The Frugal Meal*, 1904
Engraving on zinc in black, 46.3 × 37.7 cm
Museum of Modern Art
(donated by Mrs A.A. Rockefeller), New York

5 *The Blind Man's Meal*, 1903
Oil on canvas, 95 × 94.5 cm
Metropolitan Museum of Art
(donated by Mr & Mrs Ira Haupt), New York

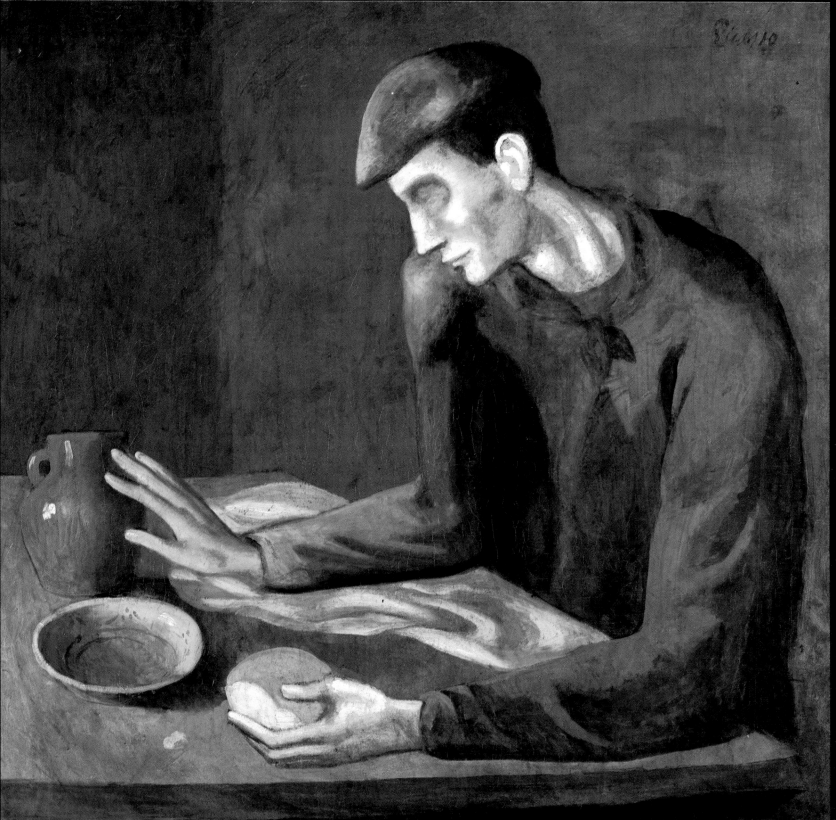

1904: 'Bateau-Lavoir'

The 'Bateau-Lavoir' was a vast, rambling building that was damp, dirty and without running water or electricity. But it was also a miraculous shelter for penniless artists who lived there as one big family. Madame Coudray, the big-hearted concierge, protected this little group as best she could, often taking bread and soup to the most hard-up. Picasso moved in in the spring of 1904, and quickly became friends with André Salmon who would recall the painter's studio in his *Souvenirs sans fin*: 'A wooden cabin for painting in

1

2

... Built inside the original shape of the studio, a small room with something resembling a bed in it ... In order to paint or to show pictures, the light of a candle was necessary ... Picasso held one high in front of me when he gave me a human introduction to the superhuman world of his starving and crippled people, his mothers with no milk; the super-real world of Blue Wretchedness.'

But if money was in short supply, an appetite for life was not lacking. Max Jacob tells of nights spent in Picasso's studio: 'We didn't have the six sous for a beer over the road, but beneath the shade of an oil lamp hanging from the cobwebby beams on a piece of bent wire, we improvised scenes, whole plays, crazy disguises. Picasso would laugh, and join in and his laughter was our aim.'

1
The 'Bateau Lavoir' at 13 rue de Ravignan. Picasso marked the exact location of his studio windows with a cross. Braque, van Dongen, Juan Gris, Modigliani, Pierre Reverdy, Mac Orlan, Max Jacob and many other major artists of the early years of this century would also live here.

2
Picasso in Montmartre in 1904. 'Yes, I was famous at the Bateau-Lavoir! When Uhde came from farthest Germany to see my paintings, when young painters from every country brought me what they were working on, asking me for advice, in the days when I never had any money. I was famous there ... a curiosity.'

3
The model was the daughter of the proprietor of the Lapin Agile, Margot, who was later to marry the writer Pierre Mac Orlan. The artist's palette is becoming warmer, no longer absolutely monochrome, an orangey ochre bringing light to the picture.

3 *The Woman with the Crow*, 1904
Gouache & pastel on cardboard, 65 × 49.5 cm
Museum of Art, Toledo

36

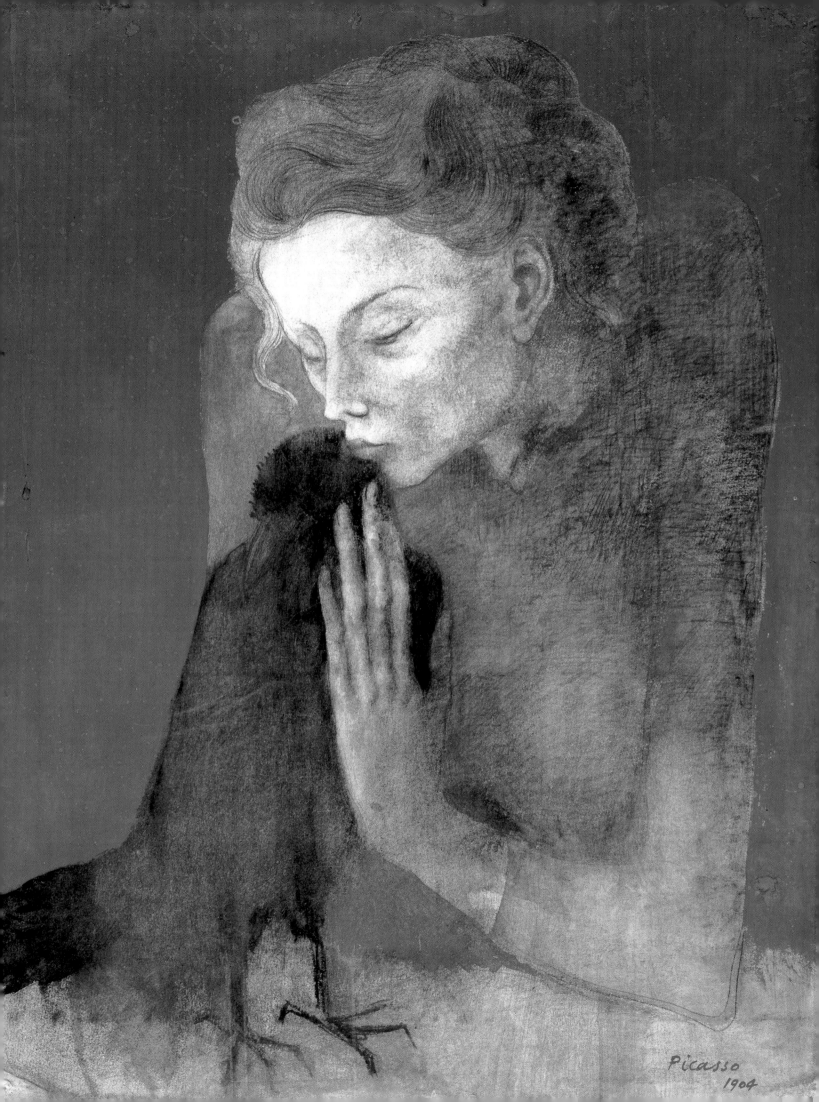

I met Picasso as I was going home one stormy evening. He was holding in his arms a very young kitten that he offered me with a laugh, but prevented me from getting by. I laughed as he did too. He showed me round his studio.'

Fernande Olivier was tall, well built, sensual with hair a deep tone of russet. Picasso liked her gaiety. The young woman and the painter were to love each other for nine years. Picasso drew her thousands of times; he was madly in love and light entered his painting.

Fernande set about organising Picasso's life as best she could, without interfering with the untidiness with which he liked to be surrounded and which he needed in order to be able to paint. Finding enough to eat and the means of keeping warm were her prime concerns. But she was a clever manager. When there was no money, she had recourse to the 'pastrycook trick': 'We would order lunch from the pâtissier in the place des Abbesses. At midday the delivery man would knock in vain, leaving his basket at the door, which was opened as soon as he had left.'

The same technique was used for coal. 'I can't open the door, I haven't got any clothes on!' Fernande would shout to the delivery boy, who would sheepishly put down his sack and clear off saying: 'You'll have to pay next time!'

Fernande and Pablo were happy, despite their Bohemian existence and its harsh realities: 'In summer the studio was like an oven. Picasso and his friends received visitors half naked, dressed only in a scarf tied around the waist. In winter, it was so cold in the studio that tea left in the bottom of a cup would be frozen the following morning. This was the end of the Blue Period. Large, unfinished paintings were propped up in the studio where everything was imbued with work, but work amidst such disorder . . . '

Fernande

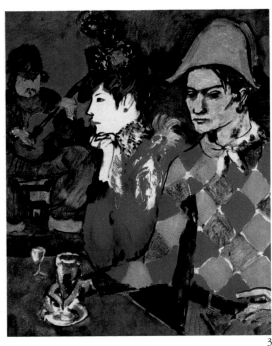

1
Van Dongen, his wife and their daughter Dolly moved into the 'Bateau-Lavoir' in 1906. The artist's studio, on the ground floor to the left, was the smallest of all, and the only one to have a window overlooking the square. Thus he was often mistaken for the concierge. The van Dongens were very friendly with Fernande and Pablo, whom little Dolly, who played with him for hours on end, used to call *Tablo*. Van Dongen did several portraits of Fernande, foreshadowing the famous women with almond eyes that were to make him famous later.

2
Fernande, Picasso and his dog Frika in 1906.

3
At the Lapin Agile (from the name of Gill, who painted the sign), a famous bar in the rue Saint Vincent, belonging to old Frédé, was the meeting place for the artists of Montmartre. Frédé is in the background with a guitar in his hand. Picasso painted himself in the guise of Harlequin. At his side is Germaine, making her final appearance in the painter's work. The arrival of Fernande in Picasso's life put an end to the Blue Period. Having freed himself of the influence of Toulouse-Lautrec and Steinlen, Picasso offers here a painting of pale colours, full of light.

1 *Portrait of Fernande*, 1906. Van Dongen
Pastel, 61 × 72 cm
Musée du Petit-Palais, Geneva (ADAGP)

3 *At the Lapin Agile* (or *Harlequin with a Glass*), 1905
Oil on canvas, 99 × 100.5 cm
Private collection, New York

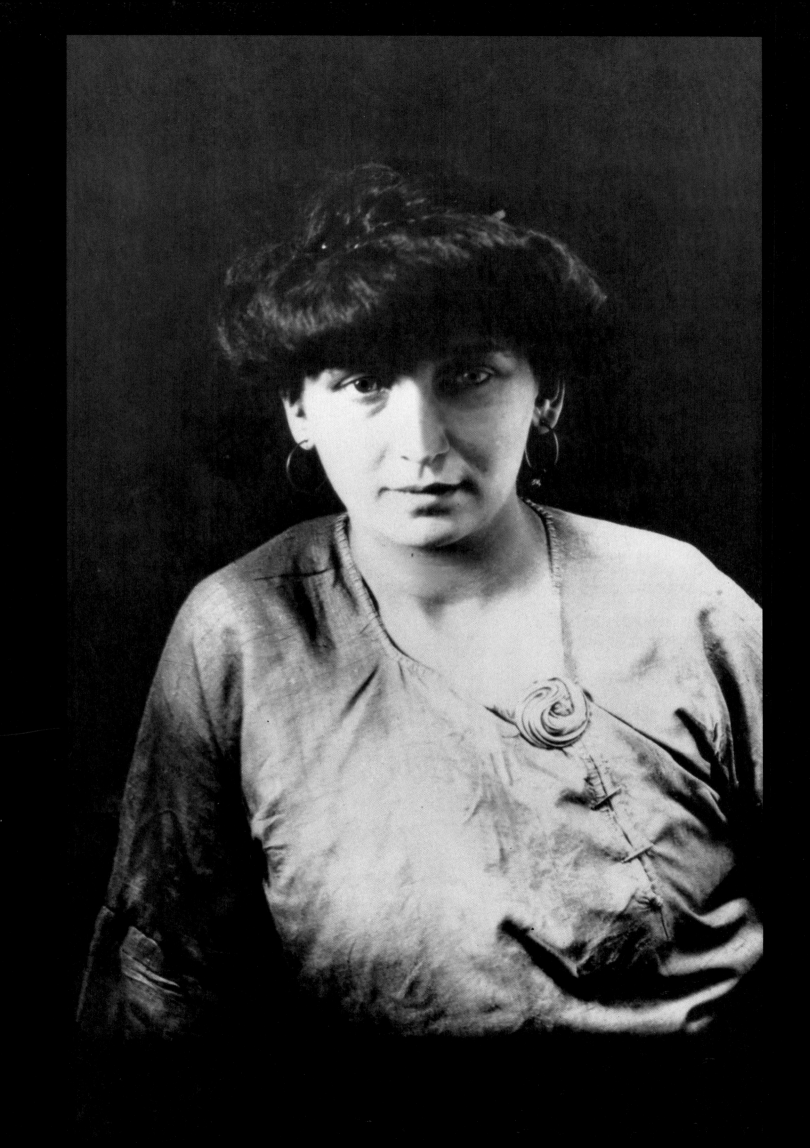

Picasso meets Matisse

In 1905, Picasso went to the Autumn Salon and was amazed to come face to face with the second exhibition of the Fauves. The public was intrigued by the paintings of these young artists, who had already attracted attention at the Salon des Indépendants in 1903. But this time a whole room was devoted to them. It was a triumph for colour, which no longer depended on reality; reality, rather, depended on it, since the painter, as he conveyed his emotion, could use his palette as his imagination inspired him. A tree could be yellow, the sky green, a meadow red. Colour was ceasing to be a means, and becoming an end in itself, outside the line of the drawing or even the very structure of the composition. A few enlightened souls were enthusiastic, but the great majority of visitors poked fun: 'Nothing to do with painting; formless stripes, blue, red, yellow, green, splashes of unmixed colour, juxtaposed haphazardly . . . Let us do no more than quote the names of these practitioners whose art would seem to proceed only from insanity or a joke: Messrs Derain, Marquet, Matisse . . . ' wrote one art critic in the *Journal de Rouen*.

Amongst those works that created a scandal was Matisse's *Woman with a Hat*, in which the painter uses green, red and yellow all together in the woman's face. Matisse, who emerged as the leader of this movement explained Fauvism in this way: 'The dominant tendency of colour should be to serve expression in the best possible way. I put on tints without prejudice of any kind . . . The expressive dimension of colour suggests itself to me purely instinctively. My choice of colours is based . . . on feeling, on the experiences of my sensitivity.'

A year after the Salon, in 1906, Matisse and Picasso met. They were thirty-five and twenty-seven respectively. The two men kept a close watch on each other, spying even; they vowed a deep mutual admiration, tinged with jealousy.

While Matisse and his disciples were letting colour burst forth, Picasso was quietly forgetting blue and thinking only of rose.

1
Fernande, Picasso and Reventos in a café in 1906.

2
This picture provoked a scandal at the 1905 Salon. But the writer Gertrude Stein and her brother Leo were confident about it and bought *Woman with a Hat* for 500 francs, before becoming friends with its creator.

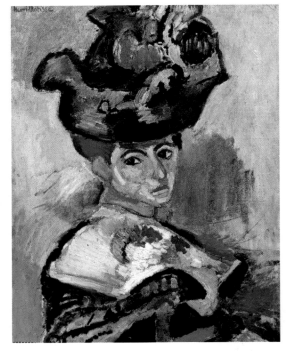

2 *Woman with a Hat*, 1905. Matisse
Private collection (SPADEM)

3 *Woman with a Blue Hat*, 1901
Pastel on cardboard, 60.8 × 49.8 cm
Galerie Rosengart, Lucerne

3
The red hair, very black eyes, strong nose and sensual lips of this elegant *Woman with a Blue Hat* are reminiscent of the face of Fernande, yet Picasso did not know her at the time he painted this picture.

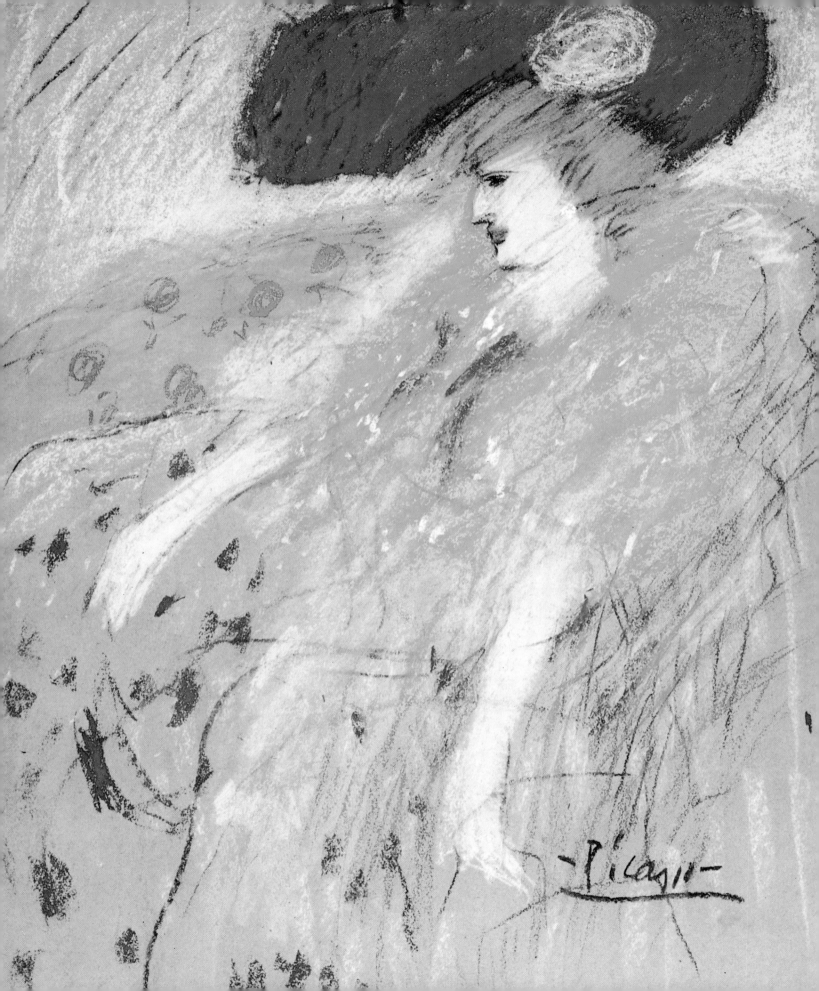

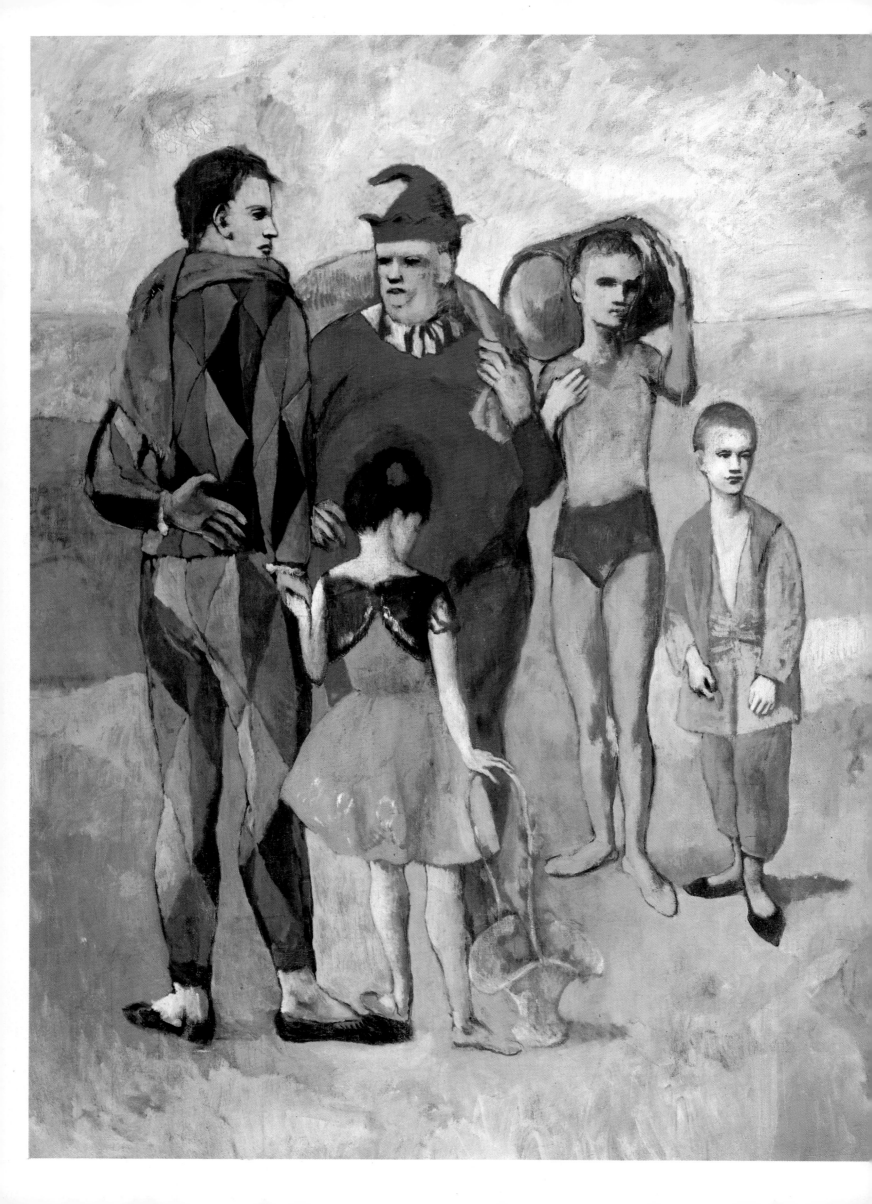

From the Rose Period to the Gosol pictures

Fernande brought gaiety into Picasso's life, and their circle of friends increased. It was no longer Spanish artists only who knocked at the studio door, but all those who, from now on, constituted Picasso's gang. The day was for sleeping or working, nightfall was for meeting up with one's friends. One of the gang's great pleasures was to meet around a good supper table, such as at the Aux Enfants de la butte, where the proprietor, M. Azon, offered simple but copious fare. Derain, Braque, Vlaminck, van Dongen, Charles Dullin, Paul Fort, Modigliani, Max Jacob, Picasso and Fernande were regulars.

On Saturday evenings, they preferred La Mère Adèle in the rue Norvin, with her two-franc banquet with as much wine and liqueur as one could drink.

When money was short, they turned to the women, all of whom had their speciality dish: rice cooked in the Valencia manner was Fernande's, soup with macaroni Marie Laurencin's, and scrambled eggs with onions and potatoes was Mme van Dongen's.

After dinner, Max Jacob would read aloud from Alexandre Dumas, Rimbaud and, occasionally, his own verse. Apollinaire introduced his friends – and, in particular, Derain's wife, who had developed a taste for it since Restif de la Bretonne's *L'Anti-Justine* – to the masterpieces of erotic literature. Derain, who was unmoved, would turn aside to try and teach Picasso boxing. He was immediately joined by Vlaminck, who was passionately keen on boxing and cycling.

But Picasso's gang was never as happy as when the Médrano circus opened its doors to them. 'We were always at Médrano's. We used to go there three or four times a week,' Fernande recounted. 'I've never seen Picasso laugh so wholeheartedly. He enjoyed it like a little boy. Modigliani, Juan Gris, Derain, Utter, Suzanne Valadon . . . would come too.'

Picasso was happy, and it told in his painting. The colour – a pale rose – sometimes deepened to red; his drawing was more supple, more rounded, more tender. And above all, he was no longer painting the wretched-

Family of Saltimbanques, 1905
Oil on canvas, 212 × 296 cm
National Gallery (Chester Dale Collection), Washington

ness of poor people, the solitude of blind men, half-starved old men, but young acrobats of slender outline, athletes with powerful shoulders, harlequins in all their finery.

For Picasso had met travelling showmen, tumblers, and it was they whom he wanted to paint.

'Picasso would remain at the bar amidst the stable smell that wafted up warm and rather sickly. He would stand there ... chatting all evening with clowns, he was amused by their clumsy ways, their accent, their repartee ... Vlaminck, Picasso, Léger wearing roll-necked pullovers were so much at ease among such people that one day they were taken for a troupe looking for work,' Fernande remembered.

The Rose Period reassured those who had

1

1/2
'Sometimes, Picasso and I, like several other artists, would try to make a sale in the neighbourhood of the Médrano Circus. We would spread our pictures out on the ground. We sold them for a hundred sous.'
(Van Dongen)

3
While Picasso was working on the bust of his friend Max Jacob, he came back from the Médrano Circus one evening and felt like changing the head, giving it the features of a clown. Only the lower half of the face bears a resemblance to that of the poet.

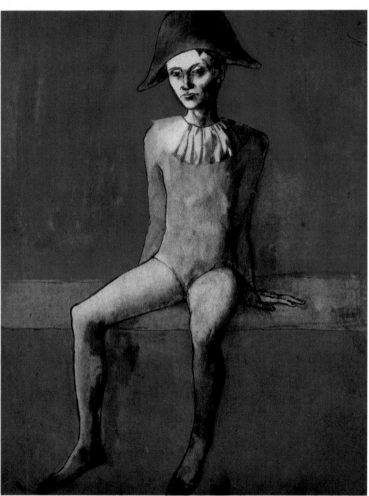

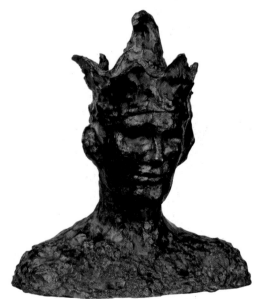

2 3

been frightened by the Blue Period. Art critics, dealers and the public came back to Picasso. In April 1905, Apollinaire wrote in *La Revue immoraliste* the first article devoted exclusively to Picasso: 'It has been said of Picasso that his works bore witness to a precocious disenchantment. I think the opposite. He is enchanted by everything, and his undeniable talent seems to me to be at the service of an imagination that mixes what is delicious with what is horrible, what is abject with what is delicate.'

Gertrude and Leo Stein went to the artist's studio and came out with 800 francs' worth of

2 *Harlequin in a Red Armchair*, 1905
Ink & watercolour on paper
Private collection, Paris

3 *The Madman*, 1905
Bronze, 40 × 35 × 23 cm
Picasso Museum, Paris (RMN)

4 *Acrobat with a Ball*, 1905
Oil on canvas, 147 × 95 cm
Pushkin Museum, Moscow

4
Picasso went to the Médrano Circus three or four times a week. He was an attentive spectator and would shudder when the trapeze artists flew through the air, laughed at the antics of the clowns, watched with wonder the skill of the juggler, the courage of the lion-tamer. He was as happy as a little boy at the circus, and drew from this world of saltimbanques, or tumblers, inspiration for his finest pictures.

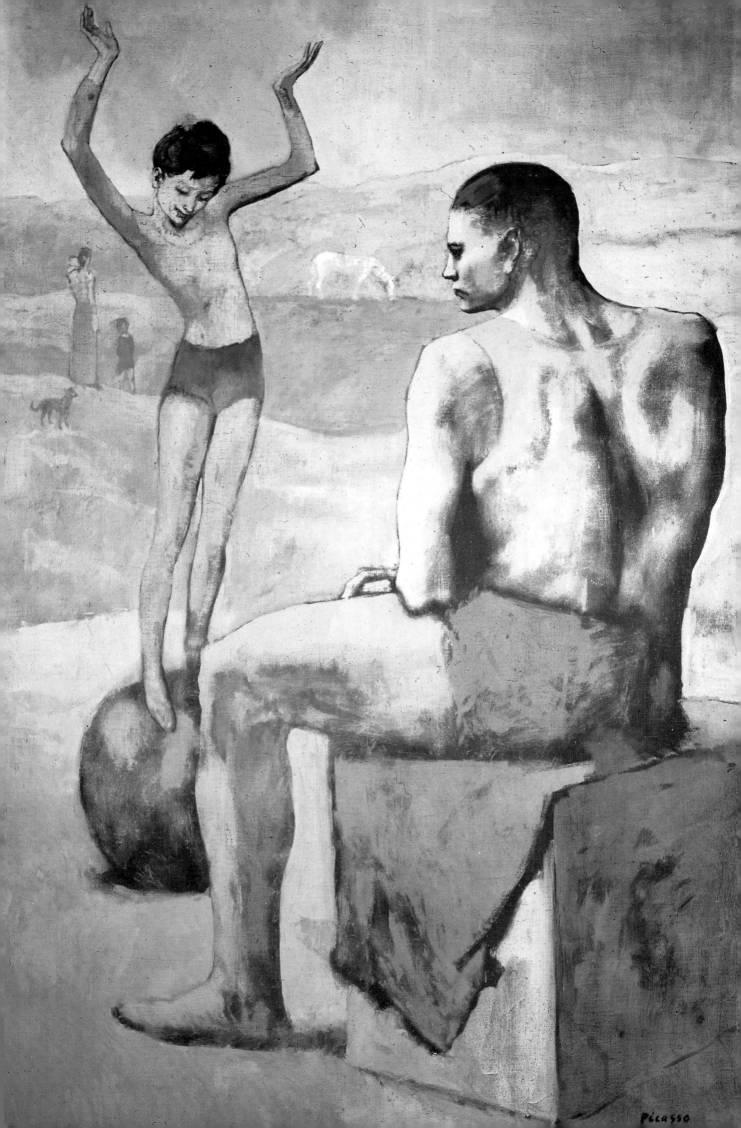

pictures. Vollard, who had probably been informed of Picasso's talent by Matisse, to whom Gertrude Stein had introduced him, bought 2000 francs' worth of canvases.

'On the material front, life was becoming easier,' Fernande relates. 'Picasso had a wallet with banknotes inside that he could not as yet make up his mind to leave at home. He would keep it in the inside pocket of his jacket, which, for added security, he fastened tightly with a large safety-pin. Each time he had to take a note out he would undo the pin as discreetly as possible.

> *In Rome*
> *at Carnaval time*
> *there are masques,*
> *(Harlequin, Columbine*
> *or Cuoca francese)*
> *who when morning comes*
> *after an orgy*
> *ending sometimes in murder*
> *go to St Peter's*
> *to kiss the toe*
> *of the prince of apostles.*
> *Such as they*
> *would delight Picasso.*
> *Beneath the dazzling fancy dress*
> *of these lithe acrobats,*
> *one is aware of*
> *young folk of the*
> *common people,*
> *versatile, cunning, agile,*
> *poor and telling lies.*
> (Guillaume Apollinaire, 1905)

Stein and Vollard's money enabled Picasso to travel. The primitive sculptures recently discovered in Spanish soil and exhibited at the Louvre earlier in the year had made a strong impression on him. He was missing Spain. And so Picasso and Fernande set off for Gosol, a small village in Upper Catalonia, perched among the mountains. Picasso's painting immediately became impregnated with the ochre colour of the dry and clayey landscape around him. He painted children, horses, and, for the first time, Fernande's naked body.

Like Ingres, Picasso moved away from appearances, from the anecdotal, in order to attain painting that was smooth, freed from the details that would distance it from pure plasticity. The face that has been 'cleaned up' in this way resembles a mask: no expression in the eyes, no wrinkles, no distinguishing marks. Expressivity is, paradoxically, considerably heightened in this way.

'Art is a lie
that enables us to grasp the truth.'

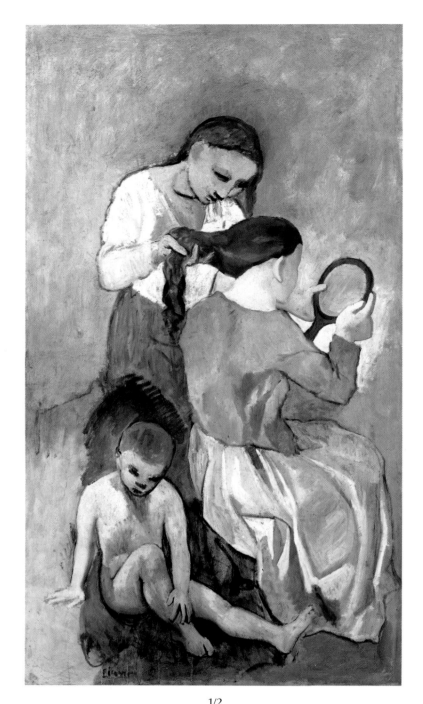

1/2

Picasso remembered certain pictures by Ingres, notably *The Turkish Bath*, which had been shown at the Autumn Salon in 1905, and Iberian sculptures of the sixth and seventh centuries BC on show at the Louvre. While remaining with the ochre and rose tones with which he had been working for several months, he tended from now on to move towards stylisation of his characters, blotting out their features and expressions. This left smooth, mysterious faces. *La Coiffure* picked up a theme dear to many painters, while in *La Toilette*, Picasso painted Fernande naked for the first time.

1 *La Coiffure*, 1906
Oil on canvas, 175 × 99.5 cm
Metropolitan Museum of Art (Wolf bequest), New York

2 *La Toilette*, 1906
Oil on canvas, 151 × 99 cm
Albright Knox Art Gallery, Buffalo

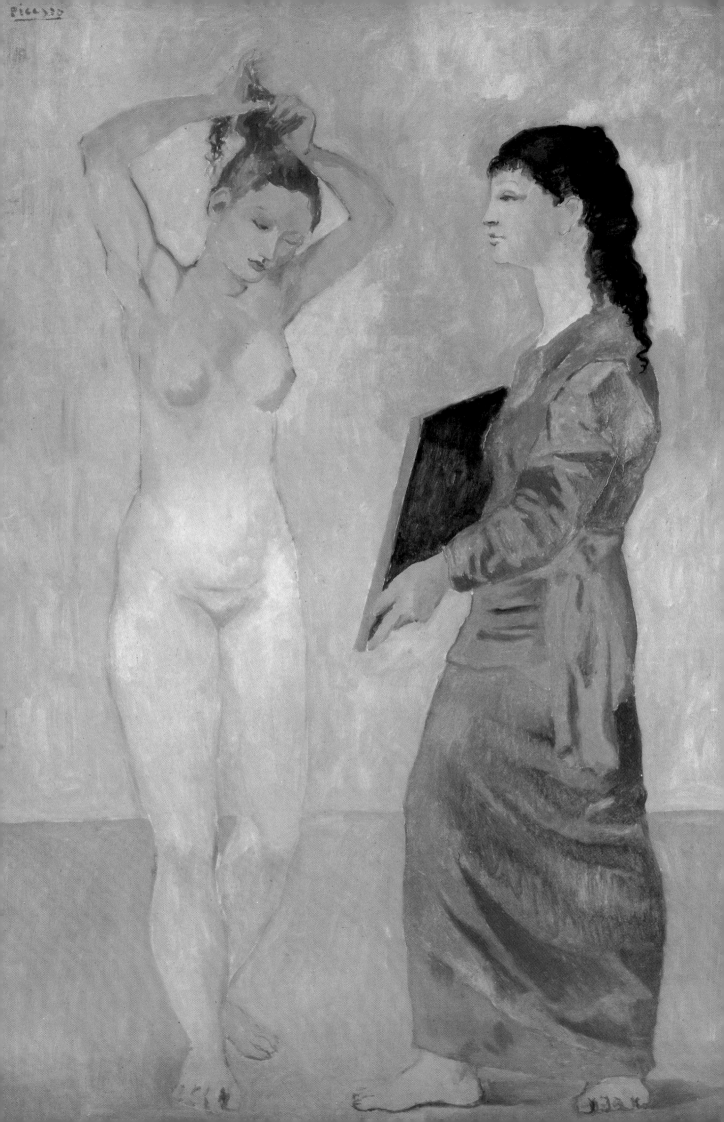

'We were dining, one Thursday evening, at Matisse's on the quai Saint-Michel, with Salmon, Apollinaire, Picasso and myself,' Max Jacob recounts. 'Matisse took from a piece of furniture a black, wooden statuette and showed it to Picasso: it was his first Negro carving. Picasso held it in his hand all evening.' Picasso was overwhelmed by the statuette, just back from Gosol as he was, and certain that one should no longer seek to paint what one saw, but what one felt, even if it meant deforming the subject in order to arrive at its essence, at its deep truth.

Black artists had already understood: the simplification of forms offers a new language. Two holes for the eyes, a triangle for the nose, a rectangle for the mouth. This geometry is a transfiguration of reality by means of which the artist exorcises his ancestral and religious fears.

When confronted with the work, feelings are no longer subjected to analysis by the spirit. They are immediate and put us in touch with our own demons.

At this time Picasso was an assiduous visitor at the ethnological museum at the Trocadéro, with his sketch pad in his hand. Works originating from the French Congo, the Ivory Coast and New Caledonia were the ones to which he felt closest. Much later on he would tell André Malraux about that day in July 1907 when he had gone to the museum for the first time: 'When I went to the Trocadéro, it was disgusting. A flea-market. The smell. I was all alone and wanted to leave. I didn't go. I stayed. I understood that it was very important; something was happening to me, wasn't it? The masks were not just any old sculptures. Not at all. They were magical objects . . . The Negroes were *intercesseurs*, I learnt that French word at that time. Against everything; against unknown, threatening spirits. I always looked at the fetishes . . . They were weapons. To help people not to be subject to spirits, to become independent . . . spirits, the subconscious, emotion, it's all the same thing. I understood why I was a painter. *Les Demoiselles d'Avignon* must have happened that day, but not at all on account of the shapes: because it was the first picture I painted with a view to exorcism. Oh, yes!' In September, Derain came back from l'Estaque, and in his own turn full of enthusiasm for African art, begged Vlaminck to sell him one of his statuettes. He got it for twenty francs. 'The atmosphere was highly charged,' notes Gertrude Stein. For, from this point on, they were all ready to launch forth into what the American woman called 'that combat that was to be known as Cubism'.

1
Apollinaire and his Friends: one can make out Gertrude Stein, Fernande Olivier, Apollinaire, the poet Cremmitz and, seated, Marie Laurencin; in the background, the Pont Mirabeau, celebrated by the poet. This picture belonged to Apollinaire, who hung it in his room, over his bed.

Negro art, that 'reasonable art'

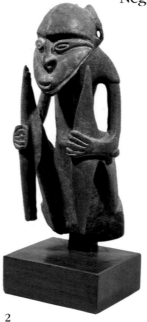

2
Negro statue
from Picasso's
personal collection.

3
'Picasso sat very tensely on his chair, with his nose up against the canvas. On a very small palette, which was of a uniform brownish-grey colour, he would mix a bit of brownish-grey. That was the first of some ninety sittings . . . Suddenly, one day, Picasso wiped out the whole of the head. 'I can't see you any more when I look at you,' he told me irritably . . . Picasso left for Spain. When he got back, he painted the head without having seen me again, then he gave me the picture. I was and still am pleased with my portrait. I think it looks like me.'
(Gertrude Stein)

1 *Apollinaire and his Friends*, 1909. Marie Laurencin
Musée National d'Art Moderne, Paris (ADAGP)

2 *Sculpture* (fragment), Sepik Basin, New Guinea
Wood, 45.5 × 20 × 17.5 cm
Picasso Museum, Paris (RMN)

3 *Portrait of Gertrude Stein*, 1906
Oil on canvas, 100 × 81 cm
Metropolitan Museum of Art
(Gertrude Stein bequest), New York

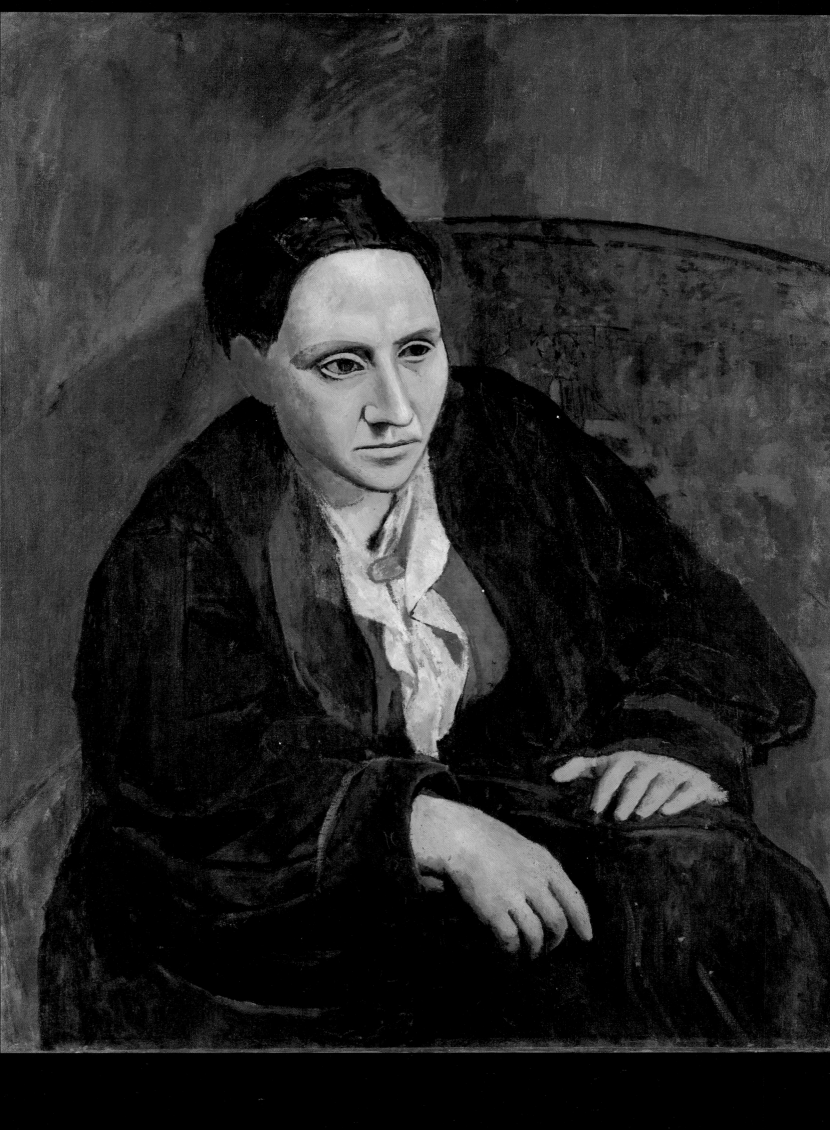

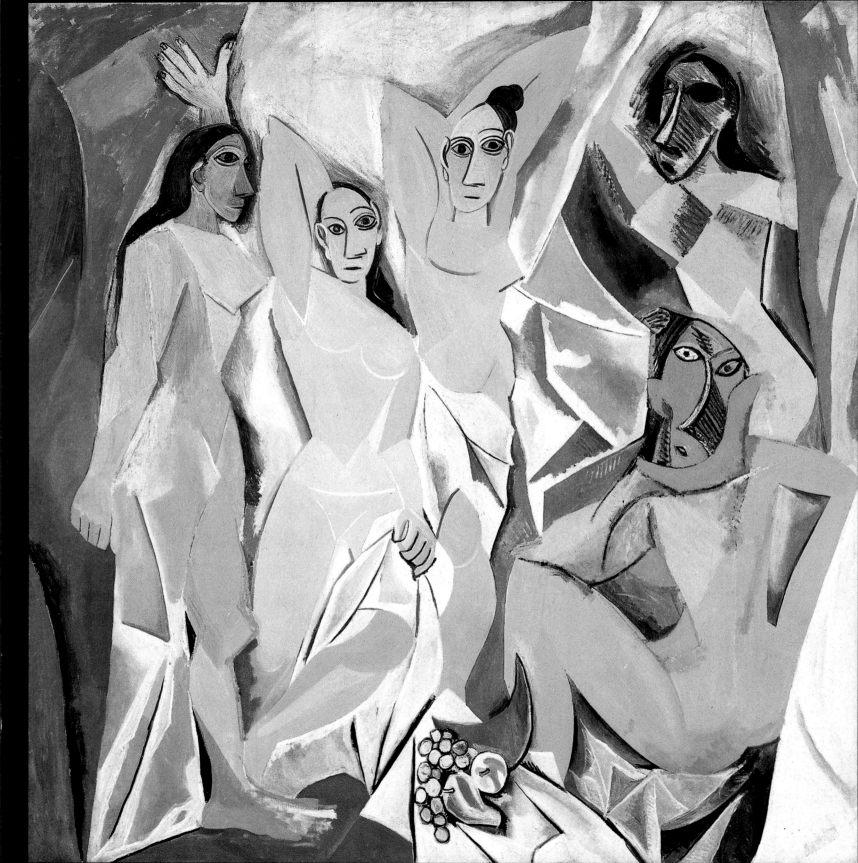

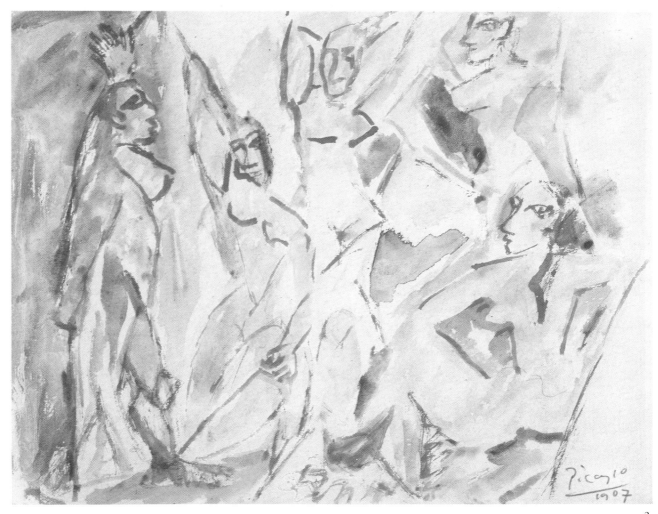

2

Scandal of *Les Demoiselles d'Avignon*

What I should like to bring home to you is the incredible heroism of a man such as Picasso whose moral isolation at that period was something frightful, for none of his painter friends had followed him. The picture that he had painted seemed to all of them something crazy or monstrous.

Braque, who had got to know Picasso through Apollinaire, had declared that it seemed to him that it was as if someone had drunk paraffin in order to spit out flames, and Derain told me to my face that one day Picasso would be found hanging behind this big picture of his, so desperate did the enterprise seem.'

Kahnweiler

André Salmon in front of *The Three Women* 3

1 *Les Demoiselles d'Avignon*, 1907
Oil on canvas, 243.9 × 233.7 cm
Museum of Modern Art (Lillie P. Bliss bequest), New York

2 Sketch for *Les Demoiselles d'Avignon*, 1907
Watercolour on paper, 17 × 22 cm
Museum of Art (A.E. Gallatin Collection), Philadelphia

Les Demoiselles d'Avignon and Kahnweiler

For weeks there had been hundreds of drawings scattered over the floor of Picasso's studio, and no one was allowed to see what he was working on. When he finally opened the door to his friends, he was completely and un-animously disowned: Braque, whom Apollinaire had introduced to him shortly before, made his famous quip reported by Kahnweiler; Leo Stein, who passed nevertheless for a man of some discernment, giggled: 'Did you want to paint the fourth dimension?' Matisse was furious and talked of mystification. Even Apollinaire came out with the laconic remark 'It's a revolution,' whereas Fénéon declared that Picasso was very gifted . . . for caricature.

Only Kahnweiler, a young collector (later to become a very important art dealer), understood the genius of the work that as yet had no name; as he painted it, Picasso had been thinking of Carrer's brothel in Barcelona. Apollinaire was to suggest *Le Bordel d'Avignon*. It was eventually André Salmon who hit on the definitive title.

'*Les Demoiselles d'Avignon*, how that name annoys me,' grumbled Picasso. 'It was Salmon who invented it . . . There was supposed to be a student holding a skull in it, a sailor as well. The women were in the middle of eating, hence the basket of fruit which remained in the picture.'

In this enormous picture of six square metres, Picasso made a clean sweep of all classical conceptions of beauty since the Renaissance. He destroyed, but recomposed in his own way in order to impose a work that is pure plasticity: stylisation of natural forms, rigorous geometry.

Yet the characters have undergone a three-fold influence: Egyptian (the flattening of the torso of the woman on the left), Iberian (the nose of each of the two women in the centre is seen in profile whereas the other features are face on), Negro (the cast of features of the woman on the right is reminiscent of the Congolese masks at the Trocadéro museum).

Kahnweiler saw things in their true light. *Les Demoiselles d'Avignon* was the cornerstone of modern art, as well as being the point of departure for the Cubist revolution.

Kahnweiler in the boulevard de Clichy studio in about 1910

1

2

2 *Portrait of Kahnweiler*, 1907. Van Dongen
Oil on canvas, 65 × 54 cm
Musée du Petit-Palais, Geneva (ADAGP)

3 *Portrait of Kahnweiler*, 1910
Oil on canvas, 100.6 × 72.8 cm
Art Institute (donated by Mrs G.W. Chapman), Chicago

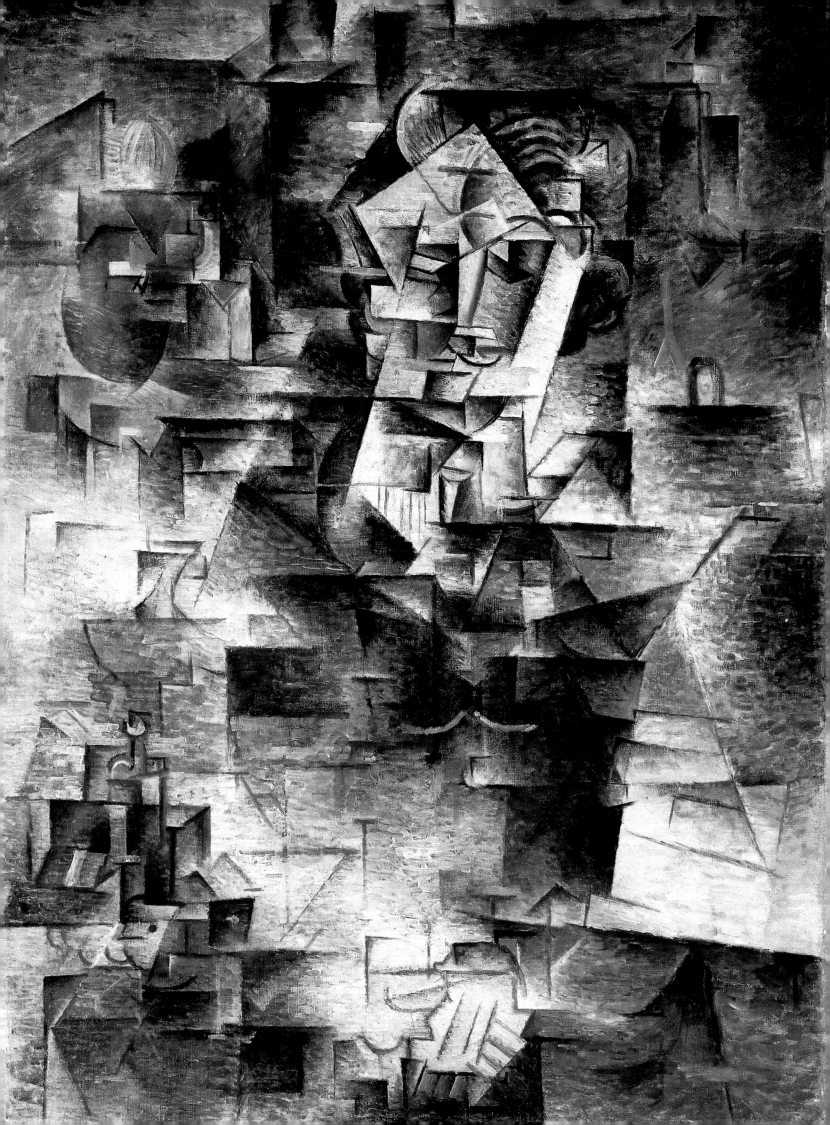

The Cubist revolution

In the autumn of 1908, the selection board for the Autumn Salon rejected two of the six paintings presented by Braque. These were six landscapes that he had brought back from his stay at l'Estaque, and which simplified the natural motifs translating them into geometric forms. Braque was furious and withdrew all of his pictures, entrusting them to Kahnweiler, who offered to organise the painter's first exhibition. Matisse exclaimed: 'But they're only little cubes!', while the art critic Louis Vauxcelles wrote in *Gil Blas* on 14 November 1908: 'Monsieur Braque is a very audacious young man. The unsettling example of Picasso and Derain has emboldened him. Perhaps also he is excessively obsessed with Cézanne's style and memories

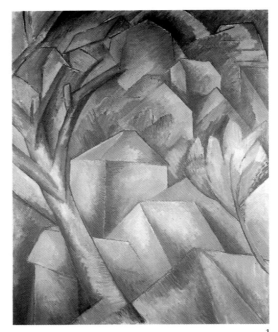

1

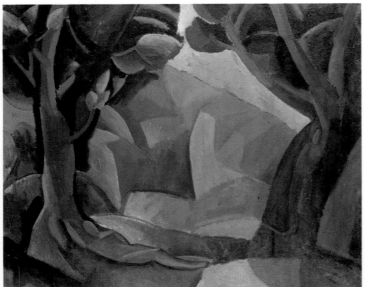

2

of the static art of the Egyptians. He constructs deformed, metallic little fellows that are dreadfully simplified. He despises form, reduces everything, views, figures, houses, to geometric diagrams, to cubes.'

Picasso, who was just back from a brief stay at La-Rue-des-Bois, near Creil, discovered the extent to which his own work and Braque's was heading towards a common desire to apply geometry to space, whilst remaining imbued with Cézanne's idea that 'Painting is a question of optics first and foremost. That is where the raw material of our art is, in what our eyes think.'

This was to be the beginning of solid affection and loyal friendship as well as unrivalled complicity as far as work was concerned. Braque and Picasso painted side by side, advising each other, criticising each other and always providing mutual encouragement.

1
In *Houses at l'Estaque* by Braque, the influence of Cézanne can be distinguished in the researches he conducted along with Picasso and followed by Derain.

2/4
In this *Landscape with Two Figures* (2), the bodies are so completely integrated into the landscape, the outlines of which are extended through them, that the casual observer might not even realise at first that they were there. Nature is dealt with as Cézanne had wished, through cylinders, cones and spheres, and the whole thing seen in perspective. *Bread and Bowl of Fruit on a Table* (4) shows well the reduction of objects to geometric shapes, while the table, which is seen head on, is still showing the whole of its surface, as if being viewed from above.

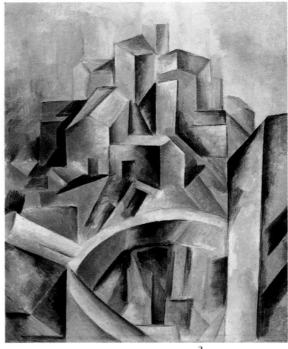

3

3
The Reservoir of Horta de Ebro was part of Gertrude Stein's personal collection. The optical effect achieved is that of an accumulation of crystals, or splinters struck off from gem stones.

1 *Houses at l'Estaque*, 1908. Georges Braque
Oil on canvas, 73 × 59.5 cm
Kunstmuseum, Berne (ADAGP)

2 *Landscapes with Two Figures*, 1908
Oil on canvas, 58 × 72 cm
Picasso Museum, Paris (RMN)

3 *The Reservoir of Horta de Ebro*, 1909
Oil on canvas, 81 × 65 cm
Private collection

4 *Bread and Bowl of Fruit on a Table*, 1909
Oil on canvas, 164 × 132.5 cm
Kunstmuseum, Basle

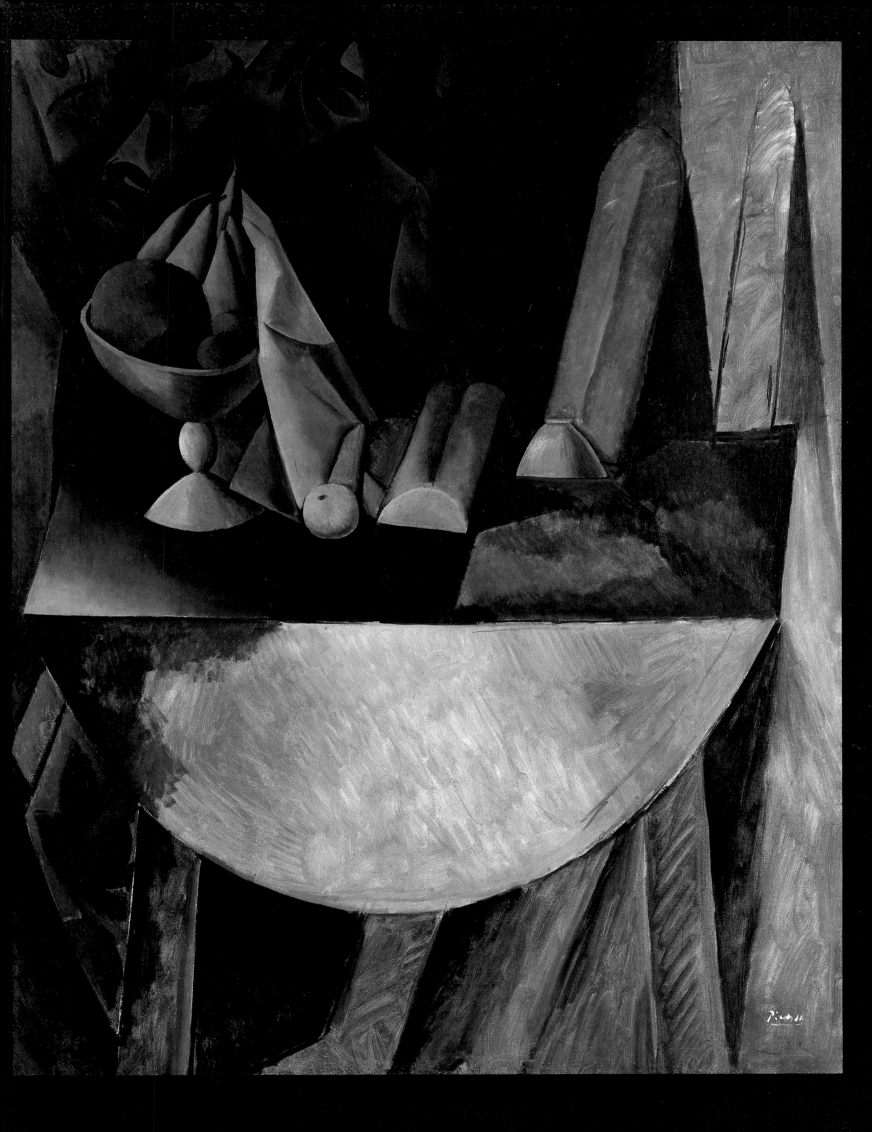

'If Cubism is still in a primitive state today,
a new form of Cubism should emerge in due course.'

1

1
Braque in Picasso's studio
about 1909. 'We lived in
Montmartre. 'We all used to
see each other and talk . . .
Picasso and I said things to
each other in those days that
no one will ever say again . . .
it was a bit like scaling
mountains with ropes.'

2

2
Picasso in his boulevard
de Clichy studio in 1910.

One thing, nevertheless, distinguished them
one from the other: the capacity for work of
Picasso, who was able to achieve in several
hours what would take Braque several
months, sometimes several years, to com-
plete. Picasso told André Malraux one day:
'Braque thinks as he paints. For my prepara-
tion, I need things, people.' That was why he
accumulated bits of cardboard, string, old
nails, anything to be found in dustbins. His
studio was a junk and scrap-iron shop. Picasso
never threw anything away. An object always
had some secret to divulge.

Braque's exhibition at Kahnweiler's and
then Picasso's at Vollard's were well received
by the public. The two painters were from
now on the two principal actors on the stage
of Cubism, which they continued to push for-
ward.

Their labours began with still lifes in a very
Cézanne-like optic in a new spatial dimen-
sion, the product of their imaginary domain.
Braque explained things: 'What attracted me a
lot – and this was the principal direction of
Cubism – was the materialisation of this new
space that I could feel. And so I began to do
still lifes mainly, because with a still life there
is a tactile space, manual almost I would say
. . . I was greatly attracted by this space, for that
was the first Cubist painting, the search for
space. Colour played only a small role. As far
as colour was concerned, we were concerned
only with the question of light. Light and
space are very close to each other and we tied
them together.'

Picasso moved house and now settled into
a large flat-cum-studio with Fernande at 11
boulevard de Clichy. As he left the 'Bateau-
Lavoir', Picasso finally ditched poverty.

3

3/4
A great banquet in honour of
Le Douanier Rousseau (4) was
organised in Picasso's studio.
Apollinaire, Marie Laurencin,
Gertrude Stein, Alice Toklas,
Braque, Max Jacob, Fernande

and many other lesser
known guests celebrated the
old artist who said to Picasso at
this time: 'We two are the
greatest. You in the Egyptian
genre, me in the modern.'

3 *The Woman Snake Charmer*, 1907. Henri Rousseau
Oil on canvas, 169 × 189.5 cm
Musée d'Orsay, Paris (RMN)

5 *Portrait of Fernande*, 1909
Oil on canvas, 61.8 × 42.8 cm
Kunstsammlung Nordrhein-Westfalen, Düsseldorf

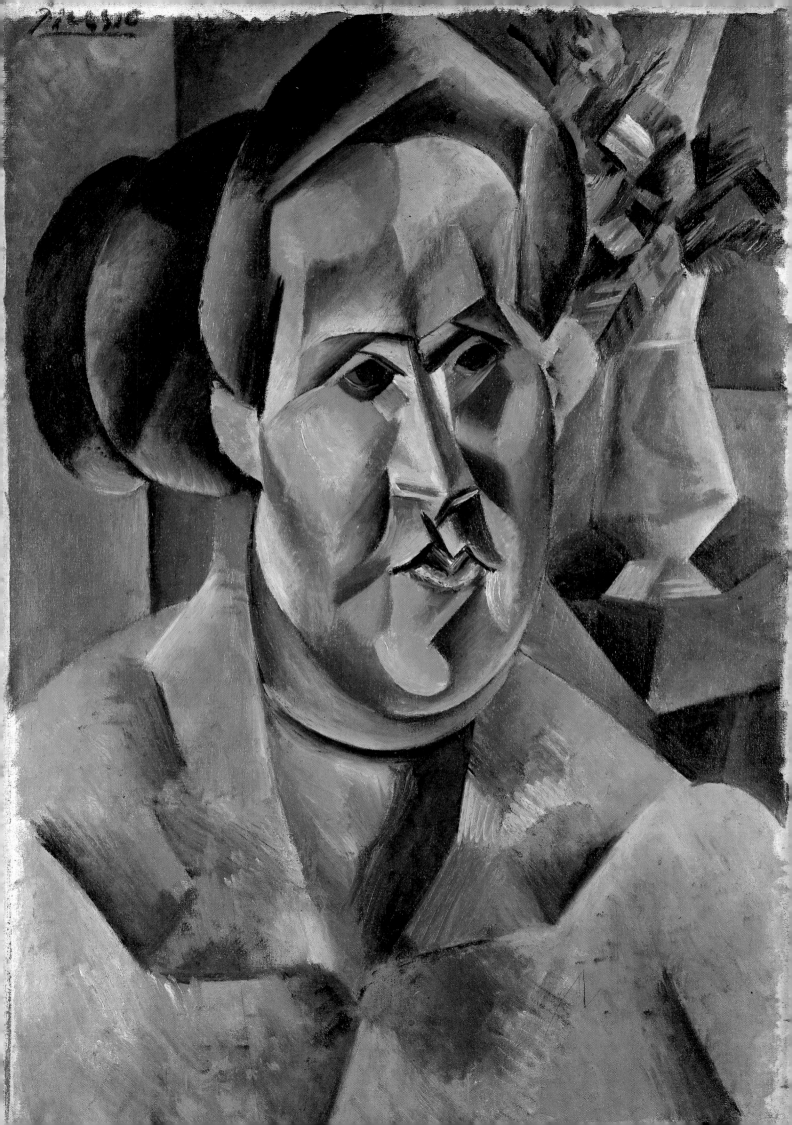

In 1911, Picasso and Fernande spent the summer for the second time in Céret, where friends had just bought a monastery, surrounded by apricot trees and vines. Despite the attractiveness of the place, the young couple experienced the first strains in their relationship. Picasso went back to Paris, where the Salon des Indépendants opened its doors to Cubism for the first time. There were pictures by Delaunay, Duchamp, Léger, Picabia and Metzinger, a painter with a theoretician's language: 'For us Cubists, surfaces, volume, line are only nuances inside a state of plenitude.' That use of 'us' appealed neither to Braque nor to Picasso and they decided not to join forces with the Cubists who were exhibiting. Braque was very clear about it: 'Neither Picasso nor I have had anything to do with Gleizes, Metzinger and the others. They have turned Cubism into a system, they have issued decrees: everything that is not like this or like that is not Cubism and so on. They've gone in for ideas instead of for painting . . .

'I love Eva'

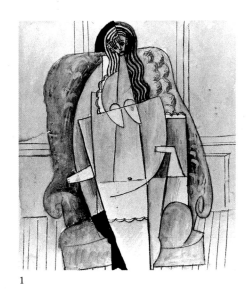

1

Eva in 1911

'They tried to explain Cubism with mathematics, geometry and psychoanalysis. All that is nothing but words. Cubism pursues aims in plasticity that are sufficient unto themselves.'

They have simply dabbled in intellectualism . . . The only one to have researched Cubism conscientiously, in my opinion, is Juan Gris.' To which Picasso added: 'When we were producing Cubism, we had had no intention of doing so, just of expressing what was inside us.'

The quarrel was underway. Braque was then reproached with intellectual frivolity: does not Cubism stem from some ideological commitment? Braque shrugged his shoulders: 'If I called Cubism a new order, it was without any revolutionary ideas or any reactionary ideas. I never weighed Cubism up, I was always finding out what it was.' Juan Gris adopted a more subtle approach: 'For me, Cubism is not a method but an aesthetic, a state of mind even.'

All of this annoyed Picasso, as did the poets who got involved in the squabble. Apollinaire, eager to clarify things, tried to subdivide Cubism into four tendencies: scientific, physical, optical and instinctive. Far from soothing things over, this classification, which was judged to be arbitrary by those involved, stirred them up. Max Jacob felt that 'Apollinaire was celebrating Cubism without really getting inside it.'

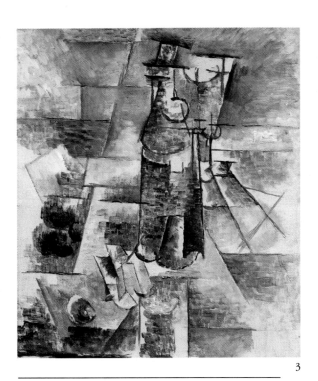

3

1 Study for *Woman in a Chemise in an Armchair*, 1913
Watercolour & Conté pencil on paper, 32 × 27 cm
Picasso Museum, Paris (RMN)

3 *Still life with Bottle*, 1911-12. Georges Braque
Oil on canvas, 55 × 46 cm
Picasso Museum, Paris (RMN; ADAGP)

4 *Nude, 'I love Eva'*, 1912
Oil on canvas, 75.5 × 66 cm
Museum of Art (donated by F. Howlad), Columbus

1
The facets of so-called Analytical Cubism have disappeared. The shapes are simple and the structure architectural. Picasso undertook a number of studies before embarking on this canvas. Paul Eluard described the picture as follows: 'The enormous, sculptural mass of this woman in her armchair, with a head the size of a sphinx and her breasts nailed on to her chest make a wonderful contrast . . . The face with tiny features, the wavy hair, the inviting armpit, the diaphanous nightdress, the soft and comfortable armchair . . .

3/4
The pictures that Picasso and Braque painted together at Céret push the destructuring of subject-matter and its fragmentation into many facets to its logical conclusion. Picasso's *Nude, 'I love Eva'* and Braque's *Still life with Bottle* (like the *Portrait of Kahnweiler* or that of *Ambroise Vollard*) are fine examples of so-called Analytical Cubism. Indeed the artists took pains to decompose the real form into its component geometric parts.

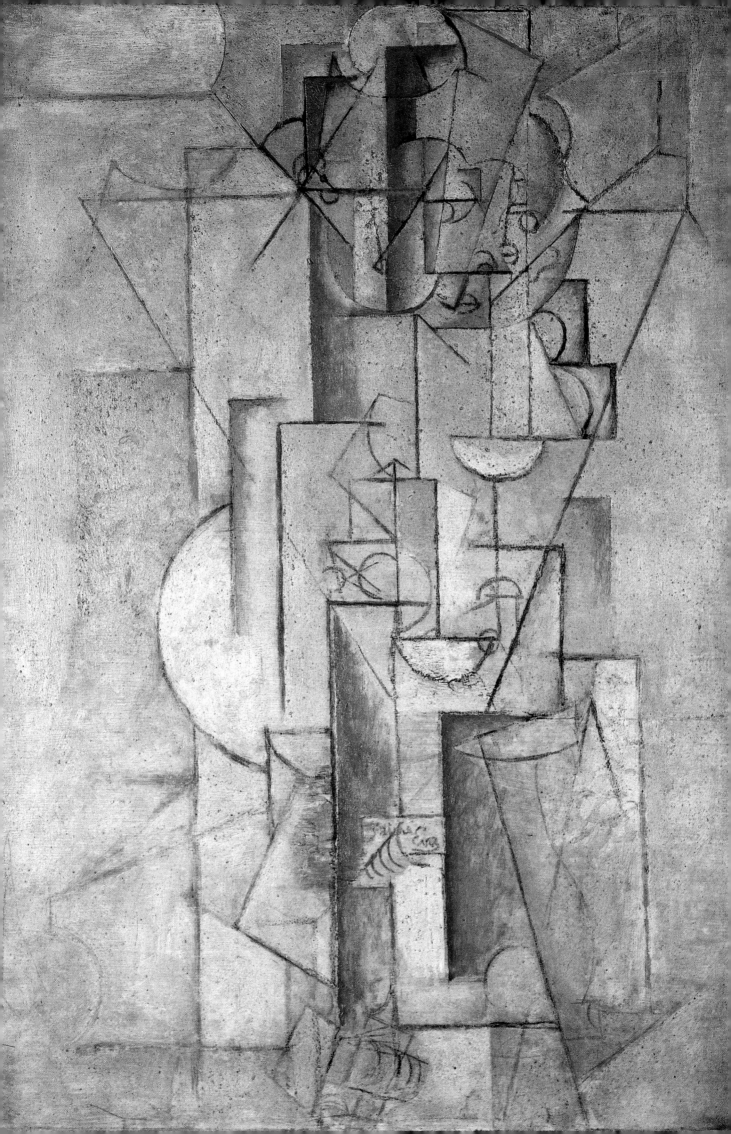

But much later on Picasso would admit to André Malraux: 'Apollinaire knows nothing about painting, yet he loved what was genuine. Poets often guess at things. In the Bateau-Lavoir days, poets guessed . . . '

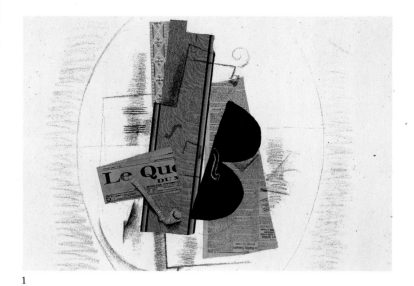

1

While he was out walking with Fernande, Picasso met a young painter of his acquaintance, Markous (renamed Marcousis by Apollinaire), in the company of a pretty woman with a pale complexion. Her name was Eva Gouel. (Sabartès would recall her in his memoirs under the name of Marcelle Humbert, a pseudonym that she had adopted. Hence the erroneous legend that Picasso had renamed her Eva, after the first woman.) Picasso fell in love with her and put an end to nine years of life shared with Fernande. Picasso and his new companion sought shelter for their love in a pretty village near Avignon, Sorgues-sur-Ouvèze. Braque and his wife rented a house next to theirs. Picasso was happy and wrote to Kahnweiler: 'I love Eva very much, I shall write it on my pictures.' A period of extreme fecundity began for the painter at this point, and he continued to collaborate with Braque in a fraternal spirit. So much so that one day the two of them decided to stop signing their paintings, so that they could be attributed to either one of them without distinction. The idea was Braque's: 'It was my judgement that the person of the painter had no business to intervene, and consequently the pictures should be anonymous. I decided that the paintings should not be signed, and Picasso did the same for a while. If someone else could do the same as me, I thought there was no difference between the pictures . . . '

But during that summer of 1912 the two accomplices busied themselves with other games besides. Braque, who had introduced lettering into his pictures the previous year, now for the first time stuck wood-effect wallpaper on to a charcoal drawing. This new technique won Picasso over immediately. It was a return to the simplest of forms, to effects with material, to colour, which had disappeared from the most recent Analytical Cubist pictures.

But Picasso was bolder than Braque, for if the latter used on his canvas materials for what they were, Picasso, for his part, used them for deceptive effects, suggesting some other representation of the object: 'I often used pieces of newspaper in my papiers collés, but not in order to make a newspaper out of them.'

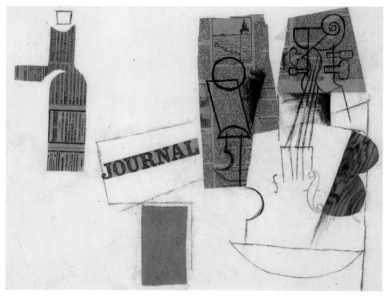

2

'My dear friend Braque,
I am using your latest
paperistic [sic] and dusty
techniques.'

1/2/3
The papier collé technique consists in sticking or pinning papers of all kinds – wallpaper, sheet music, wood or marble-effect paper, labels – on to a sheet of paper which serves as a support to the whole. The way the paper is cut out can convey the shape of an object (the bottle in *Bottle, Glass and Violin*) or become integrated into the structure of the work (the score in *Violin and Sheet of Music*). Braque was the first to introduce a real object (a nail) into his still lifes and to use stencilled letters.

1 *Violin and Pipe*, 1913-14. Georges Braque
Charcoal, wallpaper & newspaper cut out & stuck on to paper mounted on cardboard
Musée National d'Art Moderne, Paris (ADAGP)

2 *Bottle, Glass and Violin*, 1912-13
Collage, 47 × 62 cm
Statens Konstmuseer, Stockholm

3 *Violin and Sheet of Music*, 1912
Coloured paper & musical score stuck on to cardboard, 78 × 63.5 cm
Picasso Museum, Paris (RMN)

He invented a new way of representing reality, playing on the effects of material and their texture, thus creating a new pictorial space formed from superimposed planes.

To the question that Braque asked him at this time: 'Should one, if painting a newspaper in the hands of a character, take the trouble to reproduce the words *Petit Journal*, or reduce the whole exercise to gluing the newspaper cleanly on to the canvas?' Picasso answered by means of such varied compositions as *Violin with Fruit, The Bottle of Bass,* or *Bottle, Glass and Violin.*

This way of proceeding gave absolute freedom to whoever used it. One could choose to paint such material creating a deceptive effect, or one could stick on the real thing.

1/2/3
At 4.35 p.m. on 25 July 1909, Blériot landed his plane at Dover. In the night of 14 April 1912, the biggest liner ever built, the *Titanic*, struck an iceberg and sank. The epic achievements of technology inspired the Futurists in Italy and, in France, Delaunay, who took up a position in opposition to Cubism. He defended 'objective art', by means of which realism alone could give expression, with the help of pure colour, to the experiences of the industrial and technological society of the future, motor cars or aviation. *Homage to Blériot* is made up of luminous concentric circles. *Blériot XI* can be made out in the top left-hand corner, with its wheels and propeller, as well as mechanics busy at their work. In the top right-hand corner is the Wright brothers' biplane.

'We tried to stop deceiving the eye, in order to discover how to deceive the mind.'

In 1912, Picasso completed one of the most famous compositions of this period: *Still life with a Cane Chair*, introducing into his picture a piece of lino to indicate the chair.

· The novelty of this technique resided in the fact that the duality between art (the representation of the object) and reality (the object itself stuck on to the canvas) is suggested, but instantly overtaken, since the lino is not directly the cane chair seat but a deceptive cane effect.

Picasso was now introducing materials less 'noble' than wood or paper. He was to go much further still and use cardboard, string, labels torn from bottles of spirits: 'We were seeking to express reality with materials that we did not know how to handle and that we appreciated precisely because we knew that their aid was not exactly indispensable, and that they were neither the best nor the most suitable,' he explained to Sabartès. Such virtuosity depended on enjoying new explorations, making discoveries as soon as the search was begun, succeeding in going beyond the stage of deceiving the eye for what is even more subtle: deceiving the mind.

4
Malevich was a young Russian artist born in Kiev in 1878; in 1909 he adopted a form of Cubism close to that of Fernand Léger. He founded a movement called Suprematism, through which he hoped 'to untie the knots of wisdom, and liberate awareness of colour'.

2 *Homage to Blériot*, 1914. Robert Delaunay
Oil on canvas, 250 × 250 cm
Kunstmuseum, Basle (ADAGP)

4 *An Englishman in Moscow*, 1914. Kasimir Malevich
Oil on canvas, 88 × 57 cm
Stedelijk Museum, Amsterdam

5 *Violin with Fruit*, 1913
Collage, 64 × 49.5 cm
Museum of Art, Philadelphia

August 1914 marked the outbreak of the First World War. Derain and Braque were called up at Sorgues-sur-Ouvèze where they were on holiday with their respective wives. There was general consternation; none had 'foreseen' this war. Gertrude Stein and Alice Toklas were stuck in London, and Kahnweiler was caught unawares while mountaineering in Upper Bavaria.

Picasso accompanied his two friends to the station at Avignon and went back to Paris, to the flat in the rue Schoelcher to which he had moved with Eva the previous autumn. Apart from Max Jacob whose health was poor, Matisse, who was too old for the army, and Juan Gris, who had Spanish nationality like himself, Picasso saw all those who had been painting – or unpacking painting – leave for the front. Léger left on 2 August as a member of the corps of engineers, La Fresnaye signed

1

up for the infantry, and along with them Villon, Masson, Salmon, Apollinaire and Cendrars were called up; and even Marcoussis, who volunteered for the French army.

Picasso felt at a loss. The war hacked down Cubism in full flower, and it would not recover. Picasso's solitude was all the greater as Eva was ill. It was not easy to find a hospital bed in 1915. And yet Picasso managed to get Eva into a clinic at Auteuil. This was the beginning of difficult times: 'My life is hell. Eva has always been ill, and more so every day, and now she has been in a nursing home for a month. I'm barely working. I rush off to the nursing home and spend half my time on the Métro.'

But tuberculosis got the better of the young woman who died on 14 December. On 8 January 1916 Picasso wrote to Gertrude Stein: 'My poor Eva is dead . . . It was very painful for me, and I know that you will miss her.' For the first time in his life, Picasso experienced solitude and utter confusion.

'If Picasso and I had not met, would Cubism have turned out the way it did? I think not.'
(Georges Braque)

1
Still life with a Cane Chair, of 1912, was Picasso's first achievement in collage. On the bistro table are a stem glass with a newspaper entwined around it, a pipe, a slice of lemon, a knife and a scallop shell, the usual range of objects for Cubist still lifes of the period. The table, edged by a real rope – which serves as a frame for the work – reveals a piece of lino with an imitation cane effect. The oval format acquires a new significance: it encloses the work within a clearly defined and limited space. The corners remain empty, the whole of the power of the picture is concentrated in its centre.

2

2
This *Oval Composition* by Piet Mondrian dates from 1914. The artist, who discovered Cubism in 1912 at the exhibition of the Modern Kunstring in Amsterdam, was working at this time on an extremely purified form of aesthetics that he called Neo-Plasticism. In 1917, he co-founded the review *De Stijl*, the mouthpiece of the Neo-Plastic movement, which counted amongst its members the painter Theo van Doesburg and the architect J.J.P. Oud.

1 *Still life with a Cane Chair*, 1912
Oil & linoleum on an oval canvas,
bordered with rope, 27 × 35 cm
Picasso Museum, Paris (RMN)

2 *Oval Composition*, 1914. Piet Mondrian
Oil on canvas, 113 × 84 cm
Stedelijk Museum, Amsterdam

3 *Violin*, 1912
Coloured paper
Pushkin Museum, Moscow

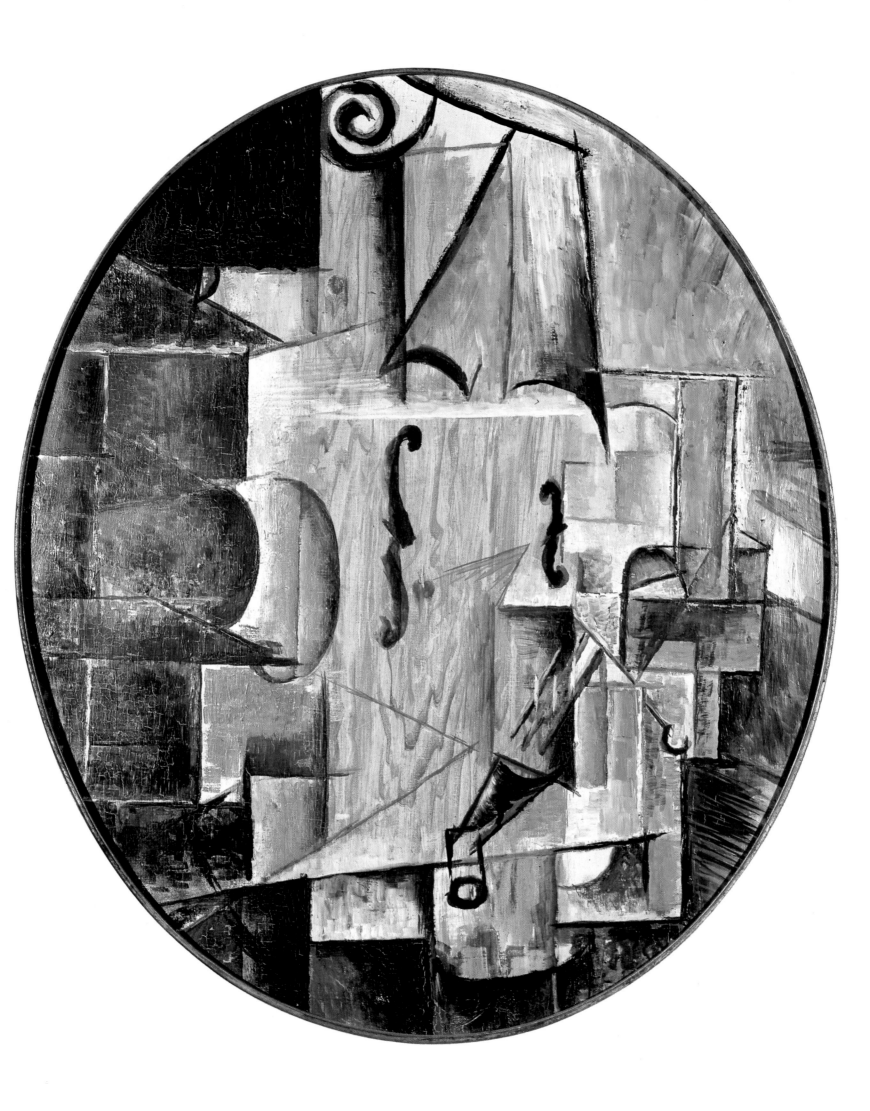

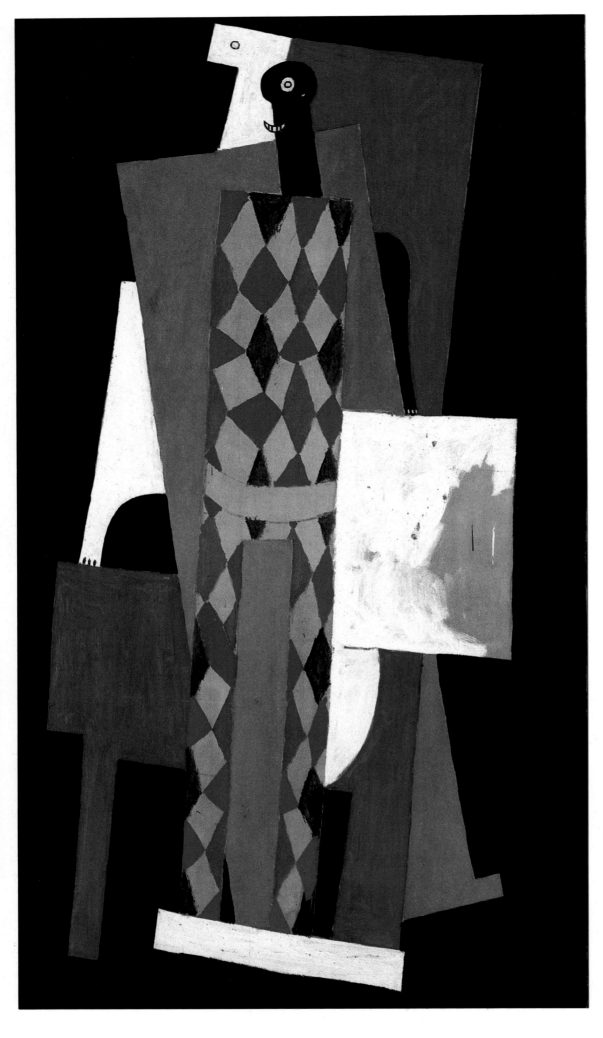

1/2
The Card Player of 1914
predated *Harlequin* by a
year or so. The posture of
the latter is an integral part
of the composition of the
painting, with its large
dimensions, creating an
effect of monumental
rigidity. The four sides of
the central figure are
represented simultaneously,
and the various flat tints
against which he is frozen
are indicative of the
Synthetic Cubism towards
which Picasso was heading.

1 *Harlequin*, 1915
Oil on canvas, 183.5 × 105.1 cm
Museum of Modern Art (L.P. Bliss bequest), New York

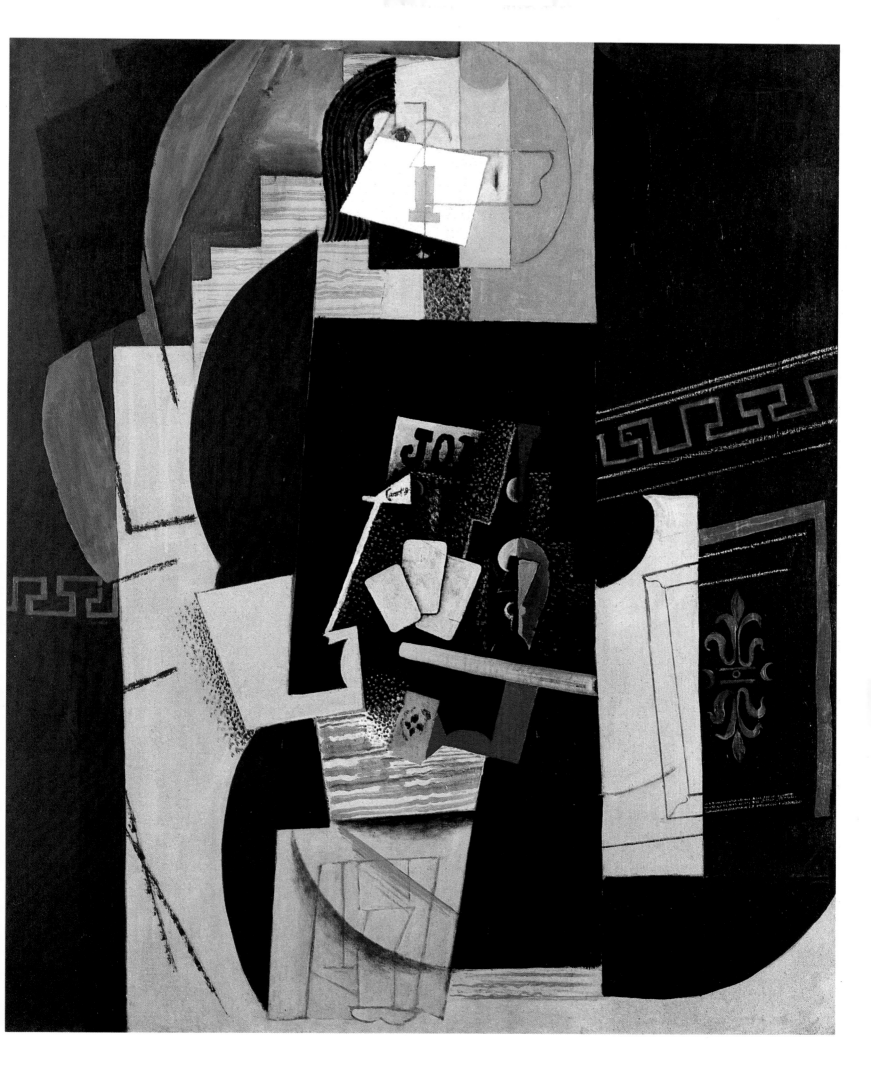

2 The Card Player, 1913-14
Oil on canvas, 108 × 89.5 cm
Museum of Modern Art (L.P. Bliss bequest), New York

Parade

One day in 1916, a young poet on leave came to visit Picasso. Beneath his raincoat he was dressed as Harlequin. His name was Jean Cocteau and he knew that Picasso had always been fond of the theme of strolling players. And so Cocteau asked Picasso to design the costumes and sets for a ballet, whose score was to be the work of Erik Satie, the synopsis was by Cocteau, and choreography and production were to be by Diaghilev. The leader of the Ballets Russes, who had brought his company out of Russia, had already had great successes with *Firebird*, Stravinsky's *Petroushka* and Tchaikovsky's *Swan Lake*.

The synopsis that Cocteau proposed to Picasso involved a circus parade on a Parisian boulevard, in front of a fairground stall, an acrobat, a Chinese tightrope walker, a young American girl, all trying to draw in the public with their acts.

Picasso listened attentively. But first of all he had to leave the flat in the rue Schoelcher, where memories of Eva were too painful, for a small house twenty minutes' walk away from Montparnasse, at Montrouge. On 24 August Picasso gave his consent, met Diaghilev, who was full of enthusiasm, and got down to work.

He very quickly invented new characters, three gigantic Managers, all dressed in Cubist constructions, and intended to make the public laugh with the grotesqueness of their dress and their clumsiness. This change to Cocteau's original plans delighted Satie but worried him at the same time, prompting him

1 *Parade*
Nicolas Zuerco in the role of Acrobat, 1917
Picasso Museum, Paris (RMN)

2 *Costume for Acrobat*, 1917
Watercolour & graphite, 28 × 20.5 cm
Picasso Museum, Paris (RMN)

3 *Study for American Girl's costume*, 1917
Graphite, 27.7 × 22.5 cm
Picasso Museum, Paris (RMN)

4 *Parade*, Mlle Chabelska in the role of American Girl, 1917
Picasso Museum, Paris (RMN)

5 Olga, Picasso and Cocteau in Rome, 1917
Picasso Museum, Paris (RMN)

6 *The French Manager*, 1917
Drawing
Picasso Museum, Paris (RMN)

7 *The Negro Manager*, 1917
Drawing
Picasso Museum, Paris (RMN)

8 Picasso and the cast of *Parade*, 1917
Picasso Museum, Paris (RMN)

'Before Picasso,
the set played no part
in the play. It was
part of the audience.'
(Jean Cocteau)

6
Drawing for *The French Manager*, with his top hat, holding a cane in his artificial hand.

7
Drawing for *The Negro Manager*, mounted on a horse of fabric and cardboard, worked by two dancers concealed inside.

3

4

8

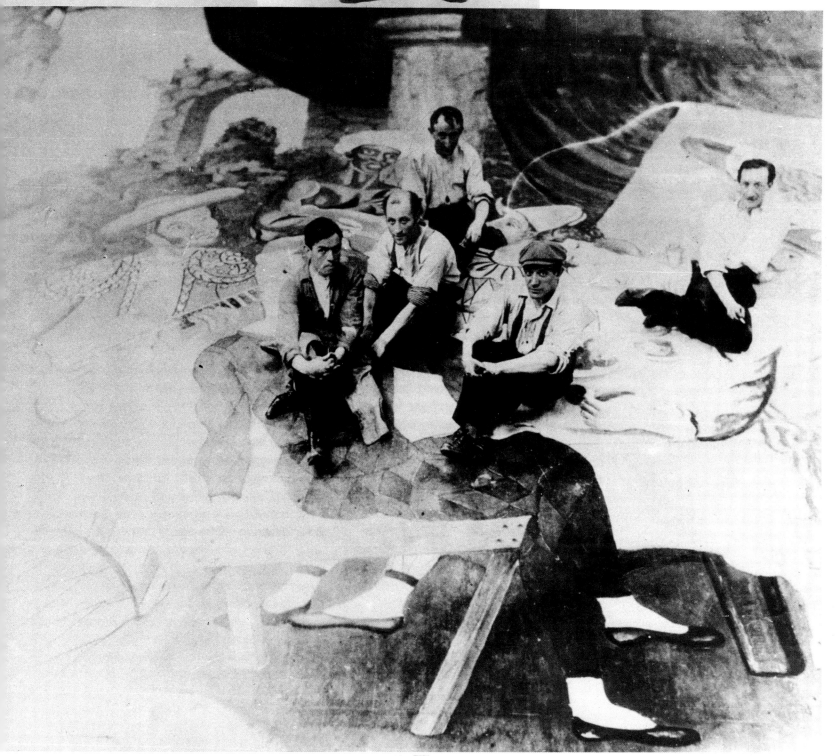

to write to Valentine Hugo: 'If only you knew how sad I am! *Parade* is being transformed for the better behind Cocteau's back! Picasso has ideas that I like better than our Jean's. How unfortunate! And I'm on Picasso's side! And Cocteau doesn't know! What am I to do? Picasso told me to work from Jean's text, and there he is, Picasso working from another one, his own ... which is dazzling! Prodigious! I'm heading for madness and sadness!'

But Satie was wrong to worry. Cocteau found out about Picasso's innovations and applauded them. The sets, handled in the Cubist manner, represented a fairground stall amidst skyscrapers. On the curtain (10 m high by 17 m wide) Picasso painted a scene of fairground life in which Harlequin, Columbine and a bareback rider on a winged mare can be made out. As the art historian Douglas Cooper

said: 'Picasso gently lifted the veil on circus people in a dream-like atmosphere before plunging them several minutes later into a *real* experience, when the curtain rose to reveal one of the colossal Managers announcing the parade and prancing about on the stage.'

On 17 February, Picasso, accompanied by Cocteau, set off for Rome, where he worked on the production of sets with the dancer and choreographer Massine. He wrote to Gertrude Stein: 'I have sixty dancers. I go to bed very late. I know all the Roman ladies. I have done some Pompeian fantasies that are a bit on the light side, and caricatures of Diaghilev, Bakst and the dancers.'

Especially the dancers. For what Picasso did not write was that he was falling desperately in love with one of the dancers of Diaghilev's company, Olga Koklova.

Olga – or the return to order

1
Three dancers from Diaghilev's Ballets Russes. Olga is on the left.

2
Photograph of Olga taken by Picasso in the studio at Montrouge.

3
At Olga's insistence that the portrait should be 'a good likeness' – for she wanted at all costs to be able to 'recognise herself' – Picasso fell back on a classical style of painting, continuing the tradition of Ingres's great portraits. There is precision in the drawing, the pose is nonchalant, and light and shade are treated in the traditional manner. And yet Picasso played with the dimension of depth, which is absent to the point that Olga appears not to be sitting in her armchair, but to be 'superimposed' on it. In the same way, the pattern on the seat is made to look like wallpaper stuck on.

3 *Portrait of Olga in her Armchair*, 1917
Oil on canvas, 130 × 88.8 cm
Picasso Museum, Paris (RMN)

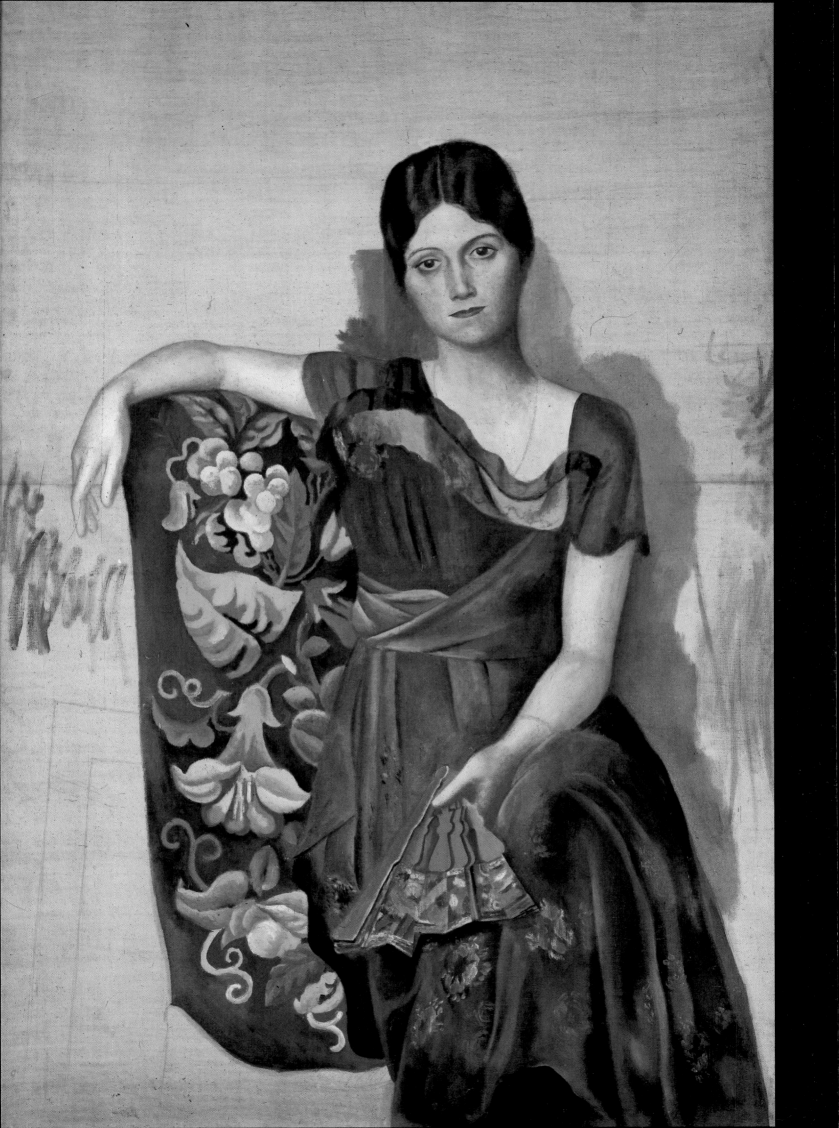

Eventually on 18 May 1917 the Parisian public rushed to the Châtelet Theatre to be present at the première of *Parade*. The curtain went up . . . and there was an uproar in the auditorium. In those wartime days, when austerity was the rule, the audience, hostile to Cubism and its extravagances, went wild at the sight of Managers three metres tall with dancers concealed inside.

People shouted and insults mingled: 'Off to Berlin with you! Shirkers! Filthy Germans!'

Cocteau would admit later that 'if it hadn't been for Apollinaire, his uniform, his shaved head, the scar on his temple and the bandage round his head, women would have gouged our eyes out with hairpins.'

But Picasso was unmoved. He was hardly ever upset by scandal . . . And Olga was occupying all of his thoughts.

Soon the company quit Paris for Spain. Picasso introduced to his mother the woman he hoped to marry. When the Ballets Russes left Barcelona for a South American tour, Olga did not go with her companions so as to stay with Pablo, with whom she returned to Paris.

On 12 July 1918 Picasso and Olga were married at the Russian church in the rue Daru in Paris. Their witnesses were Apollinaire, Cocteau and Max Jacob. The newly-weds moved in straight away to a sumptuous apartment on two floors in the rue de la Boétie in Paris. Picasso changed his style of life for good. Gone were the Bohemian ways, the meals with friends on the edge of a table all smeared with dried paint, the comfortable, worn-out old clothes.

Picasso now dressed like a dandy in a three-piece suit, with a pin in his tie and a cane in his hand. He lived in an apartment that his wife decorated in the most bourgeois style possible, and one reception followed another. 'Picasso is hobnobbing in the smart districts!' said his friends – the very ones whom he was seeing less of. For Braque, Apollinaire and many others came back from the war seriously wounded, damaged physically as well as psychologically.

1

1
Biarritz. The very spot where Picasso stood to paint *Women Bathing*.

2
Malevich, who was ever more demanding in his metaphysical quest, posited art as an abstraction.

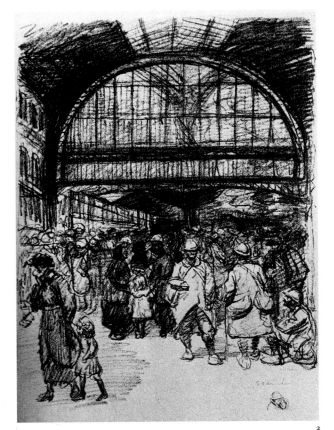

3

3
La Gare du Nord drawn by Steinlen, with soldiers off to the front and the wounded returning to their families. At the same time, Picasso, Cocteau and Diaghilev were putting the finishing touches to their plans for the ballet *Parade*.

2 *White Square on White Background*, 1918. Kasimir Malevich
Oil on canvas, 79.4 × 79.4 cm
Museum of Modern Art, New York

3 *At the Station*, 1916, Steinlen. Lithograph

4 *Women Bathing*, 1918
Oil on canvas, 27 × 22 cm
Picasso Museum, Paris (RMN)

4
In this picture painted in Biarritz during the summer of 1918, just after his marriage to Olga, Picasso amused himself by combining in his own way a number of pictorial references: allusions to the views of Port-en-Bessin by Seurat (the lighthouse, the jetty, and the horizontal treatment of sea and sky), to the works of Le Douanier Rousseau (the brilliant, sharp colours and attention to minute detail), to *The Birth of Venus* by Botticelli, but the most obvious reference is, of course, to Ingres's *Turkish Bath*.

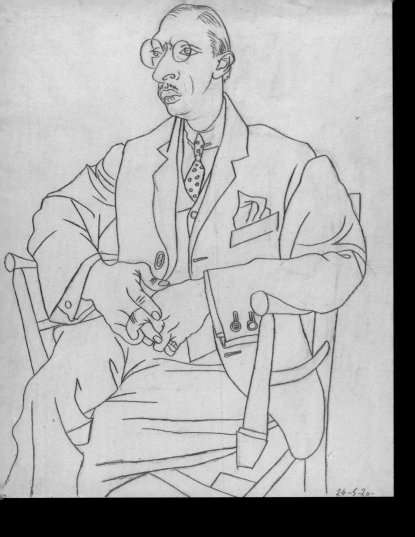

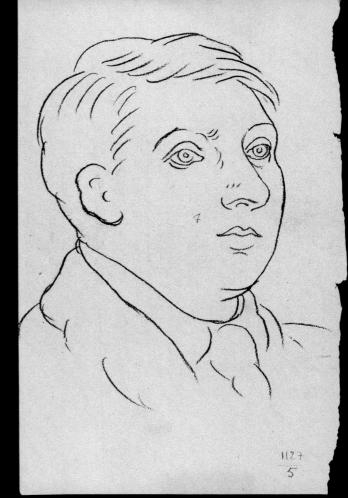

1 *Portrait of Igor Stravinsky*, 1920
Graphite & charcoal, 61.5 × 48.2 cm
Picasso Museum, Paris (RMN)

2 *Portrait of Pierre Reverdy*, 1921
Graphite, 16.5 × 10.5 cm
Picasso Museum, Paris (RMN)

3 *Portrait of Erik Satie*, 1920
Graphite & charcoal, 62 × 47.7 cm
Picasso Museum, Paris (RMN)

4 *Portrait of Olga*, 1920
Graphite & charcoal, 61 × 48.5 cm
Picasso Museum, Paris (RMN)

Following pages:

1 *The Artist's Studio, rue de la Boétie*, 1922
Graphite & charcoal
. Picasso Museum, Paris (RMN)

2 *Olga's Salon (Cocteau, Olga, Erik Satie, Clive Bell)*, 1921
Pencil on paper
Picasso Museum, Paris (RMN)

3 *Olga at the Piano*, 1921
Graphite & charcoal
Picasso Museum, Paris (RMN)

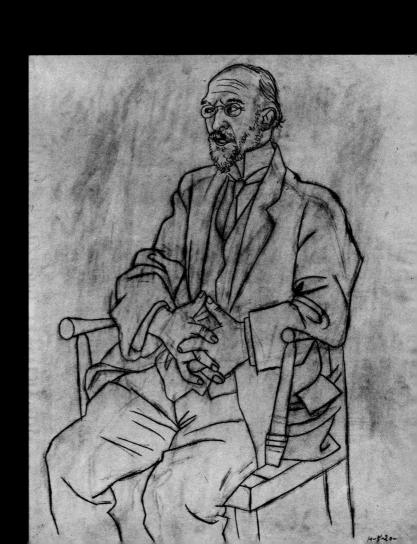

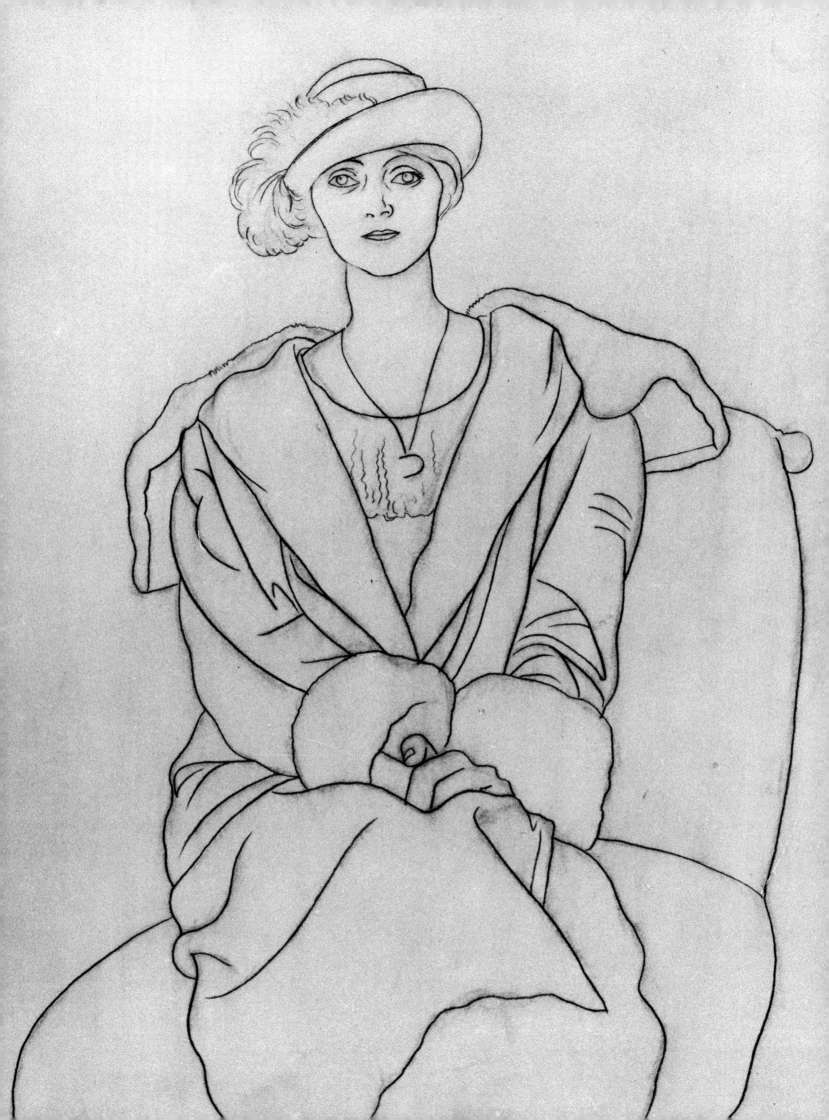

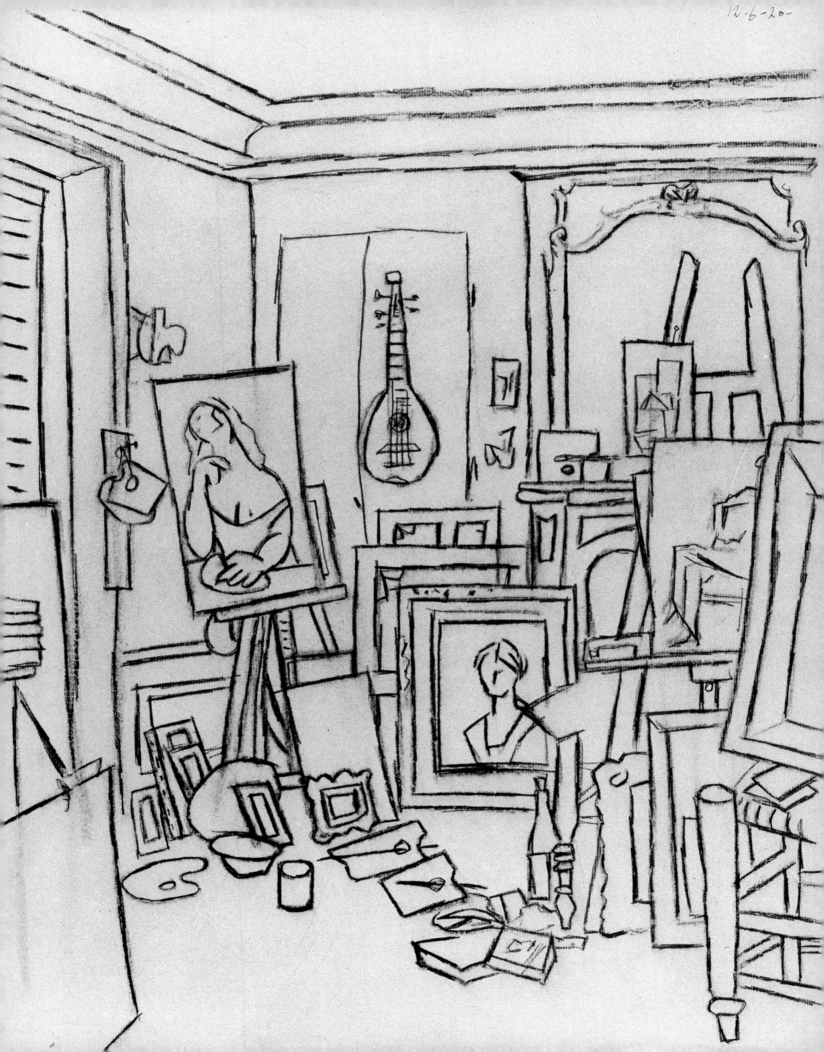

12-6-20-

6-7-21

Neo-Classicism

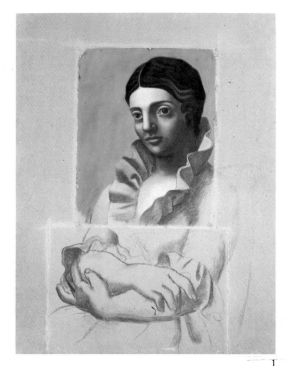

'A most enigmatic of paintings, *Reading the Letter*, which can be situated between the realism of Courbet as far as the

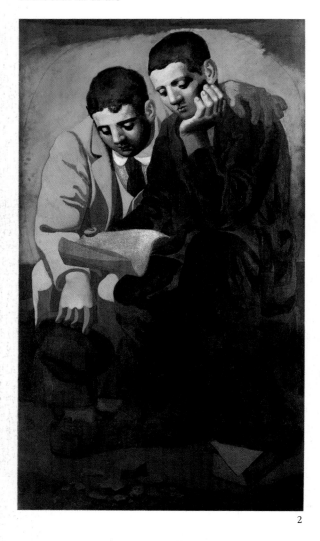

3
Sacco and Vanzetti, two Italian anarchists, presumed to be the murderers of the paymaster and watchman of South & Braintree Company in 1920, were condemned to death the same year, and executed in 1927, despite their protestations of innocence and numerous demonstrations of support that took place throughout Europe.

1

2 Demonstration in Paris in support of Sacco and Vanzetti 3

treatment of costume is concerned and Michelangelo for the expression of volume, is above all a work containing clues that must be full of evocative allusions to some friendship. That with the poet Apollinaire, with the adventurous painter of Cubism, Braque? The bowler hat in the foreground connects with portraits of Apollinaire and Braque, and the books and text are the attributes of the poet and writer.'
(Dominique Bozo)

1 *Woman in a Mauve Frilled Dress*, 1923
Picasso Museum, Paris (RMN)

2 *Reading the Letter*, 1921
Oil on canvas, 18.4 × 10.5 cm
Picasso Museum, Paris (RMN)

3 *Still life with Jug and Apples*, 1919
Oil on canvas, 65 × 43.5 cm
Picasso Museum, Paris (RMN)

4
This still life of 1919 came to light only after Picasso's death. One can detect a Cézanne-like execution at this time when Picasso was seeking to distance himself from his Cubist works.

A masterpiece of Synthetic Cubism

The war came to an end, bearing away with it Picasso's youth. Nothing now would be as it had been before. Apollinaire died while crowds were shouting out beneath his windows 'Down with William! Down with William!' (they were referring, of course, to the Emperor of Germany). The poet was just recovering from his wound when Spanish flu carried him off, two days before the Armistice.

Picasso was quite alone, deprived as he had been for some time now of the support and friendly, intelligent presence of Kahnweiler. Of German nationality, his dealer had refused his country's call-up, and had not enlisted in the Foreign Legion under French colours either. With Kahnweiler in Berne and his property sequestrated, Picasso engaged a new dealer: Paul Rosenberg.

Rosenberg was more cautious than his predecessor. He was afraid of the whiff of scandal associated with pre-war Cubist pictures. He recommended Picasso to paint more prudently, more realistically, in a way that would be accessible to all.

At this time, Picasso exhibited in the faubourg Saint-Honoré Gallery a new line in painting: antique goddesses with heavy movements, substantial still lifes. Some art-lovers accused Picasso of having betrayed Cubism, of having switched styles for opportunistic reasons. Picasso shrugged his shoulders and mocked his detractors: 'Style! ... Does God have a style?'

In February 1921 Olga gave birth to Picasso's first child, Paulo. Picasso rented a fine, large villa at Fontainebleau where he settled his family. It was here that he painted the masterpiece that was to be a synthesis of Cubism, bearing the fruit of all the years of research on Cubism and on the theatre: *The Three Musicians*.

This picture, of which Picasso would make two versions, showed three characters from the commedia dell'arte tradition: Pierrot, Harlequin and a Capuchin friar. Pierrot plays the clarinet, Harlequin the violin and the friar seems to have an accordion on his knees. The language is simplified, reduced to essentials. Picasso remembered the costumes for *Parade*, where the shapes of the dancers' bodies were broken up by geometric forms. But the impact of the palette of primary colours and the simplicity of the coloured surfaces made *The Three Musicians* a masterpiece intelligible to all.

1
Films were still silent. But in 1925, Sergei Eisenstein produced one of the finest masterpieces of that era: *The Battleship Potemkin*.

2
In 1923 the profound and serious face of a very young woman, Greta Gustavson, would be known on the screen henceforth as Greta Garbo.

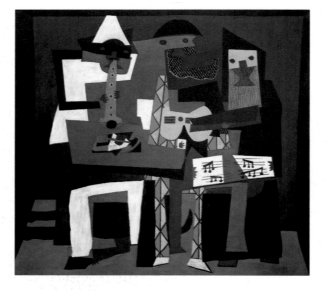

3 *The Three Musicians*, 1921
Oil on canvas, 200.7 × 222.9 cm
Museum of Modern Art (S. Guggenheim bequest), New York

4 *The Three Musicians* (or *Musicians Wearing Masks*), 1921. Oil on canvas, 203.2 × 188 cm
Museum of Art (Gallatin collection), Philadelphia

4
A masterpiece of Synthetic Cubism and at the same time a final farewell, *The Three Musicians* (also known as *Musicians Wearing Masks*) exists in two versions, each presenting the same three characters from the commedia dell'arte: Pierrot, Harlequin and the Capuchin friar (an allusion to Max Jacob who had withdrawn to his monastery?). One of these is in New York (3), the other in Philadelphia (4).

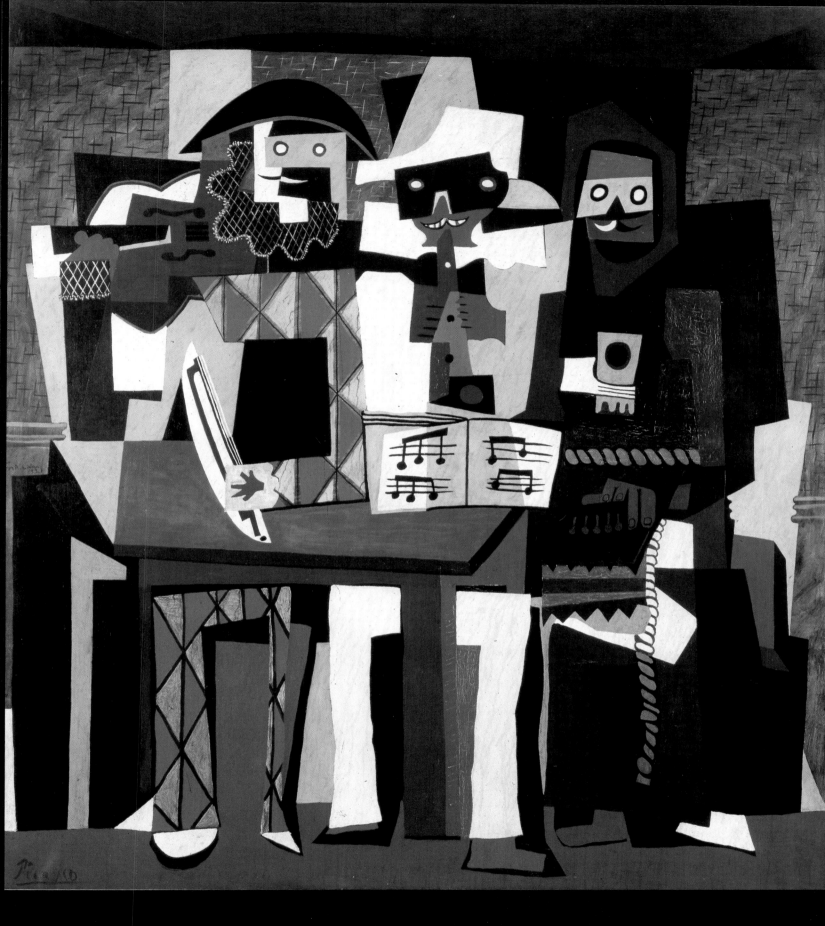

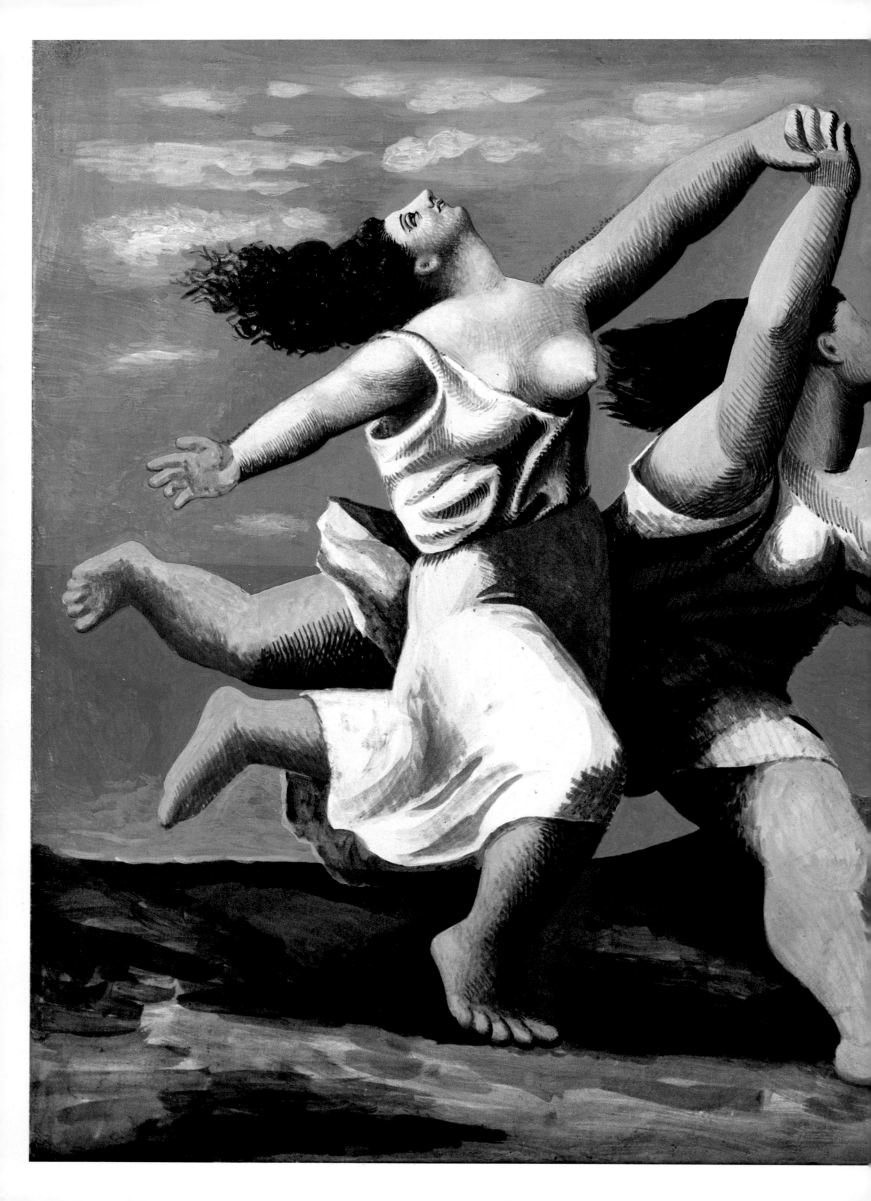

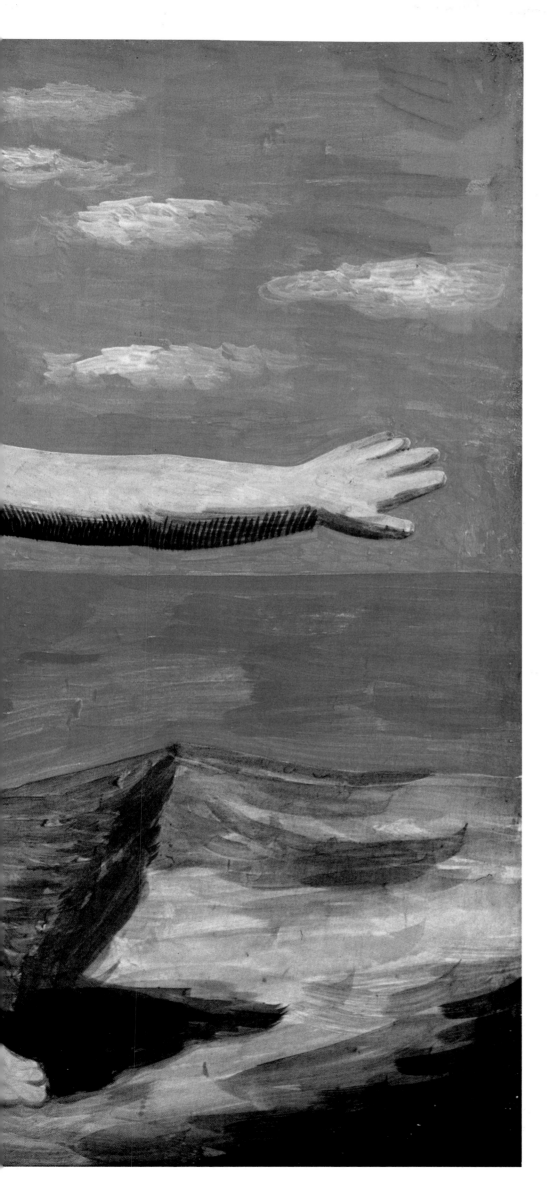

'When I was little, I often had a dream that frightened me a lot. My arms and legs suddenly became enormous and then began to shrink, becoming tiny. The same thing was happening to other people all around me, becoming gigantic or minute. This dream always caused me great anguish.'

The visual shock of *Two Women Running on the Beach* stems from the fact that the weight of these female giants hinders neither the lightness nor the gracefulness of their running. The bodies are large and robust, the limbs heavy and cumbersome. Yet the women seem to be dancing in the air, as light as a couple of ballerinas.

Mobility is created by various formal means: the hair and clothing are floating in the wind; the woman on the left has her head thrown back towards the sky, as if she were about to fly away, in a movement evocative of that of the goddess Thetis in Ingres's picture *Jupiter and Thetis*, while the woman on the right is casting her exceptionally large right arm towards the horizon, while her leg sticks out to the rear. Thus an impression of speed is achieved.

This gouache served as a model for the curtain of *Blue Train* (1924), a ballet by Diaghilev to music by Darius Milhaud, based on a text by Jean Cocteau (the action of *Blue Train* takes place on a fashionable beach during the holidays).

The stay in Rome with Cocteau for the completion of his first stage set, *Parade*, had an effect on Picasso, for he discovered the majesty of Roman statuary of the imperial period. It was not surprising that this view of Roman antiquity should combine with his creative work for the theatre, which was uppermost in Picasso's mind. One can see how, with classicism as his starting point, the painter overturned all the canons of traditional figure drawing, in order to express himself with complete freedom.

Two Women Running on the Beach, 1922
Gouache on plywood, 32.5 × 41.1 cm
Picasso Museum, Paris (RMN)

La Danse

1/2
Josephine Baker knew how to make new music catch on, ensuring the triumph of 'La Revue Nègre'. Whether wearing her famous sheath dress in the evenings, when she was acclaimed by the Paris smart-set, or dressed up like a clown in the company of the couturier Poiret to celebrate the feast of St Catherine, Josephine was the incarnation of charm and absolute grace.

I n the autumn of 1924, André Breton, who was convinced that *Les Demoiselles d'Avignon* 'is a work that in a singular way goes beyond painting, it is the arena for everything that has been happening for the last fifty years,' persuaded the journalist and art-lover Jacques Doucet to buy the picture. Picasso eventually agreed to be separated from his masterpiece and to let it 'become public'.

Doucet put his confidence in Breton and bought the picture, without having seen it, for 25,000 francs. The painter would always remember the arguments put forward by the purchaser in order to bring down the price: 'Well, you see, Monsieur Picasso, the subject is . . . well, a little delicate, and I can't very well hang it in Madame Doucet's sitting room.' And indeed, when Doucet took delivery of the picture in December, it was 'at the back of a series of rooms comprising the room where he kept his collection of unusual objects, the studio and the entrance hall-cum-landing' that he hung it.

André Breton, who had just published his *Surrealist Manifesto*, was now sovereign pontiff of the movement that formed around him with poets such as Aragon, Paul Eluard and Philippe Soupault. Breton offered the following definition of Surrealism in homage to Apollinaire who had been the first to use the term 'surreal': 'Through him, we had reached a common position on pinpointing a certain pure, psychological automatism by means of which the true functioning of thought could be expressed, either verbally or in written form . . . free from any limitation by the faculties of reason, outside any aesthetic or moral preoccupations.'

It was evident that it had nothing in common with the Dadaist movement of which Tristan Tzara and Francis Picabia were the leading lights. Dada was simply a revolt. Surrealism wanted to be a revolution with its intellectual heroes – Freud, Dostoevsky, Rimbaud, Lautréamont, Marx – and its disciples gathered around Max Ernst's painting of 1922, *The Gathering of Friends*. The Surrealists immediately felt a bond with Picasso, who had been the first to direct his gaze at what was beyond 'real reality'; what André Breton was to label the 'internal model'.

'From the point of view of art, there are no abstract or concrete forms, there are only forms, and they are all lies that are more or less convincing.'

3 *La Danse*, 1925
Oil on canvas, 215 × 142 cm
Tate Gallery, London

3
Picasso amazed people once more with *La Danse* and its syncopated composition. The colours are violent, the picture aggressive in the way the bodies are cut up, with fingers in the form of nails, severed breasts, and the face of the character whose head is thrown back resembles a skull. Picasso and Olga's marriage was in difficulties and all the violence of those feelings is concentrated in this work.

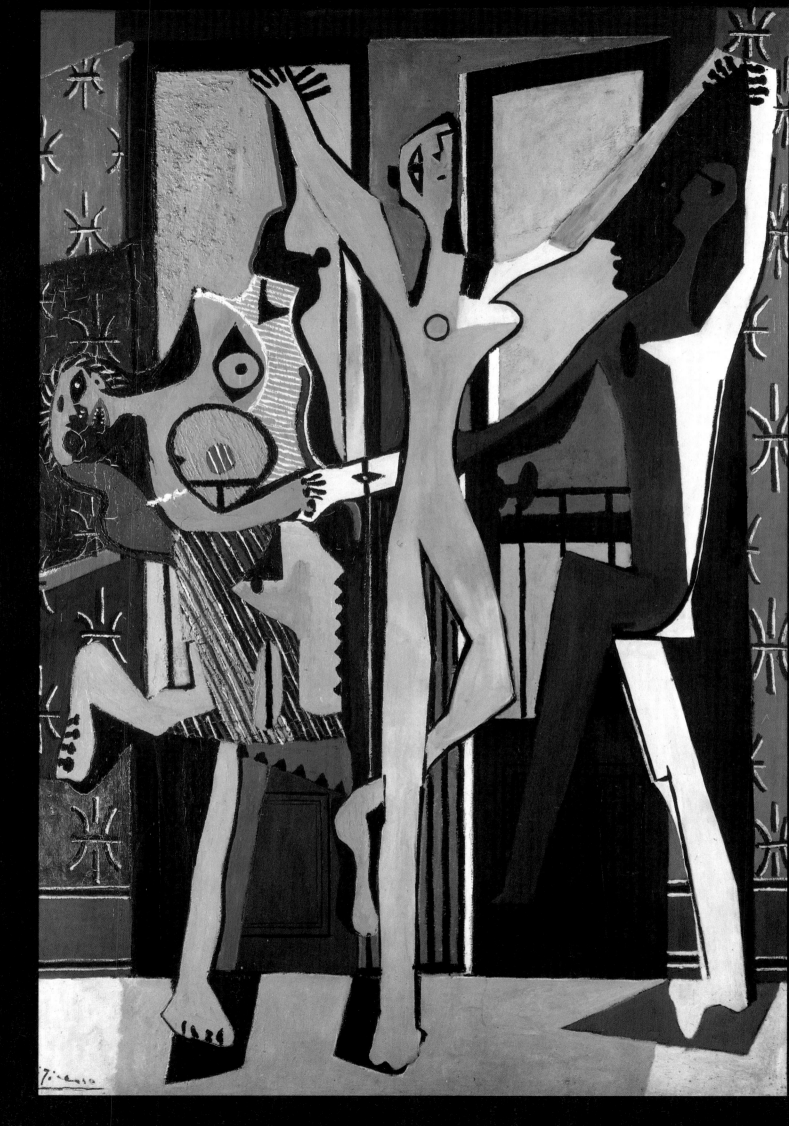

The first issue of the Surrealist magazine *La Révolution* featured a construction by Picasso dating from 1914.

In 1925 a violent argument broke out: can there be such a thing as Surrealist painting or can the exploration of the subconscious be conducted only with words? Breton immediately took up his pen, and in *Surrealism and Painting* he could find no better answer than to quote the example of Picasso. He illustrated his point with five of the artist's paintings: three from the Cubist period, *Les Demoiselles d'Avignon*, and the painter's latest work, a canvas that expressed a fair degree of violence and novelty, *La Danse*.

In order to understand *La Danse* it is necessary to backtrack a little, into the very heart of the painter's private life. He and Olga were no longer getting on. Picasso had had enough of Olga's jealous scenes, which were becoming

1
Photomontage of the Empire State Building in New York in 1931, 380 metres high with its 86 storeys, topped with a mooring point for Zeppelins. The Eiffel Tower was no longer the tallest building in the world.

2
After the Exposition Universelle of 1900, Paris was once more in party mood. The Exposition

2 3

more and more frequent, and he was weary of this well-ordered and organised life in which everything was predictable and to which he was being subjected. And so in April he went to Monte-Carlo with Olga and Paulo, in the hope that they might meet up again with Diaghilev's ballet company, Diaghilev himself even. Olga might remember their first love and regain some of that tenderness. It was a waste of time. The couple did not manage to see eye to eye. Back in Paris, Picasso painted furiously, giving birth to *La Danse*, which was his attempt at putting on canvas his drifting away from Olga. Olga loved classical ballet. Picasso painted the joyful frenzy of modern dance with its free, syncopated movements, dislocated composition and violent colour. Jazz comes on to the canvas, perhaps through the open window, and the three dancers sway their hips to convey a fast and exalted rhythm to the picture. 1925 was also the year in which Josephine Baker triumphed with her 'Revue Nègre' and danced the Charleston to New Orleans music.

4

Coloniale of 1931 was opened amidst great pomp. In the first car were President Doumergue and Marshal Lyautey; in front of the presidential car, press photographers can be seen scurrying about.

4
For Picabia, who was a Dadaist until he broke with Tzara 'art is everywhere'. It was pointless, then, to make a virtue of painting a picture. For it to exist as a work of art, and as a saleable commodity, it suffices for all those present at the 'artistic and intellectual happening of the moment' to sign it. Thus one can make out around Picabia's eye, painted by himself and treated with cacodyl, graffiti and the signatures of Tzara, Milhaud, Perret, Poulenc, Soupault, Jean Hugo.

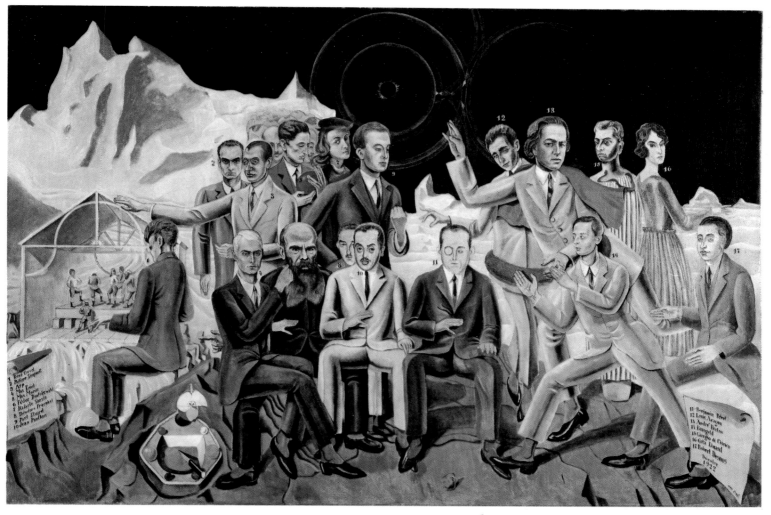

5
Banned from entry to
France, Max Ernst managed
to get across the border,
thanks to the passport of
Eluard who had come to
visit him. This former
Dadaist joined the group of
Surrealists that he
immortalised in his *Meeting
of Friends* in 1922. Around
Breton can be recognised
Crevel, Soupault, Arp, Max
Ernst, Eluard, Jean Paulhan,
Benjamin Péret, Aragon, De
Chirico, Desnos and even
Dostoevsky.

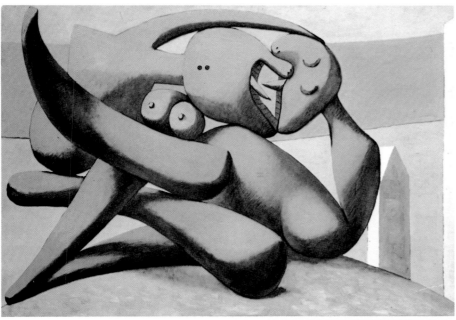

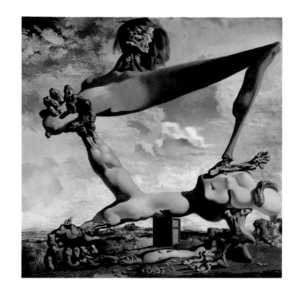

6
Figures at the Seaside are
kissing intimately with
tongues of steel, like a drill
probing troublesome teeth.
The male cannot be
distinguished from the
female, the two round
breasts could belong to
either figure. But one might
suppose that the woman has
her eyes closed and that her
face is 'taken' by the phallic
nose of the male figure.

3 *It's the Hat that Makes the Man*, 1920. Max Ernst
Papier collé, pencil, ink & watercolour, 36.5 × 45.7 cm
Museum of Modern Art, New York (ADAGP)

4 *Cacodyl Eye*, 1921. Francis Picabia
Oil on canvas, 146 × 115 cm
Musée National d'Art Moderne, Paris (ADAGP)

5 *The Meeting of Friends*, 1922. Max Ernst
Oil on canvas, 130 × 195 cm
Wallraf-Richartz Museum, Cologne (ADAGP)

6 *Figures at the Seaside*, 1931
Oil on canvas, 130 × 195 cm
Picasso Museum, Paris (RMN)

7 *Premonition of the Civil War*, 1936. Salvador Dali
Oil on canvas, 100 × 99 cm. Museum of Art,
(L. & W. Arensberg collection), Philadelphia (ADAGP)

7
Painted in 1936, at the
outbreak of the Spanish
Civil War, Dali's *Premonition
of the Civil War* is a visionary
work, a masterpiece
of Surrealist painting.

'I am Picasso. You and I are going to do great things together . . .'

The girl who was accosted in this way one day in January 1927 looked in amazement at the man standing in front of her.

Picasso? No, really, the name meant nothing to her. She was Marie-Thérèse Walter and was as blonde as Olga, Eva and Fernande had been dark. She was seventeen years old: 'I was an innocent little kid. I knew nothing – neither about life nor about Picasso. Nothing. I had been shopping in the Galeries Lafayette and Picasso saw me coming out of the Métro.'

Picasso fell instantly in love with the girl. But she was living at home with her parents,

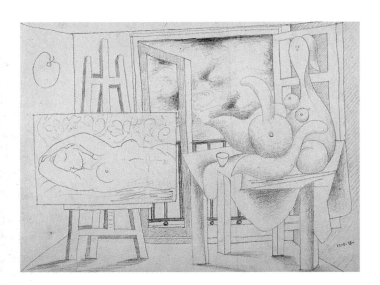

and he was married. For six months the painter courted Marie-Thérèse eagerly. Then the idyll turned passionate and tender; the lovers were happy and Picasso forgot his forty-five years and his sour wife. 'We would laugh and joke together all day long, so happy was our secret, living out a love that was totally un-bourgeois, a Bohemian love affair,' reminisced Marie-Thérèse. She now became his inspiration, and he painted her unceasingly: in sketch-pad studies first of all, then in a series of guitars, apparently abstract, but whose very structure was based on the linking of the young woman's initials, M.T.

Fortunately Olga never ventured out of her apartment with its impeccably polished floors, but she was starting to be in the way. In Marie-Thérèse he had encountered a new source of inspiration, and the presence of Olga, a permanent source of irritation, was in danger of spoiling everything.

Obliged to spend the summer with his family at Cannes, Picasso painted men and women bathing on the beach. He dreamt about his young mistress, 'always ready for caresses and her lips so soft, speaking only in order to caress the word . . . looking at the sky only while lying on the bed with her arms dangling'.

Marie-Thérèse – or the good life regained

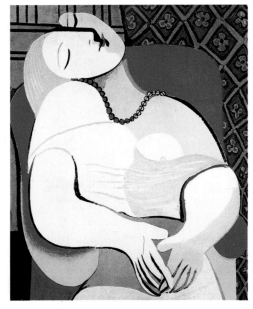

1
'Painted on Sunday afternoon, 24 January 1932,' wrote Picasso on the back of this painting, as if to reveal more adequately the serenity and tranquil happiness of that Sunday while Marie-Thérèse was sleeping. *Le Rêve* is the first in a series of pictures, mostly of nudes sleeping soundly. The bright colours, the rounded outlines, the languid pose of the model convey an erotic charm and obvious happiness. The cheerfulness of the colours, the flowered wallpaper and the sensuality of the curves are evocative of certain pictures by Matisse.

3/4
Woman Bather with a Beach Ball was inspired by a photo that Picasso took of Marie-Thérèse at Dinard.

1 *Le Rêve*, 1932
Oil on canvas, 130 × 97 cm
Ganz Collection, New York

2 *The Studio*, 1933
Graphite on paper, 25.6 × 34.2 cm
Picasso Museum, Paris (RMN)

3 *Woman Bather with a Beach Ball*, 1929
Oil on canvas, 22 × 14
Picasso Museum, Paris (RMN)

5 *Woman Bather Opening a Beach Hut*, 1928
Oil on canvas, 32.8 × 22 cm. Picasso Museum, Paris (RMN)

5
'I'm very fond of keys . . . It seems to me very important to have them. It's true that I've often been haunted by keys. In the series of men and women bathing, there is always a door that somebody is trying to open with a large key.'

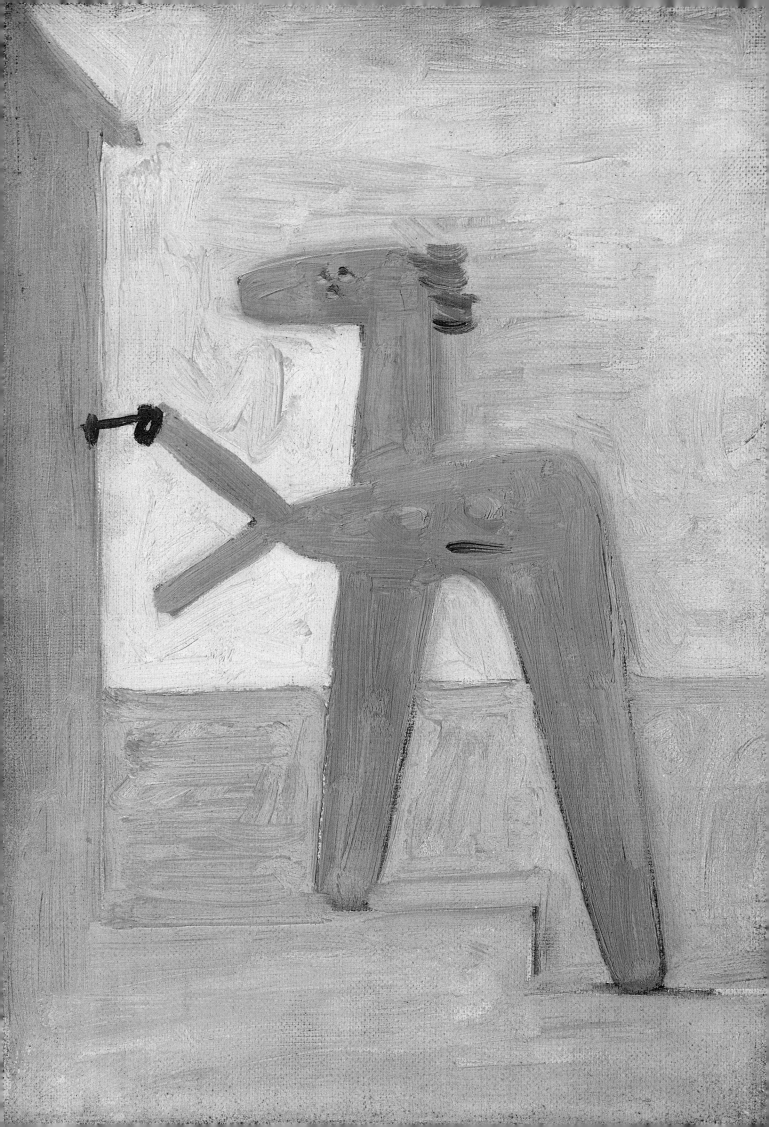

14 Decembre XXXV.

sur le dos de l'immense tranche
de melon ardent
arbre morceau de fleuve
table à rire
sous la mendée de l'aile qui
serre pour le plaisir de voir
espirer entre ces dents
distraite de son ennui
un brin d'herbe
ses deux petits boutons de prunus
tombées si bas
s'embrassent depuis deux ou trois jours
enervée par les pleurs
de la petite fille

'Basically, I think I'm a poet who turned out badly.'

1935 was a terrible year for Picasso, 'the worst period of my life,' he wrote to Sabartès. Olga had finally left, taking Paulo with her, but Picasso could not contemplate divorce. For that he would have had to give up half of the pictures that filled his studios and which were an integral part of his work. And so it was impossible to marry Marie-Thérèse and to live openly with her and little Maya, to whom the young woman had recently given birth. It was necessary to hide, always to hide. It gave Picasso sleepless nights and he could no longer manage to work. In the autumn he took refuge in the Château de Boisgeloup which he had bought as somewhere to shelter his affair with Marie-Thérèse. Here, in secret, he began to write, filling notebooks with poems and illustrating them. Picasso had always liked writing. A long time previously Apollinaire had been the first to notice: 'Even when he could barely speak French, he was in a position to judge and savour immediately the beauty of a poem . . . He himself has written admirable poems in Spanish and in French.' The painter's words were splashes of vibrant colour, drawings in which the spoken word took flight. André Breton was won over by them and published several of Picasso's poems in the magazine *Cahiers d'Art* at the beginning of 1936.

1 *Coloured Poem*, 1935
Picasso Museum, Paris (RMN)

2 *Manuscript Poem*, 1936
Picasso Museum, Paris (RMN)

'Painting is not intended
for decorating apartments with.
It is an offensive weapon of war
and a defensive one against the enemy.'

In March 1936, Picasso, Marie-Thérèse and Maya went to Juan-les-Pins. Despite the good life of his new home, Picasso was unsettled and his work showed it. He wrote some surprising remarks to his friend Sabartès: 'I'm writing to tell you that from this evening onwards I'm giving up painting, sculpture, engraving and poetry for good, in order to devote myself exclusively to singing.' A plan that was fortunately contradicted in the following letter: 'I'm continuing to work, despite singing and everything.'

The Spanish Civil War that broke out in 1936 wrenched the painter out of his melancholy. Picasso immediately aligned himself with the Republicans, against General Franco. The war was extremely violent, as those years in which Fascism sought to dominate had already been. As early as 1933, when Hitler was burning any book that had anything to do with Jewish culture or was written by a Jew, Kahnweiler had understood the gravity of the situation that was about to come crashing down on Europe.

Two months before the start of conflict in Spain, Hitler made his speech in the Lustgarten in Berlin, surrounded by leading Nazis, and in front of a crowd almost delirious with enthusiasm, their arms outstretched towards the flag bearing a swastiska.

The war against Fascism began and a certain number of intellectuals joined up. Some,

1/2
On 1 May 1936, Hitler made a speech at the Lustgarten in Berlin (1). The University of Vienna was occupied by Nazi students as early as 1935 (2). Racialist statutes were promulgated in Germany and Austria. From Hitler's accession to the Chancellery of the Reich and since the *auto-da-fé* of 1933 that aimed to destroy all so-called degenerate Jewish books, Jews were denied access to universities, to certain shops and certain professions. In France the extreme right was active and organised a large anti-Semitic rally in February 1934, that provoked a Communist counter-demonstration. In Spain, Civil War broke out, with Franco and his troops in opposition to the Republicans. On 28 April 1937 German bombers flattened the small town of Guernica. Picasso immortalised the martyrdom of Guernica in an immense painting of 3.5 metres by 7.8 metres, which became the symbol of human barbarity, and resistance to oppression.

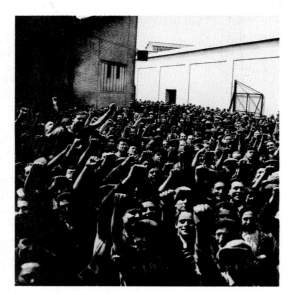

like André Malraux, did not hesitate to volunteer for the Republican side. But they were few in number and the shadow of Fascism spread over Europe.

In 1937, the French Government organised a large exhibition entitled 'Progress and Peace' that was located at the base of the Eiffel

3
A demonstration in the inner courtyard of the Renault factories at Billancourt on 28 May 1936. The Popular Front was in the ascendant.

4
Woman Weeping, a variation on *Guernica*, emerges as the symbol of Spanish women's tragedy during the Civil War. It was incarnated in Dora Maar, a woman of all the passions, Picasso's politicised companion with the excessively Latin temperament of whom he would say: 'I've never been able to see her or imagine her other than crying.'

4 *Woman Weeping*, 1937
Oil on canvas, 55 × 46 cm
Picasso Museum, Paris (RMN)

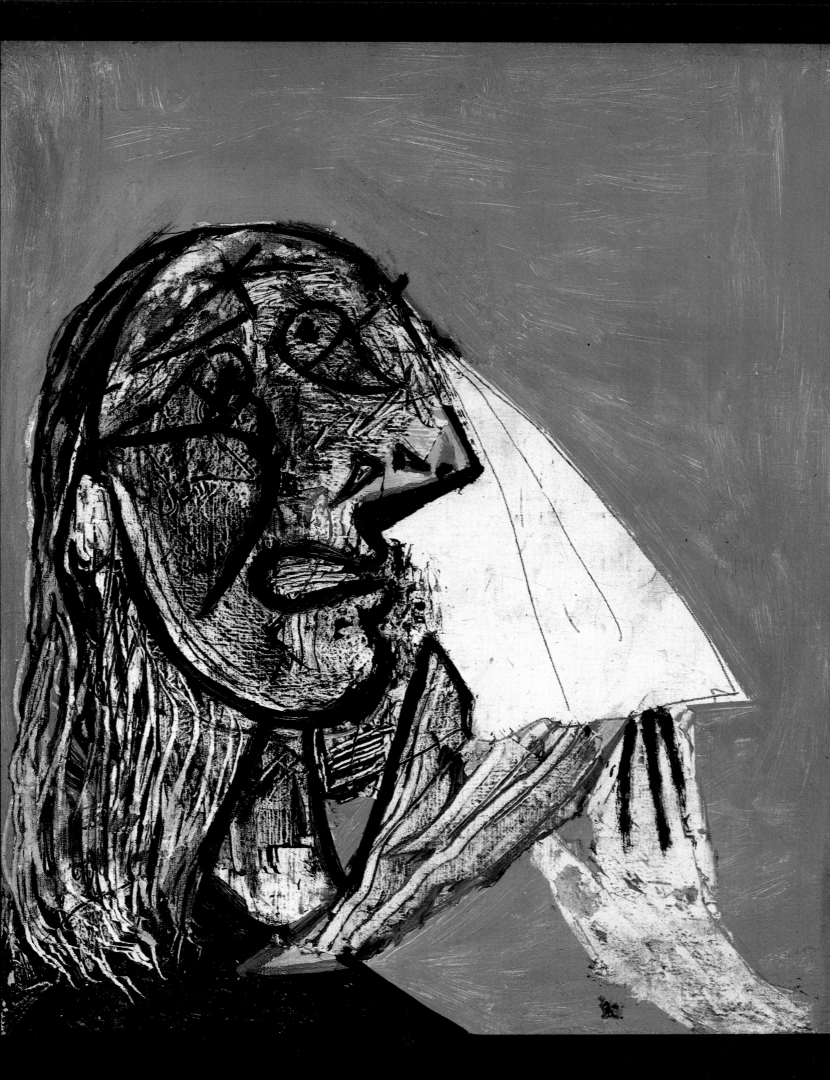

Tower and on the esplanade of the Trocadéro. The fifty-two participating countries were invited to exhibit the works of their greatest artists in a pavilion that was put at their disposal.

The Republicans of the Popular Front asked Picasso to represent their cause in the name of Spain and he accepted, beginning his work in the large premises in the rue des Grands-Augustins found for him by Dora Maar, his new guardian angel. Dora, who had been introduced to him by Paul Eluard, was a painter and photographer. She was clever, cultured and passionately interested in modern art, and, above all, she spoke fluent Spanish. Without giving up the gentleness of Marie-Thérèse, Picasso became involved with Dora, who was an intellectual and a support to him politically during this distressing time.

On 1 May 1937, the newspapers of the whole world revealed the indefensible: German bombers, called in by Franco, had destroyed the small Basque town of Guernica. The bombing had lasted almost four hours, mercilessly annihilating the town and its surrounding district over a six-mile radius. The toll was terrible: 1660 dead, thousands of wounded and homeless, ruins stretching as far as the eye could see, a town eradicated from the map.

Shocked and overwhelmed, Picasso channelled his anger into a canvas eight metres wide. It took him a month to paint the martyrdom of Guernica.

On 4 June 1937, *Guernica* took its place in the Spanish pavilion at the Exposition Universelle in Paris.

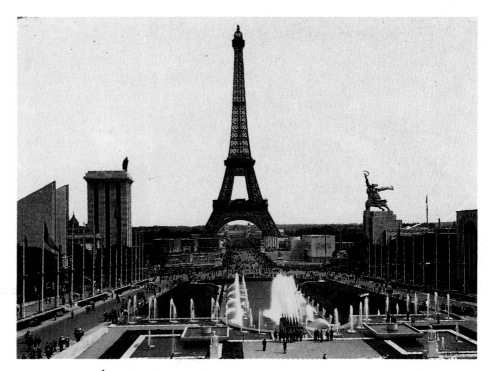

1
In a political context marked by the rise of Fascism in Europe, the Exposition Universelle of 1937 was intended as a showcase for peace and progress. In reality, it was a reflection of the upheavals that would lead to the Second World War. The eagle and swastika soared 54 metres high above the German pavilion, standing opposite the pair of statues, *The Worker* and *The Collective Farm Labourer*, 33 metres high atop the Soviet pavilion, while Fascist Italy was attempting to imitate the splendours of Ancient Rome. In the Spanish pavilion, Picasso's painting *Guernica* evoked the bloody civil war and the martyrdom of the small Basque town bombed by the Germans.

Following pages:
Guernica, 1937
Oil on canvas, 351 × 782 cm
Prado Museum, Madrid

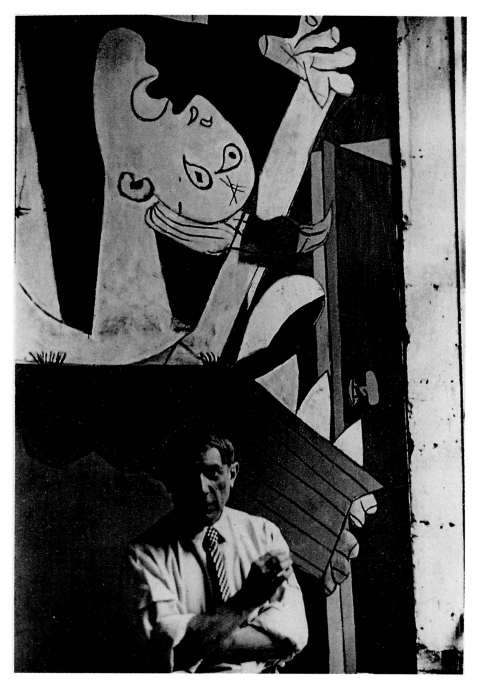

'The Spanish Civil War is a battle of reactionaries against the people, against freedom. My whole life as an artist has been nothing other than a continual struggle against the forces of reaction and the death of art. In the panel on which I am working and which I shall call *Guernica*, and in all my recent work, I express clearly my horror of the military class that has plunged Spain into an ocean of pain and death.'

3
Picasso photographed in front of *Guernica* by the American Robert Capa, one of the greatest war photographers.

2/4
Franco's army, urged on by Hitler, spared neither the Republicans nor civilians. Men, women and children were massacred with impunity, villages were razed to the ground. Many civilians would attempt to cross the border to seek refuge in France. Those who succeeded were rounded up like cattle by the French government and put into refugee camps.

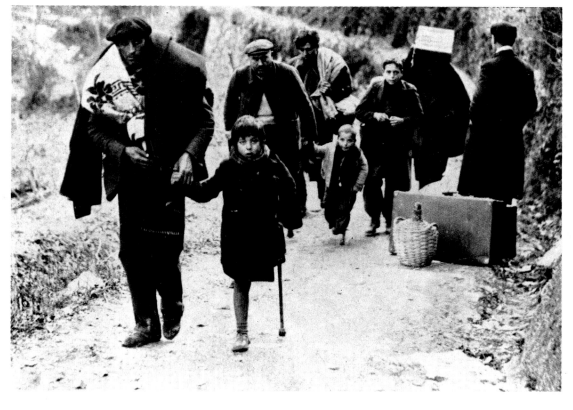

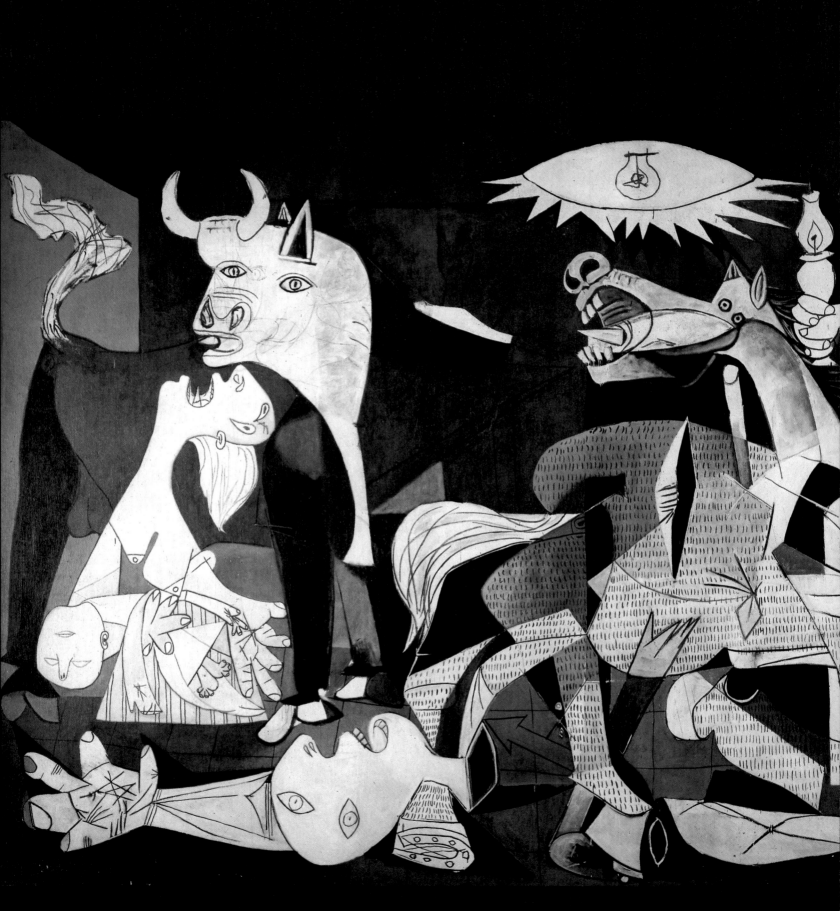

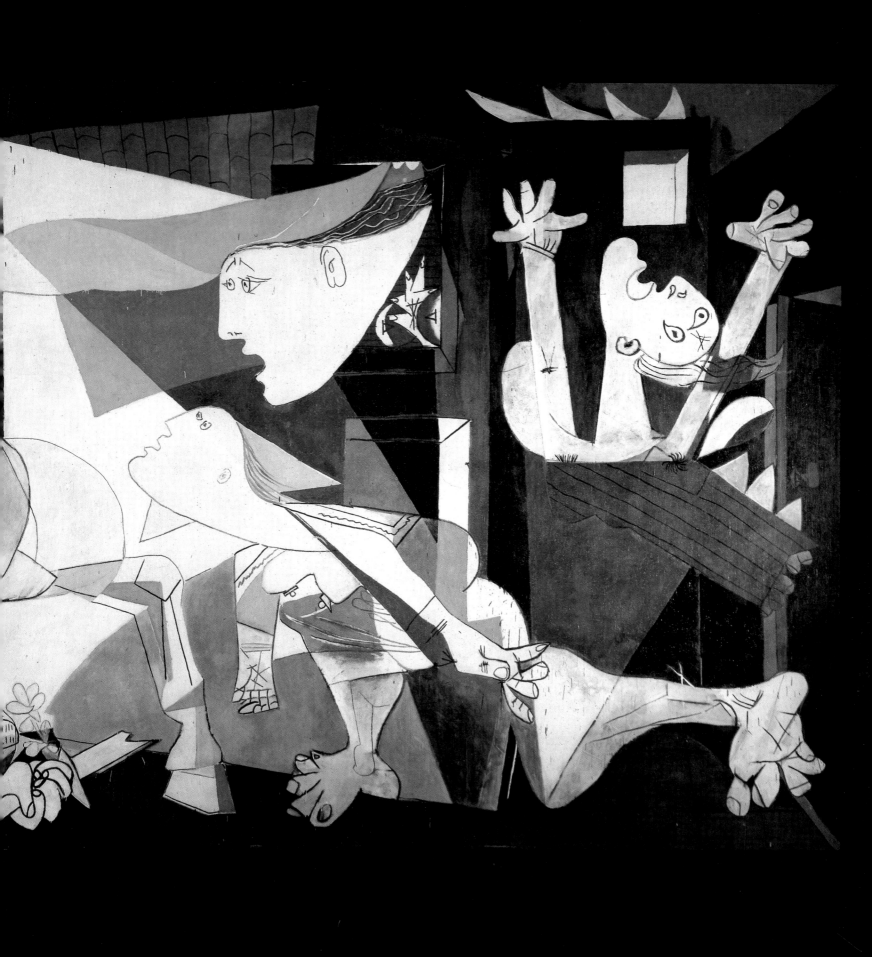

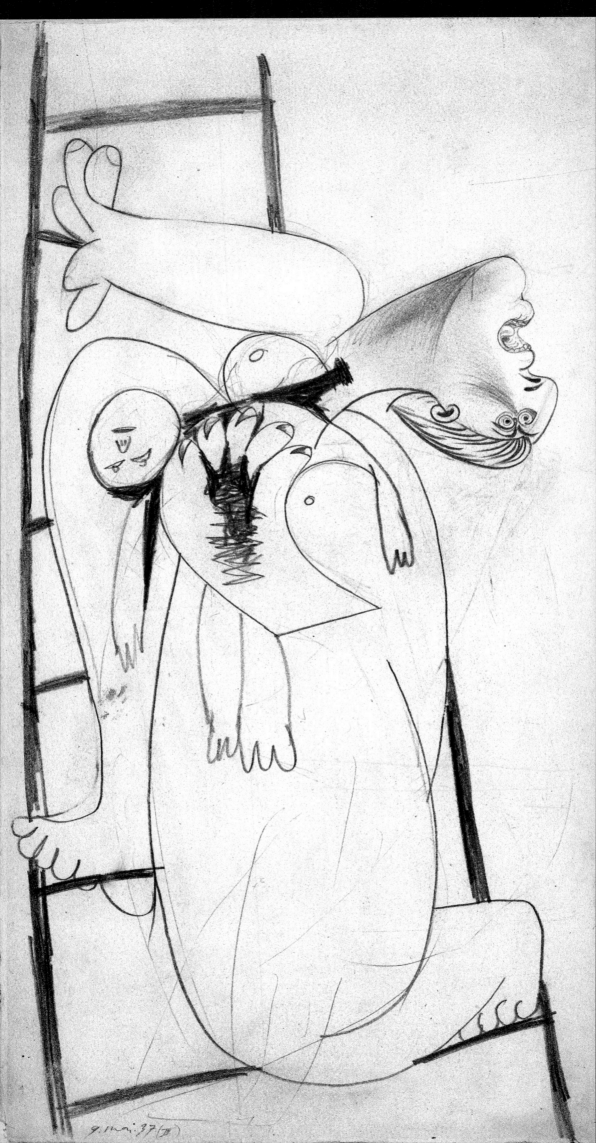

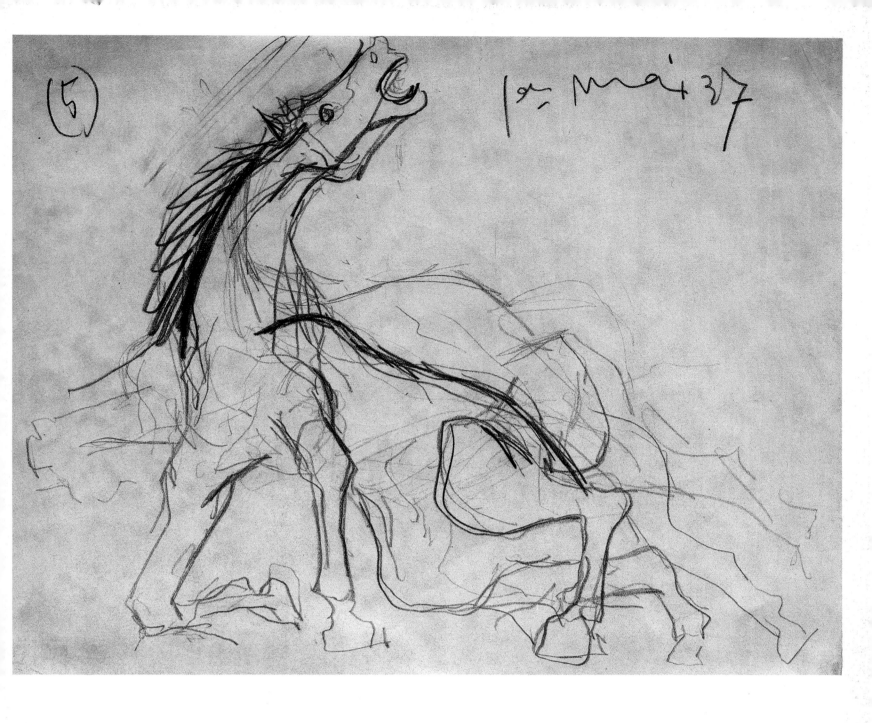

(5) 1ᵉʳ mai 37

'The bull
represents brutality,
the horse the people.
Yes, there I used
symbols.'

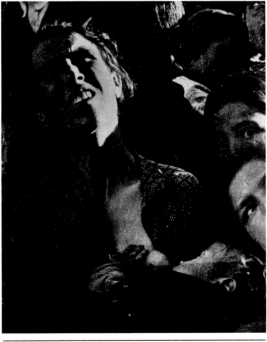

While Spain was being torn apart by civil war, the cultural attaché at the Spanish Embassy in Paris, the poet José Bergamin, got Picasso to agree to paint the large panel for the Spanish pavilion for a sum of 150,000 francs. Three photographs of the bombing of Guernica appeared in the newspaper *Ce Soir* on 1 May 1937. Picasso then flung all his feelings of revulsion into Guernica. He completed forty-five preliminary drawings, most of which were in colour. The symbolic elements were present in the very early sketches: *The Bull, The Horse, The Bearer of Light*. The whole picture is imbued with mourning, black and white ineluctably evoking death.

1/2 Preparatory drawings for *Guernica*,
Picasso Museum, Barcelona

3 Photograph by Robert Capa,
taken in Extramadure

1 Preparatory drawings for *Guernica*
Picasso Museum, Barcelona

2 *Woman Imploring*, 1937
Gouache & ink on wood, 24 × 18.5 cm
Picasso Museum, Paris (RMN)

Following pages:
1 *Portrait of Marie-Thérèse*, 1937
Oil on canvas, 100 × 81 cm
Picasso Museum, Paris (RMN)

2 *Bust of a Woman with Striped Hat*, 1939
Oil on canvas, 81 × 54 cm
Picasso Museum, Paris (RMN)

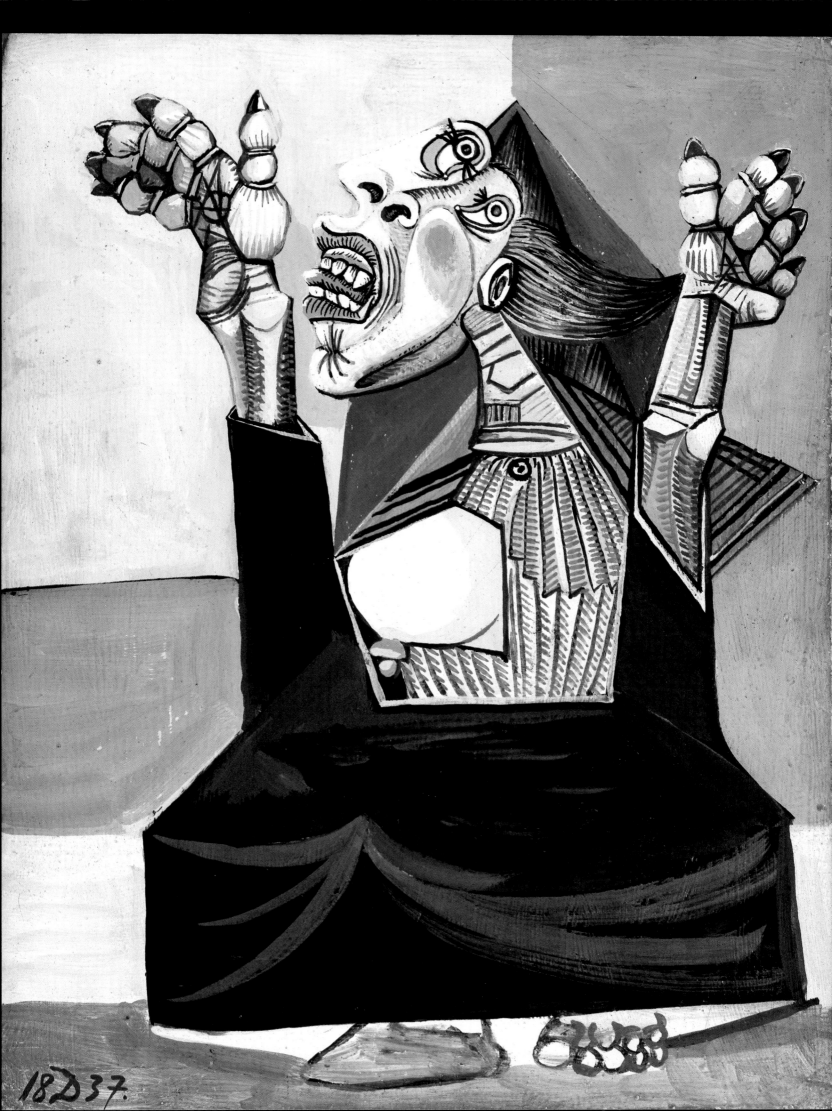

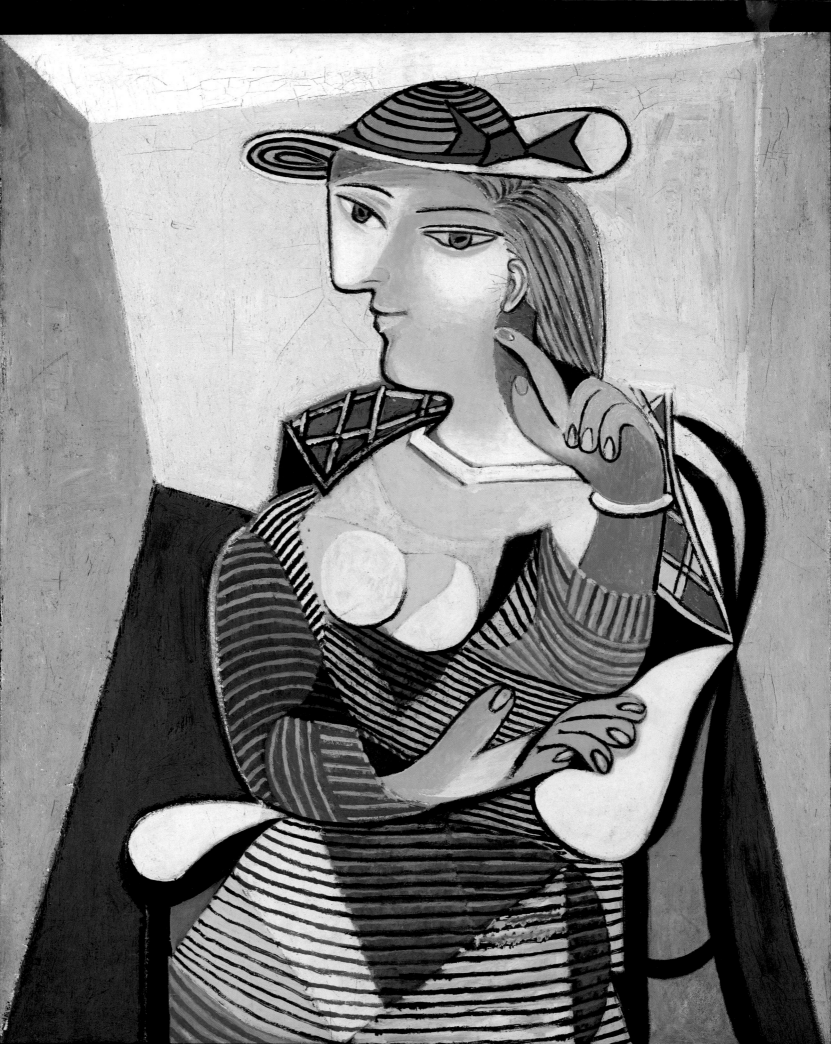

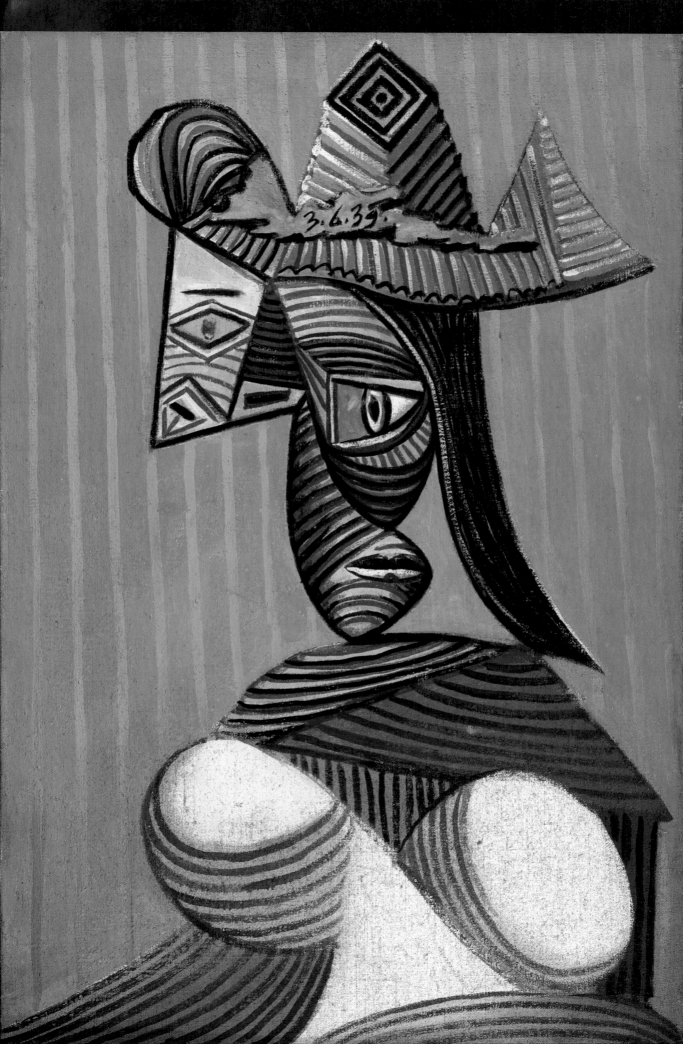

Dora Maar

'Devilishly seductive
dressed up in her tears
and wearing wonderful hats.'

1/2
Picasso with Dora in 1937 at
Juan-les-Pins and Mougins,
where they holidayed
together with Paul Eluard
and his girlfriend Nusch.

3
Picasso always painted Dora
in red and black, the
colours of passion and
death. She, alone,
embodied for Picasso the
tragedy of Spain.

From now on, Picasso had two muses, Dora Maar the brunette, and the blonde and gentle Marie-Thérèse, whom he still loved and desired. The letters he wrote to the latter bore the stamp of the greatest tenderness: 'Tonight I love you even more than yesterday, less than I shall love you tomorrow, as the man said. I love you, I love you, I love you, I love you Marie-Thérèse.'

Picasso did not leave the one for the other, even if Dora was the privileged confidante of his fears, his anger and his hope in these times torn apart by the Spanish Civil War. For the painter was still obsessed with Spain, and he engraved two plates which he accompanied with a poem: *Franco's Dream and Franco's Lie*, which was a merciless indictment of Franco and all he stood for: ' . . . children's cries, women's cries, cries of birds, cries of flowers, cries of beams and stones, cries of bricks, cries of furniture, of beds, of chairs, of curtains and crockery . . . ' Picasso was exhausted, and went off accompanied by Dora to meet up with his friends Nusch and Paul Eluard at Mougins. Picasso, who had always enjoyed the poet's company, rediscovered with him some of the complicity he had enjoyed with Apollinaire in earlier days. He rested and enjoyed himself, taking advantage of the sun and the water.

3 *Portrait of Dora Maar, c.* 1937
Oil on canvas, 92 × 65 cm
Picasso Museum, Paris (RMN)

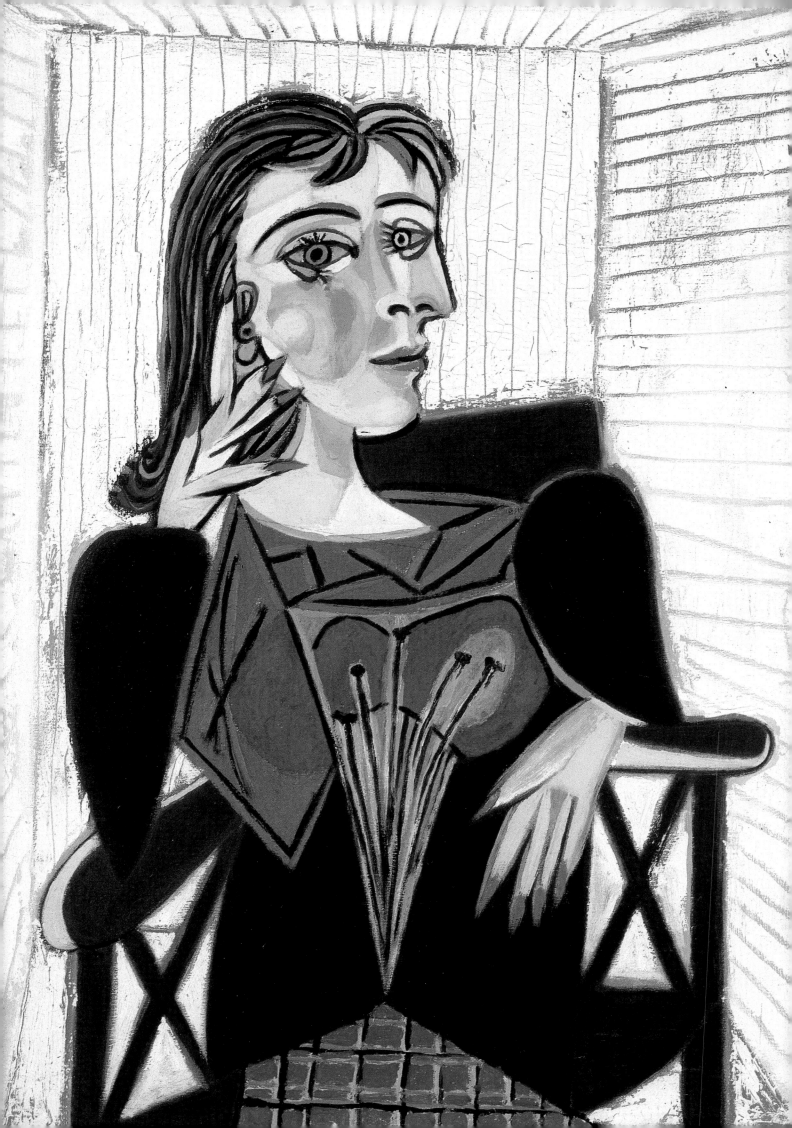

He returned to Paris in September, and painted Dora's face for the first time. But he had not forgotten Marie-Thérèse, whom he settled with her daughter in an attractive property on the outskirts of Paris where he went every week-end (Olga having taken Boisgeloup back from him). He watched Maya growing up, which he found an emotional experience; he made her rag dolls, never wearied of drawing her face, which was looking more and more like her mother's.

In Germany, modern art did not escape from the terror spread by National Socialism. Hitler, who had declared war on 'degenerate art' as early as 1933, opened a double exhibition in Munich in July 1937: 'healthy' pic-

'I've always believed, and still do, that artists who live and work according to spiritual values cannot and should not remain indifferent to a conflict in which the highest values of humanity and civilisation are at stake.'

tures, evoking family and working life against a background of bucolic landscapes, were on show in the House of German Art, while so-called 'degenerate' works, signed by Matisse, Picasso, Klee, Ensor, Chagall, Kokoschka and others were hung in studied disarray in a warehouse. For Hitler, the creators of modern art, especially when they were Jewish, were madmen, sick and perverted, whose rightful place was in prison or a psychiatric hospital. The Chancellor emptied German museums of these 'ultimate elements of cultu-

1
Max Jacob would be one of the six million Jewish victims of Nazi genocide. In spite of a petition launched by Coeteau to release him from the prison camp at Drancy, the poet died there and Picasso attended his memorial service.

2/3
In 1939, the last exodus of Spanish refugees were herded into camps in France.

4
Nusch Eluard had had a difficult time when young. As an actress in Germany in the 1920s, she had been given the roles of old women to play, despite her tender years. She tried to survive in Paris by posing for postcards. Paul Eluard, whom Gala had just left for Dali, met her in 1929 and married her six years later.

4 *Portrait of Nusch Eluard*, 1937
Picasso Museum, Paris (RMN)

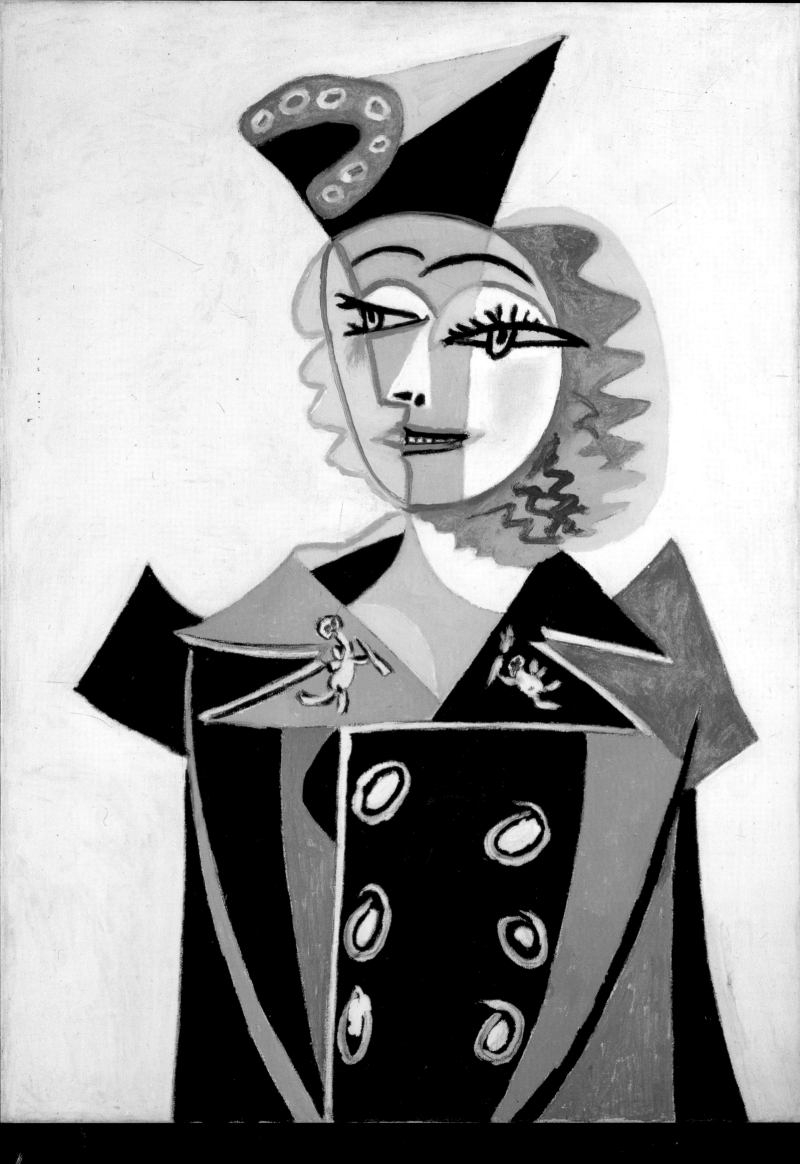

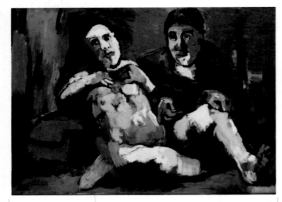

ral decomposition'. Then in 1939 there took place in Lucerne an auction sale of these works, from which the profits went straight into the coffers of the Nazi Party, while 5000 pictures, judged 'unexploitable' were burnt in a fire station in Berlin.

The invasion of Czechoslovakia, then of Poland, made the involvement of France and Britain in the war inevitable. Picasso sent Marie-Thérèse and Maya to Royan, far from Paris where air-raids were feared. The German-Soviet pact was signed on 23 August. This brought disillusionment for Picasso and Eluard, who still believed that the democratic countries and the Soviet Union would be capable of putting an end to dictatorships and their madness. He had to act quickly. He needed to protect his work from the

1/2
As he had done with Paulo, Picasso, who was filled with wonderment at being a father, produced sketch, drawing, portrait, one after the other of his daughter Maya. The child was pretty and, to the painter's delight, resembled Marie-Thérèse. The doll was a theme dear to many artists, such as Le Douanier Rousseau (2) and Kokoschka (1).

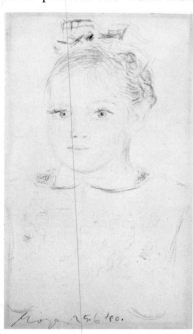

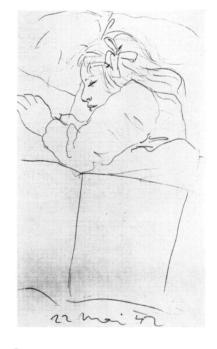

onslaught of barbarity, gather together his paintings and drawings scattered amongst various exhibitions, and put them in safety. Finally, on 29 August, Picasso set off to join Marie-Thérèse and Maya in Royan. Dora went with him. He moved in with Marie-Thérèse at the Villa Gerbier-de-Jonc and settled Dora in the Hotel du Tigre. There Picasso felt safe, with the two women he loved around him. On 21 June Pétain and Hitler signed the Armistice. France was occupied and the Germans entered Royan. Picasso then put an end to this pointless exile and returned to Paris.

1 *Man with a Doll*, 1922. Oskar Kokoschka
Staatliche Museum Prussischer Kulturbesitz, Berlin

2 *Child with a Doll*, c. 1908. Henri Rousseau
Oil on canvas, 67 × 52 cm
Musée du Louvre (Walter Guillaume coll.), Paris (RMN)

3 *Portrait of Maya*, 1940
Coloured pencil, 24 × 14 cm

4 *Maya*
Cardboard cutout, coloured pencil, 17 × 7 cm

5 *Maya*, 1942. Drawing, 35 × 21 cm

6 *Maya with a Doll*, 1938
Oil on canvas, Picasso Museum, Paris (RMN)

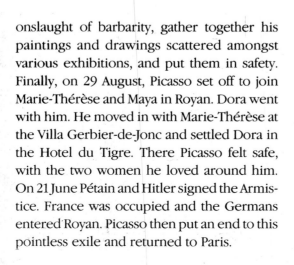

1
Picasso's studio – and his reflection in the mirror – at Royan in 1940. Discovering the exceptional view of the sea from the top floor of the villa, Picasso exclaimed: 'This would be all right for someone who thought he was a painter.'

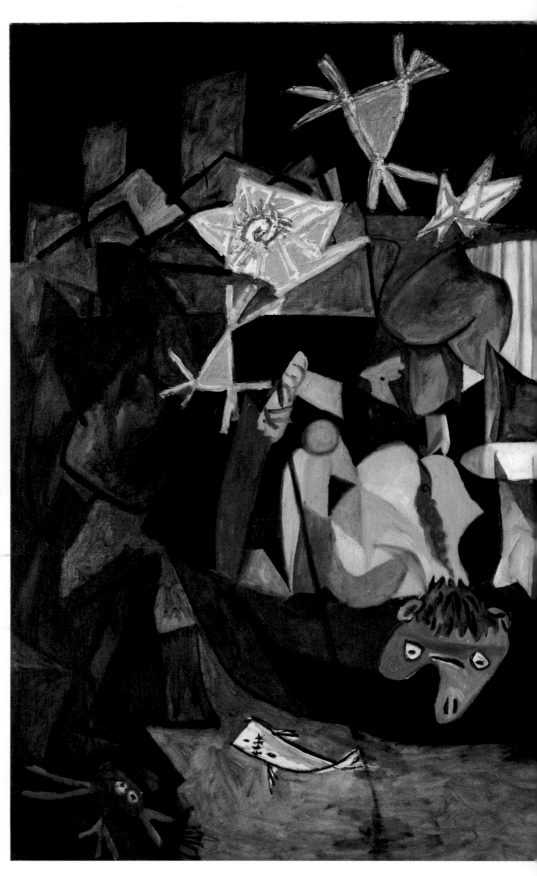

2
Fishing by Night at Antibes was Picasso's biggest picture since *Guernica*. While on holiday at Antibes, the painter had been delighted by the sight of nocturnal fishing with lamps. The technique is simple: a powerful torch or gas-lamp is placed at the bow, or stern, creating artificially the light of the full moon that attracts fish. It remains only for the fishermen to scoop them up in a net. On the quayside, two women are watching the spectacle: Dora and Jacqueline Lamba, André Breton's wife.

2 *Fishing by Night at Antibes*, 1939
Oil on canvas, 205.8 × 345.4 cm
Museum of Modern Art (Mrs Simon Guggenheim bequest), New York

For the Nazis, as for the Vichy government, Picasso was one of the proponents of 'degenerate art'. Consequently he had a ban slapped on him from exhibiting his work.

When confronted with war, French artists

1
The opening of the Arno Breker exhibition at the Orangerie in May 1942 attracted that part of Paris high society that supported the Vichy régime, or at least tolerated it. Behind the SS dignitaries one can make out Abel Bonnard, Serge Lifar, Jean Cocteau and Arno Breker. At the microphone, Benoist-Méchin, Secretary of State, paid tribute to Hitler 'the protector of the arts' and to Breker 'the sculptor of heroes'.

adopted varying forms of behaviour: there were those who agreed to work with the occupier, and even go to Germany at the invitation of Hitler's personal friend Arno Breker, the sculptor and leading exponent of Nazi art, which exalted the strength and virility of German youth; Vlaminck, Derain, Dunoyer de Segonzac, van Dongen, the sculptor Paul Belmondo were among them.

Many artists who were still in the unoccupied zone, such as Max Ernst, Dali, Masson, Brauner and Chagall, chose to leave France for the United States, where they could get on with their work in peace and quiet.

There remained those who decided to fight by offering artistic and intellectual opposition to the occupier. The painter Jean Bazaine and André Lejard, publisher of Editions du Chêne, organised under the very noses of the occupying forces an exhibition of the works of these artists who adopted the name 'painters in the French tradition'.

A year later, in 1942, Paris played host to Arno Breker, who was officially received at the Orangerie in the Tuileries. The inauguration drew in the Vichy supporters of Paris high society. Abel Bonnard, the Minister of Education, bowed to the 'sculptor of heroes'. The Secretary of State Benoist-Méchin, who saw in Hitler a 'protector of the arts', thanked the war for having 'rendered fertile Breker's

2
Heinkel 111 bombers attacking Britain, including the bombing of London.

3
It was all very well for Picasso 'not to paint the war,' he could not help but paint the effects of it. The pictures of this period often take as their theme animals' skulls, twisted cutlery, empty plates and wan candles. Deprivation was in the air.

3 *Still life with Gruyère Cheese*, 1944
Oil on canvas, 59 × 92 cm
Private collection

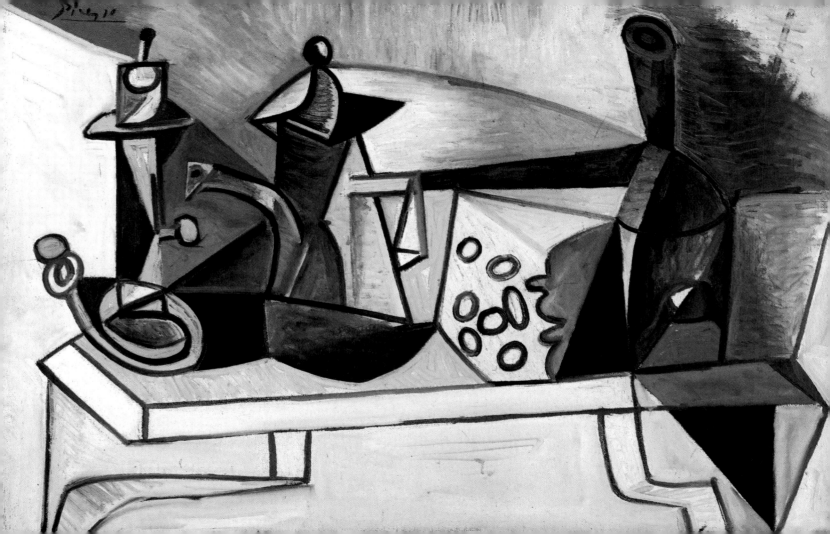

creative power'. Amongst the members of the exhibition's organising committee were to be found all of the artists who had been to Germany: Vlaminck, Dunoyer de Segonzac, van Dongen, Derain, Paul Belmondo. The public came in droves in the wake of Arletty, Sacha Guitry, Paul Morand, Jacques Chardonne, Jean Cocteau and Serge Lifar.

In the meantime, Picasso had become, all on his own and thanks to *Guernica*, the symbol of resistance to Nazi oppression. To the Germans who one day offered him an extra ration of coal Picasso replied: 'A Spaniard is never cold.'

In 1942 the SS descended on Picasso's studio. One of them looked at *Guernica* and

Françoise

'You are the only woman
I ever met who was open
to the absolute.'

1
Picasso and his friends in the studio in the rue des Grands-Augustins at the time of the Libération, August 1944

2
Paris is free. While Free French forces unhooked the big swastika banner waving over the Kommandantur on the place de l'Opéra, so as to put the tricolor in its place, German soldiers were being taken prisoner.

asked: 'Did you do that?'

'No, you did!' replied the painter without batting an eyelid.

Picasso kept himself apart from the war, yet without ever compromising his dignity as a free man: 'I don't especially want to take risks, but I don't care either to give in to force or terror.'

Enclosed within occupied Paris, Picasso, who could no longer show his paintings, produced work with a rare intensity. He left his studio only to visit Marie-Thérèse and Maya who were settled in a comfortable flat on the boulevard Henri IV. Life was difficult. People were hungry, cold and frightened. Antidotes to anxiety had to be found; one could seek refuge in non-stop creativity and, why not, in derision.

3 Portrait of Françoise, 1946
Drawing, 66 × 50.6 cm
Picasso Museum, Paris (RMN)

3
The beautiful face of Françoise Gilot, Picasso's new companion.

20 mai 46

'I did not paint the war, because I'm not the kind of painter who goes off looking for a subject like a photographer. But there is no doubt that the war exists in the pictures that I painted then. Later on, perhaps, a historian will show that my painting changed under the influence of war.'

Liberty regained

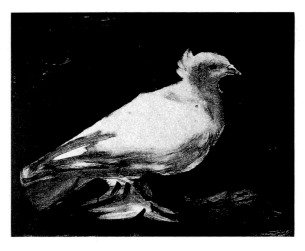

1
Picasso's dove, symbol of peace. It was Louis Aragon who, having discovered this lithograph made by the artist a short time previously, proposed it as the poster of the Peace Congress in 1949.

2
Picasso in 1949 in front of one of the two versions of *The Kitchen*.

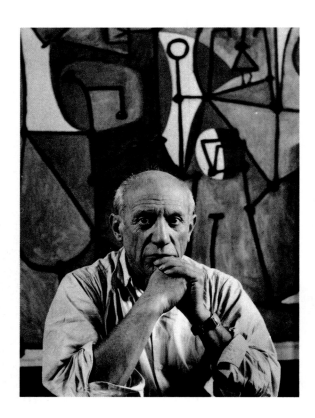

Then one evening in January 1941 Picasso wrote *Desire Caught by the Tail*, a strange, Surrealist and burlesque play, a six-act farce whose characters were called Tart, Big Feet, Onion, Skinny Anxious and Fat Anxious.

Three years later, a reading of it was organised at the home of Michel Leiris and his wife: Jean-Paul Sartre, Simone de Beauvoir, Raymond Queneau, Camus, Reverdy and Lacan shared the parts between them . . .

Paris was finally liberated on 23-25 August 1944. Picasso was restored to his public, of whom there were more than ever. Rare were the artists who had had no dealings with the occupier; Picasso was among them. Many American and British people flocked to his studio to have a chat with him.

War, once again, had taken his closest friends from him – amongst them Max Jacob. But he had met Françoise Gilot, a young and very beautiful painter. In 1945, Françoise came to live with Picasso.

3
The Nuremberg Trials, where Nazi war criminals answered for their crimes against humanity. Standing on the left is Goering.

4
As the war was coming to an end, Picasso painted *The Charnel House*, also known as *The Ossuary*. This heap of corpses, dislocated human bodies, seems to be something of a pendant to *Guernica*. Events in the immediate post-war years made this picture all the more appalling as the indefensible massacre of innocent victims was made known to the world.

4 *The Charnel House* (or *The Ossuary*), 1944-5
Oil & charcoal on canvas, 199.8 × 250.1 cm
Museum of Modern Art, New York

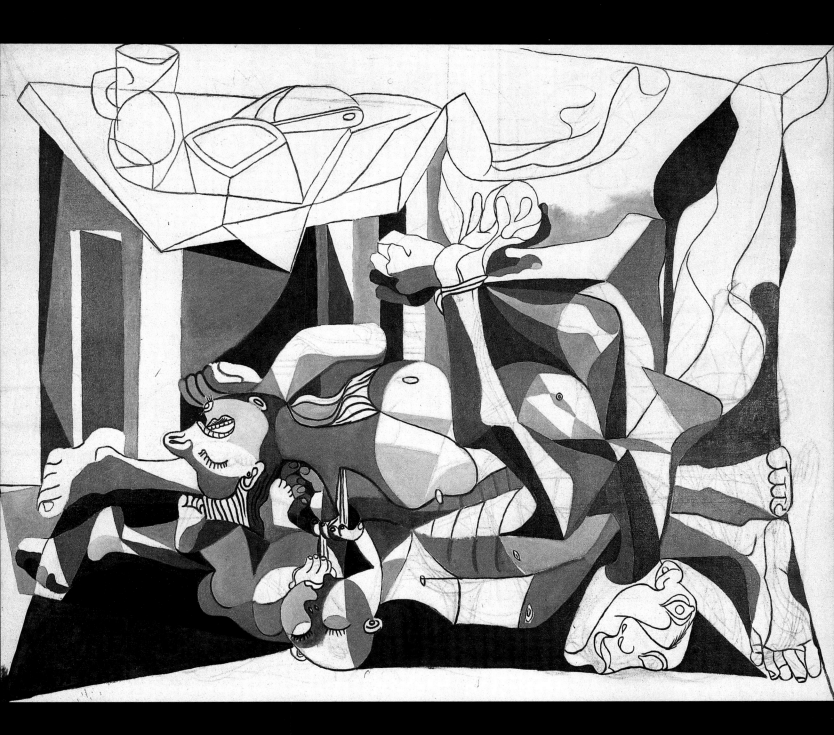

Picasso the lithographer

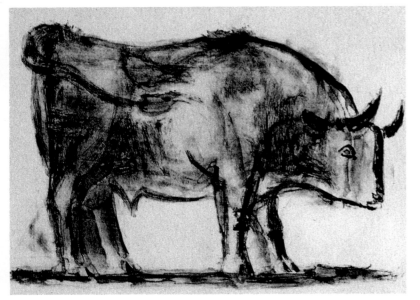

1st state

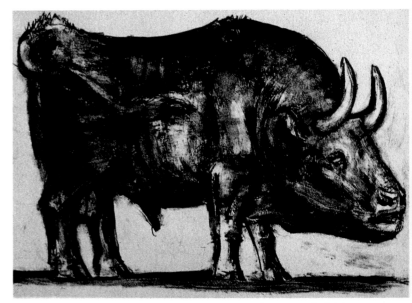

2nd state

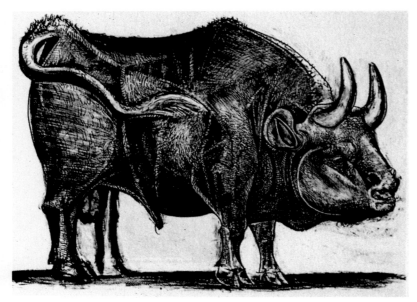

3rd state

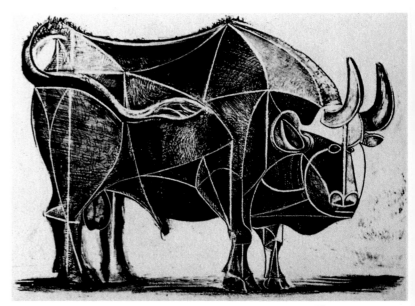

4th state

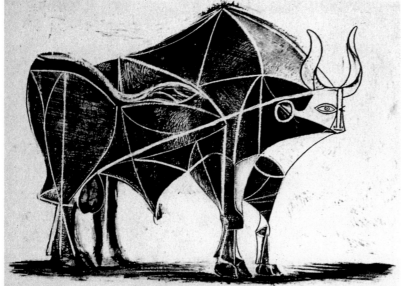

5th state

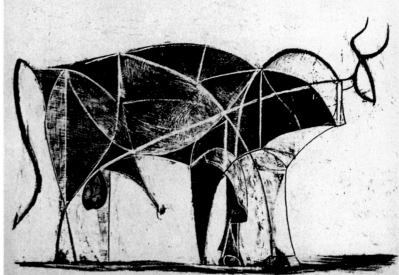

6th state

1 *The Bull*, 1st state, 5 December 1945
Format of the drawing, 29 × 42 cm
Wash-tint on stone

2 *The Bull*, 2nd state, 12 December 1945
Wash-tint & pen on stone

3 *The Bull*, 3rd state, 18 December 1945
Pen drawing on stone

4 *The Bull*, 4th state, 22 December 1945
Pen & scraper on stone

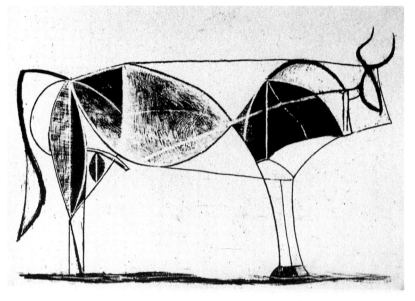

7th state

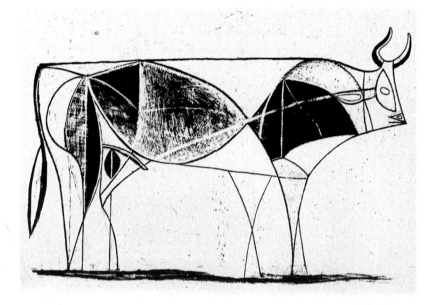

8th state

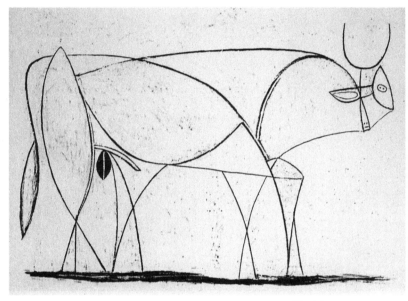

9th state

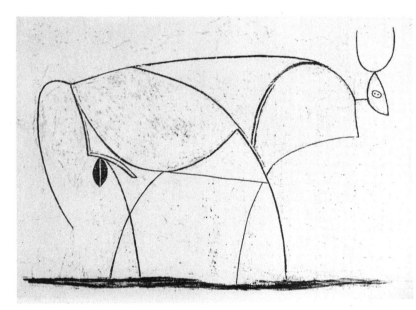

10th state

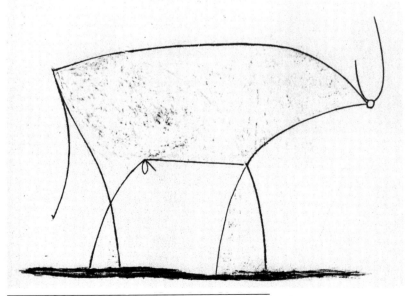

11th state

The writer Hélène Parmelin, a loyal friend of Picasso's, reported what the pressman Célestin had confided to her about the artist's work in Mourlot's workshop. Picasso made almost 400 lithographs there, using every technique: transfer paper, stone, zinc, pencil, wash-drawing, pen. Renewing in this way the old practices of the trade, he was the source of an unprecedented increase in art lithography just after the war. 'One day,' said Célestin, 'he started that famous bull. A superb bull. Quite plump. I thought it was just right. Not at all. Second version. Third. Still plump. And on it went. But it was no longer

5 *The Bull*, 5th state, 24 December 1945
Pen & scraper on stone

6 *The Bull*, 6th state, 24 December 1945
Scraper & pen on stone

7 *The Bull*, 7th state, 28 December 1945

8 *The Bull*, 8th state, 2 January 1946

9 *The Bull*, 9th state, 5 January 1946

10 *The Bull*, 10th state, 10 January 1946

11 *The Bull*, 11th state, 17 January 1946
Pen drawing on stone, 29 × 37.5 cm

the same bull. He started to reduce, to reduce in weight. On the final proof, there were only a few lines left. I watched him work. He kept on taking away from it. I was thinking about the first bull. And I couldn't help saying to myself: what I don't understand is that he has ended up where he ought to have begun! But for his part, he was looking for his bull. And to arrive at his one-line bull, he had made himself go through all those bulls. And in that line when you see it, you can't imagine the work it

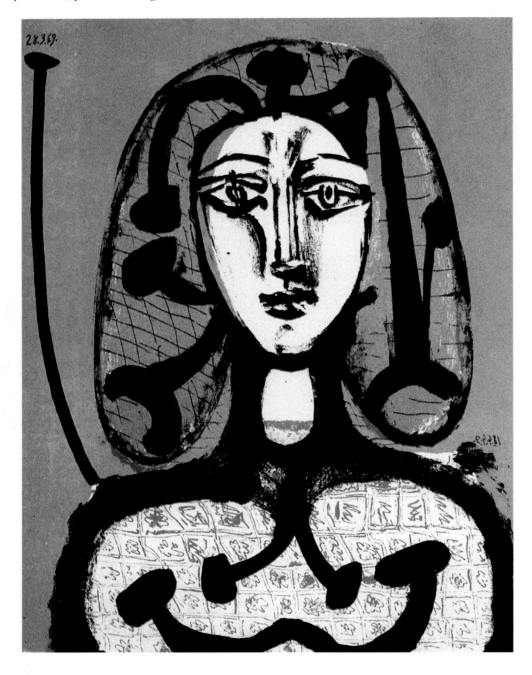

1
Four-colour lithograph: green, violet, sepia and black. On this second state, the four zinc plates have been altered but with no change in the colours.

2
This lithograph gave rise to two states with colour which did not satisfy Picasso. The plates were then cleaned up for further corrections, but each colour was to be changed to a plate of black. Every day or every night, the zinc plates were scrubbed out, wiped clean and redrawn, from November until the end of December 1948.

took.' And Hélène Parmelin added: 'This itinerary of the bull was typical. Each stage was charged with its own reality. Each of these realities was in search of some other truth. The one that is left is the one that is pronounced in the way one says the word bull. And that is also one of the strengths of lithography, of engraving too, or linogravure. These arts have declared, official "states". The stages are clearly distinguished. One has them all before one's eyes. It's a rare sensation for the viewer.'

1 *Woman with Green Hair*, 1949
Lithograph, 2nd state

2 *Woman in an Armchair* 1, 1948
Lithograph, 4th state in black

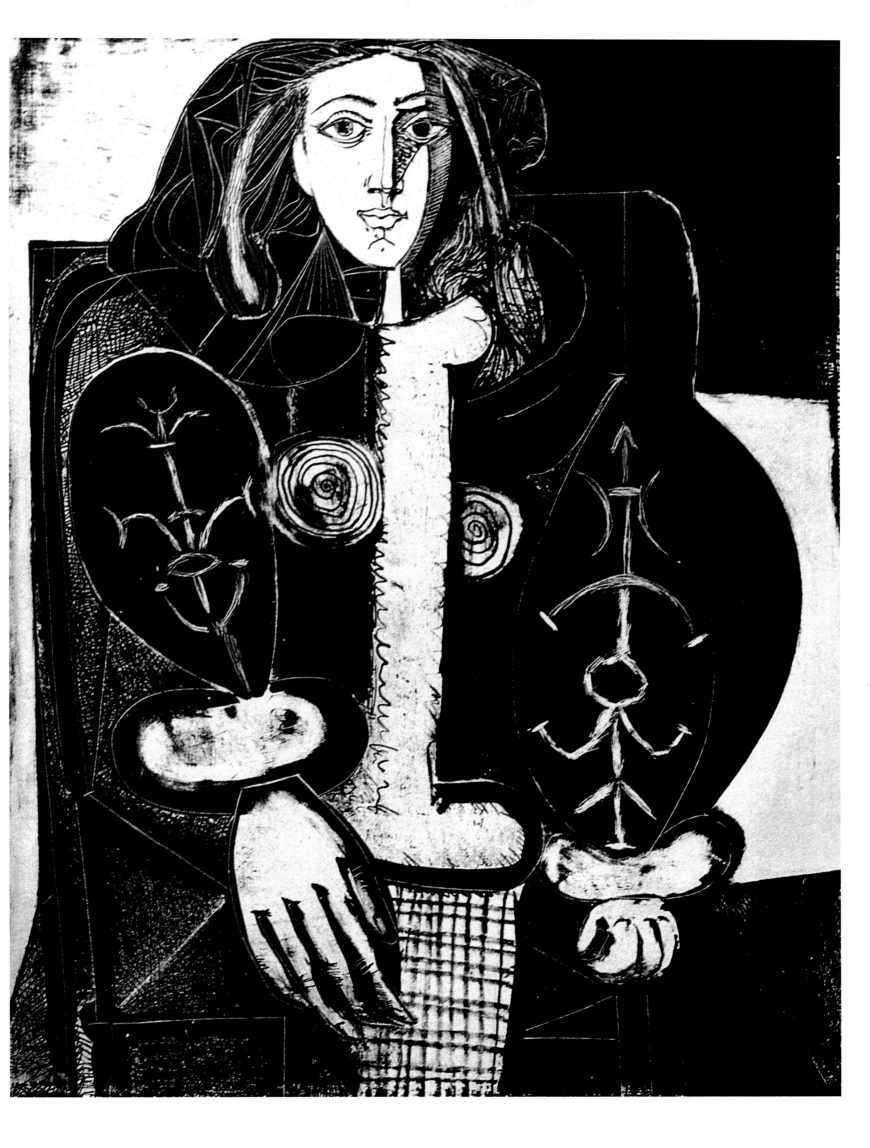

Picasso joined the Communist Party just after the Second World War: 'I went to the Communist Party without the slightest hesitation, for basically I had been with them all the time ... Those years of terrible oppression showed me that I should fight not only for my art, but for my person. I was in such a hurry to get back to my native land! I have always been an exile. Now I am not one any longer. While waiting for Spain to welcome

me back at last, the French Communist Party has opened its arms to me, and I have found in it the people I value ... I am amongst my brethren once more.'

Picasso was deeply in love with Françoise, but had not given up Dora. He thought about leading a double love-life, as he had done previously with Olga and Marie-Thérèse, and then Marie-Thérèse and Dora.

But Françoise did not see things that way. She was twenty, headstrong and with a taste for absolutes. She resisted Picasso who had asked her to come and live with him. The young woman set off for Brittany and the painter returned to Dora who was in the grip of nervous depression. He took her off to Antibes, but could not stop himself from renting a room also for Françoise ... who did not come.

And so Picasso made Dora a present of a fine old house at Ménerbes, which he paid for with a still life. It was a parting gift. Françoise's determination got the better of the old Don Juan's habits. Picasso took Françoise off on the tracks of his own youth. Together they visited Montmartre, the 'Bateau-Lavoir' and the rue des Saules. 'There, having knocked at the door of a house, he went in without waiting. I saw a thin, toothless, sick, little, elderly lady lying on her bed. I remained leaning against the door-frame while Pablo spoke to her softly. After a few moments, he put a little money on the table. She thanked him with tears in her eyes.'

Vallauris

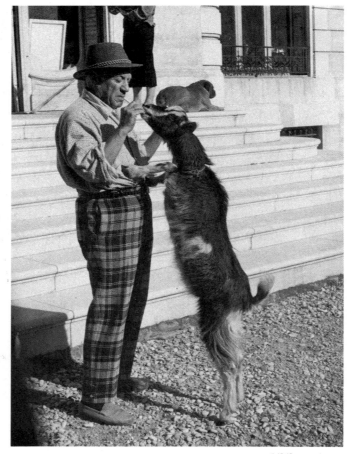

1/2/3
Picasso worked on the plaster for *The Goat* in his studio at Vallauris. This 'ingenious rag-and-bone man' used various materials in the construction of the animal, some of them from his personal collection, others gleaned from the tip at Vallauris: a wicker basket for the rounded stomach – the nanny goat is pregnant – palm leaf, scrap iron ...

'An apprentice who worked like Picasso would not find work.'
(Georges Ramié)

3 *The Goat*
Original plaster, 120.5 × 72 × 144 cm
Picasso Museum, Paris (RMN)

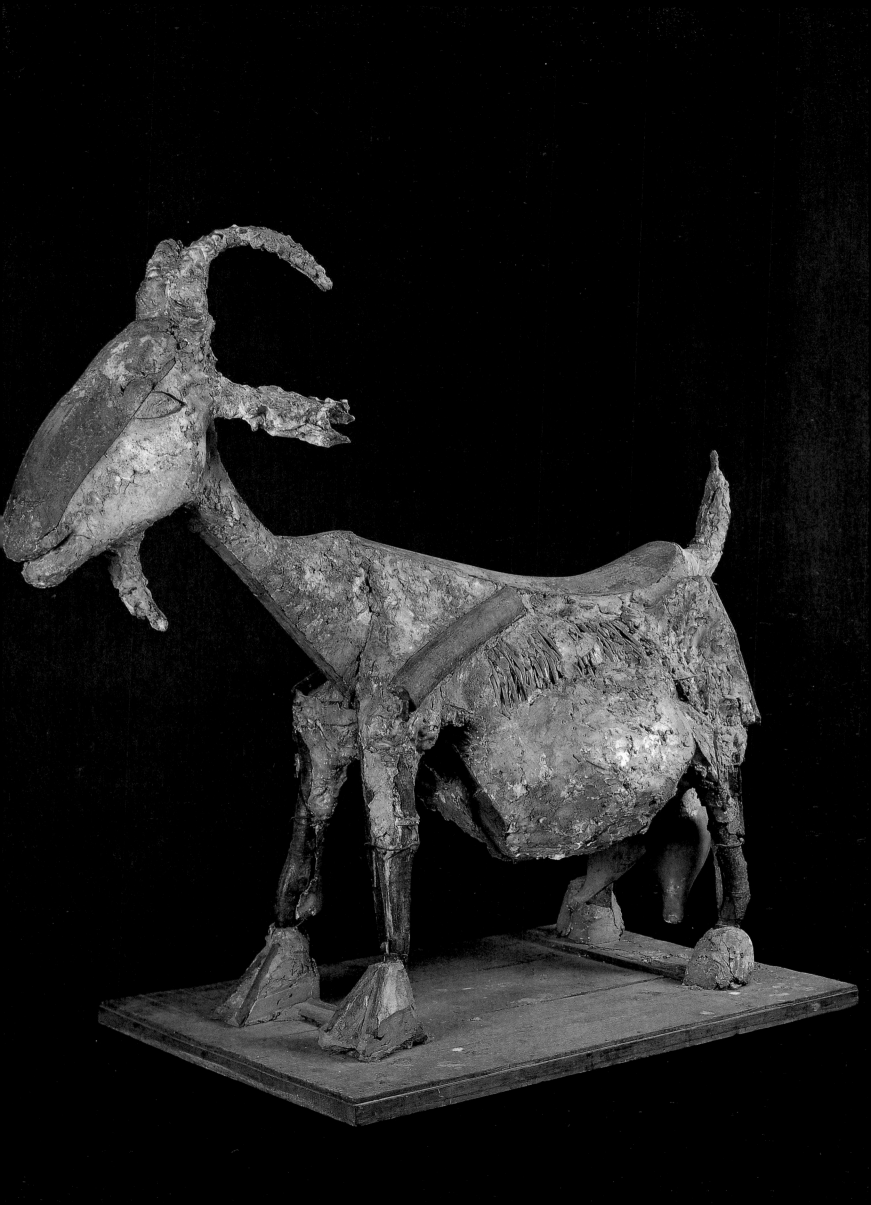

Once they were outside, Picasso told Françoise the unhappy love story that drove his friend Casagemas to suicide. The elderly lady was none other than Germaine Pichot.

On 15 May 1947, Françoise gave birth to Claude, Picasso's third child. The painter had just renewed his links with ceramics, and was working in a studio, Madoura, belonging to Georges and Suzanne Ramié. In one year, he had completed more than 2000 pieces.

Picasso the ceramic artist

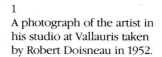

1
A photograph of the artist in his studio at Vallauris taken by Robert Doisneau in 1952.

Having discovered the village of Vallauris in 1936 while out for a drive with Paul Eluard, the artist moved with Françoise and Claude into an attractive villa called La Galloise, and pursued his work in ceramics. His daring amazed his potter friends: 'The range of ancient techniques was judged inadequate by Picasso ... For him, ceramics was only one more means of expression, to which he brought, as to everything he undertook, both revelation and enigma ... His revolutionary quickness prompted him to seek out unrestrainedly the natural expansion of his character, drawing him constantly on towards discovery of self and of the universe. Hence that flow of dynamism that was sometimes disconcerting, that creative power, that glibness that gave off streams of colour like fireworks, and all of his innovations that are first surprising, then fascinating.' (Georges Ramié)

Picasso was like a child with a new toy. Ceramics, a traditional old craft somewhat neglected by painters, suited him down to the ground. The further he advanced in his work, the more he explored new techniques. Taking a vase that a master potter had just thrown on the wheel, Picasso remodelled it with his fingers with a lightness of touch.

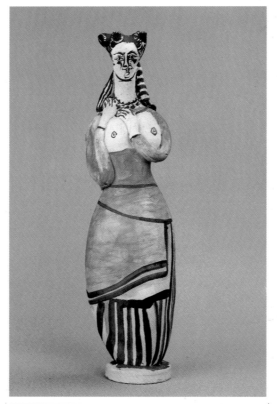

2/3
At first Picasso used traditional objects (plates, dishes and vases made in Madoura's studio) that he decorated with coloured glazes, conferring a new quality on simple everyday utensils. Then he began to model items himself. In this he was more of a sculptor than a potter. He changed the shape of objects that were still damp and pliable by bending or squashing them. Vases or bottles were transformed into little women, who, once they had been coloured, became *Tanagras*, so called on account of their resemblance to the statuettes of the Ancient World.

2 *Vase: Woman with a Mantilla*, 1949. White clay, thrown & modelled, decorated with slip
44.7 × 112.3 × 9.5 cm. Picasso Museum, Paris (RMN)

3 *Bottle: Kneeling Woman*, 1950. White clay, thrown & modelled, oxide decoration on white glaze
29 × 17 × 17 cm. Picasso Museum, Paris (RMN)

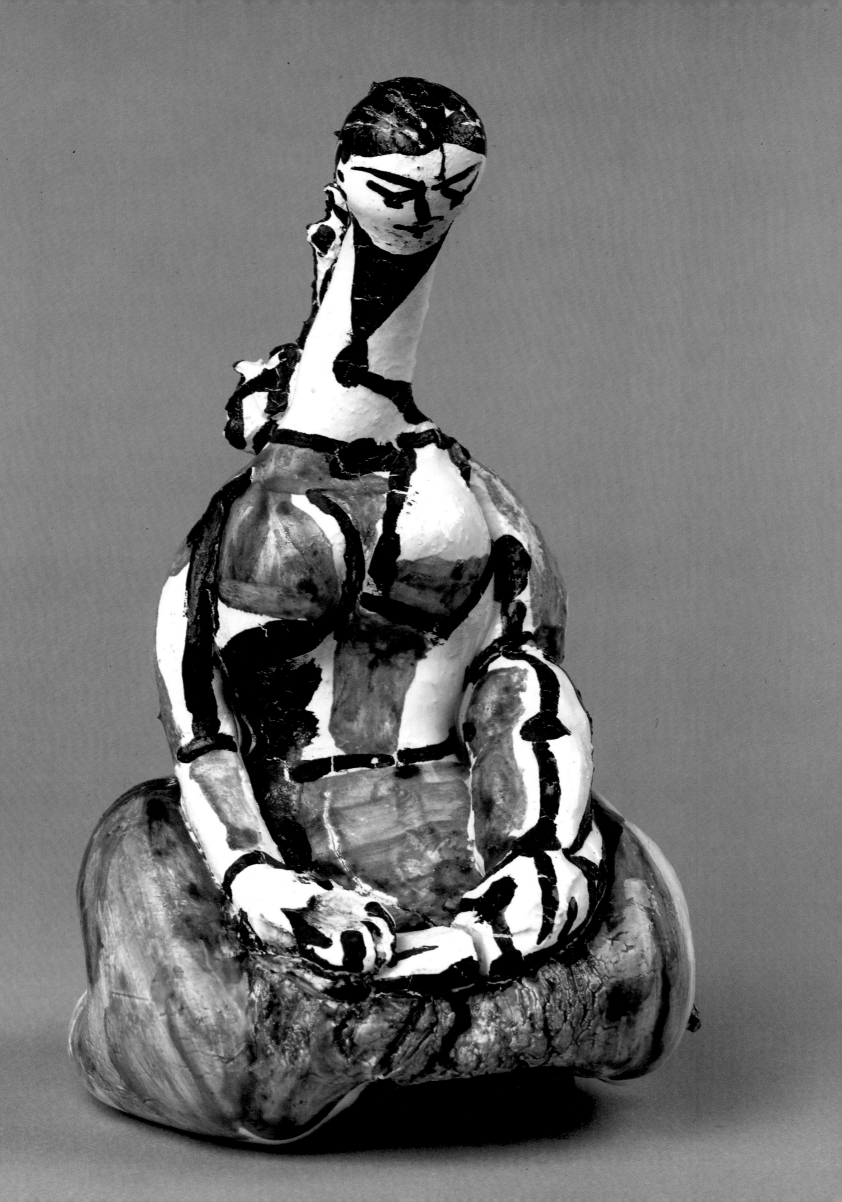

Then, with a single skilful application of pressure, he transformed the utilitarian object into a dove: 'It's funny,' he suddenly exclaimed, 'to bring a dove to birth, you first have to wring its neck!'

Shortly after the birth of Paloma, his second child by Françoise, Picasso moved into a much larger studio than that of his friends the Ramiés. He surrounded himself with the objects he had begun to accumulate: pebbles, iron bars, tiles.

The Goat, which preparatory drawings date to 1950, is a hymn to fecundity. Picasso used an old wicker basket to add volume to the stomach, a palm leaf by way of a spine, scrap iron for the feet, wrought iron for the tail; the

1

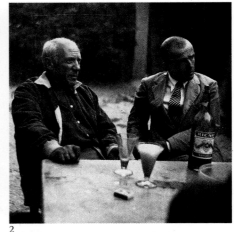

2

4

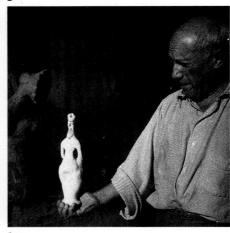

5

2/3
A moment of relaxation for Picasso and Michel Leiris at Nîmes in 1950 (2). A moment of relaxation also for Claude and Françoise, far from Rossif's cameras . . . but not from that of their friend Robert Picault (3).

1/4/5/6/7
Picasso during the shooting of the film that Frédéric Rossif made about him at Vallauris.

3

horns and beard were made from vinestocks, a tin can did for the sternum, two ochre-coloured pots the udder, a small metal lid bent in two represented the genitals and a piece of metal pipe the anus.

The whole thing was immersed in plaster. Picasso 'that ingenious rag-and-bone man' to use Cocteau's phrase, invented one thing after another. With *Girl Skipping* he achieved the first sculpture not to touch the ground.

The Woman with a Pushchair and *The Female Monkey* belong to he domain of three-dimensional collage, since these works are executed from a basis of real objects: a pushchair, or little cars given to Claude by Kahnweiler.

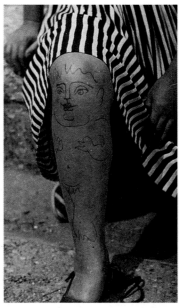

6

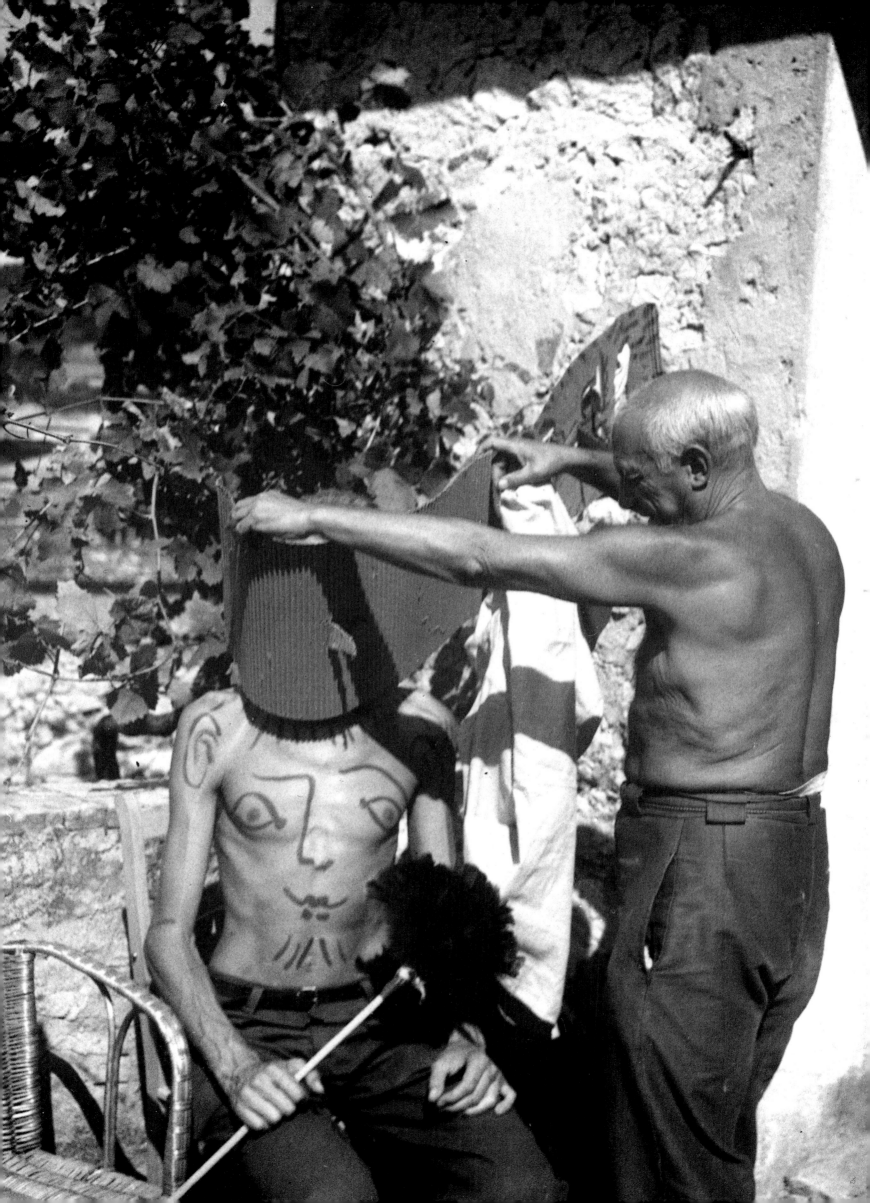

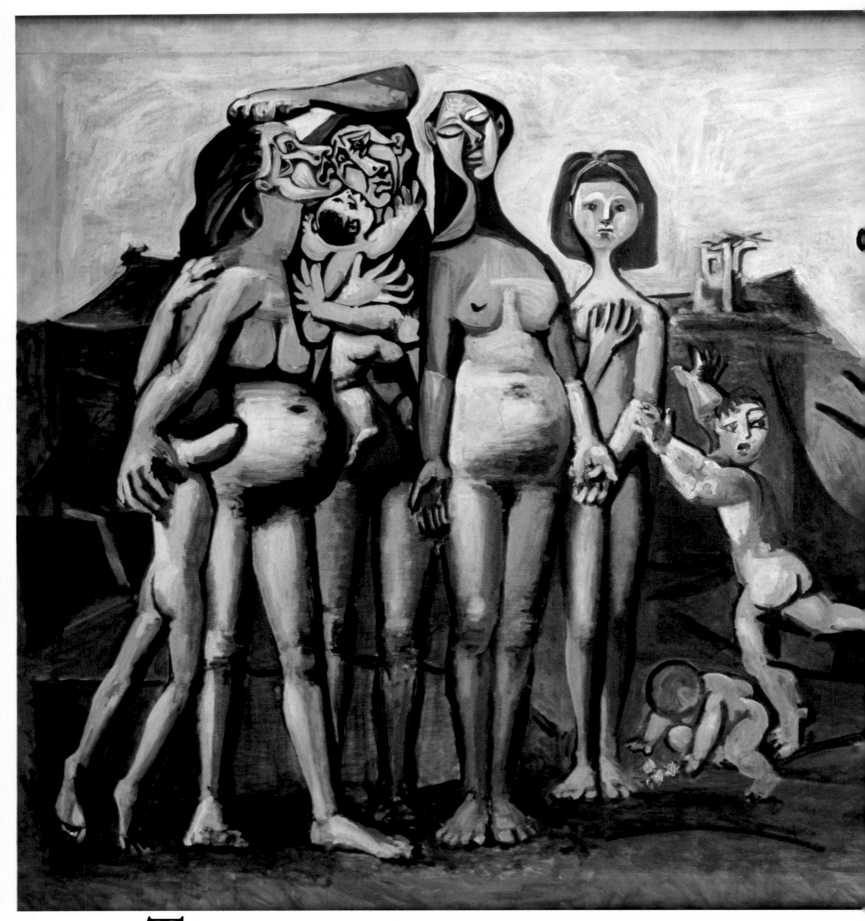

The painter got the inspiration for *Massacre in Korea* from the American intervention in South Korea, after North Korean forces had crossed the 38th parallel and occupied Seoul. Picasso, for whom it had been crucial to denounce the massacre of the small Basque town of Guernica with the famous painting of the same name or the concentration camps with *The Charnel House*, revealed once more his political commitment.

But party members disliked the picture, reproaching him once again with moving away from the party line on matters of artistic creation. They were expecting a realistic work, something intelligible, that could be understood by the great mass of working people, along the lines of the painter Fougeron's works.

The French Communist Party was furious and boycotted the picture openly. Auguste

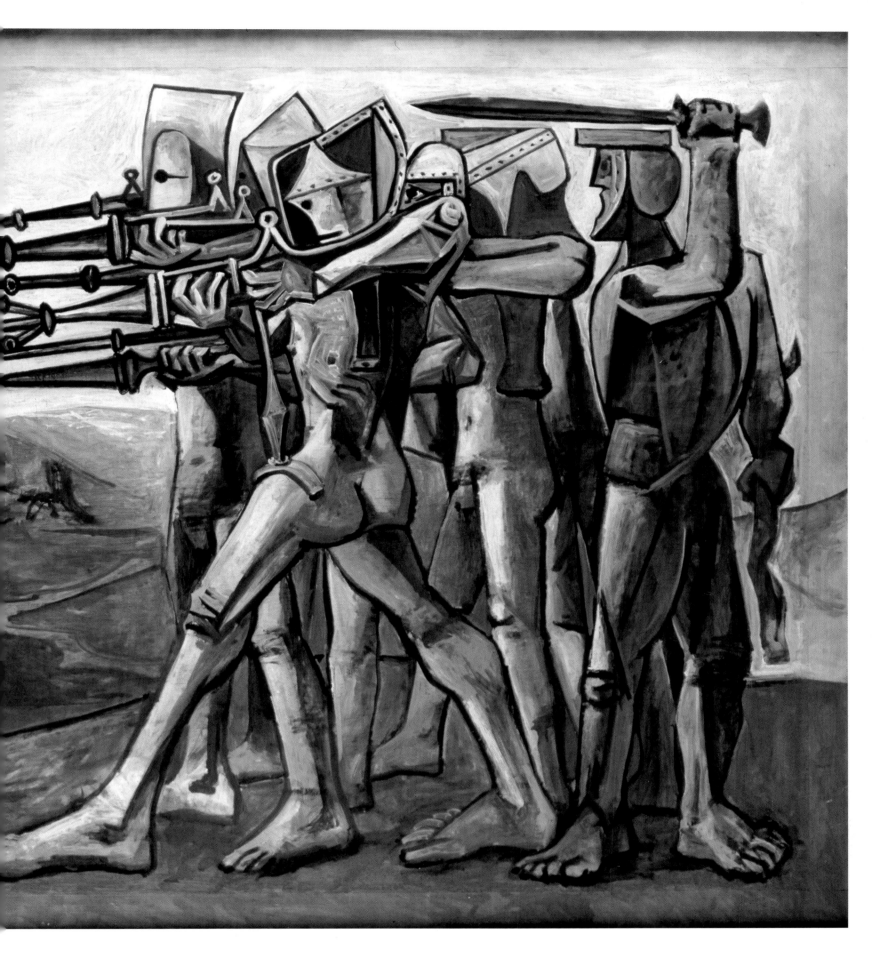

Lecoeur, secretary of the Central Committee, saw to it personally that the painting was talked about as little as possible.

The misunderstanding with the French Communist Party did not look like resolving itself. On Stalin's death in 1953, the artist drew inspiration from a photograph of Stalin when young and sent the drawing to the journal *Les Lettres Françaises* published by Aragon. Scandal broke out. The party bosses accused Picasso of having drawn 'from a bourgeois perspective'. This sudden restoration of Stalin to youth was seen as a brutal gesture by activists who were mourning a white-haired old man.

Massacre in Korea, 1951
Oil on wood, 109 × 209 cm
Picasso Museum, Paris (RMN)

Sylvette

1/3
In the early 1950s, fashions in women's hairstyles changed. Hair was no longer cut short, but tied back in a pony-tail. Picasso was particularly susceptible to this new generation of young women, symbolised by the young model he met by chance in the streets of Vallauris. Fifteen years after posing for this portrait, Sylvette came back to see Picasso at his property at Mougins. Picasso looked at her carefully. She had aged and lost some of her beauty. And so he went to look for the portrait that he placed calmly alongside the model and smiled. Once Sylvette had gone, Picasso, still smiling, took his picture away: 'You see, it's painting that has the upper hand, eh . . .

Françoise and Picasso were no longer getting on. The painter found consolation with Geneviève Laporte, 'the young woman who came to see me after the Liberation on behalf of the schoolchildren of Communist Party members'. But the disagreements with the Communist Party, together with the death of Paul Eluard, had a profound effect on him. The break with Françoise was becoming unavoidable. As she left, the young woman simply told him: 'You know, I was perhaps the slave of my love, but not your slave.' Picasso returned to the themes of the Minotaur, circus people and painted Claude and Paloma who came to see him at Easter. By his mid-seventies, Picasso remained a man of ardent temperament, sensitive to the world and to women. Women's hairstyles, something of which he was extremely aware, change with fashion: pony-tails made their appearance. In the streets of Vallauris, the painter met Sylvette, who, at the age of twenty, was the perfect incarnation of this new type of woman. Picasso was won over and wanted to paint her, and in order to do so accepted the conditions of a fiancé who demanded to be present at every sitting. The painter completed a series of more than forty paintings and drawings.

2
The resemblance between Brigitte Bardot and Sylvette is striking, is it not?

3 *Portrait of Sylvette*, 1954
Oil on canvas, 100 × 82 cm
Private collection

Jacqueline

Picasso was seventy-three when he met a young brunette with large, dark green eyes, a beauty of the Mediterranean type. The painter was struck by the resemblance between this young shop girl and one of the *Women of Algiers* in Delacroix's picture. He courted her, drew doves on the walls of her house, wrote poems to her. Jacqueline Roque entered his life, and with her a love story that only death would bring to an end. Jacqueline had just turned thirty. She gave Picasso what no other woman had yet given him: a love that was absolute, going as far as devotion and total selflessness, love without tears, without violence, balanced only by the painter's own whims and desires. Jacqueline was silent by nature. She followed Picasso like a shadow, and Picasso let himself be followed even into his studio. The young woman, sitting on a chair, would spend the whole night watching him paint. She would go to bed only when the

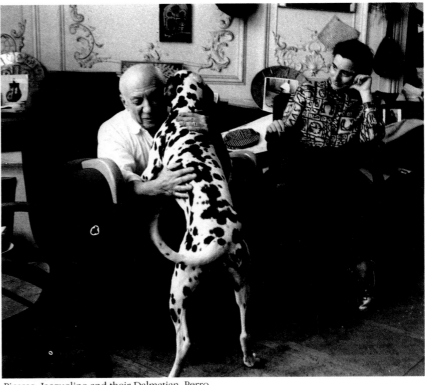

Picasso, Jacqueline and their Dalmatian, Perro

'Painting
gets the upper hand over me,
she makes me do
whatever she wants.'

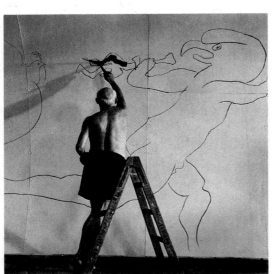

artist himself went to bed, eat only when he was hungry. Even more, she did not complain about his awful untidiness, even though it obliged her, as she walked across the rooms – however spacious – of the villa, to step over heaps of apparently useless and cumbersome objects. But this untidiness was necessary to the painter. She did not argue, she accepted it.

Her admiration was so complete that it verged sometimes on the mystical. She called her companion 'Monseigneur' or 'My Lord', regularly kissing his hands. Picasso smiled, amused at such fervency.

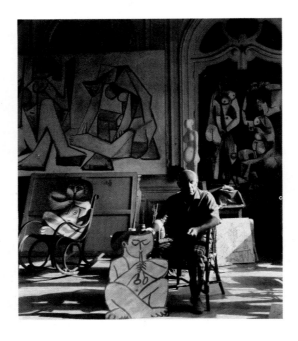

4 *Jacqueline with Crossed Hands*, 1954
Oil on canvas
Picasso Museum, Paris (RMN)

4
Picasso often portrayed Jacqueline in Arab costume and kneeling. He undoubtedly never forgot that from their very first meeting he was struck by the resemblance between the young woman and one of the *Women of Algiers* by Delacroix. The features are regular, the neck elongated to underline the gracefulness of the model. Picasso reinstated the purity of Jacqueline's features.

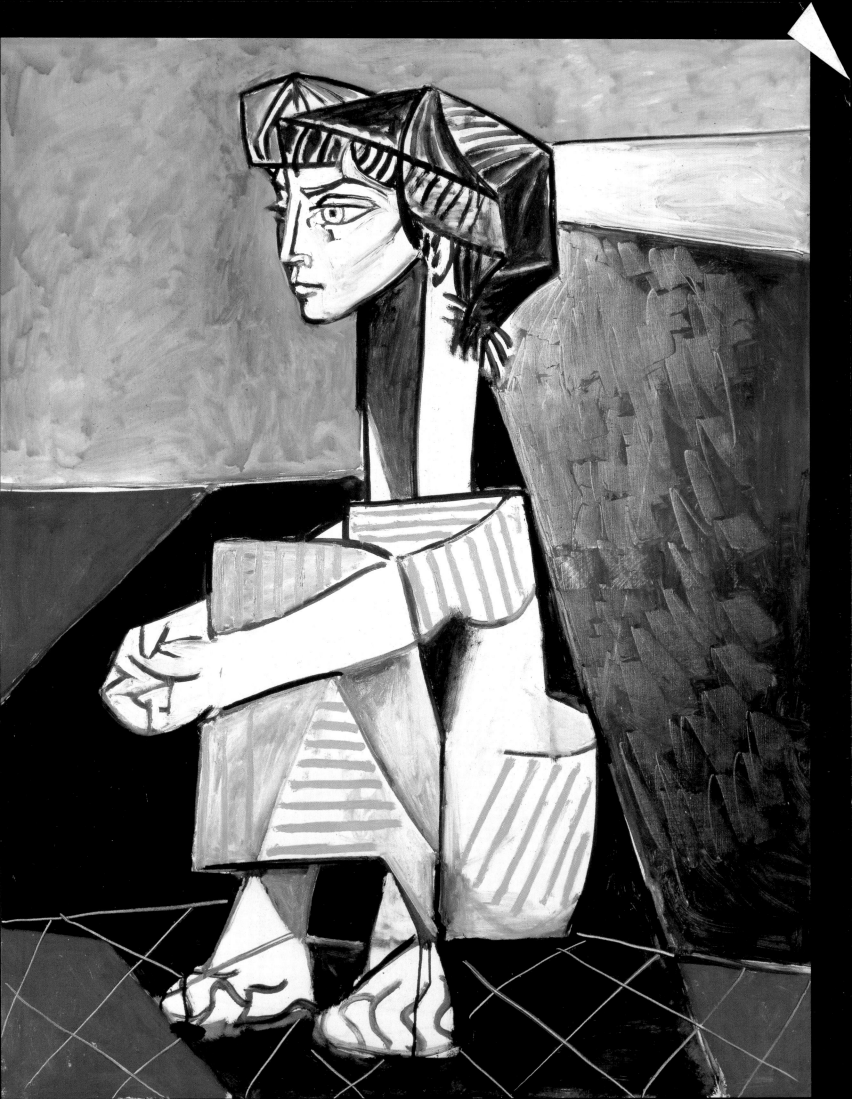

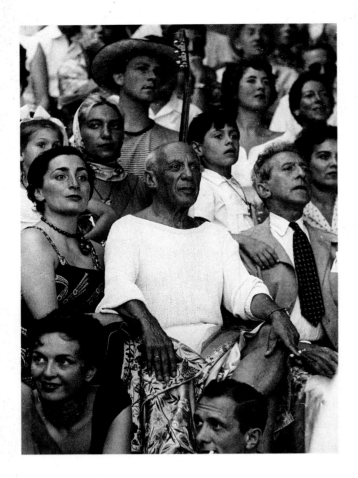

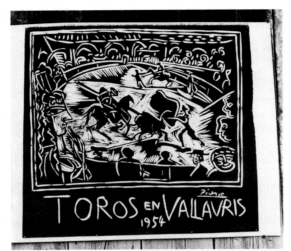

1
Picasso at a bullfight.
Surrounding him are
Jacqueline and Jean
Cocteau. Behind the
painter, his children Maya,
Paloma and Claude.

TOROS EN VALLAURIS
1954

'For us Spaniards,
it's Mass in the morning,
the bullfight in the afternoon,
the brothel in the evening.
What's the basis of the mixture?
Sadness. A funny sort of sadness.
Like l'Escurial.
And yet I'm a cheerful man,
aren't I?'

Gradually Jacqueline's love filled the whole villa. Picasso was happy, serene, free from the obsessive memory of his previous conquests. Jacqueline took care of everything, reassured him, satisfied his every desire: from now on the painter could devote himself exclusively to painting, or almost.

In 1961, amidst the greatest secrecy, he married Jacqueline at Vallauris. To those uncharitable souls who later on expressed surprise that a young woman of thirty should marry a man who would soon be eighty, Jacqueline would reply: 'I married the most handsome young man in the world. I was the one who was old.'

To a person sitting next to her in a restaurant who urged her to admire the beauty of the sunset, Jacqueline answered: 'When you have the good fortune to have Picasso in front of you, you don't look at the sun.'

Picasso and Jacques Prévert taking a walk

4
Almost half a century had gone by since *The Kiss* of Juan-les-Pins in 1925. The composition is more gentle, the execution more intelligible. At the age of eighty-eight, Picasso was mellowing, but his taste for life and love remained intact.

4 *The Kiss*, 1969
Oil on canvas, 130 × 97 cm
Picasso Museum, Paris (RMN)

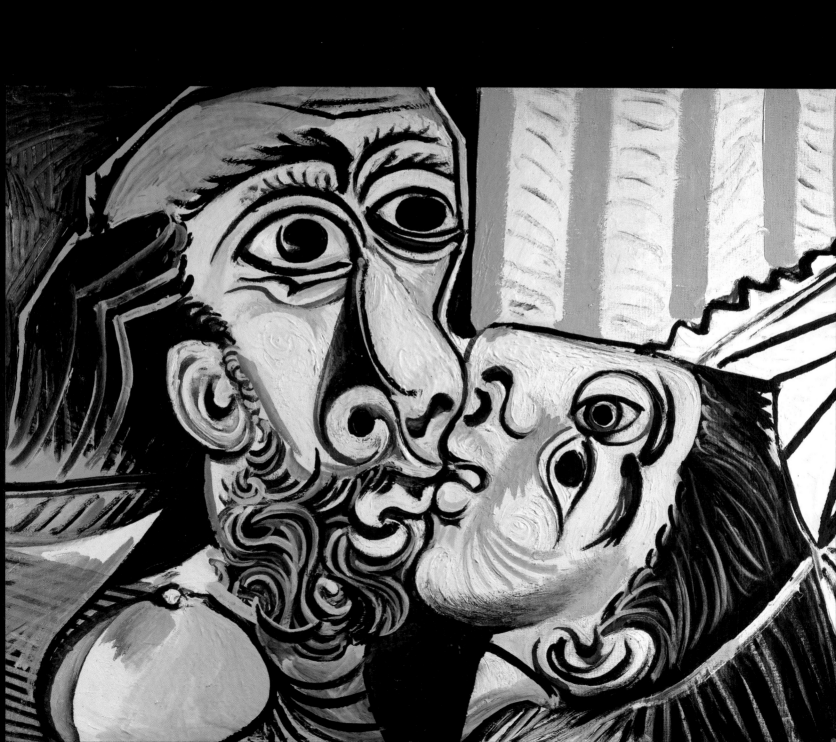

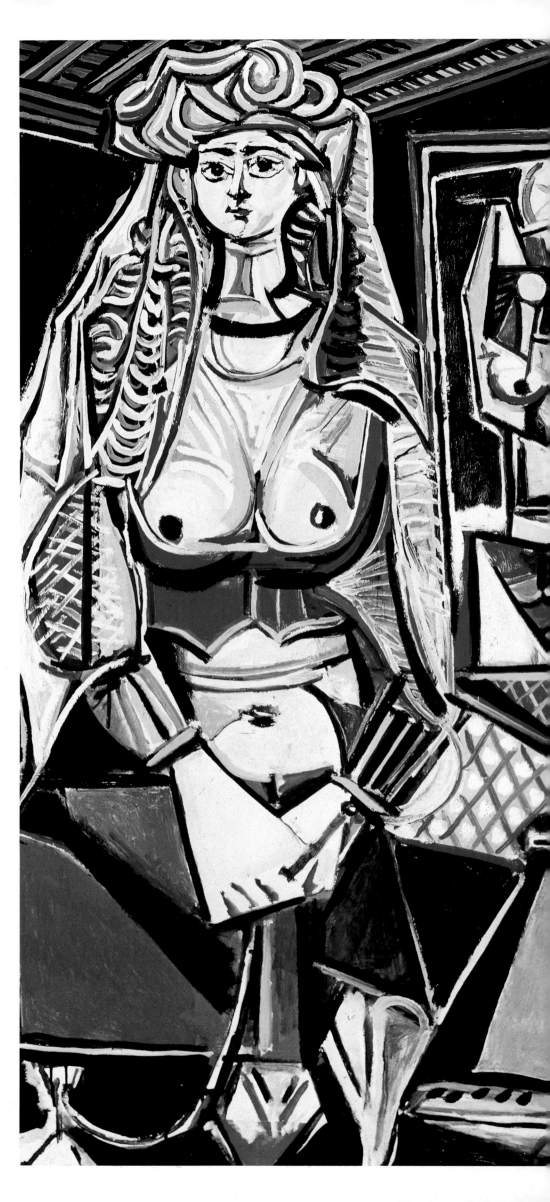

In 1955, Picasso finished a series of fifteen paintings that were as many variations on Delacroix's *Women of Algiers*. He used both the 1834 version in the Louvre and that of 1849 in Montpellier. He transformed the picture, took it apart then restructured it according to his own vision of the work. To those who expressed surprise, Picasso answered: 'The fact that I paint such a large number of studies is simply part of the way I work. I make a hundred studies in a few days, whereas another painter might spend a hundred days on one picture. As work progresses, I open windows. I walk round the picture, and perhaps something might happen.'

In the first two pictures, Picasso retained only the right-hand part of the Delacroix, stripping along the way the torso of the woman who was so much like Jacqueline, as well as that of the woman with the hookah.

The third, painted two weeks later, turned the whole thing upside down, brought the third woman back, upset the sleeping woman, who was now completely naked with her legs in the air.

Thus one amazing version followed

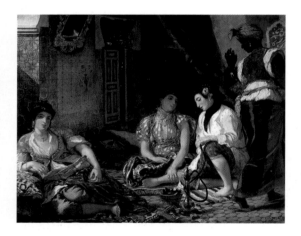

another (among them one in which Françoise can be recognised) and they were all completed towards the middle of February. At which point the violent geometry of the pictorial space created a direct link with *Les Demoiselles d'Avignon*. The metamorphosis was complete. Picasso had made Delacroix's women his own, integrating them, with a certain violence tinged with eroticism, into his own unique pictorial universe.

1 *Women of Algiers*, 1834. Delacroix
Oil on canvas, 180 × 223 cm
Musée du Louvre, Paris (RMN)

2 *Women of Algiers*, 1955
Oil on canvas, 114 × 146 cm
Picasso Estate

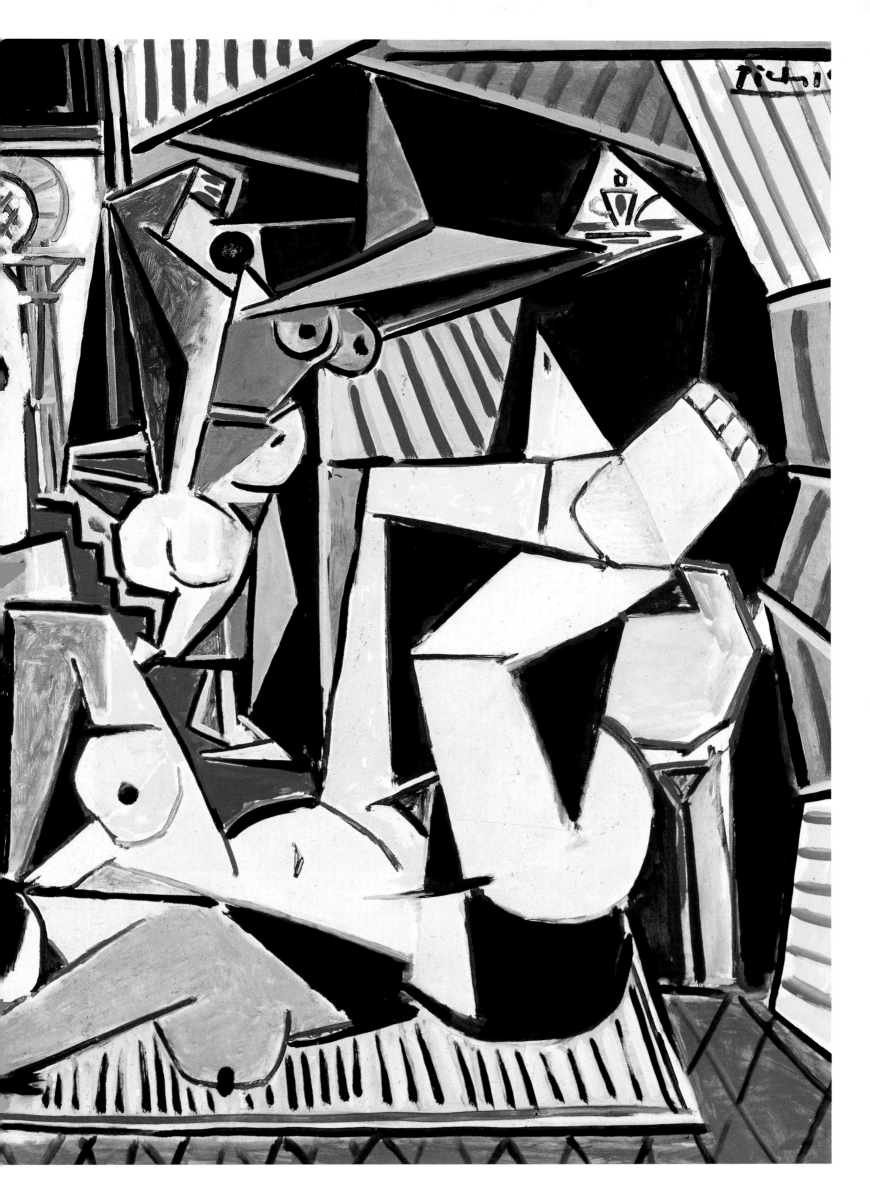

During the course of the winter of 1962/3, Picasso undertook a series of enormous paintings on the theme of *The Rape of the Sabine Women* after the painting by David. Once more Picasso decomposed, separated, cleaned up in order the better to rebuild. To David's careful staging, Picasso preferred a

'I work in a very traditional manner, like Tintoretto or El Greco, who painted entirely in cameo with tempera, and, towards the end, added transparent and resonant scumble in order to highlight the contrasts.'

tumultuous scene. His composition is violent, dramatic. The tangled bodies, trampled by horses' hooves, are reminiscent of *Guernica* or *The Charnel House*.

'Naturally, a warrior is much easier to do if he doesn't have a helmet, a horse or a head. But in that case he wouldn't interest me. Because that could be just anybody at all getting into the Métro. What is interesting about the warrior is the fact that he is the warrior.'

Picasso overturned the proportions respected by David; the figures are either gigantic or minute. Here again, monochrome grey highlights the tumult, the characters on either side – Sabines and Romans – not being differentiated by colour.

The rearing horse conveys a giddy movement to the picture, with its solid hoof raised, about to or having just struck the mutilated body of the woman stretched out on the ground. A child that has escaped from her arms is howling and attempting to flee from the massacre. The clash of these two 'clans' is spectacular, and Picasso completed hundreds of studies and preparatory drawings. The work is a difficult one. The painter confided his anxiety to his friend Hélène Parmelin: 'Things have never been like this. It's the most difficult thing I've ever done. I don't know whether it's proved worthwhile. Maybe it's terrible. But I'm doing it in any case, I'm doing thousands of them.'

1 *Portrait of a Painter*, after El Greco, 1950
Oil on plywood, 100 × 81 cm
Rosengart Collection, Lucerne

2 *Portrait of Jorge Manuel*, the painter's son, 1600-5
El Greco. Oil on canvas, 81 × 65 cm
Provincial Museum of Fine Arts, Seville

3 *Rape of the Sabine Women*, 1799. David
Oil on canvas, 386 × 520 cm
Musée du Louvre, Paris (RMN)

4 *Rape of the Sabine Women*, 1962-3
Oil on canvas
Boston Museum of Fine Arts

'*Las Meninas*?
What a picture! He's
the true painter of reality.'

It took Picasso fifty-eight variations on Velázquez's *Las Meninas*, featuring the little Infanta Margareta Teresa with her retinue of ladies and dwarf, to get to grips with it. The creator of *Les Demoiselles d'Avignon* had perhaps never taken transposition so far. He very quickly understood that in order to paint Velázquez's studio, he had to give up his own. That was why, in August 1957, Picasso renounced his studio on the ground floor and moved into the top floor of the villa, which had been left to the pigeons up until then. It was in this hide-out that he crossed swords with Velázquez, that 'true painter of reality'.

In the first painting of 17 August, Picasso turned the Master's work upside down: Velázquez was now so tall that he touched the ceiling, the king's outline was ridiculous in the mirror, the bassest hound Lump had replaced

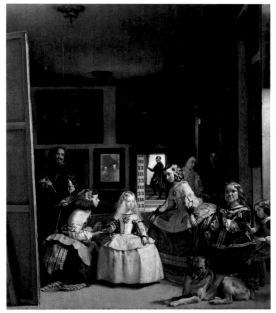

the royal dog. Then it was the turn of the two chaperones and the dwarf, rendered derisory by extreme stylisation. Parody disappears with the Infanta, the painting becomes more serious, verging at times on the tragic. Picasso reduced the ceiling height of the studio, imposing a perspective of width. He became totally autonomous. Even more than he had done with *The Rape of the Sabine Women, Le Déjeuner sur l'Herbe* or *Les Demoiselles des bords de la Seine*, Picasso appropriated *Las Meninas*.

1 *Las Meninas*, after Velázquez, 1957
Oil on canvas, 194 × 260 cm
Picasso Museum, Barcelona

2 *Las Meninas*, 1656. Velázquez
Oil on canvas, 318 × 276 cm
Prado Museum, Madrid

The Sketch-Pads

Picasso would never be separated from his sketch-pads. At the café, on a walk or at the bullfight, he was drawing all the time, a curve would inspire a woman, a fold of drapery, a character in costume, a brick wall, a stage set.

There were drawings that he worked at a great deal, in colour or black and white, but also light sketches, simply landmarks in the painter's imagination.

After his death 175 sketch-pads of varying sizes were discovered, comprising 7000 drawings, ranging from 1894 to 1967, like so many 'personal diaries', bearing witness to Picasso's work.

1 *Sketch-Pads*, 5 April 1962
Jacqueline Picasso donation
Picasso Museum, Paris

2 *Sketch-Pads*, 1 June 1966
Picasso Museum, Paris

'I want to express the nude:
I don't mean just breast,
or foot, hand, stomach . . .
I don't want to paint the
nude from head to foot
but manage to express what I mean;
that's what I want. A single word
suffices when one gets to the point.
In this case, a single look
and the nude will tell you what it's all
about, without any phrases.'

Erotica

More than those of any other artist, Picasso's works came to completion at a pace that was determined by the amorous passions that marked off the various stages of his life: Germaine in the Bohemian days in Montmartre; Fernande, with whom he moved from the sadness of blue to the happiness of rose and then on to the sudden break with the traditional way of doing things by painting *Les Demoiselles d'Avignon*; Eva, gentle with her flowing style, the companion of his exploration of Cubism, whose death left him at a loss right in the middle of the First World War; Olga, the young ballerina from Diaghilev's company and the 'return to order'; Marie-Thérèse, the young blonde to whom he promised that they 'would do great things together'; Dora Maar, the companion of his political commitment during the Spanish Civil War and the Occupation; Françoise Gilot in the years after the Second World War; and finally Jacqueline, the wife of his final phase, who was incapable of surviving him. Having arrived at the end of his life, Picasso engraved 154 plates on erotic subjects: one would have to be completely ignorant of Picasso's art to imagine him engraving on them the impotence of old age or some senile obsession. These engravings are a dazzling recapitulation of those episodes in his love-life in which his companion became the model, and the model became 'something else', as he put it.

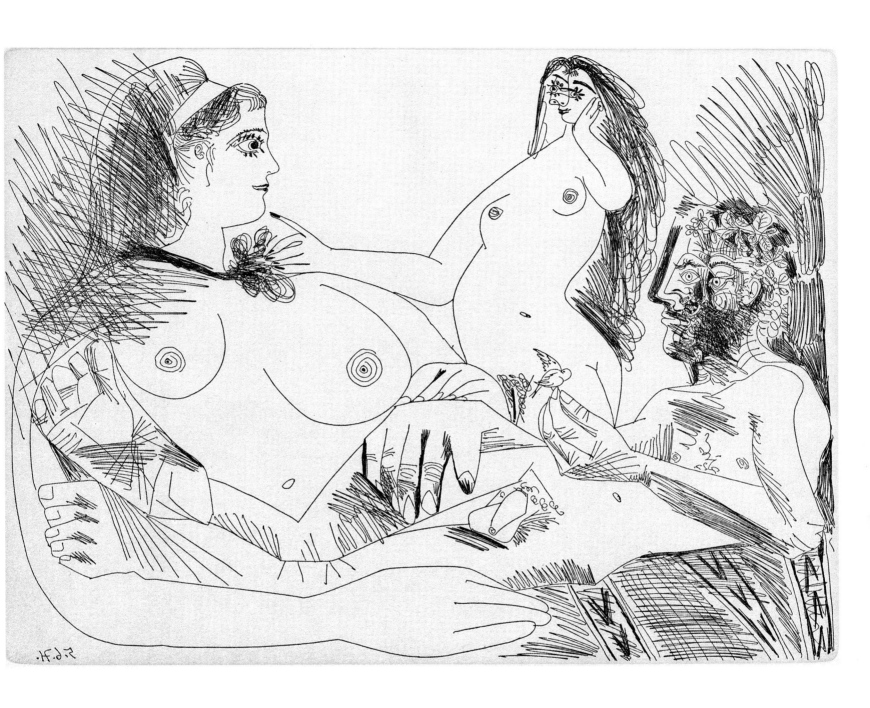

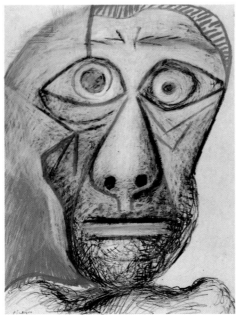

1/3

In 1970-2, at the end of his long life, Picasso returned to the brothel of his youth with Degas. Perhaps as he remembered a naked woman washing herself that he had come across amongst Degas's pastels in 1901, Picasso was affirming in his old age that he had lost none of his powers over women or over his art. And yet only three months separated him from his *Self-Portrait When Facing Death*.

1 1971
Etching, 23 × 31 cm

2 1971
Etching, 37 × 50 cm

3 *Self-Portrait*, 1972
Chalk & coloured pencils, 65.7 × 50.5 cm

For twenty years, Jacqueline was at Picasso's side, as wife, muse, lover, and also as the one who saw to the practical details concerning the painter's way of living, attentive as she was to his every need. 'When I breathe, she breathes. She loves me too much,' confided Picasso, but adding immediately: 'My wife is wonderful.' Pablo never stopped painting Jacqueline. During 1962 he completed no less than sixty-two portraits of his wife, although she did not pose for any of them. Life at Vauvenargues, at La Californie, the villa at Cannes, at Notre-Dame-de-Vie at Mougins, was gentle and serene. The couple hardly ever went out now and received few guests. Jacqueline was wary of intruders. Husband and wife were content with each other's company, and found their happiness in the love that was the bond between them. Their isolation became even greater when, in 1964, Picasso finally closed his door to Françoise and their two children Claude and Paloma. Françoise had published the journal of their life together, and he would never forgive her.

On 8 April 1973 Picasso's death agony began. Jacqueline was afraid: 'He's not going to leave me, is he? He's not going to leave me, is he?' Picasso died a few hours later. The doctors confirmed the painter's death, but

1/3
Jacqueline became Picasso's sole model and he painted her unceasingly. In the single year 1962, the painter completed more than sixty portraits of Jacqueline, revealing the extent of his love for her.

2
In September 1956, Picasso rang Kahnweiler and told him that he had bought Sainte-Victoire. 'Which one?' the dealer asked, thinking of one of Cézanne's paintings. 'The real one,'

'Isn't that enough?
What else do I need to do?
What can I add to it?
Everything's been said.'

Jacqueline obstinately refused to accept the inevitable. If someone in the room coughed, she would jump.

Jacqueline never came to terms with Picasso's death. Her life became a long series of wanderings that nothing – neither honours nor riches – managed to console. On 15 October 1986, Jacqueline lay down for the last time in the bed that she had shared with Picasso and pulled the trigger of a revolver.

Never in all the history of painting had an artist 'lived' his art to such an extent, engaged in constant self-metamorphosis, refusing to carry on with a means of expression once it seemed to him that he had understood how it worked and mastered the technique. The Blue and Rose Periods, the Gosol phase, Cubism, papier collé pictures, abstract art, sculpture, ceramics . . . So many different phases that could constitute the work of different artists. The genius of Picasso is to be found in this very diversity, that constant gushing forth, which will undoubtedly be a source for painting in the future.

3 *Jacqueline in the Studio*, 1957
Oil on canvas, 63.5 × 80.8 cm
Picasso Museum, Paris (RMN)

replied Picasso who had just acquired the Château de Vauvenargues at the foot of the Montagne Sainte-Victoire, and declared to whoever had ears to hear: 'I'm living at Cézanne's place!' It was there, at the foot of the great stone 'staircase' that he would be buried on 10 April 1973.

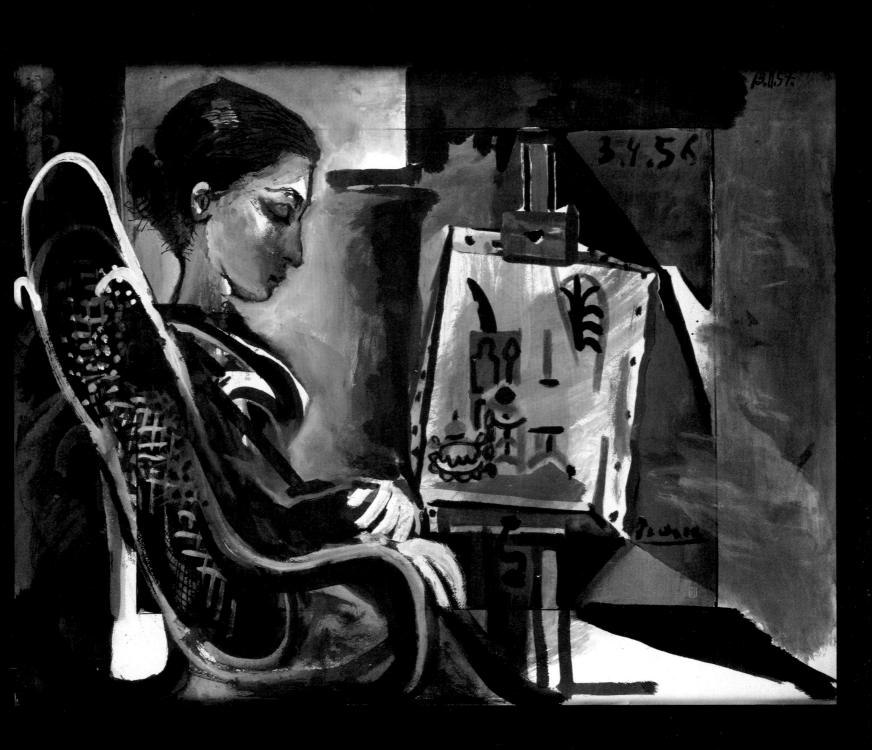

1 *Portrait of Jaime Sabartès:
The Glass of Beer*, 1901
Oil on canvas, 82 × 66 cm
Pushkin Museum, Moscow

2 *Casagemas in his Shroud*,
1901
Oil on paper, 72.5 × 57.8 cm
Picasso Estate

3 *Casagemas in Death*, 1901
Oil on paper, 52 × 34 cm
Picasso Estate

4 *Two Tumblers*, 1901
Oil on canvas, 73 × 60 cm
Pushkin Museum, Moscow

5 *Child with a Pigeon*, 1901
Oil on canvas, 73 × 54 cm
Private collection, London

6 *Mother and Child*, 1901
Oil on canvas, 46 × 33 cm
Metropolitan Museum of Art,
New York

7 *Mother and Child*, 1901
Pastel on paper, 46.5 × 31 cm
Private collection

8 *Motherhood, Mother and Child*,
1901
Oil on canvas, 91.5 × 60 cm
Private collection,
Los Angeles

9 *Self-Portrait*, 1901
Oil on canvas, 81 × 60 cm
Picasso Museum, Paris

10 *Woman Huddled, c.*1902
Oil on canvas, 63.5 × 50 cm
Private collection, Stockholm

11 *Woman Drinker Dozing*,
1902
Oil on canvas, 80 × 62 cm
Private collection, Switzerland

12 *The Dead Woman*, 1902
Oil on canvas, 55 × 38 cm
Beventos Foundation, Barcelona

13 *The Two Sisters*, 1902
Oil on canvas, 152 × 100 cm
Hermitage Museum, Leningrad

14 *Woman with a Lock
of Hair*, 1903
Watercolour on paper, 50 × 37 cm
Picasso Museum, Barcelona

15 *Head of a Woman*, 1903
Gouache on canvas, 36 × 27 cm
Private collection, Paris

16 *Soler the Tailor*, 1903
Oil on canvas, 100 × 70 cm
Hermitage Museum, Leningrad

17 *Portrait of Mme Soler*, 1903
Oil on canvas, 100 × 73 cm
Neue Pinakothek, Munich

18 *The Soler Family*, 1903
Oil on canvas, 150 × 200 cm
Musée des Beaux-Arts, Liège

19 *Poor People at
the Seaside*, 1903
Oil on wood, 105.5 × 69 cm
National Art Gallery
(Dale Collection), Washington

20 *La Vie*, 1903
Pencil, 26.7 × 19.7 cm
Private collection, London

21 *The Old Jew*, 1903
Oil on canvas, 125 × 92 cm
Pushkin Museum, Moscow

22 *Old Guitar Player*, 1903
Oil on wood, 121 × 82 cm
Art Institute, Chicago

23 *The Blind Man*, 1903
Gouache on canvas, 51.5 × 34.5 cm
Fogg Art Museum,
University of Harvard

24 *The Ascetic,* 1903
Oil on canvas, 130 × 97 cm
Barnes Foundation, Merion

25 *Célestine*, 1903
Oil on canvas, 70 × 56 cm
Picasso Museum, Paris

 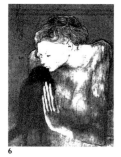 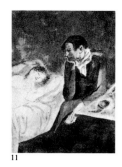 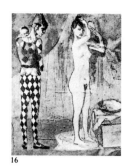

 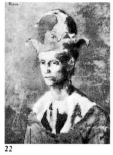 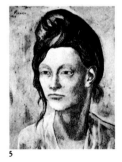

 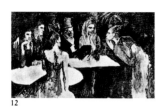 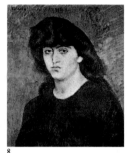 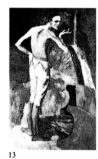

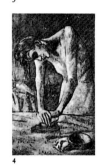 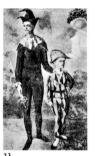

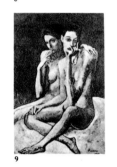 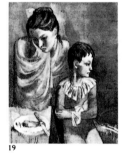

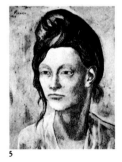 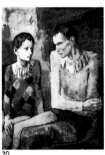 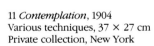

1 *Mother and Child*, 1903
Pastel on paper, 47.5 × 41 cm
Picasso Museum, Barcelona

2 *The Couple*, 1904
Oil on canvas, 100 × 81 cm
Private collection, Ascona

3 *Woman Ironing*, 1904
Pastel on paper, 37 × 51.5 cm
Private collection, New York

4 *Woman Ironing*, 1904
Oil on canvas, 116 × 72.5 cm
Guggenheim Museum,
(Tannhauser bequest), New York

5 *Woman with her hair
done like a helmet*, 1904
Gouache on paper, 43 × 31 cm
Art Institute, Chicago

6 *Woman with a Crow*, 1904
Various techniques
60.5 × 40.5 cm
Private collection, Paris

7 *Suzanne Bloch*, 1904
Various techniques
14.5 × 13.5 cm
Private collection, Ascona

8 *Portrait of Suzanne Bloch*, 1904
Oil on canvas, 65 × 54 cm
Museu del Arte, Sao Paulo

9 *The Two Friends*, 1904
Gouache on paper, 55 × 38 cm
Private collection, Paris

10 *The Two Friends*, 1904
Watercolour on paper, 27 × 37 cm
Private collection, Paris

11 *Contemplation*, 1904
Various techniques, 37 × 27 cm
Private collection, New York

12 *Pierrette's Wedding*, 1904
Oil on canvas, 95 × 145 cm
Private collection, Japan

13 *The Actor*, c.1904
Oil on canvas, 194 × 112 cm
Metropolitan Museum of Art,
New York

14 *Woman in a Chemise*, 1905
Oil on canvas, 72.5 × 60 cm
Tate Gallery, London

15 *Young Acrobat with Child*, 1905
Various techniques, 23.5 × 18 cm
Guggenheim Museum
(Tannhauser bequest), New York

16 *Harlequin's Family*, 1905
Various techniques, 58 × 43.5 cm
Private collection,
Washington

17 *Family of Acrobats*, 1905
Gouache on paper, 22 × 29 cm
Private collection, Germany

18 *Family of Acrobats with
a Monkey*, 1905
Various techniques, 105 × 75 cm
Konstmuseum, Göteborg

19 *Mother and Child*, 1905
Gouache on paper, 90 × 71 cm
Staatsgalerie, Stuttgart

20 *Acrobat with Young Harlequin*,
1905. Gouache on paper,
105 × 76 cm. Priv. coll., Belgium

21 *The Athlete*, 1905
Gouache on paper, 54 × 44 cm
Private collection, Paris

22 *The Madman*, 1905
Gouache on paper, 70 × 54 cm
Private collection, Paris

23 *Two Harlequins*, 1905
Oil on canvas, 190.5 × 108 cm
Barnes Foundation, Merion

24 *Family of Jugglers*, 1905
Various techniques, 24 × 30.5 cm
Museum of Art (Cone Collection),
Baltimore

25 *Clown with a Young
Acrobat*, 1905
Various techniques, 66 × 56 cm
Private collection, USA

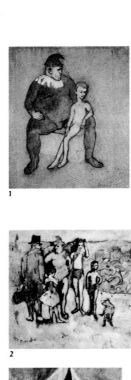
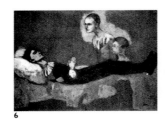

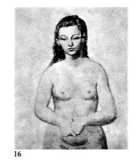

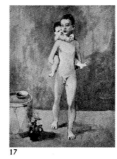

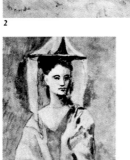

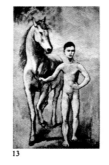
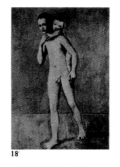

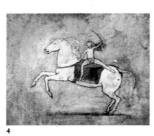
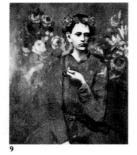
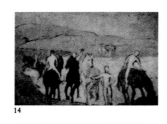
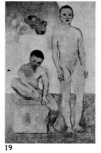

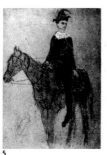

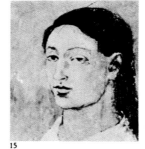
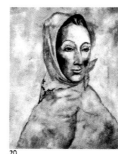

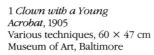
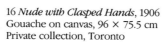

1 *Clown with a Young Acrobat*, 1905
Various techniques, 60 × 47 cm
Museum of Art, Baltimore

2 *Study for The Jugglers*, 1905
Gouache on paper, 51 × 61 cm
Pushkin Museum, Moscow

3 *Woman from Majorca*, 1905
Gouache on paper, 67 × 51 cm
Pushkin Museum, Moscow

4 *Young Horsewoman*, 1905
Gouache on paper, 59 × 78 cm
Picasso Estate

5 *Harlequin on Horseback*, 1905
Oil on paper, 100 × 69 cm
Private collection,
Washington

6 *Death of Harlequin*, 1905
Oil on paper, 65 × 95 cm
Priv. coll., Washington

7 *The Three Dutchwomen*, 1905
Gouache on paper, 76 × 66 cm
Musée National d'Art Moderne,
Paris

8 *Madame Canals*, 1905
Oil on canvas, 90.5 × 70.5 cm
Picasso Museum, Barcelona

9 *The Boy with a Pipe*, 1905
Oil on canvas, 99 × 79 cm
Private collection, New York

10 *Little Girl with a
Basket of Flowers*, 1905
Oil on canvas, 152 × 65 cm
Private collection, New York

11 *The Blue Boy*, 1905
Gouache on paper, 99.5 × 55.5 cm
Private collection, New York

12 *Portrait of Leo Stein,* 1906
Gouache on paper, 27.5 × 17 cm
Museum of Art (Cone Collection)
Baltimore

13 *Horse Trainer*, 1905-6
Oil on canvas, 221 × 130 cm
Private collection, New York

14 *Horses Bathing*, 1906
Gouache on paper, 37.5 × 58 cm
Art Museum, Worcester

15 *Woman's Head: Fernande*, 1906
Gouache on canvas, 37.5 × 33 cm
Private collection, USA

16 *Nude with Clasped Hands*, 1906
Gouache on canvas, 96 × 75.5 cm
Private collection, Toronto

17 *Two Brothers*, 1906
Gouache on paper, 80.5 × 60 cm
Picasso Museum, Paris

18 *Two Brothers*, 1906
Oil on canvas, 142 × 97 cm
Kunstmuseum, Basle

19 *Two Adolescents*, 1906
Oil on canvas, 151.5 × 93.5 cm
National Gallery of Art
(Dale Collection), Washington

20 *Fernande with kerchief*, 1906
Various techniques, 66 × 49.5 cm
Virginia Museum of Fine Art
(Catesby Jones Coll.), Richmond

21 *A Young Spaniard*, 1906
Various techniques, 61.5 × 48 cm
Konstmuseum, Göteborg

22 *Houses at Gosol*, 1906
Oil on canvas, 54 × 38.5 cm
Statens Museum for Kunst,
Copenhagen

23 *Landscape at Gosol*, 1906
Oil on canvas, 70 × 99 cm
Private collection, New York

24 *Cowherd with a
small basket*, 1906
Gouache on paper, 62 × 87 cm
Gallery of Art, Columbus

25 *Woman Carrying Bread*, 1906
Oil on canvas, 100 × 70 cm
Museum of Art, Philadelphia

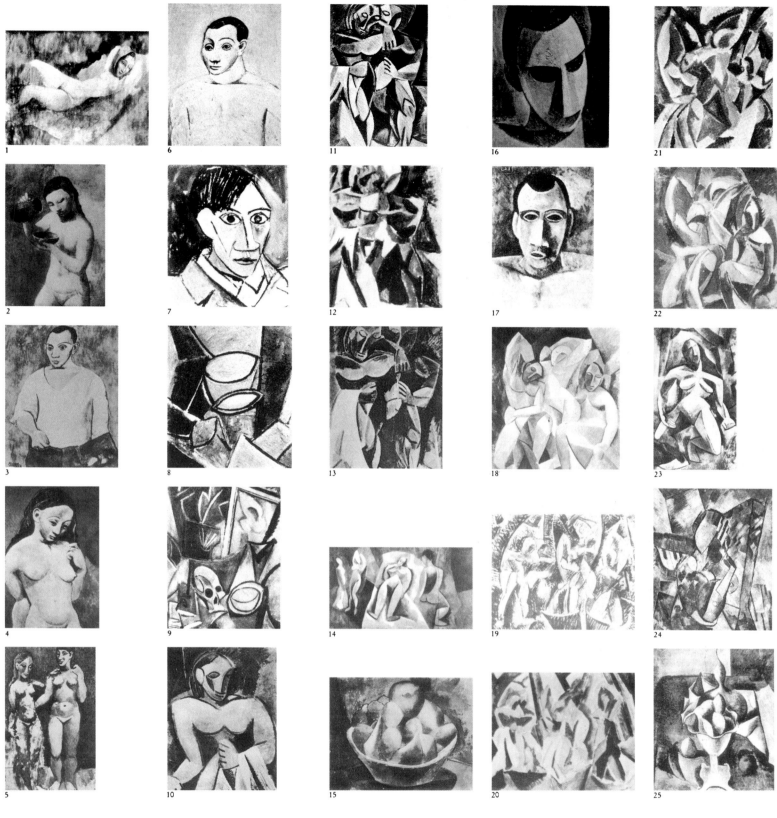

1 *Nude Lying Down*, 1906
Gouache on paper,
47.5 × 61.5 cm
Museum of Art, Cleveland

2 *Nude with a Jug*, 1906
Oil on canvas, 100 × 81 cm
Private collection, London

3 *Self-Portrait with Palette*,
Oil on canvas, 92 × 73 cm
Museum of Art
(Gallatin Collection), Philadelphia

4 *Nude, Red Background*, 1906
Oil on canvas, 81 × 54 cm
Musée de l'Orangerie, Paris

5 *Two Nudes Linking Arms*,
1906.
Oil on canvas, 151 × 100 cm
Private collection, Switzerland

6 *Self-Portrait*, 1906
Oil on canvas, 65 × 54 cm
Picasso Museum, Paris

7 *Portrait of Artist*, 1907
Oil on canvas, 50 × 46 cm
Narodní Galerie, Prague

8 *Pots with Lemons*, 1907
Oil on canvas, 55 × 46 cm
Private collection, London

9 *Composition with a Skull*,
1907
Oil on canvas, 116 × 89 cm
Hermitage Museum, Leningrad

10 *Nude with a Towel*, 1907
Oil on canvas, 116 × 89 cm
Private collection, Paris

11 *Study for Friendship*,
1907-8
Gouache on paper, 61 × 47 cm
Hermitage Museum, Leningrad

12 *Study for Friendship*, 1907-8
Gouache on paper, 61 × 41 cm
Hermitage Museum, Leningrad

13 *Friendship*, 1908
Oil on canvas, 152 × 101 cm
Hermitage Museum, Leningrad

14 *Nude Lying Down*, 1908
Oil on wood, 36 × 63 cm
Picasso Estate

15 *Bowl with Fruit*, 1908
Gouache on wood, 21 × 27 cm
Kunstmuseum, Basle

16 *Head of a Woman*, 1908
Oil on wood, 27 × 21 cm
Private collection, Paris

17 *Bust of a Man*, 1908
Oil on canvas, 61 × 46 cm
Museum of Modern Art, New York

18 *Three Women*, 1908
Oil on canvas, 200 × 179 cm
Hermitage Museum, Leningrad

19 *Study for Three Women*, 1908
Gouache on paper, 48 × 58 cm
Museum of Art, Philadelphia

20 *Study for Three Women*, 1908
Watercolour & pencil
on paper, 46 × 59 cm
Museum of Modern Art, New York

21 *Study for Three Women*, 1908
Gouache on paper, 51 × 48 cm
Musée National d'Art Moderne,
Paris

22 *Three Women*, 1908
Oil on canvas, 91 × 91 cm
Private collection, Paris

23 *Nude in a Forest*, 1908
Oil on canvas, 185 × 106 cm
Hermitage Museum, Leningrad

24 *Woman with Mandolin*, 1908
Oil on canvas, 100 × 81 cm
Private collection, Paris

25 *Bowl of Fruit*, 1908-9
Oil on canvas, 73 × 60 cm
Museum of Modern Art, New York

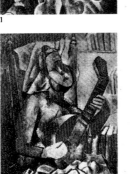
1

2

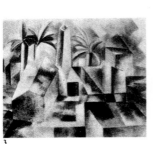
3

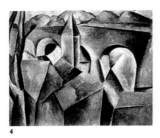
4

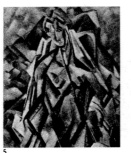
5

6

7

8

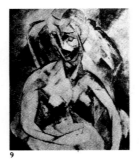
9

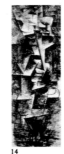
10

11

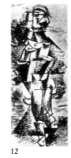
12

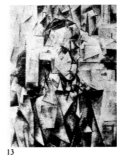
13

14

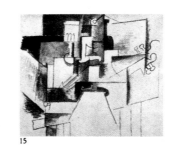
15

16

17

18

19

20

21

22

23

24

25

1 *Portrait of Clovis Sagot*, 1909
Oil on canvas, 82 × 66 cm
Kunsthalle, Hamburg

2 *Woman Playing the Mandolin*,
1909
Oil on canvas, 92 × 73 cm
Hermitage Museum, Leningrad

3 *Factory at Horta de Ebro*, 1909
Oil on canvas, 53 × 60 cm
Hermitage Museum, Leningrad

4 *Landscape with Bridge*, 1909
Oil on canvas, 81 × 100 cm
Narodní Galerie, Prague

5 *Nude*, 1909
Oil on canvas, 92 × 73 cm
Private collection, France

6 *Nude in an Armchair*, 1909
Oil on canvas, 92 × 73 cm
Private collection, France

7 *Homage to Gertrude* 1909
Distemper on wood, 21 × 27 cm
Private collection, New York

8 *Woman in Green,* 1909
Oil on canvas, 99 × 80 cm
Stedelijk van Abbemuseum,
Eindhoven

9 *Nude in an Armchair*,
1909
Oil on canvas, 92 × 73 cm
Hermitage Museum, Leningrad

10 *Ambroise Vollard*, 1909
Oil on canvas, 92 × 65 cm
Pushkin Museum, Moscow

11 *Nude*, 1910
Charcoal on paper, 48.4 × 31.3 cm
Metropolitan Museum, New York

12 *Nude*, 1910
Ink & watercolour on paper
30 × 12 cm. Priv. coll., New York

13 *Wilhelm Uhde*, 1910
Oil on canvas, 81 × 60 cm
Private coll., St Louis

14 *Nude*, 1910
Oil on canvas, 187.3 × 61 cm
National Gallery, Washington

15 *Violin with Bottle*,
1910-11. Pencil diluted with petrol,
50 × 64.5 cm. Musée National
d'Art Moderne, Paris

16 *Absinthe Glass, Bottle,
Fan, Pipe, Violin & Clarinet on
a Piano*, 1910-11
Oil on canvas, 50 × 130 cm
Private collection, Paris

17 *Mandolin and Pernod*, 1911
Oil on canvas, 33 × 46 cm
Private collection, Prague

18 *Mandolin Player*, 1911
Oil on canvas, 100 × 65 cm
Private collection, Basle

19 *Newspaper, Pipe & Glass*, 1911
Oil on canvas, 26 × 22 cm
Picasso Estate

20 *The Clarinet*, 1911
Oil on canvas, 61 × 50 cm
Narodní Galerie, Prague

21 *The Torero*, 1911
Oil on canvas, 46 × 38 cm
Museum of Modern Art,
New York

22 *Landscape at Céret*, 1911
Oil on canvas, 65 × 50 cm
Guggenheim Museum, New York

23 *The Stock 'Cube'*, 1912
Oil on canvas, 27 × 21 cm

24 *Violin, Glass, Pipe & Inkwell*,
1912. Oil on canvas, 81 × 54 cm
Narodní Galerie, Prague

25 *The Bottle of Brandy* (or
Ma Jolie), 1912
Oil on canvas, 73 × 60 cm

 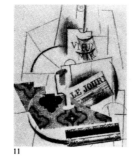 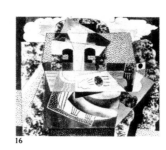 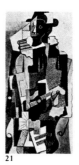

1 6 11 16 21

 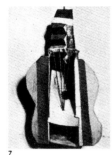 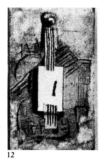 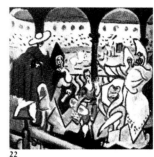

2 7 12 17 22

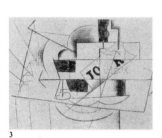 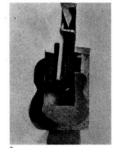 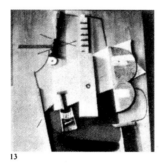

3 8 13 18 23

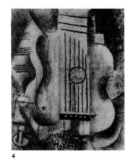 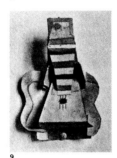 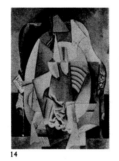 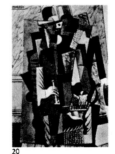

4 9 14 19 24

 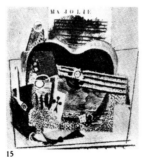

5 10 15 20 25

1 *Clarinet, Violin, Bowl of Fruit, Sheets of Music, Pedestal Table,* 1912
Oil on canvas

2 *Bottle and Glass,* 1912
Pencil & papier collé on paper, 47 × 62.5 cm. Priv. coll., Houston

3 *Bottle of Old Brandy,* 1912
Pencil & papier collé, 47 × 62.5 cm Picasso Estate

4 *The Guitar* (or *I love Eva*), 1912. Oil on canvas, 41 × 33 cm Picasso Estate

5 *Bottle, Egg & Pigeon on a Table,* 1912. Ink on paper, 13 × 8.5 cm Picasso Estate

6 *The Aficionado,* 1912
Oil on canvas, 135 × 82 cm
Kunstmuseum, Basle

7 *Guitar,* 1912
Construction of beige, blue & black paper, 33 × 17 cm
Picasso Estate

8 *Guitar,* 1912
Metal sculpture, 78 × 35 × 18.5 cm
Museum of Modern Art, New York

9 *Guitar,* 1912
Construction in paper, 24 × 14 cm
Picasso Estate

10 *Newspaper, Bottle of Bass & Guitar,* 1912-13.
Charcoal & papier collé

11 *Bottle of Old Brandy,* 1913
Charcoal & papier collé, 63 × 49 cm. Musée National d'Art Moderne, Paris

12 *Violin,* 1913
Oil & plaster on cardboard, 51 × 30 × 4 cm. Picasso Estate

13 *Bottle of Bass & Guitar,* 1913. Wood. Picasso Estate

14 *Woman in Nightdress in an Armchair,* 1913
Oil on canvas, 148 × 99 cm
Private collection, New York

15 *Pipe, Glass, Playing Card & Guitar* (or *Ma Jolie*), 1914
Oil on canvas, 45 × 40 cm
Private collection, Paris

16 *Bowl of Fruit, Mandolin & Glass on a Table in a Landscape,* 1915
Oil on canvas, 62 × 75 cm.
Priv. collection, Paris

17 *Man with Elbows on Table,* 1915-16. Oil on canvas, 232 × 200 cm. Priv. coll., UK

18 *Guitar Player,* 1916
Oil & sand on canvas, 130 × 97 cm
Moderna Museet, Stockholm

19 *Backdrop Curtain for Parade,* 1917. Glue on canvas, 106 × 172.5 cm. Musée National d'Art Moderne, Paris

20 *Man in an Armchair,* 1918.
Oil on canvas, 22 × 16 cm

21 *Harlequin,* 1918
Oil on canvas, 147.3 × 68 cm
Private coll., St Louis

22 Plan for backdrop for *The Three-Cornered Hat,* 1919
Oil on canvas, 36.5 × 35.4 cm
Private collection, New York

23 Plan for backdrop for *The Three-Cornered Hat,* 1919
Oil on canvas, Priv. coll., NY

24 Plan for backdrop for *The Three-Cornered Hat,* 1919
Pencil. Picasso Estate

25 Study for sets for *Pulcinella,* 1920
Gouache on paper

153

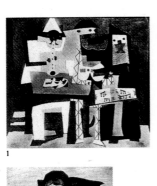 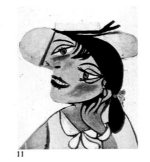 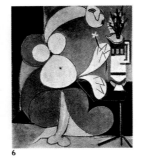 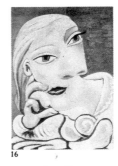

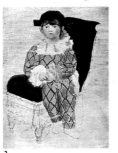 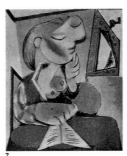 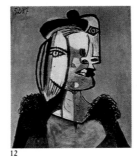 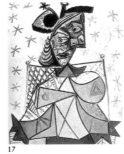

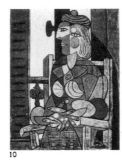 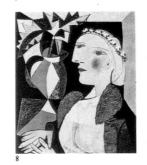 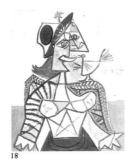

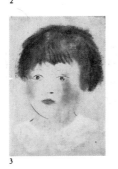 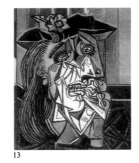 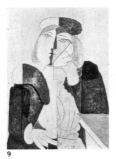 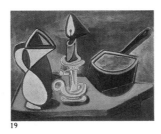 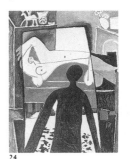

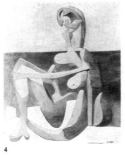 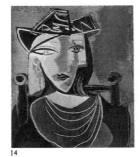 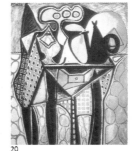 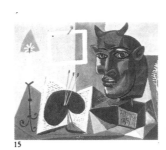 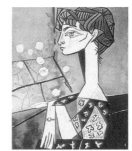

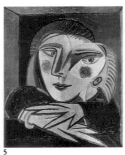

1 *The Three Musicians* (or
Musicians Wearing Masks), 1921
Oil on canvas, 201 × 223 cm
Museum of Modern Art, New York

2 *Portrait of Paul*, 1924
Oil on canvas, 130 × 97 cm
Picasso Museum, Paris

3 *Portrait of Paulo*, 1925
Pastel & wax crayon on canvas,
24 × 16 cm

4 *Woman Sitting at the Water's
Edge*, 1930. Oil on canvas,
163.5 × 129.5 cm. Museum of
Modern Art (S. Guggenheim
bequest), New York

5 *Marie-Thérèse*, 1936
Oil on canvas, 55 × 46 cm

6 *Woman with a Bouquet*, 1936
Oil on canvas, 73 × 60 cm

7 *Girl Reading*, 1936
Oil on canvas, 41 × 33 cm

8 *Marie-Thérèse with a
Vase*, 1937
Oil on canvas, 73 × 60 cm

9 *Dreaming*, 1937
Oil on canvas, 92 × 65 cm

10 *Marie-Thérèse in front
of the window*, 1937
Pastel on canvas, 130 × 97 cm

11 *Dora Maar*, 1937
Oil on canvas, 61 × 50 cm

12 *Marie-Thérèse with
Red Beret*, 1937
Oil on canvas, 61 × 50 cm

13 *Woman Weeping*, 1937
Oil on canvas, 59.5 × 49 cm
Private collection, England

14 *Marie-Thérèse with
Blue Hat*, 1938
Oil on canvas, 55 × 46 cm

15 *Still life with
Red Bull*, 1938
Oil on canvas, 73 × 92 cm

16 *Marie-Thérèse*, 1939
Oil on canvas, 65 × 46 cm

17 *Portrait of a Woman*, 1939
Oil on canvas, 92 × 73 cm

18 *Woman with Bird*, 1939
Oil on canvas, 92 × 73 cm

19 *The Enamelled Saucepan*, 1945
Oil on canvas, 82 × 106 cm
Musée National d'Art Moderne,
Paris

20 *Still life on Table*, 1947
Oil on canvas, 100 × 80 cm
Galerie Rosengart, Lucerne

21 *Woman Sitting*, 1948
Oil on canvas, 100 × 81 cm
Galerie Beyeler, Basle

22 *Nude in Studio*, 1953
Oil on canvas, 89 × 116 cm

23 *Paloma*, 1953
Oil on canvas, 130 × 97 cm

24 *The Sicilian Cart*, 1953
Oil on canvas, 130 × 97 cm

25 *Portrait of J.R. with
Roses*, 1954
Oil on canvas, 100 × 81 cm
Jacqueline Picasso Collection,
Mougins

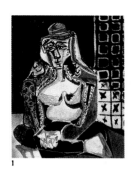

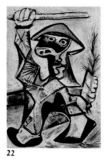

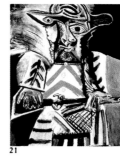

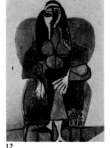

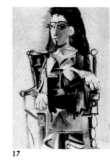

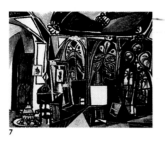

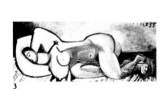

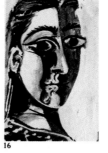

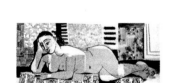

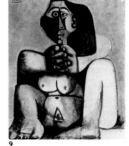

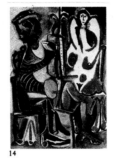

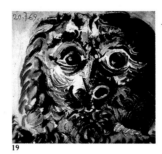

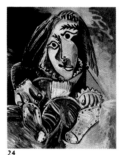

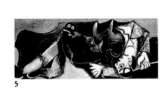

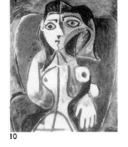

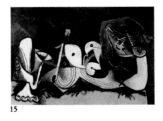

1 *Crouching Woman in Turkish Costume*, 1955
Oil on canvas, 115 × 89 cm
Perls Gallery, New York

2 Untitled, 1955
Oil on canvas, 80 × 190 cm

3 Untitled, 1955
Oil on canvas, 60 × 190 cm

4 Untitled, 1955
Collage & paint on canvas,
80 × 190 cm

5 Untitled, 1955
Oil on canvas, 80 × 190 cm

6 Untitled, 1955
Oil on canvas, 80 × 190 cm

7 *The Studio*, 1956
Oil on canvas, 89 × 111 cm
Private collection, New York

8 *Woman in the Studio*, 1956
Oil on canvas, 65 × 81 cm
Galerie Beyerler, Basle

9 *Nude Crouching*, 1959
Oil on canvas, 146 × 114 cm
Private collection, Zurich

10 *Woman in Blue Armchair*, 1960
Oil on canvas, 129.5 × 97 cm
Galerie Rosengart, Lucerne

11 *Bathers with Bucket & Spade*, 1960
Oil on canvas, 114 × 146 cm

12 *Seated Woman with Green Scarf*, 1960
Oil on canvas, 195 × 130 cm
Private collection, Bremen

13 *Woman with Hat*, 1961
Oil on canvas, 117 × 89 cm
Galerie Rosengart, Lucerne

14 *The Painter & His Model*, 1963
Oil on canvas, 195 × 130 cm

15 Untitled, 1964
Oil on canvas, 130 × 194 cm

16 Untitled, 1964
Oil on canvas, 56 × 35 cm

17 Untitled, 1964
Oil on canvas, 194 × 128 cm

18 *Seated Woman with Cat*, 1964
Oil on canvas, 130 × 81 cm
Galerie Beyerler, Basle

19 *Head*, 1969
Oil on plywood, 32 × 36 cm

20 *Man, Sword & Flower*, 1969
Oil on canvas, 146 × 114 cm

21 *Man with a Gun*, 1969
Oil on canvas, 146 × 114 cm

22 *Harlequin*, 1969
Oil on canvas, 195 × 130 cm

23 *The Kiss*, 1969
Oil on canvas, 97 × 130 cm

24 *Adolescent*, 1969
Oil on canvas, 130 × 97 cm

25 *The Young Painter*, 1972
Oil on canvas, 92 × 73 cm
Picasso Museum, Paris

	Life of Picasso	Principal Works
1881	Birth at Malaga in Spain, son of José Ruiz Blasco, teacher of drawing, and Doña Maria Picasso y Lopez	
1898	Catches scarlet fever in Madrid and returns in a state of exhaustion to Barcelona, where he begins to move in avant-garde artistic circles	
1901	Picasso moves to Paris, to 130 boulevard de Clichy. Beginning of the Blue Period	*Self-portrait; Woman Washing; Harlequin Leaning on his Elbows; Picasso in Madrid Style; Woman Drinking Absinthe*
1902	Exhibition with Matisse and Marquet at Berthe Weill's	*Seated Woman Wearing a Hood*
1903	Returns to his parents' home in Barcelona, where he begins to enjoy a degree of success	*The Blind Man's Meal; La Vie*
1904	Move to Paris to the 'Bateau-Lavoir'. Liaison with Fernande Olivier. Meets Guillaume Apollinaire	*The Frugal Meal; Woman with a Crow; Woman Ironing; Célestine*
1905	Beginning of Rose Period. Meets Gertrude Stein	*Family of Saltimbanques; The Madman* (sculpture)' *Woman in a Chemise; At the Lapin Agile*
1906	Gertrude Stein introduces him to Matisse. Stay at Gosol. Beginnings of Cubism	*Portrait of Gertrude Stein; La Coiffure;* begins work on *Les Demoiselles d'Avignon*
1907	Meets Kahnweiler. Period of Cézanne-esque Cubism. Apollinaire introduces him to Braque	*Three Women; Women;* finishes *Les Demoiselles d'Avignon*
1908	Banquet in honour of Henri (Le Douanier) Rousseau. Beginning of collaborative research with Braque	*Landscape with Two Figures*
1909	Stays at Horta de Ebro. Ferrer executed in Spain	*Portrait of Fernande*
1910	Stays at Cadaquès	*Portrait of Kahnweiler; Portrait of Ambroise Vollard; Woman with Mandolin; Man with a Mandolin*
1911	Beginning of his liaison with Eva Gouel. Picasso joins the sculptor Manolo at Céret	Four etchings for Max Jacob's *Saint Matorel*
1912	Goes to Sorgues then returns to Paris. First collages. Transition from Analytical Cubism to Synthetic Cubism	*Still life with Cane Chair; Bottles, Glass & Violin; Nude, 'I love Eva'*
1913	Moves into 5A rue Schoelcher. Meets Foujita	*The Violin; Violin and Fruit Bowl; Head of a Girl*
1914	Remains in Paris during First World War. Returns to brighter colours and more supple shapes	*The Pedestal Table; Ma Jolie; The Card Players*
1915	Death of Eva in December. Is visited by Jean Cocteau	*Harlequin*
1916	Moves to Montrouge	*Apollinaire after the Operation on his Skull; The Guitar Player*
1917	In Rome with Cocteau for *Parade*, Diaghilev's ballet, booed by audience in Paris. Meets Olga Koklova, ballet dancer	*Curtain for Parade; Portrait of Olga in an Armchair*
1918	Marries Olga and moves into 23 rue de la Boétie. Death of Apollinaire	*Women Bathing*
1921	Birth of Paulo	*Musicians Wearing Masks; Three Musicians; Olga Running* (six drawings)
1923	American magazine *The Arts* publishes the first important interview with him. Meets André Breton	*Harlequin Seated; Woman in a Mauve Frilled Dress*
1927	Meets Marie-Thérèse Walter, aged seventeen	*Woman in an Armchair; Woman Bather Opening a Beach Hut*
1930	Summer at Juan-les-Pins. Awarded the Carnegie Prize. Buys the Château de Boisgeloup	*Assemblages with sand effects;* illustrations for Ovid's *Metamorphoses*
1932	First retrospective exhibition at Georges Petit's Gallery in Paris. First volume of Zervos's catalogue	
1933	Publication of Fernande's volume of memoirs. Final crisis with Olga	*The Studio; Female Torero*
1935	End of his marriage to Olga. Birth of Maya, Marie-Thérèse's daughter. Writes poems and becomes friendly with Paul Eluard.	*The Muse*
1936	Made Director of the Prado: 'It's amazing, I'm the director of an empty museum.' Liaison with Dora Maar	

Artistic Life	History
Manet: *A Bar at the Folies Bergère*; Verga: *The Malavoglias*; Verlaine: *Sagesse*; death of Dostoevsky	Compulsory free schooling in France; Tunisia becomes a French Protectorate; Anti-Jewish pogroms in Russia
Othon Friesz in Paris; Zola: *J'accuse*; Rostand: *Cyrano de Bergerac*; deaths of Mallarmé and Puvis de Chavannes; birth of Brecht	Death of Bismark; Spanish-American War; foundation of *L'Action française*; Fashoda affair; Curie: discovery of radium
Gauguin: *Maison du Jouir*; Gallé founds the Nancy School; Mann: *Buddenbrooks*; Ravel: *Jeux d'Eau*; deaths of Toulouse-Lautrec and Verdi	International protocol on China; Roosevelt president of USA; death of Queen Victoria, succeeded by Edward VII
Gauguin: *Barbaric Tales*; Croce: *Aesthetics*; Gide: *L'Immoraliste*; Debussy: *Pelléas et Mélisande*; Méliès: *Journey to the Moon*	Combes minister in France; Balfour, Prime Minister in Great Britain; Rutherford discovers radioactivity
Creation of the Viennese Studios and of the Autumn Salon; Kandinsky in Tunis; Gorky: *The Lower Depths*; deaths of Whistler, Gauguin and Pissaro	Split between Bolsheviks and Mensheviks; Revolution in Panama; flight made by Wright brothers; Marie Curie: Nobel Prize for Physics
Cross: *Le Lavandou*; Cézanne: *Montagne Ste Victoire*; Matisse: *Luxury, Calm, and Voluptuousness*; deaths of Gérôme and Chekhov	Split between France and Vatican; Entente cordiale between France and Britain against Austro-German block; Russo-Japanese War (Port Arthur)
Cézanne: *Large Women Bathing*; Matisse: *The Gypsy Woman*; Fauves at the Autumn Salon; *Die Brücke* at Dresden; Debussy: *La Mer*	Separation of Church and State in France; Combes resigns; Russian Revolution; Einstein: *Theory of Relativity*
Klimt: *The Kiss*; van Dongen: *Fernande Olivier;* Juan Gris moves into Bateau-Lavoir'; Claudel: *Le Partage de Midi*; death of Cézanne	Algeciras Conference; Clemenceau minister; rehabilitation of Dreyfus; Erichsen's expedition to Greenland
Klimt: *Danae*; Douanier Rousseau: *Woman Snake Charmer*; Kipling; Nobel Prize; Mahler directs Metropolitan Opera in New York	Rasputin dominates the court of Tsar Nicholas II; Taylor: *Organisation of Factory Labour*; Lumière brothers' first coloured photographs
Bonnard: *Nude lit from behind*; Braque: *Houses at l'Estaque*; Matisse: *The Red Tray*; Marie Laurencin: *Apollinaire and his Friends*	Bosnia annexed by Austria; Clemenceau against CGT Trade Union; uprising of young Turks in Salonica; Tel Aviv founded
Piet Mondrian: *The Red Tree*; birth of Futurism with Marinetti; *Nouvelle Revue Française* founded	Briand minister; riots in Barcelona; Taft, President of USA; Blériot flies across Channel; Peary reaches North Pole
Delaunay: *The Eiffel Tower*; Kandinsky: *Du Spirituel dans l'Art*; Stravinsky; *The Firebird*; death of Henri (Le Douanier) Rousseau	Vatican condemns the review *Le Sillon*; Korea annexed by Japan; Mexican Revolution; fall of Portuguese monarchy
Kandinsky: Manifesto *Le Spiritual de l'Art*; Apollinaire: *Bestiary*; Kokoschka exhibition in Vienna	Chinese Revolution; Italy attacks Tripoli; Amundsen reaches the South Pole; Beaumont flies from Paris to Rome
De Chirico: *Melancholy Street*; Delaunay: *Non-Objective Art*; Schiele in prison on charge of pornography; Chagall moves into la Ruche	Balkan War followed by division of European Turkey; Kuomintang in China; Sinking of the *Titanic*
Malevich: *The Woodcutter*; Foujita in Paris; Proust: *A la recherche du temps perdu*; Stravinsky: scandal surrounding *Rite of Spring*	Second Balkan War; Independence of Albania; Mexican President Madero assassinated; Roland Garros crosses the Mediterranean
Delaunay: *Homage to Blériot*; Léger: *The Staircase*; Kokoschka: *The Whirlwind of Greens*; Gide; *The Vatican Cellars*	Assassination of Archduke Ferdinand; Jaurès assassinated; First World War; opening of Panama Canal; Pope Benedict XV
Malevich: *Suprematist Manifesto* (metaphysical painting); Duchamp and Picabia in New York; Manifesto of Italian Pride	Italy enters the war; a battalion of cyclist volunteers set up by Futurists; Zimmerwald Congress; gas used in warfare
Romain Rolland: Nobel Prize for Literature; birth of the Dadaist movement at the Café Voltaire in Zurich; Max Jacob: *The Dice Box*	Battle of Verdun; Nationalist uprising in Ireland; Rasputin assassinated; first tanks; stainless steel
Modigliani: scandal over his nudes; Mondrian: creates Neo-Plasticism; Duchamp: scandal at the Indépendants' Exhibition; death of Rodin	Italian defeat at Caporetto; mutinies in the French and German armies; United States enters the war; October Revolution in Russia
Malevich: *White Square on a White Background*; Miró: first exhibition in Spain; deaths of Klimt, Schiele, O. Wagner and Apollinaire	11 November, Armistice; execution of Tsar and his family; dissolution of Austro-Hungarian Empire; epidemic of Spanish flu in Europe
Van Dongen: *Portrait of Kahnweiler*; Picabia: *The Cacodyl Eye*; Cocteau and the group of Six: *Newly-Weds at the Eiffel Tower*	Ireland becomes a free state; foundation of the Chinese Communist Party; Sacco and Vanzetti arrested in America
Milhaud, Cendrars, Léger: *La Création du Monde*; Mauss: *Essay on Gift*; Honegger: *Pacific 231*; deaths of Proust and Barrès	Hitler's putsch fails; Poincaré occupies the Ruhr; *coup d'état* in Spain; Stalin comes to power; Mustapha Kemal President of Turkey
Chagall: La Fontaine's *Fables*; Heidegger: *Being and Time*; Disney: Micky Mouse; Abel Gance: *Napoléon;* death of Juan Gris	Failure of Socialists in Vienna, Kuomintang break with Chinese Communists; Lindbergh crosses Atlantic
Rouault: *The Passion, The Circus*; Surrealist Manifesto II; Malraux: *The Royal Way*; Buñuel: *L'Age d'Or*; deaths of Pascin and Mayakovsky	107 Nazi deputies elected to the Reichstag; Iraq becomes independent; collectivisation in USSR; Gandhi arrested
Matisse illustrates Mallarmé; Rouault: *Christ Humiliated*; Céline: *Journey to the End of Night*; Mounier founds the journal *Esprit*	Doumer assassinated in Paris; Salazar comes to power in Portugal; Franco-Soviet non-aggression pact
Matisse: *La Danse*; Rouault: *The Holy Face*; Nazis put an end to the Bauhaus; Malraux: *The Human Condition*; Lorca: *Blood Wedding*	Roosevelt President of USA; Hitler Chancellor of the Reich; Nazi concentration camps; Joliot-Curie: artificial radioactivity
Dali: *Giraffe on Fire*; Giraudoux: *The Trojan War will not Take Place*; Gershwin: *Porgy and Bess*; Crevel's suicide; death of Malevich	Italy attacks Ethiopia; anti-Jewish laws in Germany; Mao Zedong's 'Long March'; Fermi: atomic fission; Irène Curie: Nobel Prize for Chemistry
Dali: *Premonition of Civil War*; Céline: *Death on the Instalment Plan*; Chaplin: *Modern Times*; death of Pirandello; Garcia Lorca is shot	Popular Front in France; Civil War in Spain; Judeo-Arab civil war; Hitler reoccupies the Rhineland; Abdication of Edward VIII

	Life of Picasso	Principal Works
1937	New studio at 7 rue des Grands-Augustins in Paris; holidays at Mougins with the Eluard family	*Guernica* at Exposition Universelle; *Woman Imploring; Woman Weeping; Portrait of Marie-Thérèse*
1938	Distressed by the disagreement between Breton and Eluard	Exhibits *Guernica* in London; *Maya with a Doll; Naked Woman on Chair; Woman in the Garden*
1939	Death of his mother and of Vollard; goes to Antibes with Dora and Sabartès; a stay with Marie-Thérèse and Maya who remain in Royan	*Bust of a Woman with a Striped Hat; Fishing by Night at Antibes*
1940	Summer in Royan, returns to Paris in September, to the rue des Grands-Augustins	*Café at Royan; Nude doing her Hair*
1941	Writes *Desire Caught by the Tail*; resumes sculpting	*Sculpture of Dora (monument to Apollinaire); Woman in a Blue Blouse*
1943	Almost the only mourner at the funeral of Soutine, the 'Jewish painter'; meets Françoise Gilot	*The Window; Skull with Jug; Woman Sitting in a Rocking Chair*
1944	Joins Communist Party; present at memorial service for Max Jacob, died at Drancy; scandal over retrospective exhibition at Autumn Salon	*Nude Lying Down and Woman Washing Her Feet; Bacchanale* (after Poussin)
1945	Lithographs at Mourlot's workshop	*The Charnel House*
1946	Living with Françoise at the rue des Grands-Augustins; sets off alone for the South and is joined by Dora at Antibes	*La Joie de Vivre; Monument to the Spaniards who died for France*
1947	Offers 10 of his works to Musée National d'Art Moderne in Paris; birth of Claude	*David and Bathsheba*; illustrations for Reverdy's *Song of the Dead*, lithographs
1948	Moves with Françoise into the villa La Galloise at Vallauris	
1949	Birth of Paloma	Lithograph of *The Dove*, which was to become a poster for the Peace Congress in Paris
1950	Acquires the Fournas studios at Vallauris	*Portrait of a Painter* (after El Greco); *Les Demoiselles des bords de Seine* (after Courbet)
1951	Moves house as a consequence of the seizure of the apartment in the rue de la Boétie; relationship with Françoise cooling	*Massacre in Korea; Landscape by Night*
1954	Meets Jacqueline Roque at Vallauris	*Portrait of Sylvette; Madame Z*
1955	Moves into La Californie with Jacqueline; death of Olga; Clouzot makes the film *The Picasso Mystery*	*Women of Algiers* (after Delacroix); *Nude in the Garden*
1956	Signs the protest against Soviet intervention in Hungary, along with seven communist intellectuals	
1957	Picasso receives his first public commission, for the UNESCO building in Paris	*Las Meninas* (after Velázquez; 58 pictures)
1958	Buys Château de Vauvenargues, at foot of Mont Sainte-Victoire	*Jacqueline Reading; Jacqueline in Profile facing right; The Fall of Icarus* (UNESCO)
1959	Inauguration of the chapel at Vallauris	*Jacqueline with a Black Handkerchief; Jacqueline with a Pink Hat*
1961	Marries Jacqueline at Vallauris and moves with her to Notre-Dame-de-Vie at Mougins	
1963	Opening of the Picasso Museum at Barcelona	Series *The Painter and his Model*
1964	Publication of Françoise Gilot's book: *Living with Picasso*	
1966	Retrospective in Paris, *Homage to Picasso*, with 700 works exhibited	*Musketeers*
1968	Death of Sabartès; offers the series *Las Meninas* to the Picasso Museum at Barcelona	347 erotic engravings
1973	Dies at Notre-Dame-de-Vie at Mougins on 8 April; buried at Vauvenargues on 10 April	

Artistic Life	History
xposition Universelle; Dufy: *The Fairy Electricity*; 'degenerate art' ersecuted in Germany; Malraux: *L'Espoir*; Renoir: *La Grande Illusion*	Fall of Blum's cabinet; Germans bomb Almeria in Spain; Independence for Eire; Rhesus Factor discovered
nternational Surrealist Exhibition; Sartre: *La Nausée*; Artaud: *The Theatre nd its Double*; deaths of Kirchner, Dufresne and Husserl	Munich Agreement; Germany annexes Austria and Sudetenland; Biro pen in production; Hahn: nuclear fission with uranium
hagall: Carnegie Prize; Steinbeck: *The Grapes of Wrath*; Renoir: *La Règle u Jeu*; deaths of Pitoëff, Freud and Ambroise Vollard	German-Soviet pact; Hitler occupies Czechoslovakia and Poland; Britain and France declare war on Germany
atisse: *Woman Sitting in an Armchair*; Hemingway: *For Whom the Bell olls*; Chaplin: *The Dictator*; deaths of Klee and Fitzgerald	Franco-German Armistice; Pétain, French Head of State; De Gaulle's 18 June appeal; Trotsky assassinated in Mexico; Roosevelt re-elected
Vells: *Citizen Cane*; Messiaen: *Quartet for the End of Time*; deaths of elaunay and Joyce	Anti-Semitic exhibition in Germany; Germany attacks the USSR; Pearl Harbor; USA enters the war
autrier: *The Hostages*; Pollock's 1st exhibition in New York; Sartre: *L'Etre le néant*; St Exupéry: *Le Petit Prince*; death of Soutine	Uprising in the Warsaw ghetto; German defeats in Warsaw; Stalingrad; Allies land in Sicily and Corsica
ubuffet/Vasarely exhibition; Sartre: *In Camera*; deaths of St Exupéry while flying), M. Jacob, Kandinsky, Maillol, Munch and Mondrian	Allies land in North Africa, Italy and Normandy; Germans in the Ardennes; Liberation of Paris; Germans defeated in Russia
ossellini: *Rome, Open City*; deaths of Valéry, Bartok, Anton Webern; rasillach condemned for collaboration and executed	Germany concedes defeat; atomic bombs dropped on Hiroshima and Nagasaki, Japan capitulates; Yalta Conference; United Nations Charters
ollock: Action Painting; Léger and Chagall return from USA; Sartre: *xistentialism is a Humanism*; death of Gertrude Stein	Italian Republic created; UN succeeds League of Nations; Nuremberg Trials; experimental nuclear explosion on Bikini Island
ide; Nobel Prize; Camus: *The Plague*; Genet: *The Maids*; T. Williams: *Streetcar Named Desire*; death of Bonnard	*Exodus* sails for Palestine; USSR splits with the West; Indian independence
reation of Cobra; Rouault burns 135 paintings; Sartre: *Dirty Hands*; e Sica: *The Bicycle Thieves*; 1st jazz festival at Antibes	Berlin blockade; Communist take-over in Czechoslovakia; Gandhi assassinated; creation of the State of Israel
e Beauvoir: *The Second Sex*; Orwell: *1984*; Camus: *The Just*; Lévy- rauss: *The Structures of Relationship*; Armstrong at Salle Pleyel, Paris	People's Republic of China; first civil jet aircraft, the British *Comet*; NATO; creation of the Federal Republic of Germany
weden: Imaginists' Group founded; Gracq: *Digesting Literature*; Ionesco: *be Lesson*	War breaks out in Korea; Kalandra executed in Prague; anti-Communist witch-hunts in USA; Sino-Soviet pact
auriac: *Journal*; C. Parker: *Bird* triumphs in New York; Hantai: *Fourth oult*; Césaire: *Discourse on Colonialism*	Salazar dictator in Portugal; China seizes Tibet; Rosenberg executed in USA
anguy: *Imaginary Numbers*; Max Ernst excluded from France; deaths of erain, Lesage and Matisse; Brigitte Bardot's début	French defeat at Dien-Bien-Phu in Vietnam; Geneva Agreements; Nasser in power in Egypt; war breaks out in Algeria
ansour: *Rendings*; Rauschenberg: *The Bed*; Dax: *Impressions in Relief*; elze: *Oracle*; death of Tanguy	Bandoeng Conference; Morocco and Tunisia granted internal autonomy; first atomic submarine in United States
olinier: *The Countess Midralgar*; Review: *Le Surréalisme, même*; deaths f Pollock and Brecht	Moscow, 20th Party Congress, deStalinisation; riots in Poznan and East Berlin; insurrection in Budapest; nationalisation of the Suez Canal
reton and Legrand: *Magic Art*; Benayoun: *Anthology of Nonsense*; deaths f Dominguez and Von Stroheim	Independence for Malaysia and Ghana. Khrushchev sole leader in USSR; first Soviet sputnik
urrealists discover Laloy; Klapheck: *The Strict Mother*; Review: 14 July; abanel: *A l'animal noir*; Paz: *Eagle or Sun*	France: end of Fourth Republic, return of General de Gaulle; John XXIII elected Pope; creation of NASA
nternational Surrealist Exhibition in Paris: *Eros*; Breton: *Constellations*; an Genet: *The Blacks*; death of Péret; suicide of Duprey	Fidel Castro: revolution in Cuba; riots in Belgian Congo; De Gaulle president of Fifth Republic
esnais and Robbe-Grillet: *Last Year in Marienbad*; Foucault: *A History of adness in Classical Times*; Antonioni: *Night*	The generals' putsch fails in Algiers; OAS attacks in France; Russo-Albanian conflict; Gagarin in space; Berlin Wall.
ax: *At the Molluscs' Festival*; The Beatles triumph; Sartre turns down the obel Prize; deaths of Tzara and Braque	Revolution in Iraq and Syria; John F. Kennedy assassinated in USA; Profumo Affair in UK; first Kodak Instamatic camera
amacho: *The Breaking of the Egg*; Silbermann: *Cunning Signs*; French dition of Trotsky's *Literature and Revolution*	USSR: fall of Khrushchev; incidents in the Gulf of Tonkin, beginnings of the Vietnam War
umerous 'happenings' in USA; P. Vargas Llosa: *The Green House*; oucault: *Words and Things*; death of Giacometti	Cultural Revolution in China; first bombings of Hanoi by USA; catastrophic flooding in Florence
xhibition: *Art and the Machine* at Museum of Modern Art, New ork; M. Yourcenar: *Work in Black*; death of Marcel Duchamp	May uprising in Paris; Prague Spring crushed by Russian tanks; R. Kennedy and M. Luther King assassinated
artre presents to the press *Libération*, a journal produced by himself; nesco: *The Solitary*; Mitchell: *Psychoanalysis and Feminism*	Pinochet's *coup d'état* against Allende, Chile; Skylab, Soyuz missions; France: union of the Left makes progress in legislative elections

Selected Bibliography

La Jeune peinture française, André Salmon, Paris, Société des Trente, Albert Messein 1912

Les Peintres cubistes: Méditations esthétiques, Guillaume Apollinaire, Paris, Edition originale 1913 Hermann 1980

Picasso et la tradition française; Notes sur la peinture actuelle, Wilhelm Uhde, Paris, Editions des Quatre chemins 1928

Picasso et ses amis, Fernande Olivier. Paris, Stock 1933

Proudhon, Marx, Picasso: trois études sur la sociologie de l'art, Max Raphaël. Paris, Excelsior 1933

Picasso, el artista y la obra de nuestro tiempo, Jon Merli. Buenos Aires 1942

Picasso, portrait et souvenirs, Jaime Sabartès, Paris, Louis Carré & Maximilien Vox 1946

Tutta la vita di un pittore, Gino Severini. Rome, Paris, Milan, Garzanti 1946

Picasso: Fifty Years of His Art, Alfred Barr, New York Museum of Modern Art 1951

Correspondance de Max Jacob I: Quimper-Paris, François Garnier. Paris, Editions de Paris 1953

Picasso: Peintures, Maurice Jardot. Paris, Musée des Arts Décoratifs 1955

Picasso, oeuvres des musées de Leningrad et de Moscou, D.-H. Kahnweiler & H. Parmelin, Paris 1955

Portrait of Picasso, Roland Penrose. New York, Museum of Modern Art 1957

Pablo Picasso, Antonina Vallentin. Paris, Michel 1957; London, Cassell 1963

Picasso, Maurice Raynal. Geneva, Skira 1953

Mes Galeries et mes peintres, Entretiens avec Francis Crémieux, Daniel-Henry Kahnweiler. Paris, Gallimard 1961

Conversations avec Picasso, Brassaï. Paris, Gallimard 1964

Vivre avec Picasso, Françoise Gilot. Paris, Calmann-Lévy 1965

Picasso, 1900-1906, catalogue raisonné de l'oeuvre peint Pierre Daix. Neuchâtel, Ides & calendes 1966

Picasso dit . . . Hélène Parmelin Paris, Gonthier 1966

Success and Failure of Picasso, John Berger, London, 1965

Picasso, Métamorphoses et Unité, Jean Leymarie, Geneva, Skira 1971

Picasso in the collection of Modern Art, William Rubin, New York, Museum of Modern Art 1972

Picasso, naissance d'un génie, Juan-Eduardo Cirlot. Barcelona 1972

La Tête d'obsidienne, André Malraux. Paris, Gallimard 1974

Picasso, le rayon ininterrompu, Rafael Alberti. Paris, Editions Cercle d'Art 1974

Le Siècle de Picasso, Pierre Cabanne. Paris, Denoël 1975, 2 volumes

La Vie de peintre de Pablo Picasso, Pierre Daix, Paris, Le Seuil 1977

Picasso, Gertrude Stein. Paris, Floury 1938, 2n edn, Paris, Christian Bourgois 1978

Le Cubisme de Picasso, catalogue raisonné de l'oeuvre peint, 1907-1916, Pierre Daix & Joan Rosselet. Neuchâtel, Ides & Calendes 1979

Voyage en Picasso, Hélène Parmelin. Paris, Robert Laffont 1980

Tout l'oeuvre peint, Picasso, A. Moravia, P. Lecaldano, Pierre Daix. Les Classiques de l'Art Flammarion, vol. 2

Daniel-Henry Kahnweiler, Marchand, éditeur, écrivain, Paris. Musée National d'Art Moderne, Centre Georges-Pompidou 1984

Le Musée Picasso, Marie-Laure Besnard-Bernadac. Editions de la Réunion des Musées Nationaux 1985

Pablo Picasso, le génie du siècle, Ingo F. Walther, Bonn, Editions Benedikt Taschen 1986

Picasso créateur, Pierre Daix. Paris, Editions du Seuil 1987

Eléments pour une chronologie de l'histoire des Demoiselles d'Avignon, Cousins, Judith & Hélène Seckel. Paris, Editions de la Réunion des Musées Nationaux 1988

Picasso and Braque, Pioneering cubism, William Rubin. New York, Museum of Modern Art 1989

A Life of Picasso, Vol. I: 1881-1906, John Richardson. Cape 1991

A Gift from
The Friends of the
La Jolla Library

Helena Matheopoulos

THE GREAT
from Caruso to the Present
TENORS

The Vendome Press
New York

Designed by Marc Walter / Bela Vista

Copyright © 1999 The Vendome Press
Published in the U.S. in 1999 by
The Vendome Press
1370 Avenue of Americas
New York, N.Y. 10019

Distributed In the U.S. and Canada by
Rizzoli International Publications through
St. Martin's Press
175 Fifth Avenue
New York, N.Y. 10010

Library of Congress Cataloging-in-
Publication Data
Matheopoulos, Helena.
The great tenors: from Caruso to the
present / by Helena Matheopoulos.
p. cm.
Includes bibliographical references (p.).
ISBN 0-86565-203-1
1. Tenors (Singers) Biography. I. Title.
ML400. M362 1999
782.1'092'2–dc21
[B] 99-27958

Printed and bound in Italy

Contents

INTRODUCTION

Nothing in opera can compare with the visceral thrill of a great tenor in full throttle. Something about the physical quality and vibrations of the tenor sound and especially those high notes at the top of his register–the B-flat, B-natural/and high C/plus, very occasionally the D- flat (or C-sharp)–arouses audience reactions bordering on mass hysteria. These notes, labeled the tenor's "money notes" (or "bankers" in tenor-speak), are what the public pays its top dollar to hear and what, in the words of the late Kurt Herbert Adler, director of the San Francisco Opera, ensures that "a truly good tenor is the best box office." It's also what makes tenors, both past and present, very rich men–and deservedly so. (Cecilia Bartoli knew what she was talking about when she jokingly chided someone who reproached her for still driving around Rome in her battered old Fiat Topolino with the remark: "I'm a mezzo soprano, not a tenor!")

What makes tenor worship such a powerful phenomenon in operatic life is the *kind* of response a tenor arouses in his public: The adrenaline rush experienced through its participation in the tenor's tension before and exhilaration after he has hit his high notes without a hitch. For behind both the tenor's initial fear and subsequent exultation lies the very real danger that he might crack on them without warning–like an acrobat's safety net that suddenly snaps–and stand there, crushed and humiliated before his erstwhile adoring public. For however well a tenor may have sung the rest of the evening, no performance recovers from a cracked high note. This is what the audience will go home remembering. Small wonder, then, that even the great Caruso viewed every performance as a battle to be won ("I have win another victory," he would write to his wife in his inimitable English), or that Pavarotti should be so acutely aware of the fact that "the public who adores me before the concert may not love me after." For the *corrida* mentality is part and parcel of tenor worship.

Needless to say, this places an intolerable strain on the tenor, and more and more so the more famous he becomes. He has to be every bit as good as himself every time he opens his mouth. Combined with the actual physical strain of producing the tenor sound, which, as José Carreras points out, is not a natural sound–men speak in the baritone register–but needs to be *manufactured,* and other pressures on and off stage makes superhuman demands on his nervous system. It's therefore hardly surprising that tenors are a temperamental breed. They have to be if they are to survive and surmount the pressures out there in the jungle, in which rivals may be lurking to step into their shoes and steal the affections of their public, as well as the tensions in their own bodies of producing the tenor sound. The symptoms and behavior resulting from those tensions are known as "tenoritis," to which, depending on their nature, tenors are more or less likely to succumb. Tenoritis has given rise to a plethora of myths and anecdotes over the years. The main one, perpetrated by no less a man than Toscanini, would have it that tenors are stupid. "The vibrations of high notes being frequently in the tenor's brain make him stupid," was his dictum. This has been embellished to include all sorts of stories and variations designed to belittle and deride the tenor–often with the breed's own smiling connivance. "You know something?" I once heard Carreras say at a dinner party. "Once there was a tenor who was *so* stupid that even the other tenors noticed!" (In German, if one wants to say "stupid, stupider, stupidest," one says, "*dumm, dummer, tenor,*" i.e., "stupid, stupider, tenor!")

Yet amusing though the myth of the tenor's stupidity might be, it can, and should, be dispelled. For while there might well be *some* stupid tenors out there–somewhere in the wilderness–there are certainly no stupid *great* tenors. There never were. *All* great tenors are intelligent, even if not well-educated, musically or otherwise.

If they weren't, they couldn't begin to *understand*, let alone manage and master, the volatile instrument dwelling in their throat or cope with the superhuman demands it and the operatic profession place on them. (Again, the first to experience the strain of his vast fame and popularity was Caruso.) It goes without saying that they couldn't manage either their careers or their finances if, on top of that "something in the heart" pinpointed by Caruso as an essential ingredient for greatness as a singer, they didn't also possess something in the head. Primadonnas, who often don't, are usally the culprits behind many of the myths and jibes directed against tenors.

Small wonder, then, that the tenor—or some tenors at least—should need a guardian angel, or guard dog depending on whom one listens to, in the shape of that much-feared species: the tenor's wife, an integral part of the tenor legend. For, even though primadonnas behave far worse than tenors—after all there is no term such as "primo uomo" to echo the pejorative connotations of the term "primadonna"—on occasion their behavior pales when compared to that of the tenors' wives. There is a universally understood expression in Italian, "*la moglie del tenore*," that certainly evokes a harridan. But tenors' wives can range from infinitely supportive partners who not only mother the big children that tenors often are, but also contribute to their artistry by supplying an invaluable pair of knowledgeable ears, to those of the loud, interfering variety, intent on playing the roles of manager and press agent in one—and that on top of their self-appointed role as guard dog, sorry, angel. Ultimately it's up to the tenors themselves to regulate or occasionally use these attitudes to their advantage. Just as it's up to them to handle the stress and pressure arising from their profession.

As far as the tenor sound itself is concerned, officially it has a compass of about two octaves on either side of middle C, and depending on the "weight" of their voice, tenors are classified into several categories. The light lyric "*tenore leggiero*," possessing agility and extreme facility in the top register, whose principal territory lies in *bel canto*, some of the French repertoire, and the Duke of Mantua in *Rigoletto*; the full lyric or *tenore lirico*, ideal for parts such as Rodolfo in *La bohème*; the heavier lyric voices known as "*lirico spinto*" (from the Italian verb *spingere*, which means to push, because it indicates a heavy lyric voice pushing towards the dramatic), excelling in the heavier Verdi parts such as Riccardo in *Un ballo in maschera*, Alvaro in *La forza del destino*, and the title role in *Don Carlos;* the dramatic tenor, or *tenore robusto*, whose territory starts with Radames and encompasses Otello, Ernani, and most of the *verismo* repertoire; and the heldentenor, specializing in Wagnerian roles, as well as Bacchus in Richard Strauss's *Ariadne auf Naxos,* Huon in Weber's *Oberon*, and Aeneas in Berlioz's *Les Troyens*, but who can also cope with *Otello* and Canio in *I pagliacci*. Which brings us to an important point: while these subdivisions are good indicators of the weight and repertoire suitable for the various categories, these tend to overlap, and individual tenors can, and do, tackle different areas of the repertoire. Voices are unique to the artists they inhabit and generalizations can therefore serve as no more than indications rather than hard and fast rules.

The reign of the tenor as we know him began in 1837, on an historic evening at the Paris Opéra when, during a performance of Rossini's *Guillaume Tell*, the French tenor Jean Louis Duprez sang the first full-chested high C in operatic history. Until then, no high notes above A natural were ever sung with full voice, but *falsetto*, i.e., from the head rather than supported from the chest. The effect of Duprez's full-chested high C was electrifying. As Hector Berlioz, who was present, wrote in his memoirs, "silence reigned in the stupefied house. Amazement and admiration blended in an almost fearful mood." Yet Rossini himself was horrified! He likened the sound of the full-chested high C—the most expensive of the money notes—to "the squawk of a capon having its throat cut!" His own preference went to Duprez's rival, Adolphe Nourrit, who took the note in head voice.

But despite Rossini's horror, the full-chested high C was here to stay. It was, above all, *musically* necessary for the new, more dramatic and full-blooded operas being written at the time, first by the young Verdi and later by the mature Verdi and the composers of the veristic (i.e., realistic) school. These operas required a far more robust and virile sound at the top of the register than that demanded by the grace and decorum of the more sedate *bel canto* school. Soon it became *de rigueur* for all high notes to be sung with full chest. The ecstatic public reception of this new way of singing laid the foundation for the tenor worship that reached its apogee in the unique popularity of Enrico Caruso and has continued unabated to our own day. Caruso, like the Three Tenors in our day, reigned unchallenged by any Primadonna Assoluta. (The only diva whose cult equaled the intensity of tenor worship was Maria Callas.) But all this is a far cry from the tenor's modest beginnings back in the Middle

Ages and the Renaissance when he held, took, and kept the plainsong, or other melody used as "*canto fermo*" in sacred polyphonic composition. (The name "tenor" derives from the Latin verb *teneo*, "to hold.") From those humble beginnings he rose steadily in the late sixteenth and seventeenth century, which saw the birth of opera. But in early opera the role of the lover, which one immediately associates with the tenor, was entrusted to *castrati* (male sopranos or altos whose unbroken voice was artificially preserved by means of a surgical operation before puberty), who were all the rage until the late eighteenth century. Even when the role of the lover was entrusted to the tenor, as in Monteverdi's *Orfeo*, he was expected to display some of the virtues of a *castrato*, such as extreme vocal agility and flexibility, to accommodate the embellishments that were part of the style of composition at the time. Needless to say, he was still expected to follow the custom of singing all high notes falsetto. The first composer to establish the role of the tenor as we now know him and make him the hero of several of his operas was Mozart. Belmonte in *Die Entführung aus dem Serail*, Tamino in *Die Zauberflöte*, the title role in *Idomeneo* (and in some versions, also of his son Idamante), and, to a lesser extent, Ferrando in *Cosi fan tutte* and Don Ottavio in *Don Giovanni*, are the first "modern" tenor roles, written with the assumption that the high notes would be sung with full chest. Of course, Mozart wrote according to the voices available to him at the time, and this practice became even more widespread in the early nineteenth century.

The first close composer/tenor collaboration was that between Donizetti and Bellini and the tenor Giovanni Battista Rubini (1794-1854), so famous for the spectacular upper extension of this voice that Bellini wrote an F above high C for him in *I puritani* after hearing him hit that note in rehearsal by mistake! But of course this was done in a cultivated falsetto, as were all the notes above A natural. Rubini used to sing whole arias in a sort of cooing tone to ensure that his famous high notes formed part of an integrated whole. But Duprez's first full-chested high C and the audience's response to it changed this once and for all. (One can only heave a sigh of relief and say thank God!)

The first famous tenor to sing in the new style was Enrico Tamberlik (1820-1889), the first "*tenore robusto*" whose clarion, full-chested top notes electrified London audiences. After singing the first full-chested high C to be heard in that city in Rossini's *Otello* in 1850, Tamberlik became the highest paid singer of his day–with a then

unprecedented fee of four hundred and eighty pounds sterling paid in advance–thus creating the right kind of precedent for his successors! Tamberlik was also London's first Manrico, in 1855, and later sang Alvaro in the world premiere of *La forza del destino* in St. Petersburg. Verdi would soon follow this with the ultimate opera for a *tenore robusto*: his own *Otello*, created by Francesco Tamagno (1850-1905), apparently the first real singing-actor in operatic history. ("An actor and singer heads above every other artist alive," wrote London's *The Graphic*.) His almost exact contemporary was the handsome Pole, Jean de Reszke (1850-1925), specializing mainly in the French repertoire and known as "le beau Jean" by London society, which idolized him. But all these early singers are known to us only through reports in famous people's memoirs or the newspapers of the day. We don't *know* what their voices sounded like.

This is where the twentieth century and the invention of the gramophone comes in. Fortunately for all of us–the composers, future singers, audiences of the day, and, most of all, posterity–this coincided with the advent of the greatest tenor in operatic history: the unique, inimitable, and hugely popular Enrico Caruso (1873-1921), the meteor whose passage set the standard by which all tenor performances, past and present, are measured. But, needless to say, had it not been for the gramophone, he, too, might have remained a distant link in the chain of operatic tradition and history. As it is, Caruso's career was the pivot through which his successors, down to the tenors of our own day, have been able to establish contact with the unbroken tradition of the Italian operatic heritage and school of singing. Every great tenor since then has been hailed as "Caruso's successor." This is both false and true. False because if there were a tenor to equal him in greatness, he would not be "the second Caruso" but "the first X," and true because every tenor since then can trace the inspiration behind his artistry to the tradition established by Caruso. (The singular exception is Tito Schipa, in many ways an "anti-Caruso," whose style of singing looked back to the eighteenth century tradition rather than to the new style emerging in his day.)

Apart from the tenors portrayed in this book, there were several other noteworthy artists who emerged in Caruso's wake. The first was Giovanni Martinelli (1895-1969), a *tenore robusto* who made his debut at La Scala as Ernani, sang the European premiere of *La fanciulla del West*, was a great interpreter of Otello and Eleazar in *La Juive*, and ventured into the heldentenor territory by

The Three Tenors.
Placido Domingo,
José Carreras and
Luciano Pavarotti.

singing Tristan to Flagstad's Isolde in 1939 at the Chicago Civic Opera; Aureliano Pertile (1855-1952), Toscanini's favorite tenor at La Scala between 1931 and 1937, born in the same year and village as Martinelli (as interesting an astrological coincidence as that which would have Gigli and Melchior born on the same day of the same year, March 20, 1890, and later Corelli and Di Stefano both born in 1921!), the creator of both Boito's and Mascagni's *Nerone* and Wolf Ferrari's *Sly*. Pertile was a highly effective actor who used a voice that was not inherently beautiful so intelligently and skillfully that, as they both testify, he served as an example for both Bergonzi and Pavarotti. Then there was the famous high-note tenor Giacomo Lauri Volpi (1892-1966), a lyric-dramatic tenor as famous for his *legato* line as for his top.

Most of the tenors of the first half of the twentieth century and their successors of the immediate post-war era soon cottoned on to the fact that, apart from the huge fees they came to command in the opera, there was also a great fortune to be made beyond, not just in recordings, but in concerts featuring a mixed "crossover" program that included songs as well as operatic arias, in mass venues, and in motion pictures. But when in our own day Pavarotti and Domingo began branching out of the opera house and trying to reach out to a wider audience, all hell broke loose. "Sacrilege," cried the purists and self-appointed guardians of our operatic and musical heritage. Looking back, one wonders what the fuss was all about. Caruso did it. Gigli did it. The fastidious Tito

Schipa did it. Melchior did it. And, of course, Richard Tauber did it (and was criticized for it). Yet when Pavarotti went to Hollywood to film "*Yes, Giorgio,*" purists reacted as if the sacred operatic world were harboring a fifth columnist in its midst. Whether he, and Domingo after him, does it to create new audiences for opera or for sheer gain or a combination of both, they, as well as their predecessors and successors, deserve every penny.

For, as I have had occasion to ascertain through my work around and with operatic singers for nearly twenty years, no artists in any other field of the arts work harder, have to endure so much physical, mental, and nervous wear and tear, plus insecurity–for who knows how long their voice will last–as singers do. And of all singers, no one carries a bigger share of this angst than the tenor, who knows he runs the highest risks of all, and on whom the success or failure of the performance often hinges. The public sense, appreciate, and love him for this as much as for the thrill of his high notes. And they know best. As Verdi always said, "the ultimate judge is the public." Occasionally, even primadonnas give in and join the public in a little tenor worship. As Gwyneth Jones once told me, (Helena Matheopoulos, *Diva: Great Sopranos and Mezzos Discuss Their Art*, Gollansz, London 1991, Northeastern University Press, 1993): "There is only one thing more exciting than singing high Cs and that is singing them with a gorgeous tenor! You can't *believe* the sensation when soaring up there in the stratosphere with a tenor like Placido Domingo."

Enrico CARUSO

"Who sent you to me, God?" cried Giacomo Puccini to the young Enrico Caruso, who, freshly arrived at the great composer's country villa at Torre del Lago to seek his approval for his forthcoming engagement in *La bohème* at Livorno, had just sung a few bars of Rodolfo's aria.

Puccini's remark is part of the Caruso legend, the greatest and most enduring in the history of opera. For no other tenor, or any singer for that matter–not even Maria Callas–has ever so captured the public imagination. In fact, the scale and intensity of

Caruso's fame was as much a mystery in his own day as it is in ours. What was it about the Great Caruso that made him a household name to every taxi driver, cop, and man on the street in New York City, where he was even more famous than the mayor? What was his hold on the city's collective psyche that caused a vast crowd to gather outside his hotel the moment Armistice was declared and refuse to budge until the great man had sung *The Star Spangled Banner* and the British, French, and Italian anthems from his ninth-floor balcony? That he happened to have the most beautiful tenor voice the world has ever heard was only part of the story, for many of these people never had, nor ever intended to, set foot in an opera house. The answer, perhaps, lies in Caruso's own summary of what it takes to be a great singer: "A big chest, a big mouth, ninety percent memory, ten percent intelligence, and something in the heart."

In Caruso's case, this "something in the heart" was simply larger than life; his humanity, generosity, and bonhomie seemed to embrace everyone he came into contact with and, coupled with charm and spontaneous wit, captivated one and all even though, in his own inimitable English, he admitted to being "offly ogly."

Caruso was also the first operatic multimillionaire. Much has been written about his wealth in a period when great divas were covered in jewelry, traveled in private trains, and had–like Melba and Tetrazzini–dishes named after them by César Ritz. Caruso earned the highest fees of his time at the pinnacle of his career in America, a period that coincided

Opposite: "The Great Caruso" as he appeared early in his career, at the Teatro Mercadante in Naples, as the Duke of Mantua in *Rigoletto*. About the same time he is seen *above* as Nadir in Bizet's *Les pêcheurs de perles*. Both operas, particularly *Rigoletto*, are filled with magnificent arias, and it was as the Duke that Caruso later made his most important debuts.
Left: Caruso seen later in life as a dapper superstar in a self-portrait sketch. His drawings were published weekly in New York's Italian newspaper, "*La Follia.*"

9

Enrico Caruso was one of the first artists to record on a regular basis and made a fortune, both for himself and the recording companies for whom he worked; first the Gramophone and Typewriter Company, later His Master's Voice and Victor (to become RCA Victor.) In his lifetime he earned $1,825,000 in royalties. Although filled with static and sounds of breathing, his records still evoke excitement in anybody interested in the art of singing. He enjoyed listening to himself nearly as much as did his admirers.

with the advent of the gramophone. He practically inaugurated the device and became a prolific recording artist, making as much as ten thousand dollars a month from royalties (and when figures for his fees are mentioned, they must be multiplied at least twenty-five times to reflect today's purchasing power) and leaving a priceless legacy of records ranging from *bel canto* to *verismo* and dating from 1902-1920. This legacy has helped keep his legend alive.

But before the fame, adulation, and wealth there was The Voice. Nearly eighty years after his death it remains unique. No tenor–and tenors are not known for their modesty–has ever claimed to be his equal. The voice was so extraordinarily and naturally beautiful that it left both the public and his colleagues aghast. "I can still hear that velvet

voice in my ears and the *impertinenza* with which he lavishly poured forth those rich, round notes," wrote Luisa Tettrazini in her memoirs, remembering the occasion when she first sang with Caruso in St. Petersburg in 1898. Geraldine Farrar, Toscanini's favorite American soprano, recalls being initially "taken aback by this apparition in screaming checks." But when this loudly dressed extrovert opened his mouth, "I was so overcome I missed all my cues!"

Describing a voice effectively is never easy, particularly when the voice in question had every quality imaginable: virility first and foremost, plus a velvet texture with a certain "pulp," nobility of phrasing, incisive declamation, passion, and vigor in the dramatic climaxes. Although it was dark with an almost baritonal hue, it was richly colored and sensitively shaded throughout the register, especially in the *mezza voce*, to which Caruso brought a uniquely sensuous, caressing quality. All this made it possible for him to tackle and excel in over sixty-five roles ranging from the lyric to the dramatic. Except for Wagner–after an attempt at Lohengrin early in his career, he never touched Wagner again.

Books have been written about the so-called Caruso method of singing. He always said, "How can I explain what I do? I hold my

10

Caruso made New York City his true home shortly after his debut at the Metropolitan Opera in 1903. His huge fees allowed him to live in the greatest of luxury, to support a large family in several large houses in Italy, and to indulge in every comfort, including a large wardrobe. Here he is seen walking in a top hat, with friends, on New York's Fifth Avenue during the Easter Parade, whose main purpose

was to flaunt one's elegance. During most of his New York career (1903-1920) Arturo Toscanini, *below* in a Caruso cariacature, was musical director at the Metropolitan Opera, a position he held simultaneously at La Scala in Milan. Toscanini conducted the premieres of many operas by Puccini, Mascagni, and even Verdi in both houses.

chest up–so. And my stomach in–so. And my sit-down in–so. And then I sing!" According to his wife, he listened patiently and politely while others explained the Caruso method to him. He simply said that when singing, he never thought of his throat or the position of his tongue and he considered words to be the most important element. "I think to the words of my aria, not to the music, because first is written the libretto and it is the reason of the composer to put the melody, like foundation for a house.... When people think I sing freely and think I take the life easy on the stage, they mistake. At such time I am working at the top of my strength. But I must not show that I work when I sing–that is the art."

But the cords themselves were reportedly no different from those of other singers. According to many, the secret of Caruso's incomparable voice may have lain in the cavities in his face, which were extraordinary: the depth, height, and roof of his mouth, the broad cheekbones and flat, even teeth, the wide forehead above wide-set eyes–this spacious architecture gave him a deep resonance of tone. He could put a whole egg in his mouth, close his lips, and no one could guess that an egg was there. His chest was also enormous, and could be expanded by nine inches. "Does he ever breathe?" people wondered when he would use his phenomenal control to sing a phrase, unbroken by a breath, on and on to its final supreme note.

Caruso had to work extremely hard to achieve all this. In the beginning he was what is called a "short tenor," in that he had no high notes. And when he was going through the painstaking process of acquiring them, they often cracked, sometimes in performance. But when he became technically secure around 1901-1902, his high notes became steady and brilliant, and his mastery of his voice so complete that there was nothing he couldn't do. His was a unique instrument, and a very sexy one. The erotic appeal of Caruso's timbre, very much evident in his recordings, used to so set the public aflame that their endless ovations sometimes became too much, even for him, and he devised all sorts of methods and tricks to dismiss audiences without seeming ungrateful. At Covent Garden in 1914, he took his final curtain call,

Caruso sang in many roles during his 607 performances at the Metropolitan Opera. *Right*: In *La Bohème* as Rodolfo, with Geraldine Farrar. *Below*: As Riccardo in Verdi's *Un ballo in maschera* in 1905. *Opposite left*: In Meyerbeer's *Le prophète*. *Above right*: Don José in a performance of Bizet's *Carmen* in 1906, in which Olive Fremstad was Carmen and Antonio Scotti, Escamillo. *Below right*: Jack in the Met premiere of Puccini's *La fanciulla del West*, conducted by Toscanini. As can be seen, he created a distinct personality for each role and gradually became an accomplished actor.

wig in hand; in Blackpool, after endless applause, he appeared in his overcoat, carrying his hat and walking stick and smoking a cigar. But the funniest curtain call of all was in Havana, where he had to resort to making a speech in Spanish, which he conveyed in "translation" to his American wife Dorothy, in a letter he sent from there: "Excuse me, I feel so hungry, and your applause which is so kindly you are giving me doesn't fool up my stomach, for consequence I beg you to go to bed!"

All this is a long way from Caruso's humble beginnings in the magical, bustling, and extremely poor southern city of Naples. Born on January 25, 1873, Enrico (Errico in the local dialect) was the third of seven children born to Marcellino and Anna Caruso. The Caruso legend would have it that the family was destitute, which was not true. As Caruso himself explained, "My parents were not uncomfortably poor." His father was a mechanic in a large company, where he rose to the rank of superintendent and, despite his fondness for wine, was a good provider. He would have liked his son to follow in his footsteps, but his mother Anna, whom he adored, encouraged the boy to become a singer. The first person to discover Caruso's voice was the organist at the church next door, who per-

suaded his father to enroll him at a school specializing in training boys for oratorio and choir. Within a year, Enrico had developed a true passion for singing.

His father was convinced that his son was sure to starve as a singer and insisted that he also apprentice as a mechanic. It was in the factory that Caruso first discovered his second talent–a remarkable gift for drawing– which was to give him immense pleasure throughout his life. He was to become a famous caricaturist, whose sketches and cartoons were published weekly in New York's Italian-language newspaper *La Follia.*

The train of events that would result in the Great Caruso began in the rotunda of Naples' Café Risorgimento. A wealthy young baritone, Eduardo Missiano, was impressed enough by the young man's voice to suggest taking him to his singing teacher, Gugliemo Vergine, whose initial and now historic verdict was that Caruso's voice was "too small and sounded like the wind whistling through the windows." But Missiano had blind faith in

Caruso's potential from the beginning and insisted that Vergine listen to him again in a week's time and accept him as a pupil.

Caruso made his professional debut in 1894 in *L'amico Francesco,* by Domenico Morelli, and for the next six years sang at increasingly important Italian provincial theaters. In one of these, Livorno, he met the soprano Ada Giachetti, who was to become his common-law wife and the mother of his two sons. She was the greatest love in Caruso's very active romantic life, and her elopement with their chauffeur in 1902 was to prove the greatest trauma of his life–and the making of him as an artist. "I suffer so much in this life. This is what they feeling when I sing. That's why they cry. People who felt nothing in this life cannot sing. Once I had a great suffering, and from it came a new voice. It was in London this thing happen to me. With that suffering that night I must sing *Pagliacci.* Already I had been singing for many years, but that night was different. I became more than a good singer that night."

In 1900 Caruso made his debut at Milan's La Scala, where Giulio Gatti Casazza (later to become general manager of the Metropolitan Opera) and Arturo Toscanini reigned supreme. Caruso's performance as Alfredo was a flop, but within a few weeks he triumphed in Donizetti's *L'elisir d'amore,* an opera that had not been seen in the audience's living memory. It was then felt that a light-hearted *bel canto* work was beneath them. As a show of disapproval, the opening night crowd refused to laugh or clap and, by the intermission, it looked as though La Scala was heading for another disaster. Early in Act II came the lovely Nemorino-Adina duet, started by the soprano, to whom the public still failed to respond. Then as Gatti Casazza, notoriously unimpressed with and cool to opera stars, recalls in his memoirs, came Caruso. "Who that heard him would not remember? Calm and conscious that at this point the fate of the performance will be decided, he delivered the reply, '*Chiedi, al rio perché gemente*' with a voice, a feeling, and an art that no word could ever adequately

Above: Caruso as Radames in Verdi's *Aida*, which he first sang on November 30, 1903 and repeated in 91 performances. *Below*: As Samson in *Samson et Dalila*, which he first sang in 1915. *Above right*: A portrait of Caruso, with two legendary, contemporary singers: at his left the Italian baritone Titta Ruffo, at his right the Russian bass Fyodor Chaliapin. One could say that today's opera-goer must sometimes settle for less!

describe. He melted the cuirass of ice with which the public had invested itself, little by little, capturing his audience, subjugating it, conquering it, leading it captive. Caruso had not yet finished the cadenza when an explosion, a tempest of cheers, of applause, and of enthusiasm on the part of the entire public saluted the youthful conqueror."

In 1902 he made his debut at Covent Garden as the Duke of Mantua and was immediately taken up by the London public for his voice, artistry, charm, and affability–not to speak of his pranks. When Dame Nellie Melba was singing Mimi there, Caruso placed a hot sausage in the muff she used to warm her cold hands in the last-act death scene.

But that year was marked by a far more important event; Caruso's first recording. He was singing at La Scala in Franchetti's new veristic opera *Germania*, a work destined for

oblivion. But the great tenor's performance was apparently spellbinding and aroused an ecstatic response from the audience, which, by chance, included Fred Gaisberg, the American representative of the London-based Gramophone and Typewriter Company. He had been sent to persuade some famous artists to launch the new machine by lending it the credibility of their names. Gaisberg was totally enraptured by Caruso and his effect on the public and looked no further.

The new divo agreed to give it a try and asked for a fee of one hundred pounds. Gaisberg agreed and set up a makeshift recording studio in his suite at the Grand Hotel in Milan. London headquarters cabled that the fee was exorbitant, but Gaisberg was too much of a gentleman to go back on his word, and the session went ahead. Caruso recorded ten arias in two hours and sauntered out, happy as a lark, with one hundred pounds in his pocket, while Gaisberg wondered how anyone could earn so much money for so little work. In fact, he had just earned his company fifteen thousand pounds and had made himself a name in operatic history. As he was later to scribble on a photograph of Caruso, "his records made the gramophone." By the end of his career, records had earned Caruso the colossal sum of $1,825,000 in royalties, and the stream of income continued for many years after his death.

Records gave Caruso the opportunity to experience his own voice, which he could never actually hear while singing. He simply felt certain sensations when the notes came out well, but by listening to his own records he could finally experience what others heard. "That is good, it is a beautiful voice," he would exclaim in astonishment. But then he always added, a little sadly, "with a beautiful voice, it's not hard to reach the top. But to stay there, that's hard."

With his Metropolitan Opera debut Caruso reached the crest of the wave and was able to coast from then on. The historic date was November 23, 1903, and the role was the Duke in *Rigoletto*, to rapturous critical acclaim. He conquered New York in a way he

The great Caruso in full dress kilt as Edgardo in Donizetti's *Lucia di Lammermoor*, one of his best *bel canto* roles. The costumes of a great artist of the time were often far more extravagant than those today, as they were made especially for him and were taken around the world on tour. *Below*: As Eléazar in Halévy's *La Juive*, which he sang at the Met on December 24, 1920, with Rosa Ponselle as Rachel. This marked his last appearance, for which he prepared with astonishing care, even attending Friday night services in New York's synagogues in order to study the cantor's vocal style.

had no other city, and made the Metropolitan Opera his own theater. Between 1903 and Christmas Eve 1920, when he sang his last performance at the Met, Caruso had racked up 607 performances. After the end of the New York winter season, Caruso would return to Europe for a royal tour through Paris, London, Vienna, Monte Carlo, and Berlin, where he was invariably invited to dine with the Kaiser.

By this time Caruso was becoming a very rich man. He commanded fees of twenty-five hundred dollars at the Met (as a special favor to Gatti Cassazza), seven thousand dollars in Mexico City and ten thousand dollars in Havana. His lifestyle became that of a very rich man. He loved spending money and loved giving it away. He even once gave his fur-lined coat to a shivering beggar outside his hotel. When he died, it was discovered

Caruso and his wife Dorothy seen leaving New York for the last time, in the spring of 1921, by ocean liner for his native Naples. He sang there early in his career, felt he was unfairly treated by critics, and never returned. One can see the strain on his face, the result of several attacks of pleurisy which had left him in a coma for several days. He felt that, by returning to the warmth of Italy and his family, he would be able to recuperate. But this was not to be. The following August he died. But he died at home, which was, and always had been, Italy. He described America, as "just my place of work."

that he was supporting 120 people; his extended family alone cost him eighty thousand dollars a month. He received appeals for money on a daily basis and always sent a check in response. No one was ever refused. When his wife remarked that "surely all these people can't be deserving," he replied, "You are right, Doro, but can you tell me which is and which is not?" But he always managed his money well, and certainly enjoyed spending it. He lived in a fourteen-room apartment at the Knickerbocker Hotel on the corner of West 42nd Street and Broadway–then convenient to the Met. Interestingly, he never bought a home in New York, even though he spent at least half the year there from 1904 to 1920; America was his place of work, Italy was his home, and he bought two estates there. He had a valet, chauffeur, secretary, butler, and a large fleet of cars. He also had an enormous wardrobe, and when asked why he had so many clothes he responded, "Two reasons.

First reason, I like. Second reason, other people like. Also, I give to people who ask." And then there was a special case containing all his voice medicines, atomizers, inhalers, sprays, and whatever else was needed to keep his unique instrument in top order.

Despite the trappings of wealth and fame, his life resembled the imposed privacy of a recluse in its privations and austerity. This life began to depress him despite his second, apparently happy marriage in 1918 to Dorothy Park Benjamin, known as Doro, twenty-three years his junior, and the birth of his daughter Gloria in 1919. According to Doro, this was "the only thing I could give him that he hadn't had and couldn't buy."

He had married Dorothy after three months' acquaintance, and they eloped to escape her disapproving father. Caruso was forty-five when he married Dorothy and, for the first time in his life, felt really ready to settle down. "I want a woman who is truly mine," he told his German tour manager. Happily settled with a wife and a baby daughter he adored, Caruso began to find his life as a singer wearing. The constant travel, separation from his family, struggle to surpass himself all the time, the fact that every time he tried to go for a stroll people would come up and talk to him, in fact the sheer strain of being Caruso began to oppress him. "I think I don't work anymore, we have enough to leave and to pay the tax. We will go in my, our, country and we will have a good time without be nervous every moment. I am looking for this day! You can imagine how glad I will be when I have not to think about my voice! Hope God let me arrive at such a day and then my happiness will be comblet," he wrote to Dorothy. And, as he had done earlier with Ada, he wrote every single day, and sometimes twice a day, whenever they were apart. During his last tour of the U.S. and Mexico in 1920, he wrote from his hotel in Houston: "I think I am a little tired of everything, and I need to live a little outside the world, to let me forget and let people to forget me." Needless to say after a really good performance his spirits rose considerably.

After his long autumn tour in 1920, he returned to New York to prepare for Eléazar in *La Juive*, one of his most haunting portrayals. "I try really to impersonate the character, but the reality is suggested in proportion to the degree of feeling that is in the artist's heart," he told his biographer. This was a new development in his art. Early on, he was wont to stand up and sing, although he never used the gesture of opening the arms wide while singing and used to refer to those who did as "the swimmers."

The reviews of opening night of *La Juive* were raves. A critic from the *New York Times* wrote that "Mr. Caruso is a tragic actor and discloses resources of tragic power that he has never before disclosed in the same potency." Perhaps Caruso realized the end was near. His last performance came on Christmas Eve, and only his indomitable spirit had enabled him to carry on. On December 3, a pillar had hit his back during a performance of *Samson et Dalila*, and this perhaps precipitated an attack of pleurisy that left him exhausted and in tears after his last performance. Over the next three months he had no fewer than six operations, some without anesthetic, to puncture the abscesses. He fell into a coma.

The whole city was stunned. The *New York Times* ran daily health bulletins, which were also posted in his hotel lobby for the press and constant stream of callers. These ranged from the Italian ambassador, who came in the name of the king of Italy, to six Italian laborers digging on 34th Street. As his son proudly asserted, "no man was ever surrounded by more love in his hour of need–love from his family, his friends, and his faithful public." On February 16, when Caruso felt he was close to death, he asked to see some of his Metropolitan Opera colleagues, to say good-bye. As Beniamino Gigli recalls, "we stood around his bed, trying desperately to be cheerful, but most of his old friends–Lucrezia Bori, Rosa Ponselle, Scotti, De Luca, Didur, Rothier, Pasquale Amato–were unable to restrain their tears. I, of course, had known him very little. But after each of our meetings, even this last one when he lay struggling with pain, I came away feeling enriched by the generous warmth of his overflowing personality. Everything was exceptional in him, not only his voice."

As it was, as soon as he began to recover he made plans for the whole family to return to Naples where, he was convinced, the joy of being at home in that magically beautiful city would restore his strength. He moved to a hotel in Sorrento, above the sea, and for a while he did seem to get better. But an undetected abscess developed into septicemia and, on August 2, 1921, he died.

The entire world was numb with pain. Italy went into national mourning, with shops closed and flags flying at half-mast. The king gave permission for the funeral to be held in the Naples cathedral of San Francesco di Paola, hitherto open only for members of the royal family. The entire city lined the streets to bid farewell to its most illustrious son and then followed the cortege to the cemetery.

"Nice people, they don't forget me," Caruso had remarked when, after coming out of his coma, he was told of the people who had passed through his hotel to inquire after his health and wish him well. It's unlikely that the world will ever forget Enrico Caruso. As his fellow tenor Giovanni Martinelli remarked to an impertinent observer, "You can take Gigli, Pertile, Lauri Volpi, and me, roll us all into one and we would still be unfit to tie Caruso's shoelaces."

Above: One of the last photographs of Caruso, seen here on the terrace of his hotel in Sorrento, apparently in better health. Despite severe pleurisy, his voice remained intact and he could sing perfectly at full volume. Unfortunately, poor medical treatment and an excess of activity resulted in his death at an early age. Caruso was deeply missed by the hundreds of thousands of people all around the world who revered him, but his large legacy of recordings is a treasure still enjoyed today.
Below: Caruso's funeral at Naples' cathedral of San Francesco di Paola, hitherto reserved for members of the Italian royal family and made available to the Caruso family by the King of Italy. The entire city followed the cortege to the cemetery.

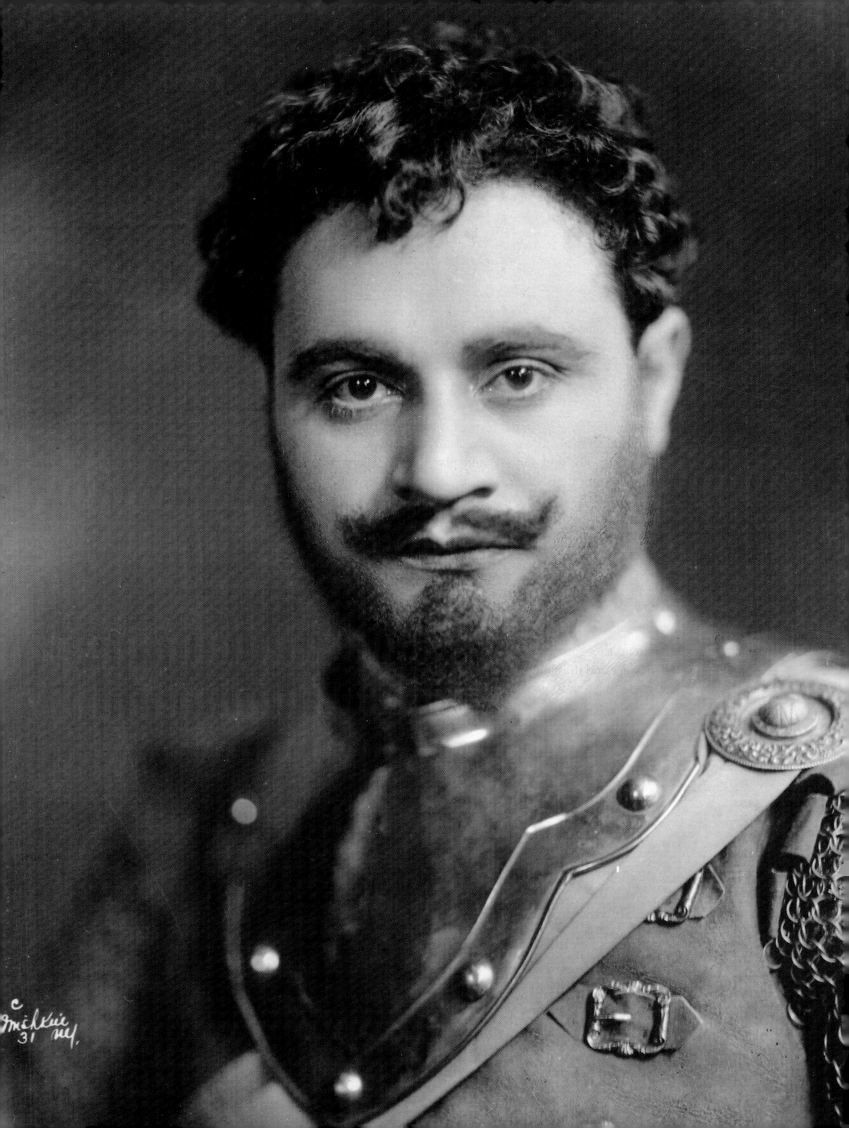

Beniamino GIGLI

"I did not have the gifts of personality that enabled Caruso to create life and warmth around him wherever he went," wrote Beniamino Gigli, chronologically Caruso's immediate successor, in his memoirs. His comment is characteristic of his self-knowledge, humility, and unfailing generosity towards his colleagues. "I was born with a voice and very little else: no money, no influence, no other talents…. I was good at singing, and nothing else. I enjoyed singing, and nothing else. I *had* to sing. What else could I do?"

This statement admirably sums up Gigli's essence as an artist: he was a superb singer. He was not a singing actor or a sophisticated musician or a fastidious stylist. But as a singer pure and simple he ranks among the greatest in operatic history, with an irresistibly beautiful, soft-grained, pliant voice and the ability to pour forward torrents of honeyed, liquid, emotionally packed sound.

Gigli preferred and excelled in the lyric roles. For a start, they showed off the gorgeous, sweet tone of his voice. But as he candidly admitted, it was not just that he sang them better, but also that they made the kind of demands on his vocal resources that nature had equipped him to meet: purity of line, evenness of tone, extensive use of his exquisite *mezza voce*. It was, he feels, due to the care with which he chose his repertoire (he always refused to sing Otello, for example) that he was able to sing in public for forty-one years, until 1953. When he was in his mid-fifties he was asked by a much younger tenor why his voice was still fresh while the young singer's was already hardening. "I think that I have

always been careful to husband my vocal resources–maybe because I come from frugal peasant stock–while you have been a spendthrift, singing away your capital."

The only criticisms ever leveled at Gigli concerned his total indifference to scenic acting and his tendency to overpack the emotion and play to the gallery. Well aware of this accusation, he answered eloquently: "A singer has a very deep need for communion. As he sings, it's vital for him to feel he is evoking an immediate response, otherwise his performance remains a matter of technique. Some-

Beniamino Gigli, Caruso's successor as the leading tenor at the Metropolitan Opera, appears *opposite* as Vasco da Gama in Meyerbeer's *L'Africaine* in a 1922 production that included Rosa Ponselle as Selika. He is also seen in two productions at La Scala: *above* as Filipete, in Wolf-Ferrari's seldom-performed *I quattro rusteghi*, and *left*, as Turiddu in Mascagni's *Cavalleria* rusticana. He is with Maria Marcucci as Lola. Previously, Mascagni had invited Gigli to sing this role in Naples.

times, in the emotion of the moment, I made the mistake of being too eager to elicit this response. But the critics must understand that a singer cannot sing without applause." He went on to add that while critics fulfill a very necessary function, from a singer's point of view "they are of a secondary importance. He could certainly manage without them, but one cannot imagine a singer without an audience. They complement each other."

Gigli felt even more comfortable singing to his audiences when he had been paid before the concert, in cash. When asked to explain this eccentricity, Gigli replied that, after certain experiences in various countries, he liked to put his fee in the back pocket of his trousers so that he could pat it between arias and know it was still there.

The comfort of a pile of cash in his back pocket was especially reassuring to Gigli, who had endured immense privation, including hunger, on his way to becoming a singer. Born on March 20, 1890 (the same day as Lauritz Melchior), Gigli was the pampered youngest child of a cobbler whose business ended with the advent of mass production. Through the intervention of the local bishop,

Gigli's father became bellringer in the local cathedral, and the family went to live in free lodgings next door. Beniamino, who had been taught to sing by his mother, became a chorister in the cathedral at age seven. At the age of twelve he got a job as assistant to the local pharmacy. Anything to do with the voice thrilled him and his one dream was to become a singer.

Egged on by one Giovanni Zerri, a cook who had worked for the famous tenor Alessandro Bonci and claimed to know all the important singing teachers in Rome–a baseless claim, it would turn out–Gigli decided it was now or never. He shared a garret in Rome with his art-student brother, living in penury until he finally found a teacher, Agnese Bonucci, who was willing to teach him free of charge. Because "I wanted to sing but I needed to eat," Gigli took a job that offered lodging, clothes, and food: he became a footman in the service of Countess Spanocchi, a noblewoman from his province who loved music and allowed him two hours off every day for lessons and study. After he was called up in the army, the Countess sent him to an acquaintance, Colonel Delfino, commander of the territorial army, who spared him the drilling and routine of barracks life, and made him a telephone operator at his headquarters. Later he encouraged Gigli to audition and apply for a scholarship at Rome's most prestigious music school, the Accademia di Santa Cecilia.

In the academy's final examination in 1914 where he sang "*O Paradiso*" from *L'Africaine*, he won first place among all the school's tenors. As a result he was encouraged to enter an international competition in Parma in which thirty-two of the 105 contestants were tenors. But after singing one of Alfredo's arias from *La traviata* and then, again "*O Paradiso*," he was proclaimed "the revelation of the contest." At the bottom of his report, tenor Alessandro Bonci wrote, "At last, we have found *the* tenor." Right away he received an avalanche of invitations to Italian provincial theaters.

He made his professional debut at Rovigo,

Gigli's brilliant career at La Scala started in 1918, in a performance of Boito's *Mefistofele* conducted by Arturo Toscanini. He is seen at this theater *above*, in the title role of Gounod's *Romeo et Juliette* and *below* with Carlo Tagliabue. Unlike Caruso, whose French diction was perfect, Gigli's left a lot to be desired.

near Venice, in October 1914 as Enzo in *La Gioconda*, an ideal role because it's not too demanding and allows the tenor plenty of scope to show off his gifts. He scored a great success at Rovigo, and at Ferrara, where the performance had been transferred and attended by the conductor Tullio Serafin (later one of Callas's main mentors and collaborators) who invited him to sing Des Grieux in Massenet's *Manon* at Genoa's Teatro Carlo Felice, one of Italy's most important theaters. Gigli was cheered so loudly and so long at the premiere that he had to repeat Des Grieux's "Dream."

While still in Genoa, he received an invitation from the equally important Teatro Massimo in Palermo for *Tosca* in two-and-a-half months' time, February 1915. This led to an invitation to sing Faust in Boito's *Mefistofele* in Bologna, the composer's birthplace. Gigli considered this event–along with his debuts at Rovigo, La Scala under Toscanini, and the Metropolitan Opera in the wake of Caruso– one of the great challenges of his career. The Bolognese public had welcomed the work in 1875, seven years after it had flopped in Milan, and considered this opera their own.

His next assignment was even more exciting: an invitation from the celebrated composer Pietro Mascagni, with whom he became a lifelong friend, to repeat his success in *Mefistofele* and sing Turiddu in his own already famous opera, *Cavalleria rusticana*, at the Teatro San Carlo in Naples, that coming December. The Neapolitan public and critics were so enthusiastic that one of them wrote:

"We must all try to hear Gigli while we can. It will not be long before America claims him." After more dates in Naples and some northern Italian cities, Gigli finally made his debut at the Teatro Costanzi in Rome on December 26, 1916, as Faust in *Mefistofele*.

Three months later, he made his international debut as Enzo in *La Gioconda* and Faust in Madrid and Barcelona as part of a troupe assembled by Tullio Serafin. Back in Rome he continued his association with Mascagni and met two of Italy's foremost operatic composers, Puccini and Cilea, with whom he became close friends. Gigli had been bypassed for the lead in *La rondine* when the work had had its Italian premiere in Bologna because Puccini felt that his appearance

Following upon his success at La Scala, Gatti-Casazza hired Gigli for the Metropolian Opera. He is seen there, above, as *Don Ottavio* in a 1929 production of Mozart's *Don Giovanni* and *below*, as Des Grieux in *Manon Lescaut*, both parts ideally suited for his plangent lyric voice with its sweetness of tone and liquid sound. Gigli really enjoyed singing in Massenet's *Manon*. His favorite Manon was Lucrezia Bori, and he sang Massenet's opera 26 times at the Metropolitan Opera alone.

Below: Gigli appears in Puccini's *La rondine* in 1928 at the Metropolitan Opera with Lucrezia Bori as Magda, Edith Fleisher as Lisette and Armand Johatynn as Prunier.

wasn't suitable for his young romantic hero. But in Rome, after learning the role in four days, Gigli surprised Puccini at the rehearsals. "Bravo, bravo," shouted Puccini, seated in the stalls. "You'll make a splendid Ruggero!" "But what about my figure, Maestro?" asked Gigli in mock humility. "I think that, after all, people won't notice your figure."

Among the most important events of this exceptional year, 1918, was Gigli's first recording, which was made for the indefatigable Fred Gaisberg of HMV and the Victor Gramophone Company. Gigli was asked to visit him at his Milan office, where he heard a gramophone record for the first time in his life. "It was Caruso's voice, which I had never heard,

Gigli, who was close to Puccini, often sang Cavaradossi in the composer's *Tosca*. In a Metropolitan Opera performance in 1920, *above*, he was joined by Emmy Destinn as the heroine and Antonio Scotti as the villainous Scarpia. Cavaradossi was a role that revealed his inability to act convincingly: he covered up the defect by conveying feeling and characterization through his singing, sometimes to excess. As a result, he was accused of playing to the gallery.

in Ernesto's aria 'Com' e gentil' from *Don Pasquale*. I listened with humility and awe," recalls Gigli. He signed a contract with Gaisberg for ten records of famous arias from operas he had already sung. Neither of them could foresee that in the not-too-distant future HMV would need to employ six people at its London headquarters whose exclusive job would be to look after Gigli's recordings.

That same year a monumental event occurred that paved the way for Gigli's debut at La Scala: Arrigo Boito died on June 10. Toscanini wanted to open the autumn season at La Scala with a performance of *Mefistofele* dedicated to his memory for the opening of the 1918-1919 season. The occasion was unforgettable. Unbeknownst to him then, it would also have a far-reaching impact on Gigli's career. Toscanini's name had invested

the event with considerable international prestige and brought Gigli to the attention of Giulio Gatti Casazza, general manager of the Metropolitan Opera. Gigli was in Buenos Aires, as part of a South American tour of Brazil and Argentina in the summer of 1920, when he received a letter from Gatti Casazza inviting him to sing at the Metropolitan Opera in two-and-a-half months' time. He was also asked to come to New York to discuss things. Gigli sailed immediately for that city, which became his home for the next twelve years. He made his debut at the Met as Faust in *Mefistofele*, and, despite his considerable experience, felt "still untried and unproved," in the face of this formidable new audience, Caruso's audience. The *Sun* wrote, "Gigli comes very close to the young Caruso," while the headline of the *Pittsburgh Dispatch* read: "Tenor with Queer Name Ranks Next to Caruso." Next morning Caruso sent him a generous message of congratulations and Gatti Casazza extended his short-term contract by three months.

Barely a month later, on December 23, 1920, he had to replace Caruso twice at the last minute. Gigli's real Metropolitan Opera debut took place two-and-a-half months later, in a new production of *Andrea Chenier*, with Claudia Muzio, that had also been planned for Caruso–a name that, as he confides in his memoirs, "was beginning to haunt me." But this time he scored an even bigger triumph

Left: Gigli as the Duke of Mantua in Verdi's *Rigoletto* with Giuseppe de Luca as the unfortunate jester. This was one of the earliest operas to be broadcast from the Met. The artists, in costume, are seen concentrating on what was then the quite astonishing mechanical equipment that first brought grand opera to the American public at large. *Below*: Gigli with the great Russian bass Fyodor Chaliapin, *center*, and *right*, fellow tenor Richard Tauber, with whom he shared a warm friendship. The two had become firm friends during a simultaneous engagement in Vienna. There, they would dine in an Italian restaurant specializing in delicious risottos, and henceforth sent each other Christmas and pre-premiere telegrams of good wishes signed "Risotto."

than at the single performance of *Mefistofele* in Boito's memory. "I identified myself completely with the role. It ceased to be make-believe. I *felt* it passionately. In the third-act trial scene, each time I cried out the words '*Colla mia voce ho cantato la patria*,' I thought of Italy. Like Chenier, I, too, expressed in song the love I felt for my country."

By then Gigli had learned to compensate for his complete lack of acting ability: "I had begun my career trying, gropingly, to act. But it was a failure. I was criticized for being wooden, and no doubt I was. My acting had probably not progressed very far beyond the burnt-cork-mustache, Sunday afternoon entertainments my brother used to organize in our village parish church. Still, the problem was there, facing me. Gradually I evolved my own approach to it: feeling. That was the key word to my method, if it can be called a method. I tried to pour feeling into the role, however improbable the libretto, to make it come alive through feeling. Not every opera responded to this treatment, but roles like Andrea Chenier or Des Grieux required no effort whatsoever. This can scarcely be called acting. But it served my purpose. It enabled me to shed real tears on stage, to feel real passion, real despair."

Above: As Walter in Catalani's *Lorelei*. Perhaps Puccini was right about his unromantic appearance! *Right*: In a 1941 concert with the Berlin Philharmonic for the benefit of the German Red Cross. He appeared there with his daughter, Rina Lanelli, who often sang with him in his later years.

24

After the performance of *Chenier*, Gatti Casazza offered Gigli a one-year contract, which would be renewed every season, with an ever-increasing fee, for the next twelve years. Gigli became a much-loved figure in New York, despite the fact that he never learned how to speak English, and felt very comfortable both around the city, where he regularly visited Little Italy and sang for Italian charities, and the Met, where "once inside the doors, I could almost imagine myself in Italy. Even though fourteen nationalities were represented there, it was so full of compatriots that Italian seemed to be the official language."

During his twelve seasons at the Met–from 1920 to 1932–Gigli would spend the autumn and winter months in New York, then tour the country with the company in May. He divided the summers between lucrative engagements in South America and Europe, and a long vacation at home in Recanati, where, after his seventh year at the Metropolitan, his architect brother helped him build an immensely luxurious villa on top of a hill overlooking the Adriatic. He bought his mother a very comfortable home in the village, and his new house became his retreat when, after a forty-one-year career, he retired.

His association with the Met came to an abrupt end in 1932, when he refused to follow the other singers in the company, who had accepted a twenty-five percent cut in their fees to help the house cope with the severe effects of the Depression. It would be seven years, by which time Gatti Casazza would have retired, before Gigli returned to the Met. Meanwhile, he strengthened his links with such important European centers as Berlin and London (in 1924 and 1930, respectively), where he had a tremendous following. His appearances in *La bohème, Tosca, Rigoletto*, and a concert of operatic arias had been greeted by some of the greatest ovations in the history of the State Opera, while his Covent Garden debut in *Andrea Chenier*, followed by *Tosca, La traviata*, and *Marta*, had established him as a firm favorite in London, culminating in several concerts at the Albert Hall.

Yet his triumphant return to the Met on January 23, 1939, in *Aida* meant even more to him. Every seat was occupied and there was a full complement of standees, he recalls in his memoirs. "To face the Met audience once again, after all that had happened, was admittedly a nervous and emotional ordeal for me. I felt some tension as I embarked on 'Celeste Aida,' but I quickly regained confidence as the aria carried me forward and the wild ovation that greeted my final B-flat brought tears to my eyes. So the New Yorkers were faithful to me. It was a wonderful moment." He had endless curtain calls and rates this as one of the most joyful experiences of his life. "More Mature in Voice, the Great Tenor Gets Caruso-esque Reception," wrote *The Evening Post*. All his life Gigli abhorred comparisons with Caruso: "Let them know me as I am, let them know me as Gigli not as someone trying to step into Caruso's shoes," he'd thought in his early years at the Met. He achieved his wish, and became known as "The People's Singer."

Gigli in a discussion with the Metropolitan Opera stage manager in a rehearsal for Donizetti's *Lucia di Lammermoor*. As a singer *par excellence*, Gigli reveled in performing the *bel canto* repertoire, which hinges predominantly on vocal excellence and does not demand great acting skill. Therefore it did not reveal Gigli's near-total ineptitude as an actor. This is one of the reasons why "singer's singers," as opposed to "singing actors" usually prefer *bel canto*, which the latter find boring and dramatically unfulfilling. Yet it took Maria Callas to demonstrate what can be done by a great singing actress.

Fernand de Gueldre
- CHICAGO -

Tito SCHIPA

"I'm not a tenor! I'm a man who happens to sing with a tenor voice," said Tito Schipa half-jokingly. He was one of the century's greatest tenors, a supremely civilized stylist with an elegant delivery of both score and text. His rejection of the "tenor" label–due to its some-times pejorative use–is ironic, for Schipa not only enjoyed immense popularity throughout his five-decade career, but was also consid-ered a singer's singer. He has earned the admiration of his fellow tenors from Ben-iamino Gigli, who said of his contemporary, "when Tito Schipa sang, we all had to bow down to his greatness," to Carlo Bergonzi and Luciano Pavarotti, who have more recently acknowledged that they owe him an enor-mous artistic debt.

"Schipa did not have the high C or even a particularly beautiful voice," reflects Pava-rotti. "But he was a great singer. His musical-ity was so great that it enabled him to override every handicap. Listening to his records you can hear him guiding his voice along, like a skipper who steers his ship through all man-ner of treacherous waters in an exemplary way that should be a lesson to us all. He had something far more important than high notes: a great line." Even Schipa's diction–so clear you could take dictation when he sang–couldn't disturb the flow and evenness of his vocal line.

Schipa's talents also included the ability to produce soft, or *piano*, sound at the top of the register and to blend the chest and the head voices in the *passaggio* zone by a hidden, highly skillful recourse to the nasal cavities. This was the secret, later copied by Bergonzi,

of Schipa's magical singing in the *mezza voce*, which enabled both of them to observe the *piano* markings in any score. Bergonzi, who also studied the recordings of Caruso, Gigli, and Pertile, found illuminating the compari-son of natural and acquired qualities of these great singers: "It's obvious that Schipa's and Pertile's voices weren't as naturally beautiful as those of Caruso and Gigli." But through exemplary vocal and interpretational tech-niques they succeeded in raising their voices to that level, and, according to Carlo Bergonzi, in "making them heard as clearly in the

Opposite: Tito Schipa as Edgardo in Donizetti's *Lucia de Lammermoor* at the Chicago Opera, where he made his American debut in 1919 and continued singing until 1932. *Below*: As the Duke of Mantua in Verdi's *Rigoletto*. Despite his small size, Schipa was a good-looking and sexy man and a great Lothario, whom the Hollywood press, impressed by what his son calls his compulsive "Don-Giovannizing," labeled "the Rudolf Valentino of melodrama." Although Schipa sang in both Chicago and the Metropolitan Opera for over a decade, his home was in the Hollywood Hills, where he made several films and chose famous film stars–such as Mary Pickford and Douglas Fairbanks Sr.–as godparents to his children.

last row of the gallery as in the front rows of the stalls." When Schipa sang Alfredo in *La traviata* at the Rome Opera, for instance, the conductor Giuseppe Morelli was surprised that his was the voice that dominated the finale in Act II–and in a house as large as the Rome Opera. "This is what vocal technique is all about: to enable an artist to reach a level of excellence where it's impossible to guess which of his qualities were innate and which acquired."

Despite Pavarotti's opinion, Schipa's even, seamless voice *was* beautiful, with a generally light and romantic color. It had limited reserves of power and was ideally suited to the repertoire of a classic *tenore di grazia*. Yet even with this light-lyric classification, and a pleading and elegiac rather than commanding and sensual tone, he nevertheless delivered among the most powerful portrayals of Cavaradossi and Werther of this century. Though these roles hardly fall within *tenore di grazia* territory, Schipa brought to them his personal style and technique of delivery.

Schipa's vocal gift was discovered very early on. Born in Lecce in Apulia, Italy, in 1889, he was christened Raffaele Attilio Amedeo. He sang in the choir from the beginning of his schooldays. When he was only eight, his music teacher wrote a hymn for a service at their local church and entrusted the little boy with a solo, which earned him a notice in the local press and his first appearance on stage, at Lecce's Teatro Greco, where he sang the single line "*Vo la tromba il cavallin*" in Act II of *La bohème*. But it was a performance several years later that would change the direction of Schipa's life. He was chosen to sing a solo for a religious festival attended by the local bishop, Monsignor Gennaro Trama, an enlightened prelate who remarked that the boy "had the voice of an angel." When Trama learned that Schipa's family was too poor to keep him in school, he paid the young singer's tuition at the seminary.

After leaving the seminary, he took singing lessons with a famous local teacher named Alceste Garunda. He had infinite faith

in his pupil, and three years later organized a benefit concert to finance sending Schipa to Milan, where he could continue his studies with one of that city's most eminent teachers, Emilio Piccoli. He too was impressed with the young man's musical intelligence and taste and set about building on and refining the solid base his student had acquired in Lecce. Within two years, Schipa was ready for his professional career. In 1910 he made his debut as Alfredo in *La traviata* at Vercelli, a town in nearby Piedmont. The opera was a modest success–despite a very large leading lady who embraced the young tenor so enthusiastically in their Act II duet that someone in the gallery yelled, "Don't crush the poor boy–we want to hear him sing!" His performance led to appearances in other Italian provincial cities–Palermo, Bologna, Parma, Trento, Perugia, Ancona, and his native Lecce–during the next two years, acquiring a repertoire of about twenty roles, including Fenton, Alfredo, the Duke of Mantua, Nemorino, Edgardo, Cavaradossi, Rodolfo, and Pinkerton.

Two and a half years later, he made his debut in Milan at the Teatro dal Verme in the role of Cavaradossi, with such success that he was asked to make his first recordings, which offer a fascinating glimpse into the young Schipa. Like Björling, the tenor who most resembles him stylistically, Schipa's voice was endemically "phonogenic." A Milan paper said his voice was "as fresh as one would expect of a twenty-four-year-old tenor, but the surprise is that he is already a refined and fastidious stylist showing purity of line, delicately shaded dynamics, and immaculate articulation." His diction was so clear, in fact, that the public didn't need to buy the libretto to follow the plot. This made him highly unpopular among the sellers of libretti, who complained that their sales dropped on Schipa nights.

Shortly after his debut in Milan Schipa sailed to Buenos Aires, where he made the first of many annual appearances at the famous Teatro Colón and began to develop an enthusiastic and loyal public. One year later came his debuts in Rome as Ernesto in

Don Pasquale, and the Teatro San Carlo in Naples as Fenton in *Falstaff*, followed by Pinkerton in *Madama Butterfly*. In 1915 Toscanini invited him for the season to the Teatro dal Verme in Milan, where he scored huge successes as Fenton and Alfredo. In addition to his collaboration with the great Toscanini, this season also brought a creative partnership with Amelita Galli Curci, with whom he would sing for many years, not only in Italy but also in Chicago and on records. The 1915 season at Teatro dal Verme also opened the doors of La Scala, where he made his debut in the 1915-16 season as Vladimir in *Prince Igor*, soon followed by Des Grieux in Massenet's *Manon*, marking the beginning of a lasting relationship with La Scala that continued through to the fifties.

Schipa's career was now advancing rapidly, and in 1917 he made his debuts in Lisbon, Madrid, and Barcelona. He became so popular on the Iberian Peninsula that for a while Spain became his second home and Spanish his second language. But the biggest event of the year was being chosen by Giacomo Puccini to create the role of Ruggero in his new opera, *La rondine*, at the Monte Carlo Opera. This was as high an honor as any young tenor could hope for. The role was almost tailor-made for Schipa's gifts: youthful and engaging while demanding lightness of touch as well as passion with a sense of measure and style. After the performance Puccini's wife rushed up to Schipa and told him that the great composer had been moved to tears by his performance.

Being chosen by the foremost composer of *verismo* to introduce this new role was a great triumph not only for Schipa's career, but also artistically. For it was a vindication of his elegant and fastidious style of singing in an era that was ushering in a louder and more expressionistic mode that often rode roughshod over style and even technique. But Schipa, whose voice was schooled in the methods of a classic *tenore di grazia*, applied *bel canto* principles to his singing of *verismo*, bringing the same elegance to it that he brought to the rest of his repertoire. Puccini's

decision to use Schipa is the ultimate vindication of this point of view.

But the elegance of his singing didn't make Schipa a static performer; on the contrary, he appears to have been quite uninhibited. He always relished the story of striking fear into the famous baritone Mattia Battistini when they were performing *Tosca* in Monte Carlo. Battistini's Scarpia was so sadistic and sardonic that, as Cavaradossi, Schipa began to feel genuine hatred. In Act II, when one of Scarpia's henchmen bursts in to announce Napoleon's victory at Marengo, Schipa's exultation overcame him and he lunged onto Battistini with such fury that the latter recoiled and was overheard whispering to the singers playing the henchmen, "*tenetelo, tenetelo*" (hold on to him, hold on to him)! This is the key to performing *verismo*: the passion and abandon should be in the acting, and should never be allowed to distort or disfigure the vocal delivery. If it does, *verismo* instantly becomes vulgar.

Schipa as Almaviva in Rossini's *Il barbiere di Siviglia* with, *left to right*, Salvatore Baccaloni as Don Bartolo, Cesare Franchi as Figaro, the great Russian bass Feodor Chaliapin as Don Basilio, Toti dal Monte as Rosina, and Schipa. Chaliapin sang with most of the famous tenors of his day, although we don't know if he felt for Schipa the same warm, joke-riddled friendship he enjoyed with Beniamino Gigli and Richard Tauber. Baccaloni, a specialist in "buffo" roles who was discovered by Toscanini, sang Bartolo more or less everywhere, including London, the Glyndebourne festival, and Chicago.

Above left: Tito Schipa, early in his career, at the Cairo Opera as the lead in Boito's Nerone. The crowned emperor is playing a lute as Rome burns, rather than "fiddling," which would have been quite impossible.

Above right: Later in his career, Schipa is seen holding up a full page review of one of his performances at the Chicago Lyric Opera, where he was a great success.

Two years after the première of *La rondine*, Schipa embarked on an American career that lasted the rest of his life and helped make him very rich. He made his debut at the Chicago Civic Opera, as Elvino in *La sonnambula*, in 1919 and continued singing there until 1932. The audience took to him right away. After one performance of Flotow's *Martha* the conductor was forced to give in to the public's insistence on an encore—a practice strictly forbidden by management, who then fired the conductor. But Schipa threatened to leave with the conductor, and there the matter ended.

In 1932 Schipa made his debut at the Metropolitan Opera as Nemorino in *L'elisir d'amore*. The audience, according to the *New York Times*, "not only applauded but shouted its approval." He continued appearing at the Met regularly until 1935, and again in 1940-1941. His first New York debut had been in 1920 at the Lexington Theater, which had been attended by Caruso, who was seen leaving after fifteen minutes. Did he not like it? "Oh, yes, but I have nothing to worry about." "Why come, then?" asked his wife. "Because he is a tenor!" Meanwhile Schipa continued his annual visits to South America, and it was there that he announced, in 1941, that he would heed the summons of Count Ciano, Mussolini's son-in-law and Italy's foreign minister, and return home for the duration of the war. (He had long been suspected of Fascist sympathies.) He continued performing at La Scala, in Rome, and other Italian theaters during and after the war, and well into the fifties.

Interestingly enough, during Schipa's years in America before the war he made his home in neither Chicago nor New York, despite his regular appearances in those cities. Instead he settled in Hollywood, where his "Don–Giovannizing," as his son calls it, made him known as "the Valentino of Melodrama." He was an avid film buff who not only starred in such films as *Vivere, Tre uomini*

in un frak (Three Men in a Tailcoat) and *Terra del fuoco*, but also sang in and composed music for many others, including *Seventh Heaven* with Janet Gaynor and a tango for *Gaucho*, starring Douglas Fairbanks Sr., who became one of his second daughter's godparents (the other was Mary Pickford). Schipa also composed an operetta called *Principessa Liana* and several popular songs. He never looked down on light music. Indeed, he regularly included such popular Spanish and Neapolitan songs as "*Valencia*," "*Amapola*," "*Santa Lucia*," and "*O sole mio*" in his recitals, and brought to this repertoire that exquisite lightness of touch, that smile in the voice that makes this music a joy to hear and divests it of triviality.

The fact that Schipa, the most fastidious of tenors, lent his talent to the movies, popular song, and other lucrative pursuits early in this century is relevant to today, when Pavarotti and, to a lesser extent, Domingo have been heavily criticized in certain sections of the musical establishment for performing beyond the opera house, sometimes singing popular songs, recording crossover albums, and, of course, for participating in the "Three Tenors" concerts. One suspects that if Schipa were still performing he would be doing just the same. But in his day the movies probably provided not just welcome cash but also, as in the cases of Richard Tauber and Lauritz Melchior, a bit of fun, and a chance to escape from the stressful and demanding world of opera.

In America, Schipa became a very rich man indeed. In Chicago he had already commanded sky-high fees of three thousand dollars per performance (compared to Caruso's Met fee of twenty-five hundred dollars). For concerts he often was paid as much as seventy million Italian lire per night, and he sang two hundred nights a year. It is not surprising, then, that he could afford to reject an offer of five hundred thousand dollars to play Napoleon in a 1931 film. But, according to his son, he also spent money as fast as he earned it, on fast cars and women, and lost it in a series of ill-judged investments, for he had no business sense.

Like Pavarotti and Domingo, nothing interfered with his constant study and hard work at perfecting his singing, and his phenomenal technique enabled him to continue his career into his sixties. As late as 1957 he was not only singing in New York, but was also about to embark on his first tour of Russia. In 1962, three years before his death, his farewell concert took place at New York's Town Hall. Though the audience was enthusiastic, his voice, inevitably was not what it had been. What did Schipa still have to offer after fifty-two years of professional singing? Harold C. Schonberg of the *New York Times* answered, "Nothing and everything. His production is unsteady, his pitch often uncertain, his breath control nil. But, and this is a big but, his singing still has style... he managed inimitably to put across song and aria, and to convince his audience that a great man was before it."

Many years before, at the beginning of his career, the young Schipa had expressed anxiety about the nature of the public adulation that lay ahead: "Might they not like my voice more than me?" he wondered. This last concert must have reassured him that they did like him as much, perhaps even more.

Schipa concertizing in Holland in October 1957. He continued giving recitals until 1957, when he made his farewell appearance in New York's Town Hall. Although his voice was not what it had been, the audience received him enthusiastically, convinced that, despite the occasionally shaky vocal production, "a great man was before them." In many ways Schipa–although an anachronism who in the age of *verismo* looked back to the eighteenth-century style of singing–remains a model for many of today's great tenors, such as Bergonzi and Pavarotti, who study and learn from his recordings. He was one of the most intelligent, astute technicians of all time.

Lauritz MELCHIOR

What is a heldentenor? To paraphrase the inimitable Anna Russell's answer, he is very big and very strong and very brave and very stupid. He carries a spear and wears a helmet, he travels by swan, talks to birds, and laughs at dragons. Throw in a vast voice with endless reserves of power and volume and a dash of lyricism–for occasionally he has to be able to lighten his voice so that he sounds like a young lyric tenor in love–add the stamina of a long-distance runner, and you have the heldentenor: a voice-type that came into being mostly for the operas of Richard Wagner. The greatest, indeed the quintessential heldentenor of this century is indisputedly the legendary Dane, Lauritz Melchior.

Melchior, whose career lasted an unbelievable thirty-six years (from 1913 to 1949) in this repertoire, possessed all these qualities plus the essential baritonal bottom. In fact, he started off as a baritone, just as several Wagnerian sopranos started off as mezzos. For, as Dame Joan Sutherland once explained, this strong lower register provides a solid base on which to build and sustain the high notes, and in Wagner even the As require so much stamina that they are more treacherous and draining than many an Italian composer's high Cs. Gustav Mahler once said to one of his Tristans in Vienna, "Before the love potion, sing as a baritone, and afterwards as a tenor." Melchior always practiced this approach, ensuring that his voice remained blissfully free of all heldentenors' archenemy: a wobble, which is the loosening of the muscles as a result of too much tension and loud singing. His flawless voice is especially astonishing con-sidering that he sang 223 Tristans, 183 Siegmunds, 144 Tannhäusers, 128 young Siegfrieds, 107 "elder" Siegfrieds (*Götterdämmerung*), 106 Lohengrins, 81 Parsifals, and, according to his biographer, Shirlee Emmons, 2,100 concerts!

"His voice was wonderful, so very, very beautiful and with a darkness that should be in a Wagnerian tenor. He had something undefinable in that voice. One was absolutely taken with it," says Birgit Nilsson, one of the great Wagnerian sopranos of our day. "I cannot explain it except by saying that it was sexy, for it had so much masculinity. When I think how long he sang, it is unbelievable to me, but seeing that man, so tall and big, you knew he must have had the stamina for three.... Right from the beginning of my career, people were always lamenting the bad timing that kept us from singing Wagner together. 'If only you had sung with Melchior.' But I'm the one who regrets it most. To have *such* a playmate would have been a fantastic experience."

This big, jovial, Nordic giant of a man (6 feet 3 1/2 inches) who, by the end of his career, looked "somewhat like a walking sofa on the Met stage," according to Rudolf Bing, the formidable late general manager of the Metropolitan, started life in his native Denmark as a very thin, gangling young man. He was the youngest son of a schoolmaster who owned his own private school (above which the family lived) and had a reputedly magnificent baritone voice. He was born when his mother was thirty-nine, and one month later she died. Henceforth he became the much-loved, fussed-over, and coddled baby of his three elder sisters and of Kristina Jensen, the housekeeper who would

Opposite: Lauritz Melchior, the greatest heldentenor of our century, is seen as Siegfried at the Metropolitan Opera. Siegfried is a role in which he has yet to be surpassed and which he considered the hardest and most vocally challenging of all Wagnerian parts. Melchior had a great sense of humor–even on stage–often to the annoyance of his female colleagues. *Above*: He is seen in a more relaxing moment at a costume party with the actress Bea Lillie.

prove instrumental in helping him along the road to his glorious career.

The Melchior household was intensely musical. But the Danish State's new system of free public education began to make disastrous inroads into the enrollment at the Melchior school. The family's financial position became increasingly precarious, and the school finally closed. When he was eighteen his father, urged by "Tante" Jensen, took him to the famous singing teacher Poul Bang to have his voice assessed. Bang classified him as a baritone, accepted him as a pupil, and laid the foundations for his vocal development.

Three years later, in 1911, Bang organized an audition at the Royal Danish Opera at which Melchior sang Germont's aria from *La traviata* and the Toreador Song from *Carmen*, and was accepted for its apprentice program. Two years later the company's principal baritone left for the Berlin State Opera, and Melchior was entrusted with the role of Silvio for the forthcoming production of *I pagliacci*. The premiere took place on April 2, 1913. Melchior did well enough to be officially engaged as a member of the Royal Opera on a three-year contract.

Above: Rose Bampton, as Sieglinde, offers her long-lost brother Siegmund a draught during a 1943 performance at the Met.
Below: After an earlier performance of *Die Walküre* in 1935, Melchior, as Siegmund, shows his magic sword "Nothung" to the Met's General Manager Giulio Gatti-Casazza and New York's diminutive Mayor Fiorello LaGuardia.

Melchior's contract allowed him to accept some engagements with freelance companies, and in the spring of 1916 the impresario Peter Gradman engaged him for the role of the Count di Luna in *Il trovatore* on tour in Sweden. Luck would have it that Sarah Cahier had been hired as Inez (companion to the heroine, Leonora, in the plot). One evening, Cahier witnessed a riveting scene: the soprano singing Leonora felt very nervous about her high C at the end of the Leonora-Luna duet, and was certain that she couldn't pull it off. In an effort to calm and reassure her, Melchior suggested she might feel better if they swapped notes, and he sang the high C instead. To her immense relief, he interpolated a resounding, effortless high C to Luna's part. After the performance, Cahier approached and told him "But you are not a baritone. You are a tenor with the lid on. Probably a heldentenor!"

Melchior began to study with the renowned Danish heldentenor, Kämmersanger Vilhelm Herold, a true singing actor and Melchior's idol for many years. Herold offered to teach him gratis. After he'd accomplished the difficult task of crossing the line between baritone and tenor, his teacher, who considered Melchior's voice inborn and inherently impressive, prepared him for the role of Lohengrin, a part ideal for a *jugentlicher* heldentenor. But the Royal Opera engaged a foreign singer and, instead, offered the much more demanding part of Tannhäuser, which Melchior had to learn in two months. It was an almost superhuman task but, as he was to comment later, "life doesn't give you roasted doves flying about. You have to work and work hard."

So, a month before the end of the World War I, the twenty-eight-year-old Melchior stepped out in his first tenor role, in a costume paid for by his brother. The reviews were favorable but not enthusiastic and the management decided not to offer him another Tannhäuser, or indeed Lohengrin, until he had done some more studying.

In 1919 some friends paid for him to come to London, where, a year later, he made his debut in a Prom Concert at the Queen's Hall under Sir Henry Wood. There he acquired a very important fan: well-connected author Hugh Walpole, a passionate concert-goer and opera lover who became instrumental in advancing the young tenor's career. Walpole brought him to the two teachers who would prepare him for Bayreuth: Victor Beigel in London, and Madame Bahr Mildenburg in Munich, where he received a telegram from Siegfried Wagner summoning him to Bayreuth.

Tannhäuser was one of Melchior's great roles, and he immensely enjoyed singing it–as is evident in these two photographs dating to 1934. *Above*: During a dress rehearsal, the heldentenor strums his harp for school children in New York. *Below*: He is seen at the Met with Lotte Rehmaun as Elizabeth.

It was a daunting prospect. Acceptance meant access to an international career, but failure would signal the end of his prospects as a heldentenor. Overawed by the grandiose and emotionally charged atmosphere at the Villa Wahnfried, he arrived at "The Hall," a huge room where he was to audition. At the piano sat Bayreuth's chief coach, Professor Karl Kittel and, waiting to greet him, Wagner's son Siegfried, director of the festival since 1924, in his eccentric clothes of knee breeches and yellow stockings.

Melchior had chosen Tannhäuser's "Rome Narration" and Siegmund's "*Winterstürme.*" It was the first time he sang the former in German. Siegfried Wagner sat in an armchair, rose when Melchior finished, and, saying nothing, climbed the narrow stairs to the third-floor gallery. Melchior and the professor waited in silence. When he came down, Siegfried said: "Mother has complimented you, she likes your singing." That's when Melchior realized that Cosima Wagner had been there, in the gallery, all the time. Siegfried engaged him on the spot as Siegmund and Parsifal in the coming festivals.

With this all-important stamp of approval on his Wagnerian singing, Melchior stayed on in Bayreuth for a month, learning the roles

and "the real Wagner style" with Professor Kittel, who was considered as much of a repository of the authentic Wagner style as the Wagners themselves. Many years later Melchior acknowledged that "what he taught me about my Wagner roles has stayed with me always." As he explained to the Wagner Society in 1932, in the works of Richard Wagner, "melody is, always has been, and always must be, the lifeblood of the drama. Complete integration of dramatic impulses with musical expression forms the basis of the Bayreuth style." Indeed, one of Melchior's greatest and unique qualities as a Wagner singer is that he never committed violence against the vocal line.

Having absorbed the Bayreuth style, Melchior returned to Covent Garden in May 1926 for his first staged Siegmund, a role heldentenors learn first because it's the shortest and a good way to build up Wagnerian stamina. It also has the lowest *tessitura* and is a good test of the tenor's vocal foundation. "The heroic tenor must learn to conserve his energy. It's like a horse race. You must have a good lower register to build high tones. If you try to lead the field the whole time, you'll never make the finish." Then it was back to Bayreuth for *Parsifal*. Siegfried and Cosima considered Melchior "the greatest Parsifal" and praised his performance. Melchior had a very special view of this work, which he considered "a sort of Oberammergau play, which I feel should

not be given except at Easter. For Parsifal is the embodiment of the spirit of God, of what is right on this earth."

Melchior's next great challenge after his Bayreuth Parsifal was Siegfried. It is the longest and one of the two most difficult roles in the Wagnerian repertoire (the other is Tristan). It is two thousand notes longer than Tristan, double the length of Verdi's *Otello*, seven times the length of Canio in *I pagliacci*, and fraught with both vocal and dramatic problems. Melchior's recording of the role makes one understand why he became the pre-eminent heldentenor of the twentieth century. Never in our day have we heard it sung like this. Cosima Wagner complimented him twice.

After this Bayreuth triumph, Melchior brought his Siegfried to the Met, where it aroused intense enthusiasm in public and critics alike. He was beginning to find his public in New York and, thanks to his former teacher Victor Beigel, was being taken up by such influential figures in the city's music world as Otto Kahn, the Lewinsohns, and the Guggenheims–friendships that would prove very useful for his American career.

The next big challenge was Tristan, which he first sang in 1930 in Barcelona on the advice of Leopold Sachs, the intendant of the Hamburg Opera with whom he was on cordial terms, before singing it in Bayreuth in a historic production conducted by Arturo Toscanini, the fiery Italian maestro, with whom he struck an excellent rapport and collaborated very harmoniously. It was Toscanini who, after Melchior's immense success in the role, christened him "Tristanissimo" because of his emotional, almost mystical identification with this role: "*Tristan und Isolde* is the greatest love story in the world because it sets forth the ideal of what love should be between a man and a woman. It's a drama of love, of love never dying. If there is anything after this world, these two people will certainly find it.... In this world, though, they must die together, for they cannot die apart."

Melchior's success in Bayreuth was such that the Nürnberg critic who after his Tannhäuser had predicted that the world

would never hear of him again, wrote, "It's a great pity that Richard Wagner did not live to hear his noblest dreams fulfilled through Melchior." More praise was heaped on him when his Tristan finally reached New York, via London and Philadelphia, where the Metropolitan Opera used to perform on certain days of the week. It was to be the first of over two hundred performances of Tristan in this theater (the celebration of the two hundredth was during the 1944-45 season), where in the next twenty-five years he would perform five hundred fifty Wagnerian evenings. During these years he canceled only three performances, causing the assistant manager, Francis Robinson, to call him "a great natural phenomenon, something on the order of Niagara falls!"

Melchior's return to Bayreuth the following summer for Tristan was a less happy occa-

At the Met in the title role of *Lohengrin*, alone and with Kirsten Flagstadt. Melchior's last appearance was with Helen Traubel in 1950.

Above: Playing cards backstage with his second wife. Cards and hunting were Melchior's favorite hobbies.
Below: Shooting, in this case in New Jersey, was Melchior's principal passion dating back to his youth in Denmark. He owned a large shooting estate east of Berlin, to which he retired as often as he could. After the advent of Nazism, the Melchiors hid numerous Jewish colleagues and acquaintances there who were awaiting transportation to neutral Sweden. After a visit from the Gestapo, Melchior unleashed his ferocious shooting dogs the moment the officers had shut the front gate. The estate was confiscated by the Nazis as soon as the Melchiors left Germany for America, where he became an American citizen.
Opposite: Melchior, a notorious prankster and practical joker, during a fancy dress party at the Metropolitan Opera with the ballerina Mia Slavenska.

sion, and was to be his last appearance there. Siegfried and Cosima Wagner had both died in quick succession, and, on the musical side, he did not enjoy the same happy collaboration with Furtwängler that he had with Toscanini. Furtwängler was as notorious for his quirky, erratic conductor's beats as Melchior was for rhythmical inaccuracy.

But more important than musical considerations was Melchior's abhorrence for the rising Nazi influence at Bayreuth after the deaths of Siegfried and Cosima. The former's English widow Winifred was besotted by Hitler, who expressed enthusiasm for this Danish Tristan. She duly summoned Melchior to his presence to be congratulated, but he refused to go, or to return to any German theater, ever.

Before World War II, Melchior based himself entirely in America and eventually became an American citizen. He was the reigning heldentenor of the Met, and reached his peak as an artist towards the middle of the decade. His performances exuded such authority and his voice was so secure that nobody in his day was in a position to challenge him. His one regret was that "owing to the Italian lobby" Gatti Casazza never let him sing Otello, Canio, or Radames, roles often

sung by heldentenors and at which he thought he could excel. For many of these years, he based himself at the Ansonia Hotel, where he would amuse himself by playing cards late into the night. Apart from music, food and drink (especially beer and aquavit) were what he most enjoyed, while his principal hobby was shooting, and he hunted wherever game could be found.

Melchior was greatly looking forward to his silver jubilee at the Met, which was due in 1950-51, but it was not to be, owing to Rudolf Bing's churlish decision not to renew his contract in 1947. Bitterly hurt, Melchior retired to California, where he bought a huge house and proceeded to turn himself into a filmstar. He also appeared in countless radio shows and musicals. He had begun this expansion into the world of light music during the late forties, much to the disgust of some of his Wagnerian fans.

Melchior lived to be eighty-three. He died on March 18, 1973, three days before his birthday, and up to the last weeks of his life enjoyed robust health. Ten years before his death he had suffered a devastating blow: the premature and sudden death of his beloved second wife Kleinchen. To alleviate his loneliness he married again, this time to a Californian businesswoman who had been a good friend of his wife, but the union lasted only a few months.

The important compensation for the loneliness of the last decade of his life was the joy of getting close to his children again, from whom Kleinchen had kept him, sometimes through a web of Machiavellian schemes. He also got to know and love his grandchildren. Indeed, it was his dearly loved granddaughter Helle who was at his bedside (at the hospital in Santa Monica where he had been taken after four successive bouts of flu had left him too weak even to eat) when he died and heard his last words: "Have a good life," he whispered while squeezing her hand. Then he just stopped breathing, doubtless content in the knowledge that he had had such a life and made the most of "that little touch of God's finger," as he called his voice and talent.

Richard TAUBER

"Some singers of the past come across as little more than outstanding voices on old recordings while others, through an extra dimension to their singing, emerge as vital and familiar personalities–almost like old friends," writes Nigel Douglas in his informative and entertaining books on legendary voices. This is certainly true of Caruso's recordings and second only to him, as Douglas points out, would be Richard Tauber.

This unique Austrian tenor, who was once called "a Jekyll-and-Hyde tenor" due to his excellence in singing both Mozart and operetta and light songs, was a sparkling, hugely entertaining presence. Even in his recordings there always seems to be an audible smile in the voice. One need only listen to a few bars of Tauber singing operetta–be it Lehár, many of whose works he premiered, or Strauss or Kalman–for the sense of fun that bubbles out of him to engulf and instantly switch one into a champagne mood.

The voice itself is appealing to the ear–a supple, soft-grained lyric voice with a pleasing, sunny timbre, but sunny in a very different way from Italianate voices such as Caruso's. While the latter instantly evoke a Mediterranean landscape, Tauber's conjures up the vineyards of Grinzing, the countryside around Vienna. Occasionally there is a hint of that particularly Austrian melancholy, but without it ever degenerating into outright schmaltz: in short a voice ideal for romantic music.

Tauber was not a high-note tenor in the Gigli, Björling, or Pavarotti mold. Although he could reach up to high C–after all, through a fluke he sang the German premiere of *Turandot* in 1926–his voice was at its best up to B-flat. But in his repertoire this hardly mattered, especially considering his other gifts, the most obvious being charm. He simply oozed it. This made him popular not only with his adoring public but also everyone he worked with. Most of all it made him popular with the ladies, to whom he was extremely prone. "Give me a beautiful woman and a piano and I'm happy," he used to say. He was married twice, once to opera singer Carlotta Vanconti and later to film actress Diana Napier, of whom he said, "such a treat to have a wife who knows nothing about music!" In between and concurrently there were many other women. Yet Tauber was far from handsome. On the contrary, he was short, stocky, and lame. His limp was a legacy of rheumatoid arthritis that nearly crippled him in 1929.

But Tauber's brilliant show-business personality often blinded people to the fact that he was actually a supremely gifted musician with a multifaceted talent; not only a distinguished Lieder singer (as his wonderful renditions of Schubert, Schumann, and Grieg on EMI demonstrate), but also an accomplished conductor, good enough to conduct and tour with the London Philharmonic, and a composer with three operettas–the most famous of which was *Der Singende Traum* (*The Singing Dream*), which was premiered at the Theater an der Wien in 1934 with great success–and dozens of songs to his credit. "He was first a great musician and second a great singer," said conductor Joseph Krips after his death. Nature had a hand in predisposing Tauber

Richard Tauber was extremely versatile, and sang both opera and operetta roles with equal ease. He also put his acting talent to use in films. *Above*, he is seen in the role of Goethe in Franz Lehár's *Friederike*, and *opposite*, as Cavaradossi in Puccini's *Tosca*.

for a singing career. In 1891 he was born in a hotel room in Linz with the theater in his blood. He was the illegitimate child of the well-known German-Jewish actor Richard Anton Tauber and Austrian soubrette Elisabeth Demeny, who was the daughter of an actor and a famous opera singer. Both parents loved the child dearly and agreed that he would spend the first years with his mother, and then, when he was old enough, would move in with his father.

Tauber had shown signs of musical talent very early and could pick up any melody. But he hated school, where, unable to concentrate or interest himself in any subject, he would spend his time fidgeting. The headmaster finally called his father and explained that Richard's continued attendance was pointless. To Richard's delight, his education was then entrusted to private tutors, and by the time he reached his teens his father, who had initially wanted him to become a doctor, was resigned to his trying to become a singer. But first he had to find out whether there was any real potential there. The problem was that Tauber had fallen in love with Wagner in general and Lohengrin in particular and idolized the theater's resident heldentenor, Heinrich Hensel, whom he tried to imitate at every opportunity, including auditioning for prospective teachers, who, as a result, saw little future for him as a singer.

Fate, in the shape of a female friend, finally led him to the right teacher: Carl Beines, in Freiburg, who was not only a famous singing teacher but a first-rate musician, and the man who made Tauber. "Now, what do you want to sing for me?" he asked the eager young man. "Lohengrin's Narration of the Holy Grail," he replied, undeterred by his earlier failures and his father's admonitions to stay away from Wagner at all costs. He had only sung a few bars when the professor shouted for him to stop. Tauber was crestfallen, but the professor said, "I hear from your father that you only choose Wagner for your auditions. No wonder you make no progress! Now listen to me. Never try to sing Wagner. He is not suited to your voice. Come, let's try something a little bit less noisy." He played some scales for Tauber to sing and after an hour accepted the young man as his pupil. "You have a very beautiful *bel canto* voice, and if you work hard, come here daily, and abstain from singing at parties, until I tell you so, I promise that I will make you the greatest Mozart singer in the world." After eighteen months of constant and painstaking work, Beines was asked if he could recommend a young tenor to the Court Theater at Mannheim. He recommended Tauber, who,

overcome with excitement, danced all over the professor's studio. Nevertheless, Tauber's debut took place elsewhere.

For that same year his father became general manager of the Municipal Theater at Chemnitz near Dresden, and it was there that, aged twenty-two, Tauber made his singing debut as Tamino in *Die Zauberflöte*, followed by Max in *Der Freischütz*. But even before he made his debut, a successful audition had led to his being hired by the Dresden Opera, one of the greatest theaters in Germany, with a five-year contract as its principal lyric tenor. During the next five years he sang almost all the Mozart repertoire, *bel canto*, some French roles–most notably the title role in *Les contes d'Hoffmann* –and some operetta.

In 1921, he sang in Lehár's *Zigeunerliebe* at the Salzburg Landestheater, the first of a long string of operettas by the famous composer of *Die lustige Witwe*, with whom he would form a close and mutually beneficial artistic association. He followed this with the lead part in *Donna Frasquita* at the Theater an der Wien in 1922 (while on contract with the Vienna Scene Opera) and turned what had been a flop into a hit.

As Tauber explains, he became hooked on Lehár's music, "especially the song 'Hab ich blaues Himmelbett,' from *Donna Frasquita*, which thrilled me. I love singing Lehár songs, they are so gay." Lehár was equally smitten by this young tenor's unique flair for the genre, and told him, "you are singing like a god. I believe you have the most beautiful voice in the world. The sound of it stimulates me to compose for you.

Tauber became a matinée idol in Britain after he appeared as the composer Franz Schubert in the film *Blossom Time*. *Above*, he is seen in his second British film, *Heart's Desire*, directed by Paul Stein and made at London's Elstree Studios. He played the role of an unknown *biergarten* singer who comes to London and rises to fame. Tauber, who was half Jewish, had indeed emigrated to London and left everything behind except his fame and talent.

Above, playing the piano at his London hotel. Some years before, when informed of the Anschluss, which he had refused to believe would happen, he was so shocked that he locked himself in his Milan hotel room and played the piano for three solid days without uttering a word.

You are always in my thoughts." Once they had worked together, Lehár composed all his leading tenor roles with Tauber in mind.

He made his 1919 debut in the Vienna Volksoper as Rodolfo, followed by Pedro in *Tiefland*, Tamino, and Don Ottavio. In the same year he also sang three roles at the Berlin State Opera, which was to be one of this itinerant tenor's main bases over the next decade. The successive premieres of the Lehár operettas, especially *Das Land des lächelns*, and the hit status of their songs made him vastly popular and almost as famous for his flamboyant spending as for his singing. He owned a luxurious villa in Grünewald, as well as several other properties and one of the most striking 140-horsepower Mercedes in town. At the same time he made a string of German films that further increased his popularity.

But this highly satisfying state of affairs soon came crashing down when Hitler assumed power. He was not prepared to tol-

Below, with Marlene Dietrich, another famous Jewish show-business refugee. Although small, stocky, and lame, Tauber was a lady-killer whose charm and enthusiasm most women found hard to resist. His romances, before and after his marriage, were legion, but he was lucky to find in his second wife, the actress Diana Napier, a generous and forgiving partner.

erate half-Jewish status even in a superstar such as Tauber. Like many artists, Tauber was nonpolitical and, as events before the Anschluss of Austria were to prove, a naive and inveterate optimist. But this time he got the message and left Germany for Vienna immediately. All the money and property he left behind was confiscated by the Nazis and so he had to make a fresh start and concentrate on his connections with Viennese theaters and on expanding his international career. Perhaps the experience of losing the home he had loved so much was the reason why for the rest of his life he refused to buy a house. He felt more comfortable in the transient world of hotels. After the Anschluss England, his wife's country, was to be his home. But his recovery was only skin deep. According to her, he nursed a secret misery from which he never quite recovered.

Back in England, Tauber took up a tour of Australia, and followed it with a visit to South Africa. While visiting his father in Switzerland he received an invitation that, according to his wife, transfigured him. Covent Garden asked him to sing in four productions: Belmonte in *Die Entführung aus dem Serail*, Tamino in *Die Zauberflöte*, Don Ottavio in *Don Giovanni*, and Janik in *The Bartered Bride*. What's more, they were to be conducted by Sir Thomas Beecham. "At last, at last!" he shouted. "For years it has been my ambition to sing at Covent Garden and now it's happening."

It was also at Covent Garden that, nine years later in 1947, Tauber was to make his last public appearance as Don Ottavio, during the first post-war visit by the Vienna State Opera. He was already desperately ill with lung cancer but had asked, and was granted, the last performance of the run, under Joseph Krips. The next day Tauber went to the BBC to record the last two broadcasts due under his contract, one prerecorded, one live. The atmosphere in the studio was emotion-charged, and when he finished he quietly put the lid down on his piano and said "Goodbye, piano," in the way he had of saying goodbye to objects. Then he said goodbye to everyone on the broadcasting team.

The following day he had his operation. One lung was removed, but, alas, the cancer had spread to the other as well. For a while, he recovered enough to convalesce at the Imperial Hotel in Torquay. But in January 7, 1948, gasping for breath, he was rushed to the London Clinic where later on in the night he died. He had once said, "When I can no longer sing, life will be over. Somewhere among the mountains, or beside the blue Mediterranean, you will find a body that answers to the name of Richard Tauber, but I shall have faded away with my final song." But blessedly fate spared him the torment of a life without singing.

After the war Tauber conducted several concerts with the London Philharmonic Orchestra in Britain and on tour. Tauber's close involvement in operetta and light music sometimes blinded people to his prodigious gifts as a serious musician. But as he often remarked, "the Vienna State Opera doesn't pay my taxes! I will sing in both worlds and no one can stop me. Besides, I *like* light music."

rnand de Gueldre

Jussi BJÖRLING

"Jussi, you are the only one worthy of dear Rico's mantle," the great Caruso's widow Dorothy once told the Swedish tenor Jussi Björling. There can be no higher praise for any tenor, and, despite the obvious differences between Caruso's and Björling's temperaments and styles, it is justified. Björling is a giant in the history of tenors and had one of the most naturally beautiful and meticulously trained voices of the century: seamless, richly colored in every register, with a distinctive, instantly recognizable timbre, an exciting thrust, and considerable reserves of power.

This unusual combination of qualities helped him excel in every area of the tenor repertoire–light lyric, lyric, and dramatic–with distinction. This is one of the characteristics he shares with Caruso, despite the differences in the timbres of their voices: Caruso's sunny in color and texture, while Björling's, though luminous, was also melancholy; a voice, in the words of a BBC radio listener, "heavy with unshed tears." In stylistic matters, though, Björling most resembles Tito Schipa in the rare talent of total control over his vocal instrument, which gave him freedom of interpretation. His vocal flexibility spanned all tempos and dynamic ranges from *pianissimo* to *fortissimo*. Although the obvious ideal for all singers, male or female, in practice few achieve such choice of possibilities. Yet this choice is central to the art of singing. Singers like Björling who have this choice can decide to sing a phrase a certain way because they feel it's the right way. But if they sing it a certain way because it is the *only* way they can get these notes out, then there is

less merit to their interpretation because it's dictated by necessity rather than choice. His two recordings of *Faust* are perfect examples of his total artistic freedom: in one of them he sings the famous high C at the end of the aria "*Salut demeure*" piano and in the other forte, both with the control of a master.

It was Björling's good fortune that the peak of his career coincided with the advent of the long-playing record after World War II. Entire operas were recorded far more easily than before, and singers recorded more than ever. Björling's voice, perfectly modulated and admirably controlled, lent itself to recording from the beginning. His RCA recordings of *Il trovatore* and *Aida* (both with Yugoslav soprano Zinka Milanov and the American baritone Leonard Warren) became the yardsticks by which these roles are measured. The recordings virtually crackle with white heat in Manrico's and Radames's dramatic climaxes, while the phrasing in the intimate moments is breathtaking. His equally electrifying discs of *Manon Lescaut, Cavalleria rusticana, La bohème*, and *Madama Butterfly* rank among the best in recorded history.

According to those who knew and worked with him, Björling was a man of contradictions. As the distinguished accompanist Ivor Newton confided to Nigel Douglas in his fascinating book, *Legendary Voices*, Newton considered Björling superb as an artist with a remarkable range and impeccable style, but as a man he found him "obstinate, difficult, taciturn, and unusually lazy. He hated to rehearse and would find endless excuses–his health, the weather, all varieties of ingenious

Opposite: Jussi Björling as Des Grieux in Massenet's *Manon* at the Chicago Opera. *Above*: as Cavaradossi at the Swedish Royal Opera. Björling's richly colored voice with its considerable reserves of power enabled him to tackle every area of the tenor repertoire with equal distinction and stylistic perfection. This, along with the beauty of his sound, is what makes him one of the most important tenors in operatic history. He could lighten his sound or darken and inject it with massive power and volume at will.

Jussi Björling as Faust at the Metropolitan Opera. His two recordings of this role demonstrate the complete artistic freedom he enjoyed thanks to his superlative technique. Such was his mastery over his voice that he once managed to sing an entire performance of Cavaradossi in *Tosca* at the Royal Opera in Stockholm blind drunk, without a hitch. As far as the French repertoire is concerned, Faust, Massenet's Des Grieux, and Nadir in *Les pêcheurs de perles* were his best roles. The timbre and color of his voice, combined with his vocal and stylistic refinement, made him nearly as good an exponent of the French as of the Italian repertoire. French roles require the voice to be a little bit less full and sensual than Italian parts, and Björling managed to control and hold back his volume—which is much more difficult than opening up the voice and allowing it to swell to full volume—to achieve the sense of measure quintessential to the French style.

reasons–to avoid doing so." Björling's weaknesses as a man also included a severe drinking problem, movingly described in the biography written by his wife. But surprisingly his alcoholism had no effect on either his performances or his excellent memory.

His only weak points artistically were his relative ineptitude as a linguist (in marked contrast to his younger compatriot Nicolai Gedda) and his inadequacy as an actor. His imperfect grasp of Italian largely explains why he never received the recognition he deserved in Italy. He was one of the supreme interpreters of the Italian repertoire, but his performances on Italian soil were limited to two appearances at La Scala: in 1946 as the Duke of Mantua and in 1951 as Riccardo in *Un ballo in maschera*. Björling's lack of acting ability did not prevent him from being involved in the characters he portrayed. Like Bergonzi, he acted vocally rather than histrionically, through his expressive phrasing–cultivated, nuanced, and thoroughly passionate. As soprano Elisabeth Söderström, a fellow

Swede who sang with him many times, explains, "on stage, he didn't appear to be acting." And director Kurt Bendix remembers that "Jussi just stood around, but he did so with great authority." Söderström continues, "but when you looked into his eyes, you saw that he had ceased to be Jussi and had become Des Grieux or Rodolfo or whatever role he was playing. And the sound he produced was so beautiful and so utterly free that you couldn't help losing your own tensions and singing better than you had ever done before."

Indeed, as a singer pure and simple Björling was as close to perfection as is possible. The fact that he died at the age of forty-nine in 1960 was a tragedy for the world of opera, but thanks to an early start he had enjoyed a thirty-year career.

He was born in Stora Tuna in 1911 to a musical family brimming with good voices. His father had been a good enough tenor to sing at the Metropolitan Opera, and his two brothers were also gifted with exceptional

voices as young boys. When Jussi was just six, the four of them formed The Björling Male Quartet and toured Sweden and Swedish communities in the United States. Björling was one of those seamless boy sopranos whose voices don't so much break as settle down to being tenors. The absence of that awkward gearshift that plagues so many singers, male and female, was a gift. But, like all singers, he had to study breath control, voice placement, and the other essentials of vocal technique.

When he was only sixteen both his parents died and he was left to fend for himself. For a year he struggled through a variety of jobs. Then, in 1928, he auditioned for the leading Swedish tenor of the day, Carl Martin Oehmann, who was so impressed by the young man's potential that he recommended him to John Forsell, a distinguished baritone and the director of the Royal Swedish Opera in Stockholm. He, too, recognized the young man's potential and per-

suaded the board to grant him a generous stipend of 320 krona per month for his tuition, board, and lodging.

Forsell was so convinced of Björling's potential that he took personal charge of his training. He was a demanding teacher, requiring discipline in musicianship, style, and acting. Björling doubtless owes his phenomenal vocal control and stylistic finesse to Forsell. Two years after joining the conservatoire of the Royal Opera, Björling was judged ready to make his professional debut. After a couple of walk-on parts, he made his official debut on August 20, 1930, as Don Ottavio in *Don Giovanni*. Although this is a difficult role for a nineteen-year-old, it was relatively simple when compared to his next part, Arnold in Rossini's *Guillaume Tell*. But the young Björling acquitted himself superbly, and in the next five years he sang no fewer than forty-four roles in this theater. Toward the end of this period, in 1935, he married the soprano

Below: As the Duke of Mantua in Verdi's *Rigoletto* and *right* as Riccardo in Verdi's *Un ballo in maschera*, both at the Metropolitan Opera, where he made his debut in 1938 and sang every season until 1958 (except during the war years, which he spent at home in Sweden). He left because of a falling out with the general manager, Rudolf Bing. He sang his first *Rigoletto* in 1940 at the Met with Lily Pons as Gilda and Laurence Tibbett as Rigoletto, and his leading lady in *Ballo* was Zinka Milanov.

Anna Lisa Berg, with whom he sometimes appeared on stage.

In 1936 he made his all-important international debut at the Vienna State Opera as Radames under the baton of Victor de Sabata with Gina Cigna as Aida. A beginner tackling this role with so established a conductor and cast at the Vienna State Opera was virtually unheard of. But the recording made only a few months later demonstrates that at the age of twenty-five, Björling already possessed the gifts that made him such a special singer: the even, seamless line, the seemingly effortless high notes and his extraordinarily expressive phrasing. Other recordings offer a rare glimpse of him as a Lieder singer, a genre he didn't pursue due to his linguistic shortcomings.

Björling's Vienna debut led to immediate invitations to make his debut in Paris at the 1937 World Trade Exhibition, in London at Queen's Hall, and at the Chicago Civic Opera as the Duke of Mantua. The following year was even more eventful, as he sang the Verdi *Requiem* at the Lucerne Festival under Toscanini and made his debut at the Metropolitan Opera, as Rodolfo in *La bohème*, one of the best roles in his repertoire. After his first Manrico there the same year the reception was dazzling: "Not in a long time has anything more lovely than his performance of '*Ah sì, ben mio*' been heard at the Metropolitan," wrote *Musical America*. Manrico–in which Björling also made his Covent Garden debut a year later–requires two tenor voices, one lyric for the intimate moments and one dramatic for the outbursts, and was thus ideal for displaying Björling's splendid vocal gifts and training.

Björling stayed in America until 1941, when he returned to neutral Sweden for his obligatory six-month stint in the army. He spent the entire war there, performing at the Royal Opera. The only times he ventured abroad were in 1942, when he appeared in Budapest and Florence. Plans to appear at the Vienna State Opera came to nothing when he was banned by the Nazis for refusing to learn *La bohème* and *Rigoletto* in German.

After the war he returned to America to begin the most glorious period of his career. He appeared at the Metropolitan several times each season and became one of the New York public's great favorites, until 1958, when he fell out with the Met's general manager Rudolf Bing. Inevitably the public's increasingly high expectations began to exact a toll on his nervous system. Knowing that the public expects perfection every time a tenor opens his mouth and also knowing how easy it is for things to go wrong is harrowing, especially night after night. Elisabeth Söderström, who was partnered with Björling as Marguerite in *Faust*, remembers that he was loath to rehearse. Because she was singing the role for the first time this made her very nervous, but when she complained to Björling he replied: "What have *you* got to worry about, my girl? They won't be expecting anything from you. *I'm* the one who should worry!" And worry he did. He had always been a heavy drinker, and his drinking now degenerated into full-fledged alcoholism. Every tenor has his own way of reflecting the stress of the profession: Corelli was plagued by nerves, Pavarotti put on weight, and, worst of all, Björling turned to the bottle.

Remarkably, Björling's performances and excellent memory didn't suffer. A soprano who sang Tosca with him in Stockholm recalls one night when, ten minutes before the curtain went up, he staggered through the stage door, blind drunk. His leading lady was certain that he couldn't make it through the opera in the leading role, but make it he did, not only without a single mistake but lucid enough to tell the rest of the cast where they had gone wrong.

But Björling's drinking rendered him unreliable in recording sessions. In the summer of 1960, three months before his death, Decca's recording of *Un ballo in maschera*, planned around him and Birgit Nilsson, to be conducted by Sir Georg Solti, had to be canceled when Björling didn't come to the studio. He was found lying in his hotel room, incapable of anything but "incoherent abuse," according to the late Decca producer John Culshaw.

Björling already had intimations of the

heart condition that was to kill him within three months. He had been increasingly worried about his heart, especially after the shock of Leonard Warren's sudden death in March 1960. Warren, who had been a regular colleague of Björling both on stage and in the record studio, dropped dead on stage at the Metropolitan Opera in the middle of a performance of *La forza del destino* just after the end of the baritone's aria, "*Urna fatale del mio destino.*" Björling was deeply distressed and, according to those close to him, became a hypochondriac. But he was well enough during the summer to give a concert in Gothenburg that was recorded live and shows him in splendid vocal form. A few weeks later, though, he had a heart attack in his summer home; he was rushed to a Stockholm hospital where he died on September 9th of the same year.

Despite his premature end, Björling's thirty-year career and priceless legacy of recordings earned him a place at the top of the operatic pantheon. This legacy also gives posterity a glimpse of the fastidious artistry that, combined with his superb voice, enabled him to make a vital and lasting contribution to the art of the tenor.

Above: One of the very early telecasts from the Met. Björling appears as Rodolfo in Puccini's *La bohème* with Renata Tebaldi as Mimi. This came at the end of his career, when the tenor had become somewhat unreliable.
Below: As Canio in Leoncavallo's *I pagliacci*, the dream role of any tenor, at the Royal Swedish Opera, Stockholm.

Mario
DEL MONACO

"You know, careers go by like the wind and it's awfully difficult to part from one's whole reason of being," confided Mario del Monaco in 1981, seven years after his retirement and barely eighteen months before his death at the age of sixty-seven. "I'm happy to be leaving behind so many records, including twenty-six full-length operas.... For a tenor to go on singing lead roles until he's sixty, in good condition, is something of an achievement, and I'm proud of it."

Del Monaco was a proud lion of a man throughout his twenty-year career. It was no accident that the role with which he was most identified was Otello, "the Lion of Venice," which he sang no fewer than 427 times, and for which he possessed the ideal temperamental and vocal resources: a manly, thrillinghy erotic voice of immense power and volume, with a gleaming, bronze timbre and burnished, "gladiatorial" color that instantly bespoke the leader. This impression was strengthened by his broad, generous phrasing and noble declamation, both ideally suited to heroic characters. It was fifteen years before another tenor, Placido Domingo, took on the mantle of Otello and made it his own.

Del Monaco's prodigious vocal and scenic gifts and filmstar good looks were accompanied by intelligence, self-knowledge, and a gift for self-examination. He was equally knowledgeable about singing, forever studying and experimenting with vocal and dramatic possibilities. He probed his characters very deeply and identified with them with every fiber of his being. He burst into prominence after ten years of studying singing, longer than most artists.

Del Monaco, the eldest of three sons, was born in Florence on July 27, 1915, to a Neapolitan father and a Florentine mother, Floria Giachetti, a cousin of Caruso's common-law wife, the soprano Ada Giachetti. Caruso was still discussed as a member of the family and was to remain del Monaco's idol and, through his records, also his teacher for the duration of his career.

His father was a civil servant whose work involved several changes of residence. First, when Mario was three, to Cremona, Monteverdi's and Ponchielli's birthplace, then, six years later, to Libya–"a lovely country in those days"–and back to Italy, where they were free

The first time the Italian tenor Mario del Monaco sang Otello, at the Teatro Colón in Buenos Aires in 1949, the public went wild. Not only was he handsome and virile, he was obsessed with the role and radiated both authority and vulnerability. He sang Otello all over the world, including at the Metropolitan Opera, *below*, with Leonard Warren as Iago and Renata Tebaldi as Desdemona, and at La Scala, *opposite*.

Above and below left. He is seen at the Metropolitan Opera, being taken off to prison in the lead role of *Andrea Chenier*, and as a rather naked Radames in *Aida*. It was as Radames that he made his American debut in San Francisco in 1949.

to choose where they wanted to live. Del Monaco's father, who had apparently decided that his sons would be musicians, chose Rossini's charming birthplace of Pesaro on the Adriatic coast, which boasted one of the best conservatories in Italy, where Mario began to study the violin. But as an insurance policy, he stipulated he should also study art at the local academy, the foundation of a life-long passion for painting, sculpture, and architecture. At the age of thirteen, it was discovered that he had a tenor voice, and his father sent him to study with the locally well-known Professor Rafaelli.

But his next teacher at the conservatory was a woman who almost ruined him. Lamberto Gardelli, a fellow student, and later well-known conductor, advised him to change teachers and he went to Arturo Melocchi, who reconstructed his voice to its original form. This involved a singular and, for most people, dangerous method of sound emission, centered on the throat, particular to and perfect for del Monaco, but which reportedly had ruined many other voices. "My method is very controversial," admitted del Monaco many years later. "For it involves rather violent, not to say superhuman muscular exercise of the larynx and the palate. But I owe what I am to this method." He studied with Melocchi for six years, until 1936, when he was one of five students to win an advanced scholarship to the school of the Rome Opera, where he met his future wife, soprano Rina Filippini, and where his voice was nearly ruined for the second time. During his second year he returned home to Pesaro, convincing Professor Melocchi to accept him as a pupil once again.

Melocchi performed his miracle for the second time; within six months, del Monaco's voice was back in its full splendor, having regained its former amplitude and natural brilliance. At the same time he was called up in the army, but had the good fortune to serve in Milan. He fell into the hands of a music-loving colonel, who was prepared to grant him leave whenever an audition or engagement came his way.

On Easter Saturday, 1940, del Monaco made his professional debut as Turiddu in *Cavalleria rusticana*. Soon after he was invited to sing Pinkerton in *Madama Butterfly* at Milan's Teatro Puccini, which proved the real launching pad of his career, and was soon followed by the same role at the Teatro Verdi in Florence. He spent the next two years appearing all over Italy–Parma, Treviso, Sicily, Trieste–and also made his international debut at the lovely Royal Opera House in Cairo that was later destroyed by fire, as Cavaradossi in *Tosca* .

Oddly enough, his debut at La Scala in 1945, also as Pinkerton, did not cause a sensation. But in 1946 a series of appearances propelled his career forward. After successful appearances in Treviso and the Teatro San Carlo in Naples, the company engaged him for its forthcoming visit to London's Covent Garden, where del Monaco scored his first big international successes. His Cavaradossi was called "the most romantic to walk the boards of Covent Garden," and his Rodolfo, Pinkerton, and Canio were also warmly praised.

Del Monaco was then already thirty-one and hungry for recognition. After further performances back in Naples, in *Manon Lescaut* and

As of the mid-fifties, del Monaco alternated opening nights between the Metropolitan Opera and La Scala. *Opposite, right* and *above*, he is seen with Maria Callas at La Scala, as Pollione in *Norma* in 1955, and in an informal picture including another of his leading ladies, the mezzo soprano Giulietta Simionato. Del Monaco was a good colleague yet stood no nonsense from leading ladies with ideas of upstaging him by sustaining high notes longer than they thought he could, as Callas once found to her cost in Mexico City.

Fedora, his first Don José in *Carmen* was greeted with such enthusiasm that he was invited to perform it at the Rome Opera as well.

Almost immediately after his successes as José in Naples and Rome in early 1947, del Monaco was off on the first of many South American tours to Brazil and Argentina. This is where he first discovered what he would call his "best teacher" the tape recorder, which became "my mirror and my conscience." It was through these machines that he managed to improve the fault singled out by many critics and that caused him anxiety in those early years of his career: his lack of *mezza voce*. Although he corrected this to some extent, del Monaco's strength lay precisely in the power and glorious color–that single brilliant color characteristic of his voice–whose ability to excite, thrill, and send female members of the audience swooning was limitless. That is precisely what hooked the Brazilian public back in 1947 and caused his fee to rise ten times within a few weeks.

Above: Del Monaco as Lohengrin at La Scala in 1957-58, one of the most moving artistic experiences of his life. *Right*: At La Scala the same year, with Magda Olivero.

He scored an equally great success with the more knowledgeable and discerning public of the four thousand-seat Teatro Colón in Buenos Aires. "I returned from South America with my suitcases full of gold," he confided. "And I mean this literally, because I had converted all my checks into Mexican gold pieces! I sang much too much on the tour, I sang as much as I could. If I could, I would have sung day and night! It would have made me sick to let go of all that money after so many privations, efforts, and difficulties."

On his return to Italy his good looks and clarion voice attracted the attention of the film industry, and he received an offer for his first film, *The Man in Grey Gloves*, a thriller in which he sang several operatic arias. Meanwhile, echoes of his successes at Covent Garden and South America had reached La Scala, where he returned in the 1948-49 season as Des Grieux in *Manon Lescaut* and in the title role of *Andrea Chenier*, which now became one of his main battlehorses.

The 1949-50 season was to prove an important milestone for many reasons. Chief among them was his first ever *Otello* at the Teatro Colón in Buenos Aires. The public went wild. From that moment on, Del Monaco made Otello *his* role. He was already obsessed with it for months before he sang it. The thirty-four-year-old tenor was rewarded with an ovation the likes of which he had never seen.

But del Monaco's portrayal developed over the years: "In the beginning I was too violent, too 'external,' too up-front, especially in my scenes with Iago in Acts II and III. Then I began working out a new concept of the role. I decided that dignity was more important than passion. I began to see him as a man too noble to be able to murder out of jealousy alone, despite all the 'complexes,' such as age and color, that might push him beyond the brink, to say nothing of Iago's expertise at inflaming him. I think he kills in the name of justice, because even in his fury he demands 'a sure, visible proof' before enforcing what he called 'the supreme laws.' Formerly I believed that Otello killed only in a jealous

frenzy. Now I think him a judge and not an assassin."

By the sixties, del Monaco had refined his concept even further: "In the end, I came to view *Otello* as a very symmetrical opera; I should sing and act the Finale of Act IV in the same way as I do the Finale of Act I: in a mood of serenity, perfectly illustrated in Verdi's music. At the beginning, in '*Gia nella notte*

densa s'estingue ogni clamor,' it's a joyous serenity in love; and at the end, '*niun mi tema,*' it's serenity in death."

Del Monaco had arrived at the Met during the 1950-51 season, after his very successful 1950 North American debut in San Francisco as Radames in *Aida*. He stayed on at the Met for ten seasons, and sang in four opening nights; two *Aidas* with Zinka Milanov in the title role, *Norma* with Maria Callas, and *Tosca* with Renata Tebaldi. He was to total almost

A group shot, after a performance of Berlioz's *Les Troyens* at La Scala in 1959-60. Aeneas was an ideal role to convey del Monaco's glorious, heroic voice. Kneeling is Piero Zuffi, behind him the conductor Rafael Kubelik, and next to Kubelik the mezzo soprano Nell Rankin.

1954-55 with *Norma,* in which he sang a splen-did Pollione opposite Maria Callas, with whom, despite reports in the press to the con-trary, he enjoyed a fruitful collaboration and held in high esteem.

Of del Monaco's worldwide performances in the fifties, several stand out: two produc-tions in Florence–*La forza del destino* in 1953 and *La fanciulla del West* in 1954–under the baton of Dimitri Mitropoulos, and his first Otello at the Vienna state opera under Her-bert von Karajan. During the late fifties, del Monaco signed an exclusive contract with Decca, to which he remained faithful for the rest of his life. He also acted in five Italian films as an actor, and was considered both a good enough actor and sufficiently photo-genic for Metro Goldwyn Mayer to consider him for *The Student Prince* instead of Mario Lanza. But as his operatic commitments pre-cluded taking months away from the stage, these plans came to nothing.

Del Monaco, never a man to rest on his laurels, found new challenges, including his first Aeneas in *Les Troyens* at La Scala, a role that demands almost a heldentenor voice, and Samson at the Paris Opera and the Met in 1959-60. The public flocked to all thirteen performances, and when he took his Samson to the Paris Opera in 1960 he was awarded the Silver Medal of the City of Paris.

One of the challenges that del Monaco was greatly looking forward to in the early six-ties was an expansion into the Wagnerian repertoire in a new production of *Rienzi* at La Scala in 1964. He had already sung *Lohengrin* there in 1959 and Siegmund in Stuttgart, to the evident delight of Wieland Wagner, with whom he had had numerous conversations about possible Wagnerian roles. "The Wagner heroes, as I felt them, touched me deeply," del Monaco told *Opera News* at the time. "I always gave my all, even if I took precautions. Wieland had thought about me as Tannhäuser or Lohengrin, which I consid-ered too lyrical for my voice. As far as I was concerned, from the purely vocal point of view, the German master's role that suited me best was Siegmund, which is more baritonal.

Opposite, below; Canio in Leoncavallo's *I pagliacci* at the Metropolitan Opera. His first performance of the role there was in 1953 with Delia Rigal as Nedda and Leonard Warren as Tonio.

150 performances in sixteen roles, including all the parts he came to be closely associated with: Andrea Chenier, Don José, Canio, Turiddu, Manrico, Enzo in *La Gioconda,* and Alvaro in *La forza del destino.* He left the Met in 1961 when, despite the management's pre-vious promise, another tenor was chosen to open the season.

From the mid-fifties on, del Monaco had begun alternating opening nights at the Met with those at La Scala. They began in 1953 with Catalani's *La Wally* and continued in

But spiritually I had experienced a profound joy when singing Lohengrin at La Scala, albeit in Italian, and felt strongly excited by what amounted to a total novelty for me. For Wagner's music is a great change from my usual roles and brings me close to a philosophy unknown to the Italian lyric tradition. One knows that Wagner always composed his works on the theme of idealized love; in *Lohengrin* I am a superior being, detached from this world, capable of loving Elsa without touching, without possessing her. And this, basically, is the greatest joy in singing the Knight of the Swan, this sensation of floating above terrestrial feelings that permeates every single note and, if he feels it, transforms and transports the singer to the very depths of his being."

But del Monaco's profound and moving need to experience this different dimension was to remain unfulfilled. He had always been passionate about fast cars and owned a number of the very fastest, but in 1963 he crashed into an oncoming truck. He was dragged from the wreck bleeding profusely, with his left leg smashed. When it was finally reconstructed it ended up eighteen inches shorter than his right. But before he would let the doctors carry on with their transfusions and injections, he let out a loud high C to reassure himself that the voice, at least, was intact. He spent three months in the hospital and three months in rest and rehabilitation, to learn to walk again more or less normally. His only goal was to be able to sing on stage once again.

Sadly, his first appearance after the accident was not *Rienzi* as planned, because soon after the beginning of rehearsals he contracted jaundice, and the project had to be abandoned. But in the summer of 1964 he sang Cavaradossi in Puccini's birthplace of Torre del Lago, the only time in his career when he felt nervous. Before his retirement in 1975 he managed to learn two new roles: Stifellio, which he sang at the San Carlo in Naples, and Luigi in Puccini's *Il tabbarro* at Torre del Lago in 1974. His final role was Canio at the Teatro Massimo in Palermo in 1975.

There were overtures from the San Francisco Opera for a comeback, but he always declined. He retired to his luxurious Villa Luisa in Lancenigo near Treviso, surrounded by his collections and indulging his passions for interior decorating and painting. (He also owned a large nine-room duplex apartment in Milan, an apartment in Manhattan, and a property outside Rome.)

But however passionate about his hobbies and happy in his homes, one cannot imagine Mario Del Monaco existing without music. (Nor could he: when Giuseppe di Stefano visited him in the hospital, del Monaco said, "If I can't sing again, I'll kill myself!") He took up teaching and giving master classes.

About eighteen months before his death, he was visited at his country villa by Lanfranco Rasponi, who found him as handsome and immaculate as ever and as proud. There was no hint of complaint about the torment of undergoing four hour sessions of dialysis three times weekly for a kidney dysfunction. Yet Rasponi was deeply distressed to feel that "this veritable lion of a man" was now somewhat caged. Del Monaco's parting words were: "Looking back, I know I achieved all I set out to do. I got a lot and gave a lot ... the present I don't wish to discuss. Let's be thankful for what has been."

Samson, in Saint-Saëns's *Samson et Dalila*, was one of del Monaco's favorite roles, in which he particularly stressed the hero's humanity and vulnerability. *Above* is the Metropolitan Opera production in which he first sang in 1958 with Risë Stevens in the title role, and *opposite*, he appears in the same opera at La Scala with Giulietta Simionato.

Giuseppe DI STEFANO

"The only thing today's tenors seem to think about is preserving their voices," mused Giuseppe di Stefano in an article about his friend, Luciano Pavarotti. "Everything boils down to money. But when one is too preoccupied about one's voice, the interpretation suffers. Personally, I always tried to sing the way Verdi wanted, thinking mainly about the text, the meaning of the words. The music should follow afterwards, and follow naturally. When singing, most tenors try to visualize the notes. I tried to visualize the words. My friend Luciano keeps telling me that my way of singing ruined my voice. Maybe he is right. But I sing on every day God grants me, and never listen to anything I'm told. I just love singing."

This accurate self-appraisal points to why di Stefano's splendid career, which began brilliantly when he was twenty-five, ended after just over a decade on stage, although he did continue giving concerts for a lot longer. But di Stefano, a lyric tenor with a velvety voice of rich texture and substance, unfortunately didn't believe either in coaches or the importance of a sound singing technique. "There is nothing to teach. I study every day. I always have and always will," he said in an interview in the eighties, long after his retirement, "but nobody can teach you how to sing."

Di Stefano may not realize it, but this attitude precluded his vocal longevity and the fulfillment of his terrific potential. Singers who have studied technique–Pavarotti and Domingo in recent years, not to mention those paragons Bergonzi, Gedda, and Kraus–often have careers of thirty-five years

or more. But artists neither can nor, perhaps, should change their psychological makeup, and when they walk on stage singers carry with them all their emotional, intellectual, and metaphysical baggage.

Di Stefano's gorgeous, natural lyric voice, sunny, engaging personality, and gift for communication made him one of the most popular tenors of his day. He was especially loved by the capricious Milanese from the moment he made his debut at La Scala in 1947, when he was just twenty-six. Despite the fact that, as some critics have pointed out, the very qualities that endeared him to the public also worked against him, his popularity, which at

Left: The moving death scene of Mimi in Puccini's *La bohème* at La Scala during the 1958-59 season.

Right: Maria Callas, the great Greek diva, takes a curtain call with di Stefano and Maestro Carlo Maria Giulini, after the second act of the La Scala *La traviata* seen on the previous page. Di Stefano and Franco Corelli were Callas's most frequent tenor partners during the last decade of her career, and after she retired, Callas attempted a comeback in concert with di Stefano. It was too late for both of them, as their voices were in tatters.

times approached a collective madness, represented genuine adulation rather than fame fabricated by the media and the recording industry, as is so often the case today. Despite his short-lived career and misgivings of some critics, no one can dispute Carlo Maria Badini, former general director of La Scala, who said that "this champion of genius and abandon gave his audiences immense pleasure every time he sang."

Di Stefano's repertoire consisted mainly of light-lyric and full-lyric roles, including Elvino in *La sonnambula*, Arturo in *I Puritani*, Nemorino in *L'elisir d'amore*, Edgardo in *Lucia di Lammermoor*, Des Grieux in *Manon*, Nadir in *Les pêcheurs de perles*, Alfredo in *La traviata*, the Duke of Mantua in *Rigoletto*, Rodolfo in *La bohème*, and such *verismo* parts as Cavaradossi in *Tosca*, Turiddu in *Cavalleria rusticana* and, on occasion, Radames in *Aida*.

Di Stefano's view on the selection of his roles was that tenors "should not worry or be too choosy about their repertoire or be divided into categories, like boxers. All of us should be able to sing any role in the tenor repertoire, on condition that we do so with our voice, that we stay within the limits of our voice. But if we have a lyric tenor moving into the dramatic repertoire then he could be sailing into tricky waters."

Di Stefano, known as "Pipo" to his friends and colleagues, was born in 1921 in the Sicil-

ian village of Motta Sant' Anastasia. Six years later, like many Sicilian families of that time, the family moved to Milan in search of work. At the age of sixteen, encouraged by a friend who was impressed by his voice, he decided to pursue a singing career. After two years of study with the tenor Adriano Tocchio, di Stefano won several singing competitions. In 1941 he was accepted as a student by the well-known baritone and fellow Sicilian Luigi Montessanto, a singer of the old school whose career lasted from 1915-1940. But he was drafted before he could begin his studies, and when the retreating German army reached Lombardy in 1943, di Stefano, by then discharged from the Italian army, fled to Switzerland, where he was interred in a refugee camp. There his vocal talents were recog-

Backstage after the premiere of *La bohème* are, *left to right*, the baritone Ettore Bastianini, Maestro Leonard Bernstein, and di Stefano as Rodolfo.

Below: As Calaf at La Scala in 1956 in Puccini's *Turandot*, with Birgit Nilsson in the title role.

nized, and he began to sing in local concerts and broadcasts on Radio Lausanne. These proved so popular that, as early as 1944. His Master's Voice recorded ten songs with him. After the war di Stefano returned to Milan and briefly resumed his studies with Luigi Montessanto.

In 1946, three months before his twenty-fifth birthday, he made his professional debut at Reggio Emilia as Des Grieux in *Manon*. A few months later he opened the 1946-1947 season at the Teatre del Liceu in Barcelona and made his debut at the Rome Opera House as Elvino in *La sonnambula*. His performances were well received by the public and critics alike. "His lovely timbre and expressive phrasing were quite admirable," wrote *Il messaggero*, which also said, of di Stefano as Des Grieux in the same theater six days later, "undoubtedly the best of the young singers to appear in Rome in recent years."

After singing Nadir in *Les pêcheurs de perles*, he left Rome, and an enthusiastic press and public, behind to make his historic debut at La Scala, again as Des Grieux in *Manon*, with the famous soprano Mafalda Favero in the title role. "Bardolfo," the pseudonym of a famous critic for *Il corriere della sera*, wrote that di Stefano "only had to come on stage for the Chevalier Des Grieux to leap from the pages of Prevost's novel. I have never seen it before, in any *Manon*, and I can't imagine it happen-

In September 1951 di Stefano made a crucial debut in Rio de Janeiro, singing Alfredo in *La traviata* with Maria Callas in the title role. The following year he sang a string of performances with her in Mexico City: Alfredo, the Duke of Mantua, Edgardo in *Lucia di Lammermoor*, Arturo in *I Puritani*, and Cavaradossi. It was the beginning of a long and rewarding artistic partnership and friendship that has been immortalized in vintage recordings made by EMI from 1953 to 1958, when di Stefano's voice was still at its best. The freshness and ardor of delivery give us an inkling of the qualities that so aroused the audiences of the day. Peter Andry, then head of EMI, remembers that Pipo "sang wonderfully well. At that time his voice was at its best. The material itself was lovely, like a fine wine. You seemed to hear so many overtones and details you never heard with anyone else. I feel that the fact that Italians at the time expected their tenors to sing flat-out all the time had a lot to do with eventually impairing this quality."

Soon di Stefano's lack of technique really began to cause problems. As early as 1953 he was booed at La Scala for a poor performance as the Duke of Mantua in *Rigoletto*. "Bardolfo," a former admirer, wrote: "Why a young man of such talent as di Stefano should have taken such a dangerous path remains a mystery to me. There is no doubt that singing so openly, constantly forcing the sound to its limit, using

Above: Di Stefano in Leoncavallo's *I pagliacci*, as Canio the grieving clown who must give a performance.
Center: With Edward Johnson, the elegant general manager of the Metropolitan Opera, where di Stefano made his debut as the Duke of Mantua in Verdi's *Rigoletto* in 1948. Johnson is seen with the tenor, reading congratulatory telegrams.

ing again. He is a fine looking man, he moves well, has a bright, penetrating gaze, his gestures are spontaneous and his diction crystal clear." As for his singing, the critic praised "the gentle, ingratiating quality of the voice and its refined, well-blended sound in the middle register," but expressed reservations about the young singer's way of approaching top notes. This soft alarm bell, as fellow critic Giorgio Gualerzi called it, would soon start ringing loudly as the young tenor broadened his repertoire. But di Stefano ignored recommendations that he sing more carefully, which would have meant covering the *passaggio* notes (F and G) by closing the throat a little to ensure a secure top register. He considered this anathema: "It alters the quality of the sound and renders technique too evident. A good technique should never be noticeable. But in my opinion closing the throat produces the effect of a cold shower." Yet di Stefano's lack of technique didn't immediately affect the course of his career. He became La Scala's top tenor, just as Pertile had been in his time, and no one else since. His great success at La Scala led to his 1948 debut at the Metropolitan Opera, to which he returned regularly until 1952, then again for the 1955-1956 and 1964-1965 seasons.

voice, and came to rely on the impact and easy appeal of his impassioned delivery, however generalized and superficial." His rejection of technique also forced him to abandon some roles that he could no longer handle, technically or stylistically, and take refuge in parts where a generic vocal style masked his technical deficiencies and lack of stylistic understanding and finesse.

Di Stefano's reckless and self-indulgent attitude toward his gift and his art not only prevented his voice from lasting but also kept him from exerting the lasting influence on the art of tenor singing that his early performance had promised. He was still capable of giving immense pleasure to audiences—in his debut in Chicago, in Berlin in 1955, and Vienna in 1956 as Edgardo—but most likely this pleasure would have been even greater if his public had been given the chance to follow their idol's progress to full vocal and artistic maturity. Other circumstances worked against him as well: by the late fifties, di Stefano had developed a respiratory problem that seriously affected his stage performances, and he concentrated only on concerts.

In 1973 di Stefano persuaded Callas to come out of retirement, and the two embarked on a world tour of recitals. Both artists were mere shadows of their former selves, but the performances were probably good for their morale and deepened their friendship. Peter Andry remembers that di Stefano, a lovely man, always good fun, who always apparently enjoyed himself, was warmly supportive of his partner. After Callas's death, Pipo's tribute was among the most moving and perceptive.

Di Stefano's depth of feeling and warm heart make doubly sad his early artistic self-destruction. And rather than squander his gift as so many others did, by singing the wrong repertoire, he abused it by singing the right repertoire in the wrong way: without a technique.

Left: Di Stefano singing the superb tenor aria "*Recondita Armonia*" in the first act of Puccini's *Tosca*. This performance was conducted by Maestro Gavazzeni, who is seen *opposite below* at the dress rehearsal with di Stefano. *Above, top*: He is seen with Maestro Antonino Votto, as Maurizio in Cilea's *Adrianna Lecouvreur*. All these performances were at La Scala, where di Stefano reigned for about a decade after his debut in Manon in 1946. Nobody before, except for Aureliano Pertile, had enjoyed equal adulation, and nobody has enjoyed it since.

the throat to 'spin the notes' and never singing below a *forte* not only leads to monotonous phrasing with no touches of color or subtle shading, but also causes shaky intonation."

"Basically," wrote *Opera*, "di Stefano was opting for self-destruction, sooner or later. His lack of technique began to exact a heavy toll on his voice, which was getting harder and heavier through forcing. More and more, he sang the only way he knew, at the top of his

Franco
CORELLI

Franco Corelli was the leading heroic and romantic tenor for two decades: from his La Scala debut in the mid-fifties to his premature retirement, with his voice still intact, in the mid-seventies. Strikingly handsome and tall, with the most exquisite pair of legs ever seen on a tenor, he could easily have pursued a career in the movies. Instead, the operatic world could count itself lucky. As the voice expert John Steane wrote in _The Grand Tradition_, his was "a voice one could drink and want more of... and we ought to thank our lucky stars that in a world of pop-grinding and filmmaking, a man like Corelli chooses opera."

Corelli's huge voice had both epic and romantic dimensions. Its extraordinary volume and power were controlled and refined by a sensitive and searching mind into an instrument so well focused and finely honed that it excelled in most areas of the repertoire, from _verismo_ and some of the bigger _spinto_ and dramatic Verdi roles, to the lighter, more romantic _bel canto_ repertoire. Disciplining his massive sound from what has been described as "its original, chaotic state" into a voice that could distinguish itself in so many repertoires was a truly remarkable feat requiring a phenomenal breathing technique. The achievement is even greater considering that Corelli was almost entirely self-taught, and that large voices, whether male or female, are much more difficult to harness and control than those whose volume is smaller and more manageable.

Corelli was driven and obsessive about his art, toward which he felt a burning commit-

Franco Corelli possessed not only a thrilling, heroic tenor voice but also one of the most sensational pairs of legs in operatic history, seen _left_ when he appeared as Raoul in Meyerbeer's _Les Huguenots_ in 1961-62 at La Scala, and _opposite_ as Calaf in a Covent Garden production of _Turandot_.

ment akin to that of Maria Callas, whom he often partnered on stage and records. "Singing must be taken up with love and seriousness," he told bass Jerome Hines for the latter's important book on technique, _Great Singers on Great Singing_. "You need not only a voice, but also intelligence and persistence in studying." In Corelli's case, this took the form

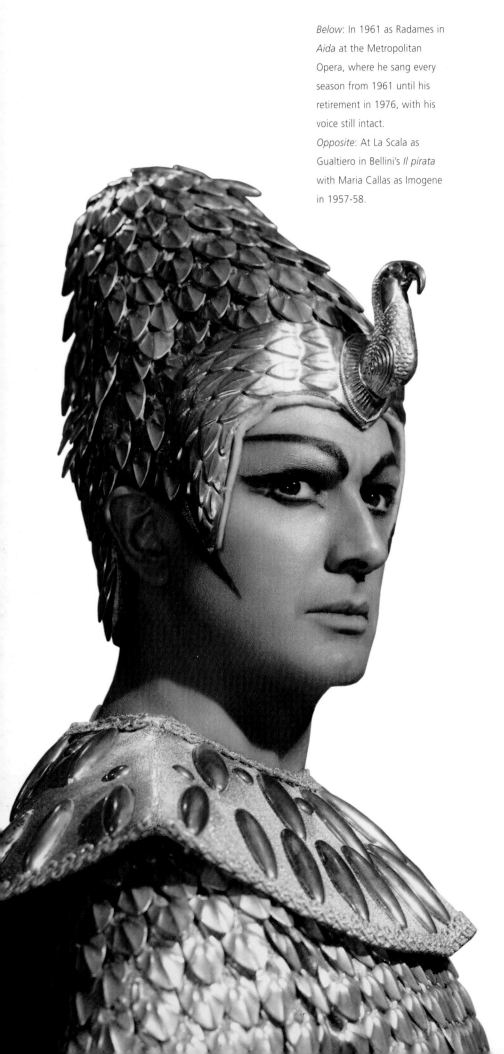

Below: In 1961 as Radames in
Aida at the Metropolitan
Opera, where he sang every
season from 1961 until his
retirement in 1976, with his
voice still intact.
Opposite: At La Scala as
Gualtiero in Bellini's *Il pirata*
with Maria Callas as Imogene
in 1957-58.

of a passionate, incessant quest to understand and know more about the voice, "because, unfortunately, the voice is a mystery. You can form and mold it, but only up to a point."

Corelli's repertoire consisted of a fascinating mixture of romantic and heroic roles. In the *bel canto* repertoire he sang Gualtiero in Bellini's *Il pirata*; Pollione in *Norma*; the title role in Donizetti's *Poliuto*; and Licinio in Spontini's *La vestale*. Select Verdi parts included Arrigo in *La battaglia di Legnano*; Alvaro in *La forza del destino*; Radames in *Aida*; and probably the most thrilling Ernani and Manrico in *Il trovatore* in living memory. In *verismo*, such Puccini heroes as Cavaradossi in *Tosca*; Dick Johnson in *La fanciulla del West*; and Calaf in *Turandot*; as well as the title role in Giordano's *Andrea Chenier*, and Maurizio in Cilea's *Adriana Lecouvreur*. He also distinguished himself in the French repertoire, especially Don José in *Carmen*, one of his greatest portrayals, and the title roles in Gounod's *Romeo and Juliette*, Massenet's *Werther*, and Raoul in Meyerbeer's *Les Huguenots*. The unique, heroic quality of the Corelli sound has been immortalized in a series of vintage recordings for EMI–many with Callas.

Corelli's only weakness was his nerves. Like many artists who strive for perfection in their work, he suffered terribly before performances and was equally nervous in the recording studio. James Lock, chief engineer at Decca, recalls, "He was a very complex, insecure man–although he had no reason to be–who became a real bundle of nerves the moment the microphones were turned on, when he would be seized by a real terror of performing. I remember a telling incident that occurred when we were recording a disc of duets with Renata Tebaldi in Geneva. The orchestra were waiting upstairs, Tebaldi was waiting upstairs in the studio, but Corelli was still lingering downstairs. Suddenly we heard a sharp, clap-clap. It was the sound of his wife, the formidable former soprano Loretta di Lelio, slapping him. 'Now go upstairs and do it,' she snapped. So up he came and sang quite beautifully, as he invariably did. But one had to keep tabs on him, because he would

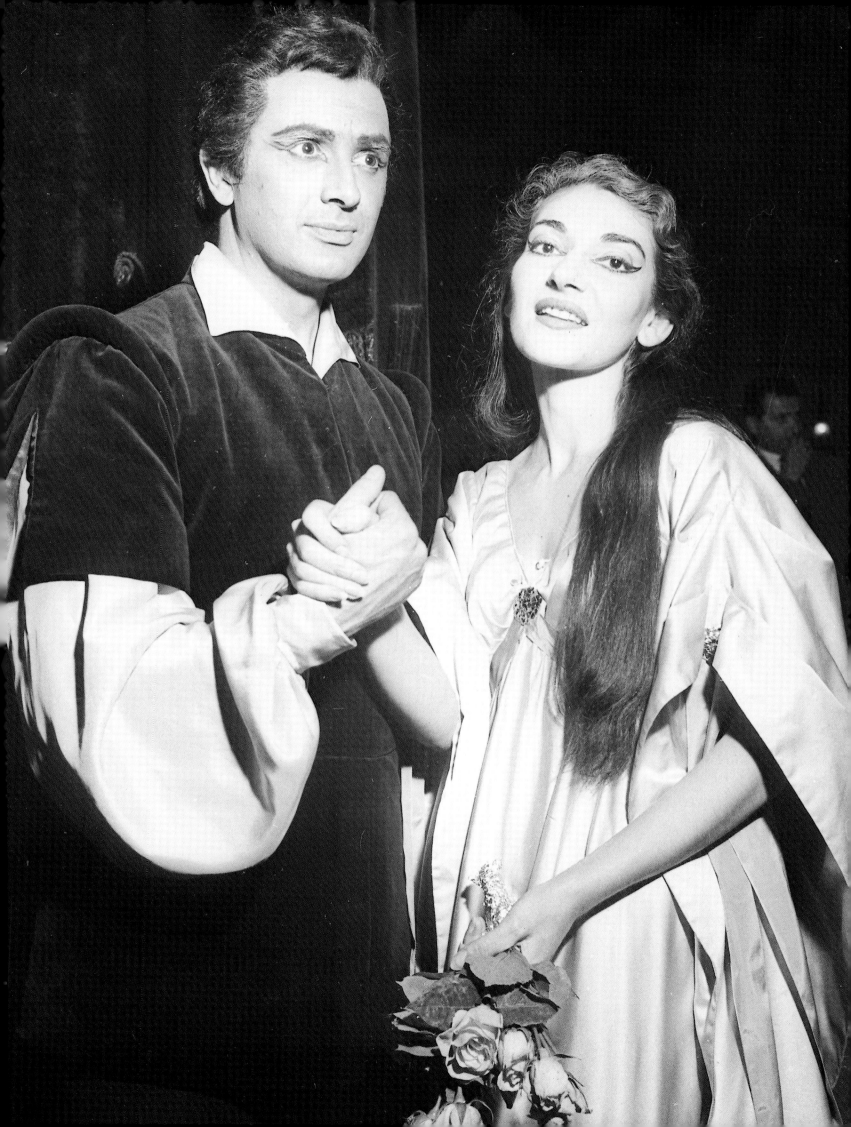

Corelli's enormous voice was so well focused and controlled that it enabled him to tackle both romantic and heroic roles, ranging from *bel canto* to *verismo*. *Center:* As Don Alvaro in Verdi's *La forza del destino* at the Metropolitan Opera with Leontyne Price as Leonora, in a performance broadcast in 1968 that included Robert Merrill and Jerome Hines. *Right* in the title role in *Andrea Chenier*, one of his most famous roles at La Scala in 1959-60.

Above as Maurizio in Cilea's *Adriana Lecouvreur* in 1963 at the Metropolitan Opera with Renata Tebaldi in the title role.

sometimes do a disappearing act. He was just eaten up by nerves and insecurity."

Corelli was born in Ancona, on Italy's Adriatic coast, in 1921. Unlike most professional singers, he never sang when he was a child and only discovered his voice at the age of eighteen. He then entered a local contest at which the composer Ildebrando Pizzetti was present. He was so impressed by the size and volume of the young man's voice that he told him to study singing. Corelli's appraisal of himself and his voice at the time is characteristically self-deprecating. "I had plenty of volume, but the voice was incomplete," he explained to Jerome Hines. "I had no high notes. I had a problem reaching up even to a B-flat. It was a yell. So when I returned home to Ancona, I began to do some vocalizing with a friend who was studying with Mario del Monaco's teacher, Maestro Arturo Melocchi, in neighboring Pesaro. My friend Scaravelli was a young man passionate about understanding vocal technique. Working with him and all the information he brought back from his sessions with Melocchi was like a scientific study for me."

In 1951 Corelli won the Maggio Musicale Fiorentino vocal competition and made his debut in Spoleto as Don José, which would remain one of the greatest roles in his repertoire. He played the same role the following year in Turin, where he also sang his first Cavaradossi, opposite Maria Caniglia, both heavy roles for a beginner. This is where the eminent Italian musicologist Giorgio Gualerzi, who later became a lifelong admirer of Corelli, first heard him. He was immediately struck by "the contradiction between his striking physical presence, which gave him a certain ease and authority on stage, and a vaguely timid air. There was at all times something anxious and unsure about him, odd in a young man of thirty, and which would stay with him throughout his career." But in those days the self-taught Corelli still had considerable technical problems, and Gualerzi's first response to him was suspicion.

In 1954, three years after his professional debut, Corelli made his debut at La Scala, as Licinio in *La vestale*, with Maria Callas in the title role. It marked the beginning of a steady relationship with Italy's premier opera house, where in the next few years he would sing most of his great roles: Pollione, with Callas as

Norma; Poliuto, with Callas as Paolina, in 1957; and Gualtiero in *Il pirata* (performed for the first time in 118 years), again with Callas as Imogene. Corelli's Gualtiero dispelled Giorgio Gualerzi's reservations and converted him into an ardent devotee. "Here," he wrote, "one could witness a tenor at the height of his powers, a tenor rooted in late-Romantic music, with some *verismo* influence and, despite his extraordinary vocal and dramatic power, tempered by a certain distaste for coarse effects." Also in 1957 came Corelli's debut at Covent Garden, as Cavaradossi.

Now stronger technically, Corelli began to move to such higher roles as Manrico in *Il trovatore*, which he first sang in 1958 and in which he would make his Metropolitan Opera debut in 1961. But before he could sing this he had to find his top notes. He did so mostly by listening to recordings of other tenors, especially Caruso. He explained to Jerome Hines: "In my earlier years I had sung a very heavy repertoire. When I first started singing Pollione, for instance, I used to make my voice very heavy. Then, when I began singing Manrico and Calaf, both very high roles, I tried to put the voice in a lighter position and make it brighter. Before that it was quite baritonal. But going for a higher sound also opened up the high notes. In 1960 I found a way of singing right up to D-flat. This lightness that gave me the extra notes at the top also brought a little more sweetness and gentleness to the voice. I began to sing more 'on the breath.' Imagination plays a crucial part in singing. Basically, it's the brain that commands. But when on stage there are so many other things to think about besides voice emission; you have to move, interpret, follow the conductor, watch the prompter. Yet in spite of all of this you still have to control the sound. By which I mean that technique involves more than just thinking about singing a sweet, beautiful note. You must simultaneously 'think sweet,' *technically* as well. It's certainly not true that you can always be completely free of technique. Only when you're singing easy passages, can you do so without thinking. When the voice is rightly

placed, singing is like walking. You don't usually have to think consciously about walking. But if you have to climb a flight of stairs, you had better pay attention to the steps, or you'll fall flat on your face."

By the early sixties Corelli had gained full control of his spectacular vocal instrument and his career began to benefit. His triumphant debut at the Metropolitan Opera in 1961 as Manrico led to annual appearances there, where he sang most of his great roles

Here, Maria Callas's acting abilities are perfectly demonstrated. She plays Paolina in Donizetti's *Poliuto*, with Corelli in the title role. This 1961 performance was a revival after a lapse of 31 years. Leopold Stokowski was the conductor and the sets and costumes were designed by Cecil Beaton.

Corelli in one of his most famous roles, at which he has yet to be topped; Calaf in *Turandot* at the Metropolitan Opera with Birgit Nilsson as his partner in the title role. They often verbally sparred on stage.

than anything, Corelli's typically impassioned phrasing and delivery." Soon after, in 1963, Corelli also made his debut at the Vienna State Opera, and San Francisco. He was now at the top of his field.

Corelli's intensely emotional, highly strung nature and his stage fright contributed to his temperamental personality on and off-stage. Scores of anecdotes circulated during his days at the Met about his rivalries with some sopranos, especially Birgit Nilsson, his frequent partner in *Turandot*. Despite the rumors, he did not bite her during a Boston performance of *Turandot*, but he did upstage her in the final duet, by changing the words of the libretto. When Turandot sings "*la mia gloria é finita*" (my glory is over), and the tenor is supposed to reply, "no, no, it's just beginning," Corelli apparently replied, "*si, é finita*" (yes, it's over). But the second time, as Nilsson told *Newsweek*, she attempted to even the score by singing, "now your glorious time is past," to which he replied, "oh no, it's just beginning." "In Italy the tenor always comes first," was Corelli's laconic comment, "but in America, you have a matriarchal society."

By the mid-seventies, the stress and pressure of producing such supercharged performances night after night got the better of Corelli. The strain of living up to the Corelli phenomenon had become acute. Suddenly in 1976 he decided to retire, for no apparent vocal reason. Shortly before, in March of that year, he gave an indication of his state of mind to an American journalist who interviewed him for *Newsweek* shortly before the premiere of *Romeo et Juliette* in Miami: she found him closeted in a hotel room, with cardboard pasted over the air conditioning, worried sick about being sick.

"I have always been afraid," he confided. "In the beginning I was afraid because I didn't have the B-natural and the high C. Later, when I did have them, I became afraid I might lose them. Sometimes I wake up in the morning and the voice doesn't answer. If I'm on holiday and not singing I worry if the voice is still there. I tape every performance. After the performance, I spend three hours

and acquired a tremendous following. During the same year he also made his debut at the Deutsche Oper in Berlin, and in the following year gave one of the greatest performances of his career as Raoul, the fiendishly difficult tenor hero in a star-studded production of *Les Huguenots* at La Scala. "A Raoul of extraordinary vocal and dramatic power. In fifty years of opera-going I have rarely felt such intense emotion," wrote Giorgio Gualerzi in *Opera*. "At the end of that stunning duet at the finale of Act IV I found myself on my feet in the press box shouting with enthusiasm for, more

listening to it. I'm exhausted, I need rest, but I can't sleep. If the performance was good, I can't sleep for joy. If it wasn't good, I can't sleep for despair. What is this life? It's the life of a prisoner, in a hotel room, in front of the television, or playing solitaire. You know, I was born free. I was born just 50 meters from the sea, in Ancona. Caruso said it best, 'We tenors know our beginning but not our end.'"

The end of Corelli's glorious career was sudden, premature, and a devastating blow to the operatic firmament, now bereft of one of its brightest stars just at the time when video and television were beginning to make such dramatic inroads in the way opera reaches and is perceived by the masses. One can only guess at the impact Corelli's electrifying voice and stage presence (to say nothing of those legs) would have in this new, televisual era. As it happened, his successors reaped the benefits of this expansion. Interestingly, though, Corelli's voice continued to be in top condition for many years after his retirement. Around 1980, he sang two arias at the New Jersey State Opera annual ball and brought the house down. Pandemonium also ensued after a couple of other select appearances, but even the sound of his own glorious instrument in peak condition could not tempt him back to the boards.

These photographs demonstrate the quality of both the productions and casting at La Scala in the 1950s when Antonio Ghiringel'i was the director.
Above: A dress rehearsal of Verdi's *Il trovatore* with, left to right, Corelli as Manrico, Fiorenza Cossotto as Azucena, conductor Gianandrea Gavazzeni, and Ettore Bastianini as the Conte di Luna.
Left: Discussing the staging of *Poliuto* with the designer Nicola Benois and an anxious Maria Callas. Benois, who came from a Franco-Russian family that had created the Bolshoi theater in Moscow and produced many leading ballet and opera designers, was extremely active at La Scala for nearly a quarter century.

Carlo BERGONZI

Carlo Bergonzi has been called "a miracle" by fellow tenor Jon Vickers, while soprano Magda Olivero sums up his artistry as "a superior vocal civilization." Voice experts and musicologists also heap praise on this small, stocky, affable man who combines Italian charm and warmth with the wit, robustness, forthrightness, and tenacity typical of people from his birthplace, Emilia. "All students of tenor singing should, as an obligatory part of their education, listen to Alfredo Kraus singing the French repertoire and Carlo Bergonzi singing Verdi," states the eminent London-based laryngologist Dr. E. Khambatta, who has treated most great singers over the past thirty years. "He only has to open his mouth and sing a single phrase for all the instinctive impulses that bind me to Verdi to spring alive," wrote distinguished musicologist Rodolfo Celletti.

When Bergonzi sings Verdi, the listener is aware of a fusion between the composer and his interpreter and a conviction that everything about his singing is right: the size, timbre, and colors of his voice, the accents, the special way of singing *legato* and declaiming, and, most important of all, the proud, noble virility of his Verdian phrasing. To be sure, Bergonzi is also an excellent singer of *verismo* and some of the *bel canto* repertoire, but it's mainly as a Verdi tenor that he has earned his place among the immortals of opera.

Bergonzi's flair for creating an instant Verdian atmosphere seems even more remarkable considering that he was always rather static on stage. He is, however, an exception among singers whose acting was rudimentary:

through the vividness, power, and sheer commitment of his vocal characterizations Bergonzi succeeded in convincing the audience that they were in the presence of the characters he portrayed. His interpretations rang true. The sunny timbre of his beautifully modulated lyric voice was devoid of any hint of metal and possessed a radiant luminosity that caressed, rather than scorched, the ear. His Verdian phrasing was considered by Celletti "the most authentic to be heard in the past forty years, not only among tenors but also among baritones and basses."

Opposite: Carlo Bergonzi as Nemorino in *L'elisir d'amore* at Covent Garden and *below* as Manrico in *Il trovatore* with Gwyneth Jones as Leonora at La Scala in 1966-67. Although Bergonzi was a distinguished interpreter of both *bel canto* and *verismo*, it is as a Verdi tenor that he earned his place in the operatic pantheon.

Bergonzi sang the entire Verdi lyric and *lirico-spinto* repertoire with equal ease. The only Verdi tenor role he didn't perform on stage was Otello, which he considered too dramatic for his voice: "I just never found the right colors for Otello–colors that would instantly convey a great commander. To me the only tenor who possessed these colors was Ramon Vinay."

Even his birthplace seems to have played a part in turning Bergonzi into a Verdi tenor. He was born on July 13, 1924 in the hamlet of Vidalenzo halfway between Verdi's birthplace Bussetto, and his villa at Sant'Agata. His father, a cheesemaker by profession, was an ardent opera lover and took his six-year-old son to a performance of *Il trovatore* at the local theater. The child was spellbound, and next morning could be found in the family kitchen singing what he could remember of "*Di quella pira*" with a pasta-making utensil substituting for Manrico's sword. During his growing years he sang in local churches and as an extra in productions at the local theater. In 1938, at the age of fourteen, he finally made up his mind to be a professional singer: "It was on a hot August morning and, as usual in the school holidays, I was working in the same cheese factory as my father, pushing a wheelbarrow full of coal for the cheese machines, and singing. The boss stopped me and said, 'One cannot do things at once. One can either work, or sing.' Hot, tired, and exasperated, I exclaimed: 'In that case, I'd much rather sing!' I flung away the barrow and ran into the shed where my poor father was churning the cheese molds. Surprised, he looked up questioningly. I told him what had happened. 'Good,' he smiled, 'Now go home.' Next morning with his blessing, I went to audition for the baritone Edmondo Grandini, who was singing Rigoletto in Bussetto."

Grandini thought Bergonzi had a promising voice, but classified him as a baritone. He

added that since he was about to retire, he would be prepared to give Bergonzi singing lessons if the young man didn't mind studying in Grandini's home town of Brescia. Bergonzi agreed and stayed in Brescia till the onset of the war, when he became active in the anti-Nazi resistance. In 1943, while serving in the military in Mantua, he was captured by the Germans and spent the rest of the war in a German prisoner-of-war camp. He returned to Italy at the end of the war, "bursting with the desire to sing." He enrolled as a full-time student at the Boito Conservatoire in Parma, where he studied for three years. The training he received there was so thorough that he has since been able to study his roles alone.

His professor in Parma was Ettore Campogalliani, who also taught Tebaldi, Scotto, Freni, Pavarotti, and Raimondi. He also classified Bergonzi as a baritone, as did the famous conductor Tullio Serafin, for whom he auditioned at La Scala in 1947. Although Bergonzi always felt he was a tenor, he didn't

dare contradict the experts, and so he began his career as a baritone. He made his debut in Lecce as Figaro in *Il barbiere di Siviglia*, and sang baritone roles for three years, often with great tenors such as Schipa, Tagliavini, and Gigli, who was then approaching the end of his career. "The only problems I had were the top notes F and G-sharp. Hardly surprising, I would add with hindsight, because the bari-

Right: At La Scala, after
the *Aida* performance
seen on the previous
page (*left to right*:
Bergonzi, Maestro
Gianandrea Gavazzeni,
Franco Zeffirelli,
Leontyne Price, and two
admiring members of
the audience.)
Left: A 1966 rehearsal
for *L'elisir d'amore* at La
Scala with, *left to right*,
Bergonzi, who appeared
as Nemorino, Mario
Sereni as Belcore, and

Renato Capecchi as
Dulcamara.
Right: In *La Forza del
destino* at Covent
garden.

dramatic passages, and how to shape broad, soaring phrases. From Schipa I learned a crucial thing which became an essential part of my technique: how to produce light, soft sound at the top of the register and how, through a hidden and highly skillful recourse to the nasal cavities, to blend the chest and the head voice in the *passaggio* zone."

Another important lesson was the power of acquired knowledge to augment one's natural voice. Bergonzi felt that Schipa's and Pertile's voices were only comparable to those of Caruso and Gigli due to the former's voice training and interpretation. "This is what vocal technique is all about," says Bergonzi, "to enable an artist to reach a level of excellence where it's impossible to guess which qualities were innate and which acquired."

Bergonzi's intelligent management of his own vocal resources and his phenomenal breathing technique are the secrets of his success. A sound breathing technique is the foundation for all good singing. So much so that when Bergonzi was asked to describe his technique, he would reply, "I breathe." He relied so much on breath control and the need to keep his diaphragm elastic that he did

tone's high notes coincide with the tenor's passaggio notes—E, F, and G above middle C. So clearly something was wrong."

This "something," as he discovered on October 12, 1950, was the fact that he was, indisputably, a tenor. He was singing Sharpless in *Madama Butterfly* in Livorno at the time and had made a bet with himself to try to reach a high C while vocalizing before the performance. He succeeded, effortlessly. Elated, Bergonzi realized that a singer who cracks on F but can sail up to a high C is not a baritone, so he began to re-train his voice for the tenor register using only the recordings of four great tenors—Enrico Caruso, Beniamino Gigli, Tito Schipa, and Aureliano Pertile—as a guide. He didn't aim to copy these artists, but rather to learn, through their techniques, how to solve his own vocal problems.

"When hearing Gigli's amazing use of the *mezza voce*, I would ask myself, 'How does the man do it?' Then I would try singing the same phrase with my own voice until I found the position used by Gigli. When listening to the pulpy, powerful, yet never forced notes of Caruso I tried to figure out exactly how he supported them. From Pertile I learned the all-important lesson of alternating singing '*piano*' with singing '*forte*,' even in the most

breathing exercises for half an hour every morning. "Nothing spectacular, just breathing naturally, inhaling and exhaling rhythmically, to help the diaphragm retain its elasticity. Vocal sound is the result of a huge muscle apparatus. Therefore, the best way to warm up the voice is by warming up those muscles." Before a performance he vocalized minimally, just the *passaggio* notes because "if those are in place everything else will happen naturally."

Three months after switching to the tenor register Bergonzi was ready to make his real professional debut in the title role in *Andrea Chenier* at the Teatro Petruzzelli in Bari. His big international break came in 1955 when he made his American debut at the Chicago Lyric Opera, where he sang Turiddu in *Cavalleria rusticana*, Luigi in *Il tabarro*, and Avito in *L'amore de tre re*. The following season, 1956–57, he sang Manrico and Radames at the Metropolitan Opera, to which he returned almost every season into the mid-seventies. In the late 50s he also started what were to become regular annual appearances at the Verona Arena and in 1962, made his Covent Garden debut as Alvaro in *La forza del destino*, returning there for most of his Verdi and Puccini roles. La Scala lagged behind–as it later did with Pavarotti–although Bergonzi had made his debut there in 1955 following Giuseppe di Stefano in *La forza del destino*. It was for the late Maestro Herbert von Karajan that he sang Radames and the Verdi *Requiem* in 1963, performances that revealed to La Scala's audience and manager Bergonzi's true worth.

Bergonzi shares vocal longevity with Alfredo Kraus and Nicolai Gedda. In fact an enterprising manager once tried to get them together for another version of a "Three Tenors" concert, but they all declined. Bergonzi, who was awarded the Caruso Prize in 1981 for being "the ambassador of Italian *bel canto* worldwide," says that one of the proudest moments of his career was singing Edgardo at the Covent Garden production of *Lucia di Lammermoor* (1985) with Dame Joan Sutherland in the title role. At the age of sixty-one this performance still prompted a

rapturous public reception as well as praise from leading critics. "The attack and accuracy of this tenor remain undimmed, and the way Bergonzi started the sextet should be a model for all aspiring Edgardos," wrote *The Times*. Bergonzi commented, "Being able to pull this off at my age *was* satisfying, I must say."

In his later years, Bergonzi–like many artists–moved from opera productions to such recitals as the one *above* at La Scala in 1983. *Below*: The tenor is seen at home in Milan; he also owns a country inn called I due foscari, after Verdi's opera. A photograph of his own two sons is on the piano.

Nicolai
GEDDA

"I always wanted a long career. Not a short, glittering, Callas-type thing, but a long, solid, fine career and the gratification of knowing that the people who come to my performances and recitals now still go away feeling satisfied and enriched. That has always been my ideal. So I took care of myself and sacrificed certain things. You have to, if you want to last. You have to be in good physical shape and very disciplined."

Gedda, now seventy-two, continued his operatic appearances until his late sixties and still gives occasional recitals, which remain a lesson in stylistic perfection. His abilities as a stylist and linguist–he sings with perfect diction in six languages–earned him the Nobel Gold Medal in 1976 and the label "A paragon of extraordinary and unusual artistry." He is also one of the most prolific and versatile tenors in the history of the operatic stage, with a repertoire of over seventy roles in all styles of singing.

He attributes his stylistic excellence largely to his expertise as a linguist, and his vocal longevity to his excellent technique. Unlike many of today's younger singers, who leave their years of study behind once they make their debut, Gedda has never ceased to work at his technique throughout his forty-plus-year career. "Technique, above anything else, determines a singer's lasting power and level of artistic excellence. The human voice is like a diamond–in need of constant polish, without which it becomes abused. The first telltale signs are tiredness and wear and tear, then the high notes disappear, and so on. Technique becomes even more important with

advancing years because after a certain age, the muscles tend to stiffen so that you cannot absolutely rely on them. That's why, if you want a long career, it's vital to have a good technique." It's also vital for singers to look after their health and refrain from smoking, excessive drinking, too much night life, and even from an excessively active sex life. Gedda explains that he has led a normal, moderate life. "I haven't lived like a monk or a hermit but I've always been conscious, at the back of my mind, of the need to exercise care."

Gedda has also exercised self-discipline in choice of repertoire, only singing roles with which he felt "personally happy." His seventy-

Opposite: Nicolai Gedda as Nemorino in Donizetti's *L'elisir d'amore* at the Rome Opera in 1980 and *above*, in the title role in Berlioz's *Benvenuto Cellini* at La Scala in 1975-76; he was the only tenor of his day capable of tackling this fiendishly difficult, very high part.

recording of the Bach *B Minor Mass* and made his debut at La Scala as Don Ottavio. His voice and knowledge of French secured him a three-year contract with the Paris Opera, where he made his debut in 1954 as Huon in Weber's *Oberon*. Later on in the 1954–55 season, he made his Covent Garden debut as the Duke of Mantua. Thus, in the two years since his debut in Stockholm, Gedda had embarked on a fully fledged international career. He made his Salzburg Festival debut, as Belmonte, in 1957, followed in the autumn of the same year by his American debut as Faust in Pittsburgh and, a month later, by another triumphant debut in the same role at the Metropolitan Opera. In January 1958 he sang the tenor lead, Anatol, in the world premiere of Samuel Barber's *Vanessa* as well as Don Ottavio. His impact on Metropolitan Opera audiences was so great that he was invited back several times every season for the next twenty years.

His international career made it impossible for him to study regularly with Oehmann, so Gedda began to search for a new teacher. He found one in Madame Paola Novikova, who had been a pupil of the great Italian baritone Mattia Battistini, and who taught in New York, where he would be spending a good part of every season. "When I think of Novikova's method, which I use and which works perfectly well, I hear the good old Italian school, the school of Caruso, Gigli, and all the Italian greats."

Indeed Gedda is as great a master of the Italian as of the Russian repertoire. For the latter he feels that the key is to learn to handle the *rubato*, which is the essence of the Russian style, especially in Tchaikovsky, "where the phrasing always hinges on *rubato*. You cannot sing Tchaikovsky academically. You have to know what kind of things you can allow yourself–where to breathe and where not to breathe in those long *legato* phrases."

Gedda was also, along with Kraus, one of the two foremost singers of the French repertoire, for which, according to Janine Reiss, the world's top French coach, "he possesses the ideal voice, with a timbre which, like that of the late Georges Thill, instantly evokes a landscape of the Ile-de-France." Gedda has sung almost the entire French tenor repertoire, ranging from such light-lyric roles as Nadir in *Les pêcheurs de perles* and Vincent in *Mireille* to full-lyric title roles including *Werther* and *Faust*, as well as dramatic parts like Don José in *Carmen* to the title role in *Les Contes d'Hoffmann*. But, along with the Gounod *Faust*, Gedda's favorite French part was the title role in Berlioz's *Benvenuto Cellini*, an opera very seldom performed for the good reason that, apart from Gedda, there was virtually no tenor who could sing it. This is confirmed by Luciano Pavarotti, himself a

Left: As Don Ottavio in *Don Giovanni*, with Edda Moser as Donna Anna at the Metropolitan Opera. An exemplary Mozart singer, Gedda believes that singing Mozart is the best way for young singers to acquire stylistic sensitivity and refinement.

Above: As Jeník with Teresa Stratas as Marenka in Smetana's *Bartered Bride*.

high-note tenor par excellence, who nevertheless generously affirms that "there is no tenor alive with a greater ease in the upper register than Gedda."

He excelled in *Faust* because he possesses both the sensuous, lustrous timbre necessary for the young Faust and the vocal weight required for the older Faust's more baritonal *tessitura* in the prologue, which had posed some problems for Kraus, the role's other distinguished interpreter. Gedda, who was "always drawn to interesting, psychologically complicated characters," was dubbed "The Faust of Fausts."

He explains that "half the difficulty of the French style lies in the language, which is dif-

ficult to master, and which few foreign singers succeed in doing. But there is no reason why foreigners cannot master French. Listen to Caruso's singing of the French repertoire. It's perfection, even though he was a Neapolitan! But unlike Gigli, whose French was far from perfect, Caruso must have worked at it. It's the only way. All stylistic details and nuances boil down to a question of willingness to work, work, and work. You have to see yourself as the composer's servant and work until you have grasped all the intricacies of his style."

The combination of impeccable diction and a capacity for spinning long, *legato* lines in the warm, sensuous timbre of Gedda's voice also rendered him an excellent interpreter of Italian opera of all styles: *bel canto* (Edgardo, Nemorino); Verdi (Alfredo, the Duke of Mantua, Riccardo, and Arrigo in *I vespri siciliani*); and *verismo* (Pinkerton, Rodolfo). The most outstanding among these roles were the Duke of Mantua and Nemorino. "Nobody since Gigli has sung the aria '*Una furtiva lagrima*' in such a way," exclaimed a member of the orchestra during a recording session in Rome.

No discussion of Gedda would be complete without discussion of the genre in which no living tenor surpasses him: operetta. A string of superb EMI recordings, including *Die Fledermaus, Der Zigeunerbaron, Eine Nacht in Venedig, Das Land des Lächelns,* and *Die lustige Witwe,* are classics in the field, and bear witness to his excellence. All were recorded between 1952 and 1954, shortly after his professional debut in Stockholm. He was only twenty-seven, and being given this opportunity at such an early stage in his career seemed "like a dream come true." During those two years, according to Walter Legge, "Gedda had become a master of this literature," and the recordings all won great critical acclaim. His interpretation of Prince Sou Chong in *Das Land des Lächelns* in particular was described as being "not only impeccably well sung but possessed of a patina, a luster, a mixture of charm and sparkle rarely encountered in any performance, least of all in the recording studio."

Gedda owes his mastery of this genre entirely to Walter Legge, who taught him that to sing operetta, you need "imagination, the right phrasing, the ability to play with words, and colors. All this I learned from him," he gratefully told *Opera News* after Legge's death in 1980. "He was not only a great recording producer but a great musician as well, with enormous insight into phrasing and vocal technique. He used to correct me here and there by suggesting I put more *legato* in a phrase, or emphasize some tiny inflection there. Everything he told me was constructive. With him I always did my best, was open to suggestions, and unlike most young singers today, never came back with my own arguments. I was young and knew very little and everything he told me I absorbed and followed. And I have never regretted doing so. In a way it is understandable that one cannot work as one used to, what with rising costs, singers' schedules, lack of time, and the pressure that conductors work under. But I fear that, as a result, something has gone out of recordings—as it has, most of the time, out of live performances."

Opposite: In the title role in Pfitzner's *Palestrina* at the Royal Opera House at Covent Garden. With a libretto by the composer, this opera was first produced in Munich in 1917. It includes a mass written for the Council of Trent.
Above: Gedda was one of the most versatile tenors of the century, with a repertoire of over seventy roles, encompassing many different styles from French and Italian to Russian and German, including operetta. He appeared, late in his career, in many recitals such as the one above at La Scala in 1993. These, which he continued well into his 70s, remained a lesson in stylistic perfection, based on his expertise as a linguist.

Alfredo KRAUS

Alfredo Kraus is the antithesis of the tenor as we have come to know him in the 1990s. He belongs to a breed that nearly vanished from the operatic stage in the 1980s: a stylist who limited his repertoire to a handful of roles for which his light-lyric voice was considered ideal: *bel canto*, a couple of Verdi parts, and the French repertoire. Yet Kraus is the first to admit that, had he been born later, his mentality might have been different: in other words, he might have had a more "populist" approach.

Today a slim, elegant man in his seventies, Kraus has always cut a dashing figure on stage, and even in his sixties sounded younger than many a tenor half his age. He seems perfectly content with a reputation resting on artistic achievement alone and built entirely without the aid of public relations. This explains why Kraus, who was reportedly the most highly paid tenor of his day, was never, in the broadest sense of the word, the most popular.

Kraus's beautifully modulated light-lyric voice has a remarkable upper extension stretching effortlessly up to a D natural. His respect for the works he interpreted and for the public was such that he never allowed himself to sing the wrong roles or debase his exacting artistic standards. He refused to transpose the *tessitura* of roles he might have liked to sing, but for which he didn't possess the necessary vocal resources. "Sure, I would have loved to sing Lohengrin, Radames, and Calaf. But this would have been dangerous for my voice and unfair to the music."

He therefore decided to concentrate on the light-lyric repertoire of a classic *tenore di grazia* (an eighteenth century term used to

describe a tenor closely resembling what we now call a *tenore leggiero*, or light-lyric tenor), plus some fully fledged lyric French and Italian roles that require an easy top–but he never expanded into the *lirico-spinto* or a dramatic repertoire.

This means that Kraus's repertoire was limited to about twenty roles, divided into *bel canto* (Elvino in *La sonnambula*, Arturo in *I puritani* by Bellini, Nemorino in *L'elisir d'amore*, Edgardo in *Lucia di Lammermoor*, Tonio in *La fille du regiment*, Fernando in *La favorita*, and Gennaro in *Lucrezia Borgia* by Donizetti; Almaviva in Rossini's *Il barbiere di Siviglia*, and Faust in Boito's *Mefistofele*); three Verdi roles, Alfredo in *La traviata*, the Duke of Mantua in *Rigoletto*, and Fenton in *Falstaff*;

Opposite: Alfredo Kraus in one of his most famous roles, the Duke of Mantua in Verdi's *Rigoletto* at La Scala. He brought vocal, stylistic and stage elegance as well as lightness of touch to the role, which he sang all over the world.

Left: Kraus at his debut at La Scala as Elvino in Bellini's *La sonnambula* with Renata Scotto as Adina in the 1959-60 season. Kraus excelled in *bel canto* as well as the French repertoire. Alfredo in *La traviata* and the Duke formed the core of his small repertoire of twenty roles, for which his perfectly modulated lyric voice was considered ideal. One of Kraus's most famous recordings of *La traviata*, with Maria Callas in the title role, was recorded live at Lisbon's Teatro San Carlo in 1958. Kraus was then a young tenor of thirty-one and Callas's presence exhilarated and stimulated him so much that he sang better than he had ever done before. So much for tenor-primadonna rivalries.

and a rich slice of the French repertoire, Nadir in Bizet's *Les pêcheurs de perles*, Gerard in Delibes's *Lakmé*, the title role in Offenbach's *Les Contes d'Hoffmann*, Des Grieux in Massenet's *Manon*, and the title role in *Werther*.

The legendary Giacomo Lauri Volpi, one of the famous high-note tenors of the past, recalls being visited by the young Kraus in the 1950s: "I was greatly impressed by the voice of this personable young man and by its uncommonly easy upper extension, suppleness, and finesse, as well as by his line and spontaneity. 'Here, at last, is a typical classic *tenore di grazia*,' I exclaimed. What a change from the paltry, short voices one is used to hearing today, with their anemic top and disproportionately heavy middle."

Lauri Volpi put his finger exactly on the qualities that render Kraus so important in the line of tenor singing that stretches back to the tradition of Caruso and beyond. For according to the distinguished Italian musicologist Rodolfo Celletti, by the 1950s stylists had nearly vanished from the operatic stage: "Therefore, the appearance on the scene of a singer like Kraus was tremendously important. Along with Carlo Bergonzi, he was

Above: Kraus in one of his most famous French parts, the title role in Massenet's *Werther* at La Scala in 1975-76, with which he identified himself so completely that when he stepped on stage to sing it he said "I did not simply portray Werther; I *was* Werther."

Right: In 1983 as Tonio in Donizetti's *La fille du régiment* at the Metropolitan Opera. A single phrase of his aria "*Ah, mes amis, quel jour de fête*" contains no fewer than nine high Cs.

arguably the only tenor of the last thirty years capable of giving performances of Bellini, Donizetti, and certain Verdi roles based both on real professional skill and a direct link to the stylistic vision of the romantic musical theater of the period of 1830–60."

Kraus rightly turned his back on the operas of *verismo* composers (Puccini, Mascagni, Cilea, Leoncavallo, and Giordano), recognizing that his light, highly musical, but slightly dry voice, with its clear, controlled timbre, did not possess the necessary weight, roundness, and lusciousness of tone for this repertoire. Attempting to force it would certainly have ruined its top and damaged its agility. The result of his prudence has been an amazing vocal longevity. In early 1998, at age seventy-one, Kraus gave a recital with high notes intact at London's Barbican Hall that had the audience stampeding for more.

Kraus believes that the reason for his phenomenal longevity and excellence in his chosen field is his realistic, clear-sighted assessment of his vocal potential. "As in everything in life, self-knowledge is the key. In our case this means a thorough, accurate understanding of our voice, the instrument we have to manage. For it goes without saying that we cannot manage an instrument we only half-understand. Then, having assessed our qualities and, most important, accepted our limitations, our next step should be to choose a repertoire that takes both into account."

Kraus was born in 1927 at Las Palmas to an Austrian father and a Spanish mother. He learned to play the piano as a child and then sang in local choirs. He studied at Las Palmas and then in Valencia, Barcelona, and Milan, where his voice teacher was the Spanish soprano Mercedes Llopart, who had sung at La Scala in the twenties and thirties under Toscanini and who taught Kraus elements of his stupendous technique. "Technique is the basis for everything. You cannot be an artist if first you are not a good singer."

He made his professional debut in Cairo as the Duke of Mantua in *Rigoletto*, which became one of his calling cards. Few have since performed it with such debonair ele-

Above: In 1982 as Edgardo in *Lucia di Lammermoor* at the Metropolitan Opera, a role to which, like most *bel canto* parts, he brought the stylistic finesse of a classic eighteenth-century *tenore di grazia* and a great elegance.

gance and lightness of touch. His 1956 Cairo debut was followed by invitations to sing Alfredo in *La traviata* in Venice, Turin, and Barcelona in 1957 and at the Stoll Theater in London in 1958, with Renata Scotto. Later that year he sang the same role in Lisbon in a historic production, recorded live with Maria Callas, a recording no opera buff should be without. To his amazement, the great Diva proved outstandingly supportive, encouraging, and invigorating to her young colleague. "If I had had a more ordinary partner, I would never have had the success I did," recalls Kraus. "But Callas's presence was so stimulating that it spurred me on to sing better than I ever had in my life!"

A year later, Kraus made his debut at La Scala as Elvino in *La sonnambula* and as Edgardo in the Covent Garden production of *Lucia di Lammermoor* that turned Joan Sutherland into a star. His Metropolitan Opera

92

debut, again as the Duke of Mantua, came in 1965, followed by his debut at the Salzburg Festival as Don Ottavio in Herbert von Karajan's production of *Don Giovanni.*

By the 1970s, Kraus had expanded into the French repertoire of which he, along with Nicolai Gedda, became the embodiment. Kraus feels that in the French repertoire he experienced "a fusion of the singer and the actor" and his histrionic ability, which had hitherto been somewhat wooden (largely because of the nature of most of his *bel canto* roles), began to flower. Janine Reiss, the world's top French coach, has worked with most great singers of the past three decades and believes that, just as there are naturally Italianate voices, there are also such singers as Kraus and Gedda whose vocal timbre and color are particularly suited to French music and the French style of singing, the chief characteristics of which are clarity and measure. Voices like Domingo's and Carreras's, for instance, are a little bit too rich, too lusciously sensuous for French music, since the ideal voice is

one whose timbre is sufficiently warm and rounded to make it beautiful, but when compared to an Italian voice such as Bergonzi's, a little bit less sunny and, consequently, a little less warm.

Kraus agrees with this analysis and adds that the French style of singing–in which both *portamenti* and *coronas* are taboo and a *legato* is always a *legato* without ever becoming a *portamento*–demands good taste, subtlety, sensitivity, finesse, and great technical control, as those *legato* phrases demand very long breaths. His first French part was the title role in Massenet's *Werther,* which he first sang in Rome (1970), then Chicago (1971) and finally at the Paris Opera (1984). The magazine *Opera International* hailed him as "the greatest French singer of the post-war era."

Werther and the Chevalier Des Grieux in *Manon* remained Kraus's most famous and favorite French roles. "When I walk on stage to sing those two, I don't simply *portray* them, I am them," he says, and the critics concur.

Opposite above: As Gennaro in Donizetti's *Lucrezia Borgia,* with Joan Sutherland in the title role, at the Royal Opera House, Covent Garden, in 1980 and *opposite below* as Nemorino in *L'elisir d'amore* in the same theater in 1992. Thanks to his vocal longevity and the care he took of his voice, its quality is still impressive.
Above: In the title role of Massenet's Werther at the Royal Opera House, Covent Garden, with Teresa Berganza as Charlotte.
Below: As Edgardo in *Lucia di Lammermoor* at Covent Garden in 1983-84, which he sang with a voice fresher than that of many a young tenor.

Luciano PAVAROTTI

Luciano Pavarotti is one of the most popular tenors of the past quarter century: a household name among masses of people who may not have set foot in an opera house but are, nevertheless, familiar with this amiable giant whose infectious grin stares out of countless posters, billboards, and advertisements for products ranging from Rolex watches to Blackglama mink. Pavarotti achieved this mass popularity by being the first modern-day tenor to break out of the confines of the opera house and purely operatic fame. He was the first to give concerts in such mass venues as stadiums and parks, and, most important, the first to grasp and benefit from present-day publicity and marketing techniques. During the 1980s Pavarotti became ubiquitous: he appeared on television talk shows, held exhibitions of his paintings, became passionate about horses, even buying a string of showjumpers and leading the Columbus Day parade in New York City on horseback. He was also the first tenor to command fees initially of twenty thousand dollars and ultimately in excess of two hundred thousand dollars for solo recitals and over one million dollars for the "Three Tenors" concerts televised around the world.

Yet when Pavarotti began his expansion beyond the opera house all hell broke loose. The self-appointed purists on the opera circuit greeted his efforts with fury and disdain, as if Pavarotti were some sort of operatic renegade, and as if no other great singer had ever attempted such a thing before. Yet Caruso, Gigli, Schipa, Tauber, and legendary heldentenor Lauritz Melchior had all done it long ago, some going much further than Pavarotti:

Schipa and Tauber each appeared in a string of films, while Melchior not only followed suit, but added music halls to the venues in which he sang the very "crossover" repertoire for which Pavarotti was so reviled.

It's true that if the "King of the High Cs"–as he was labeled by Decca, the recording company to which he has remained faithful throughout his career–began to bellow them out with relentless volume in mass venues he might come to vocal harm. But Pavarotti is neither a fool nor a gambler: "I am not a man who risks wildly. I prepare every step," he once told *Newsweek*. He is also a shrewd and realistic judge of his own voice and his performances. When singing in mass venues he is always

Opposite: Luciano Pavarotti, as a young Duke of Mantua in *Rigoletto* at Covent Garden in 1966-67, and *below* in the role that turned him into an operatic superstar, Tonio in *La fille du régiment* at Covent Garden in 1966. The young tenor is seen turning out one of the nine high Cs with Joan Sutherland as Marie.

95

Pavarotti enjoyed a long and fruitful relationship with the Australian fellow superstar Joan Sutherland. Most of the performances were conducted by her husband Richard Bonynge, and happily many survive on records. *Right*: As Manrico and Leonora in Verdi's *Il Trovatore*, and *below* in Bellini's *I Puritani*, in which the tenor lead, Arturo, is one of the highest in the tenor repertoire.

His assessment of his artistic and human qualities and of the reasons for his popularity is characteristically direct: "I am a real singer–very professional. Ergo, I am an eternal student, which is possibly my greatest quality. I also have a natural flair for phrasing that can be neither taught nor acquired. The next two most important gifts for any singer are a tremendous personality and the ability to make contact and communicate with the public. Otherwise he might as well stay at home and sing in the bath!"

It is interesting that Pavarotti doesn't include his remarkable capacity for high notes among his most important musical qualities, even though in earlier years he reveled both in the fear and the exultation that are part of producing them. "Top notes are satisfying only because they show that your voice is in good shape. You can say that they are like the goals in football. If you can do them, fine. If not, no matter. You can still be a great tenor without the high C. Caruso didn't have it (although he did acquire it along the way). Neither did Tito Schipa, who had something far more important than high notes: a great line."

Line, or phrasing–the way a singer shapes the music within the beat given by the conductor–is, according to Pavarotti, a singer's greatest gift. It cannot be taught, but constitutes part of innate musicality. It can compensate for the absence of high notes, as in Schipa's case, or for lack of sophisticated musical education, as in Pavarotti's. His voice coaches and accompanists point out that he can barely read music and learns his roles mostly by ear (until recently, this was not unusual for Italian singers). Although he is not an especially good musician, he is very musical. Leone Magiera, the distinguished accompanist, points out that, "He comes up with interpretative ideas that I, for one, may never have thought of. He has this incredible ear and instinctively knows how a phrase should be sung. He just *feels* it and is almost always right."

Another prominent characteristic of Pavarotti's artistry is his exemplary way with the Italian language. As early as 1963, when he

miked and therefore doesn't need to shout. And the proof that his voice came to no harm is the fact that at the age of sixty-four Pavarotti's voice is in excellent condition. In the spring of 1999 he sang Cavaradossi in *Tosca* at the Metropolitan Opera. He was slimmer by fifty pounds, rid of the knee-joint problem that had hindered his movements on stage for several years, and delivered a portrayal vocally astounding for a man of his age and dramatically more credible than ever before.

Yet the quality and exquisite beauty of Pavarotti's lyric voice–with its honeyed timbre, *pastosa* (soft, elastic) texture, and prodigious ease at the top–is only part of the reason for his immense popularity. The secret lies in the combination of this glorious instrument with a captivating, larger-than-life personality exuding charm, bonhomie, a quick, spontaneous wit, and an appetite for the good things in life: food, wine, fame, applause, and the admiration of pretty women. One of Pavarotti's main characteristics is his combination of direct, refreshing simplicity with a shrewd, tough-minded attitude toward himself, his voice and artistry, life in general, and money in particular.

made his British debut at the prestigious Glyndebourne Festival, his diction impressed the distinguished accompanist Geoffrey Parsons, who had worked with the best contemporary singers. Being Italian doesn't automatically mean that a singer's diction is as superb and refined as Pavarotti's; Parsons stated that he had "never before heard anyone singing Italian like that. The quality of the sound of his Italian makes the language itself sound like music."

Although Pavarotti did not attend a conservatory, he did have seven years of vocal studies in Modena, where he was born in 1935,

and in neighboring Mantua with Arrigo Pola and Ettore Campogalliani. His father, Fernando, a baker by profession, was a passionate opera buff with a good enough tenor voice to sing in local church choirs as well as the opera chorus, and had a large collection of recordings of all great tenors, past and present, and to this day drives his famous son mad by comparing his performances to those of Caruso, Gigli, Schipa, or Tagliavini. Pavarotti displayed early on one of his greatest qualities as an artist. Not just that he is an eternal student, but that he is a very *serious* student, eager for advice and obedient to teachers. To this day he listens to advice and follows it, provided it doesn't sound destructive.

Pavarotti made his professional debut in Reggio Emilia in 1961 as part of the first prize he won at the Achille Peri competition for singers from all over the province. The role was Rodolfo in *La bohème*. "This has always been a lucky role for me, a beautiful, young role which I could immediately identify with and which always strikes a universal chord. Rodolfo is a romantic like me, who speaks a universal lovers' language as true of yesterday and today as it is of tomorrow, and which can be understood even on the moon! The words are great and if you follow the composer's instructions faithfully, you can't go wrong."

It was also as Rodolfo that Pavarotti was to make his debuts at Covent Garden (1963), La Scala (1965), and the Vienna State Opera (1965), the last in Franco Zeffirelli's landmark production conducted by Herbert von Karajan. San Francisco came in 1967, the Metropolitan Opera in 1968, and the Paris Opera in 1974. The performance as Rodolfo at Reggio Emilia proved to be fortuitous. It was attended by an influential Milan-based agent, Alessandro Ziliani, who signed up Pavarotti and immediately organized debuts for him in provincial Italian cities–the most important being the Teatro Massimo in Palermo in 1963, as the Duke of Mantua in *Rigoletto*, conducted by Tullio Serafin. He also appeared in Amsterdam and Dublin, where one of the performances was attended by Joan Ingpen, then artistic administrator of the Royal Opera,

As Fernand in Donizetti's *La favorite*, generally sung in Italian as *La favorita*. In this production at the Met, Shirley Verrett sang Leonora. Donizetti is the composer Pavarotti believes best fits his voice, even though he prefers to sing Verdi. In fact Pavarotti considers one of the main reasons for his vocal health and longevity the fact that he spent the entire part of his early career singing mostly Donizetti and Bellini, which he considers the best training for young singers. "But, alas, very few singers nowadays are prepared to try this solution. Most prefer to plunge straight away into the meatier repertoire–a sure guarantee that they will fail to fulfill any early promise they might show."

Covent Garden, and on the lookout for a cover for Giuseppe di Stefano, who had a history of cancellations. Pavarotti accepted, with the proviso that he could sing the last performance. As it happened, he sang all but the first and half of the second performance and scored a huge success on the other nights.

As well as being the first of a string of international debuts, the Covent Garden performances led to an introduction to Joan Sutherland and her husband, the conductor Richard Bonynge, with whom Pavarotti was to enjoy a long-lasting collaboration, both on stage and on records. This began with his American debut as Edgardo to Sutherland's Lucia in 1965 and was followed, soon after, by an Australian tour during which he sang Alfredo in *La traviata* and his first three *bel canto* roles: Edgardo in *Lucia di Lammermoor*; Elvino in *La sonnambula*; and Nemorino in *L'elisir d'amore.*

Pavarotti considers *bel canto*, which was the mainstay of his repertoire in the sixties, to be the essence of music and musical expression.

As he says, "I may like Verdi, but my voice likes Donizetti. *Bel canto* is the best medicine for the voice because of the discipline and combination of qualities it requires: agility, elasticity, a smooth, even flow of liquid, well-focused sound, uniformity of color, the ability to spin long, expressive *legato* lines without recourse to *portamenti* and, most important, without ever overdoing anything or giving the impression that you are over-exerting yourself. Every singer needs all of those qualities as part of their technical equipment."

The role that helped pave Pavarotti's way to operatic superstardom was Tonio in Donizetti's *La fille du régiment*, which he first sang with Sutherland at Covent Garden in 1966, and later at the Metropolitan Opera in 1971. The reason is that one of Tonio's arias, *"Ah, mes amis, quel jour de fête,"* contains no fewer than nine high Cs in quick succession. Pavarotti distinctly recalls thinking that Sutherland and Bonynge were mad when they first suggested it. But since they were good friends he agreed to try, on the condition that

if the high Cs didn't come–as he was sure they wouldn't–he would transpose them to B-naturals. The high Cs did come, all nine of them, and after the Metropolitan Opera performances, Pavarotti came to be regarded as a major vocal phenomenon. Tickets became gold dust and Pavarotti was swamped by extremely lucrative offers from just about everywhere. This is when Herbert Breslin, who masterminded Pavarotti's transformation from operatic superstar to household name, entered the picture, first as his press agent and eventually as manager.

During the seventies, Pavarotti began a gradual expansion into the *lirico-spinto* repertoire, including Riccardo in *Un ballo in maschera*, Rodolfo in *Luisa Miller* in 1974, Manrico in *Il trovatore* in 1975, Enzo in *La Gioconda* in 1979, and Cavaradossi in *Tosca*, to coincide with the natural darkening of tenors' voices when they reach their late thir-

ties. Although he sang with distinction, these roles revealed the only chink in Pavarotti's artistic armor: his lack of acting ability. This is due partly to his size (his weight, though never officially disclosed, is estimated to fluctuate between three-hundred-and-fifty and four-hundred pounds) and partly to his conviction that "it is not necessary to be a Laurence Olivier," as he once snapped at a *Newsweek* reporter who accused him of "strolling around the stage in a variety of loose smocks in a lavish Hollywood musical called *The Great Pavarotti.*"

Pavarotti's expansion into solo recitals began gradually, but from the very first recitals–in Minneapolis, Dallas, Washington, Chicago, and finally Carnegie Hall in New York–the response was rapturous, "bordering on hysteria," as a Chicago critic wrote. A superstar was born and opera burst out of its cage, soon reaching the masses in such

Below: As Nemorino in Donizetti's *L'elisir d'amore*, a 1990 Covent Garden production. Pavarotti brought to the role all his innate charm, wit, and sense of fun. *Overleaf*: Two wonderful Puccini roles; *left*, Calaf in *Turandot* and, *right*, Cavaradossi in Tosca. Pavarotti–who, despite his compulsive but lighthearted flirtatiousness is a clearheaded realist where women are concerned–gasped in disbelief when asked if he, in Calaf's shoes, would risk his life to win Turandot. "Never," he replied categorically. "Still," he mused, "if she were really a '*bellezza meraviglia*,' as described in the libretto, who knows?" He says that as a lyric tenor he has been able to tackle this dramatic part with such distinction because of the "perhaps excessive caution" he always exercised in his choice of repertoire.

venues as New York's Madison Square Garden and London's Hyde Park.

Many of Pavarotti's millions of fans claim that he is at his best at recitals where his glorious musical instrument and larger-than-life personality can be enjoyed unhampered by the need to act. He points out that solo recitals require even greater concentration than operatic performances because "unless I, myself, believe in what I'm doing, the public will get bored." The strain on the nervous system is also much greater, for everything depends on the artist. "Sometimes I think I'm the only one who realizes how easily things could go wrong," Pavarotti explained in his book, *My Own Life.* "My staff all tell me that the people out there love me. What they don't realize is that they may not love me when it's over."

Pavarotti's usual remedy for stage fright is to surround himself with people before performances. I remember feeling astonished when, several years ago, I went to interview him in Milan for a London Sunday newspaper and he suggested that we begin our interview in his dressing room forty-five minutes before a performance of *La bohème,* while he was being made up and fitted into his costume. He explained that "talking takes me out of myself

Above: As Calaf in *Turandot* at The Metropolitan Opera.
Below: As Cavaradossi in *Tosca* at Covent Garden.
Opposite: Pavarotti in one of his most distinguished portrayals, the title role in Mozart's Idomeneo, seen here at the Metropolitan Opera in 1982. He also sang the role at the 1983 Salzburg Festival.

and, provided it's not too loud, also helps warm up the voice." He views intermissions as a sort of "no-man's land when you are out of battle for a brief respite, but the war is by no means over." And although he does receive a few people during the intervals, he is by no means the social animal he becomes after the show, when he receives almost everyone who wishes to see him and, being a consummate and lighthearted flirt, kisses every woman on sight, signs autographs without demur, and generally revels in the afterglow of applause and the palpable affection–"the oxygen I breathe"–of his adulating public.

In earlier years Pavarotti's ideal way of unwinding after a performance was to take a luxurious, hour-long bath followed by dinner in his own or a friend's apartment. Since he is an excellent cook–with a cookbook to his credit–he often used to do the cooking himself. But the lines of people outside his dressing room today preclude the bath, so he makes do with a gargantuan–or, now that he is on a spectacular diet, less gargantuan–meal after he has signed the last autograph. Perhaps eating is his way of cop-

ing with the enormous stress of being The Great Pavarotti. Whatever the reason, he considers "the inability to push away the dining table the biggest and, because I'm normally a very strong-minded and determined person," his unique weakness. "I could tell you all sorts of fanciful stories about my glands or whatever making me fat. I would be lying. It's the food."

But Pavarotti's main relaxation is his month-long annual holiday in August at his wonderful seaside villa at Pesaro on Italy's Adriatic coast, where he indulges his passion for fishing, and where he is on a first-name basis with the local fishermen. He would gladly forgo any post-performance event to go fishing at night with one of his pals.

For many years he would gather his entire family–wife, three daughters, parents, sisters, in-laws, nephews, and nieces–around him during his retreats. Among his many properties is a spacious seventeenth-century mansion, which he converted into a house for himself with separate apartments for his entire family, on twelve acres near his native Modena. "We're all going to live there. Everybody," he said while the mansion was being converted. "I want to prove that families can stay together, even in this day." But, in the end, Pavarotti's family did not stay together. A few years ago he left his wife Adua, a well-

known artist's agent, for his secretary, with whom he appears to be living happily. After about two years of appearances in mass venues that turned him into a household name, in 1982 Pavarotti re-established himself as a serious singer with a tremendously moving, deeply felt, and beautifully sung portrayal of the title role in Mozart's *Idomeneo* for the opening of the Metropolitan Opera season, and later at the 1983 Salzburg Festival.

Pavarotti was prompted by his tremendous love for Mozart. Although Verdi is his favorite operatic composer, his favorite classical composer of all is Mozart, "because as an overall musician Mozart is the best, the greatest, the most immense genius of them all. And *Idomeneo* is his most forward-looking opera; a work that paved the way for what future composers, such as Verdi, would do." Singing Idomeneo was something of a sacrifice, in vocal terms, which he undertook for his personal pleasure and satisfaction and also in order to prove even to his most ardent fans that he was capable of stretching himself and delivering more than they had come to expect.

The vocal sacrifice lies in the fact that the role is basically written for a baritone with a good top. Its highest note is a mere G–with an optional A and A-flat in one aria–while

Pavarotti is a high-note tenor whose voice is at its best above G. Keeping his voice down to this *tessitura* was therefore a sacrifice, but rewarding because of "the upliftment I experienced, especially at that terrible moment when the chorus appears and you can almost feel the presence of death. At that moment you feel yourself lifted so high, that the whole performance becomes a spiritual, mystical experience." As Sir John Tooley, then General Director of the Royal Opera House, Covent Garden, stressed: "With Idomeneo, Pavarotti regained his true form."

Posterity will undoubtedly class Pavarotti as one of the greatest tenors of the century–a great singer even if not remotely a singing actor–and also as a pioneer who initiated the effort to bring opera to the masses. For, like Domingo, Pavarotti is acutely aware of the need to spread the message of opera to increasing numbers of people if it is to thrive in an age of television and pop music. And if this movement, pioneered by Pavarotti and culminating in the "Three Tenors" concerts seen worldwide, has succeeded in doing this, Pavarotti will go down in history not just as one of the century's greatest tenors but as the first operatic crusader to cross into the enemy territory of pop culture–and win.

The latest "Three Tenors" concert in Paris on July 10, 1998. The first of these concerts, which took place at Rome's open-air Terme di Caracalla in 1989, was a promotion to mark the end of the World Cup finals. Its success was greater than anyone, including the tenors themselves, had ever imagined in their wildest dreams. Televised live worldwide, it was followed by a CD that sold eleven million copies. Since then there have been "Three Tenors" concerts nearly every year in different parts of the world, including Japan, Australia, and most European capitals. These have made each of the three tenors extremely rich. In each German city in which they sang in 1997, each is reported to have received four million deutschmarks per concert. Tenor enthusiasts point out that the possibility of making so much money together smoothed over real or imagined rivalries between the the singers.

Placido
DOMINGO

Two artists have decisively influenced the art of the tenor in opera–as opposed to singing pure and simple–in our century: the Great Caruso during its first quarter and the Great Domingo in its last. Domingo, whose lustrous, highly individual sound has been described as "a lover's voice–dark, sensuous, and velvety, with the resonance of a cello," is poised at the pinnacle of a glorious singing career that spans four decades and embraces one-hundred-thirteen roles, including Wagner's Lohengrin, Siegmund, and Parsifal, as well as most of the French and Italian tenor repertoire. The breadth of his repertoire eclipses even that of the legendary Caruso, who shied away from Wagner and who never fulfilled his dream of singing Otello.

Genius is not an adjective often associated with singers. Yet it undoubtedy applies to Domingo, an artist whom Leontyne Price calls "a tenor in a class of his own," and Ileana Cotrubas describes as "the most complete artist I have ever worked with." More than any performer in recent years, Domingo is a consummate actor who has carried the Callas Revolution–the movement, spearheaded by Maria Callas, that turned opera into believable theater–to the domain of the tenor. An astute journalist once remarked that future generations looking back at the history of opera in the second half of the twentieth century will be able to divide it into two periods: BC and AD, which in this case means before Callas and after Domingo. Indeed the dramatic power and credibility of Domingo's performances permits them to stand their ground as straight theater. "Not only does he act it as well as I do, but the

Left: Placido Domingo as Pollione in a production of Norma at the Metropolitan Opera during his early years. Opposite: As Calaf in Andrei Serban's colorful production of Puccini's Turandot at the Royal Opera House, Covent Garden.

Above: On horseback with Elena Obratsova during Zeffirelli's 1978 production of Bizet's *Carmen* at the Vienna State Opera. The Russian mezzo sang the title role.

Five years earlier in his career, *center*, he sang the same part at Covent Garden with Kiri Te Kanawa as Micaela.

Bottom: At the Metropolitan Opera in Mozart's *Idomeneo*.

bastard sings it as well," was the late Lord Olivier's verdict after seeing Domingo's Otello.

"I find his total, no-holds-barred generosity and capacity for giving all of himself to his operatic characters mysterious," explains Piero Faggioni, who directed Domingo in numerous historic productions. "He plunges into each role like a bull into the *corrida*, and at every performance seems to go through a sort of trance, a process of self-liberation through singing. I never get the impression that singing tires him, or imposes any sort of physical strain or exertion on him. Just a liberation, an explosion of energies that, I feel, can be freed only through singing, like a volcano that can only free itself by erupting."

Domingo is passionately committed to his ideal of opera as "the most exciting experience imaginable, the most beautiful thing in the world," a vision formed in his childhood when he saw his first full opera: "But when badly conducted or acted in an old fashioned way, nothing could be worse! I mean I would walk out

after five minutes! Nowadays all of us are so spoiled by films and television–by cinematic criteria of dramatic credibility–that we demand that opera be believable theater. And most of the time, even when operatic libretti are somewhat primitive, we are dealing with masterpieces so infinitely profound that to get to the heart of characters like Otello, Hoffmann, Des Grieux, Canio, or Cavaradossi and recreate them in a way that does justice to the composers' imagination, we almost have to go to a stage further than the composers themselves: we have to make all those characters inhabiting different centuries and civilizations relevant to today; we have to find a way of conveying the feeling of their period while interpreting them with the insights of the late 1990s. This is one of the most difficult things about operatic singing. Making the imaginative link with those bygone eras through the way you walk–on your toes and sort of floating for Romeo, for instance, and like a panther, with strong yet gliding steps for Otello—and the way you move your hands.

For as Verdi used to say, '*Il gesto e la pronuncia del corpo*' (gestures are the pronunciation for the body). Today the less you move your hands the better, but when you do, they should have an impact of a whiplash!" All this, he feels, is part of the effort to make opera valid by contemporary standards. "What we must do, what I'm trying to do, is reach many, many more people than the two thousand or so who fill each of the world's opera houses every night. To succeed, though, we must first strive for the same level of dramatic credibility that they are used to on film and television."

"But acting is only part of operatic interpretation. The musical side is even more complex and presents singers with a colossal challenge. Having a voice and being a singer is not enough. To serve the composers properly, you have to be a musician as well. To *really* sing, you must delve deeply and meticulously into the score and seek to unravel all its secrets, all the little things behind the notes and between the lines. For instance, whenever there is a

Above: As Calaf in Puccini's *Turandot* at Covent Garden, a role he first sang at La Scala in 1982. He brought enormous charisma, vocal artistry, and visceral excitement to his interpretation of the long-lost son of the King of Tartary who falls in love with a cruel Chinese princess.

change of key there is also usually a change of mood—from joy to wistfulness or whatever—and you must modulate your voice accordingly, even though the audience may be unaware of it. Equally important is to color your voice according to the instrumentation. Being a tenor doesn't mean you have to sing with the same voice all the time. Although you only have one voice its color can, and should, vary tremendously with the character and style of the music, and especially the orchestration, which, in opera, is everything. The geniuses who created the masterpieces we are trying to interpret and who worked so intensely on the storyline, the background and feelings of each character, set the mood and atmosphere of every scene mainly through their choice of a particular kind of instrumentation. They do this so effectively that all we singers have to do is carry the mood a stage further, with our voices."

Domingo is also an accomplished musician—a comparatively rare attribute among singers—who studied composition, harmony,

Domingo has starred in several movies of operas.
Above: With Franco Zeffirelli, while shooting the acclaimed filmed version of Verdi's *La traviata* in 1983 with Teresa Stratas in the title role.
Right: As Cavaradossi in a Covent Garden production of *Tosca*.

and the piano. This explains the ease with which he took up his second career as a conductor and the refined musicality of his performances. When he is really on form one can hear him shaping the phrases, not always in the same way from performance to performance, and the results are incomparable. He probes the characters deeply and recreates them as a singer-actor in a most remarkable, imaginative, and indeed compelling way.

Domingo, a theater-child, was born in Madrid on January 21, 1941. His parents were well-known performers of *Zarzuela*, a Spanish form of operetta or romantic musical. When he was eight his parents settled in Mexico, where they started their own company, in which the young Placido played small parts and accompanied singers on the piano. Indeed, it was as a pianist that he enrolled at the National Conservatoire of Music in Mexico City. But his formal education was interrupted when, at the age of sixteen, he entered into a hasty and secret marriage that resulted in the birth of a son. To help him support his family his parents somewhat reluctantly employed him in their company, and he supplemented his income by playing the piano at nightclubs and singing baritone parts in such musicals as *My Fair Lady*. Two years later, the marriage ended in divorce and Domingo, now free, felt confident enough to audition for the Mexican National Opera. Much to his delight the panel pronounced him a tenor and hired him on the spot.

At first he sang only small parts, including Borsa in *Rigoletto* for his professional debut in 1959, and gained local fame as a presenter on a television music show. Three years later he married Marta Ornelas, a musically sophisticated young soprano whose career was slightly more advanced than his own. Both were acutely aware that Mexico offered limited opportunities for artistic growth and career advancement, so in the autumn of 1962 they joined the Hebrew National Opera in Tel Aviv. This two-and-a-half year period proved crucial to Domingo's vocal development: he sang over 280 performances in eleven different roles and acquired his now legendary breathing technique, a skill largely responsible for

his vocal longevity and the unblemished condition of his voice. Most remarkable, though, is the fact that Domingo is not a natural tenor, but a baritone who lifted his voice up to the tenor register through constant hard work. As he recently confided in *The Sunday Times*, "Many, many tenors–like Pavarotti and Kraus–they were born tenors. They opened their mouth and the *tessitura* was there. I had to fight for it, I had to gain every step. Every day I have to fight to gain my *tessitura*."

The Domingos left Tel Aviv in the summer of 1965 to settle in New York, where Domingo

Above: In a new production of Massenet's *El Cid* at the Teatro de la Maestranza in Seville. This is Domingo's latest role which he will he shortly be singing in the world's great opera houses.

109

Domingo in one of his greatest and most famous parts: the title role of Verdi's *Otello*, of which he is the supreme interpreter of the past quarter century. He manages to bring new insights, both vocal and dramatic, every time he tackles the role, not only in different, but even in the same productions. He is seen *right* in Elijah Moshinsky's production at Covent Garden in 1992 and *below* at the Metropolitan Opera production of 1989-90.

made his debut at the City Opera in Ginastera's *Don Rodrigo* on February 22, 1966, the night the NYCO opened its new theater at Lincoln Center. In 1967 Domingo had great success in his first two European debuts, Hamburg and Vienna, which were followed in 1968 by the Metropolitan Opera and La Scala in 1969, the same year he made his London debut in a Festival Hall performance of the Verdi *Requiem* conducted by Carlo Maria Giulini. His first Covent Garden performance, as Cavaradossi in *Tosca*, came in 1971.

By the early 1970s Domingo was recognized as one of the leading tenors of the younger generation. His wife had renounced her career to dedicate herself to her husband's, and to this she brought both one of the finest musical ears in the business and an acute critical faculty to match. Domingo has always taken her advice, which is invariably sound. By the 1980s Domingo had risen to the peak of the operatic profession: he sang in the great theaters of the world, took up conducting with

considerable success, appeared in enormously popular television specials, and was honored with a number of awards. It was toward the second half of this decade that he made the transition to superstardom, culminating in his appearance in the "Three Tenors" concert in the summer of 1989 at the Terme di Caracalla in Rome. Henceforth he was able to dictate the terms, financial and artistic, of his engagements secure in the knowledge that "they want me everywhere."

By his fiftieth birthday in 1991 Domingo had added another role to his repertoire: successful operatic administrator, in his position of artistic advisor of the new Los Angeles Opera Company. In 1996 he was also named artistic director of the Washington Opera, which he is currently transforming into a company worthy of the nation's capital. Next year he also becomes general manager of the Los Angeles Opera. Domingo is therefore a phenomenon not just as a singer and musician but also as a force in the music world.

Later in his career Domingo decided to tackle Wagner, belying the myth that only Nordic tenors can sing in his operas: *above* in 1984 as Lohengrin, *below* as Siegmund in *Die Walküre*, both productions at the Metropolitan Opera, and *right*, as Parsifal at Bayreuth.

If one had to choose the most outstanding of Domingo's more than one hundred roles (in over 2,800 performances to date) they would be his towering portrayals of the leads in *Les Contes d'Hoffmann* and *Otello* and, more recently, Siegmund in *Die Walküre*, which he first sang in Vienna in 1992. His Siegmund is quite the most romantic, exquisitely sung Wagnerian hero in decades. Hoffmann, which he first sang in Cologne, then at the Salzburg Festival and Covent Garden in 1980, the Offenbach centenary, is a difficult role, says Domingo, "both to act and to sing, with a high, uneven *tessitura*, which demands different kinds of vocal color, ranging from light singing in the Olympia Act, pure lyrical sound for the Antonia Act, a rich, passionate voice for the Giulietta Act, and dramatic yet sort of destroyed tones for the prologue and epilogue. And the tremendous scope, not only for vocal but also for emotional and even physical development, provided by this role is what makes Hoffmann so very challenging and rewarding to portray."

Before his first performance in *Otello*, at the Hamburg State Opera in 1975, Domingo had one hundred and fifty rehearsal hours. The opening night was a triumph, with fifty-eight curtain calls and unanimously enthusiastic reviews. Since then Domingo has become the greatest living interpreter of this role, which he also sang in Franco Zeffirelli's film. But he explains how difficult it is: "From the vocal point of view, Otello is one of the most challenging roles in the tenor repertoire, largely because of the enormously demanding second act, which is almost an opera in itself, the equivalent of *Pagliacci*—tremendously intense. Along with Arrigo in *I vespri siciliani*, which I first sang in Paris in 1974 and which has a murderous *tessitura* stretching up to a high D, Otello is the most demanding of all my Verdi roles. From a singer's point of view, anything connected with Verdi is damn serious. Any Verdi role is the most difficult singing you'll ever be called to deliver. Even though Puccini and the other *verismo* composers can destroy your voice more easily, they are easier to sing. Even a young singer could sail around some of the difficul-

ties. But no inexperienced young singer can hope to make any sort of impact in a Verdi role because he demands everything you have, both as a human being and as a singer. His music has feeling, it has pulse, it has red blood, and most of all, *it has heart*. Therefore the sound has to be not only beautiful but *generous*: it has to have light and it has to be sustained by a very good technique. Without any of those things, you just *cannot* sing Verdi."

Domingo's great talents–voice, musical training, and passion–are well-matched in Verdi's demands, and his description of Verdi's music seems a summation of his own character.

Domingo is such a consummate musician that he regularly appears as a conductor. Here he is in the pit of the Metropolitan Opera, where, in the 1998-99 season, he conducted *Aida*. Conducting fulfills him so profoundly that after a performance, he says he hardly needs applause and would be quite happy to simply go home. *Below*: In 1990, with José Carreras and Luciano Pavarotti after the second "Three Tenors" concert, televised live and watched by millions worldwide.
Opposite: Domingo in the title role of *Simone Boccanegra* in Elijah Moshinsky's Covent Garden production, gorgeously designed by the late Sidney Nolan, the eminent Australian painter.

José
CARRERAS

"I couldn't bear a boring career of going around the world year after year with a repertoire of about a dozen roles, even if I were to sing them near-perfectly," José Carreras said in the mid-eighties, when he was riding the crest of his career. "This way when my career is over I will, at least, have sung what I wanted to sing," he added, expressing a point of view diametrically opposite to that of his compatriot Alfredo Kraus.

Carreras found success through his beautiful, highly individual lyric voice, laced with the dark colors often associated with Spanish voices, his musical sensitivity, attractive stage presence, and engaging personality with a quick, sharp sense of humor. But when he referred to the end of his career he had no way of knowing just how harshly prophetic those words would be. In 1988 his career came to an abrupt halt when he was stricken with leukemia. After months in a Seattle hospital and treatment including a bone-marrow transplant, the disease was pronounced in remission. He returned home to a hero's welcome and, heartened by the love and support of millions of fans from around the world, very gradually resumed his international career. Not surprisingly, he felt like a new man, with a different outlook and altogether different priorities: "I now value things I used to consider unimportant and ignore others, which I used to prize, but which have now lost all meaning. Singing remains the single most important thing in my life. But even my attitude to this has changed: I no longer allow any stress to enter into the picture and no longer need to prove anything to anyone,

myself included. I know what I can do, I know my capabilities. I know what more I may allow myself to want. Singing is now a pleasure, a source of joy, pure and simple. Something I do for my own sake–because *I* need it–not for the sake of my career. And when my own joy and happiness in singing gives joy and pleasure to others, then my artistic life is fulfilled."

Carreras had decided on an operatic career at the age of seven, after seeing in his native Barcelona the film *The Great Caruso*, starring Mario Lanza. The film left him spellbound, and from that day on he never stopped singing. His parents were not musical: his father, a schoolteacher who was banned from the class-

Opposite: José Carreras in perhaps his greatest role, Don José in *Carmen*, with Agnes Baltsa in the title role, at Covent Garden in 1983.
Below: as Don Alvaro in *La forza del destino*, with Richard Vernon as the Marquis in a 1983-84 production at the Met.
Overleaf above: As Arvino in *I Lombardi all prima crociata* at La Scala.
Below: During recording sessions for *West Side Story* with (left to right) the late mezzo Tatiana Troyanos (Anita), the composer/ conductor Leonard Bernstein, and Dame Kiri Te Kanawa (Maria).

room after the Civil War because of his Republican sympathies, could only find work as a traffic policeman. Yet he and José's mother decided that, since their son loved singing, he might as well be taught properly. They enrolled him at the local conservatory, where he studied the piano, *solfège*, and singing, the latter with Professor Francisco Puig.

When Carreras was only twenty-two, Carlos Caballé, the impresario brother of the famous soprano, went to hear one of Professor Puig's other pupils. "But for the first and last time in his life he arrived early, so he also heard some of my lesson," beams Carreras. Caballé was impressed enough to tell the young tenor to get in touch when he felt ready. Carreras did so a few months later, and Carlos Caballé immediately organized his professional debut at the Theatre de Liceu as Ismaele in *Nabucco* (1968). The following season he was cast as Gennaro opposite Montserrat Caballé in Donizetti's *Lucrezia Borgia*. In 1971 he made his Italian debut in Parma as Rodolfo in *La bohème*, the role with which he identified most. As Carreras said, "Of all the roles I sing, Rodolfo is the one most like the real me, as well as being ideal for my voice, which it fits perfectly."

The next year brought his American debut as Pinkerton in the New York City Opera's *Madama Butterfly*. He accepted the offer of a three-year contract with the company, where he enjoyed artistic fulfillment

singing for the first time all the lyric roles destined to become the staples of his repertoire. During 1972 and 1973 he learned no fewer than eleven new roles in sixteen months. During his years at the City Opera he also made a string of important international debuts: the San Francisco Opera and the Teatro Colón in Buenos Aires in 1973, and the Metropolitan Opera, where he sang Cavaradossi in *Tosca*, the Vienna State Opera, as the Duke of Mantua in *Rigoletto*, and finally Covent Garden as Alfredo in *La traviata* in 1974. In 1975 he first sang at La Scala as Riccardo in *Un ballo in maschera*, and by then Herbert von Karajan had booked him for the Verdi *Requiem* and the title role in *Don Carlos* at the Salzburg Festival.

Despite finding a sensitive and understanding teacher in Francisco Puig, Carreras that he is largely self-taught: "Although find the right teacher who understands and is sensitive enough to ...ining your best qualities, singer himself. Singing ...ed through constant self-

appraisal, and the best time is after a performance, when you are lying sleepless in bed. And by self-examination I don't mean bemoaning the fact that you may not have hit a certain note straight or sustained a high note long enough; I mean more basic and important things that have to do with artistic truth, such as: Were you honest with yourself? Did you sing for yourself or did you indulge in cheap histrionics to please the gallery? How much of your basic conception of the character at hand came through at this evening's performance? And if you succeed in answering this sort of question truthfully, you will open yourself up to an unending process of self-improvement."

Carreras managed to do just that, throughout his career. The first important improvement happened in the mid-seventies, when he began to energize his singing. Although Carreras's voice was always very beautiful and well centered, early on it was rather passive and lacked energy. As Sir John Tooley, general director of the Royal Opera House, Covent Garden, from 1970–88 explains, "However

Above: Carreras in one of his most successful *lirico-spinto* parts, the title role in Giordano's *Andrea Chenier*. His expansion into this heavier repertoire, which he found much more interesting and dramatically satisfying than his earlier roles, caused his acting ability to flower and turned him into a convincing and moving singer-actor.

Left: Carreras with Placido Domingo during rehearsals for a gala evening, "Fanfare for Elizabeth II" at Covent Garden and, *right*, during a recording session with his mentor Montserrat Caballé, whose agent-brother Carlos was responsible for discovering and launching his career.

beautiful a singer's voice and however beautiful the line they can spin, this line will become twice as beautiful if they energize it. During his early years, José didn't seem to be aware of this very obvious point, possibly because he is largely self-taught. Yet gradually he realized that he had to find the intensity needed for full-blooded, as opposed to his earlier, somewhat 'wooden,' portrayals, and find it he did."

This vital improvement in Carreras's singing was evident when he sang the aforementioned Don Carlos, under Karajan, at the Salzburg Festival in 1976. "Carreras is the most-improved tenor of the year," wrote *Opera* magazine. "The acting is still wanting, but when he opened his lungs, the rewards came. The voice is now large enough for the Festspielhaus, the tones have a new heroic ring."

Carreras's acting ability began to flower as he explored the *lirico-spinto* repertoire, playing Cavaradossi, Alvaro in *La forza del destino*, Don José in *Carmen*, Werther, and Andrea

Chenier. He found these roles more satisfying than his earlier lyric and light-lyric repertoire, which ranged from *bel canto* roles such as Edgardo in *Lucia di Lammermoor*, Gennaro in *Lucrezia Borgia*, and Nemorino in *L'elisir d'amore* to Alfredo, the Duke of Mantua, and the Rodolfos in *La bohème* and *Luisa Miller*.

Yet this expansion of an essentially lyric voice, however dark-colored, into the heavier, *lirico-spinto* repertoire initially caused concern that it could damage Carreras's voice. But it was part of a natural development of most tenor voices that takes place, first between the ages of twenty-five and thirty, and again between thirty and thirty-five. As the voice gains volume and acquires greater weight and a darker, more substantial timbre, it loses some of the feathery lightness and agility characteristic of very young tenors. "Ideally," sighed Carreras, "one should possess all of those qualities at the same time! But, alas, it doesn't work out that way."

However, Carreras stresses two important guidelines for tenors singing *lirico-spinto* roles: the first is never to change the basic nature of their voice. "Even when singing roles more dramatic than you are used to, you should approach the drama through interpretation, rather than trying for a vocal size you don't have." The second guideline is to balance their repertoire and ration the more arduous *spinto* roles. If a tenor has been singing a run of six Don Josés or Cheniers or Samsons or Alvaros they should (as Carreras always tried to do), return to something lighter like Rodolfo or Nemorino "to freshen up the voice again." His observation of these safeguards probably explains why Carreras's portrayal of Andrea Chenier at Covent Garden in 1984 was such a triumph. Although he claimed that the role stretched his voice to its limit, he surprised even his critics by singing it gloriously, seemingly without effort, with total conviction, and no sign of forcing in any

way. His voice soared loud, clear, and thrilling in the dramatic climax of the third act, while in the more intimate moments it retained the warm, melting, lyrical sound typical of Carreras at his best.

His other vintage portrayal in the *lirico-spinto* repertoire was undoubtedly Don José, which he first sang in Madrid and Zurich in 1982, and recorded in 1983 with Karajan at Covent Garden. It was a gamble for Carreras because, unlike the Italian *spinto* roles he mentioned above, Don José requires something more than the ability to add dark colors and the right accents to the voice. "For this role, you need a certain pulp, a certain volume, especially for the very dramatic third act, which I had by the early eighties but which I didn't have five years before."

Carreras's view of Don José was as "a man at the mercy, instead of in command of, his destiny, yet a subtler character than he is often portrayed to be." His dramatic and

Opposite and below: In the title role of Saint-Saëns's *Samson et Dalila* in 1991, the first time he sang the opera, with enormous success, at Covent Garden after his long and serious illness. "At this stage in my career, it's only worthwhile to sing something new. Singing Alfredo in *La traviata* for the umpteenth time would be boring both for myself and the audience." This was a tremendous achievement in its own right, and even more so for a tenor who had undergone long and painful treatment, including a bone-marrow transplant for leukemia. It is one of a string of new parts including the title role in *Stiffelio* (1993), Loris Ipanov in *Fedora* (1994), and *Sly* (1998), which he sang for the first time after his recovery.

musical interpretation was shaped by his recording (with Agnes Baltsa in the title role) under Karajan, "who made me understand Don José more deeply through this recording than I would have even if I had sung the role on stage a hundred times. For example, he wanted the Flower Song sung much more softly and intimately than usual, because although José begins it in anger, as he remembers his thoughts of Carmen in jail, gradually he softens as he approaches that high B flat in the phrase, '*et j'étais une chose à toi*,' which, Karajan insisted, showed a man no longer capable of restraining himself. But Karajan was a genius with a sensitivity so incredible that it unleashed hitherto untapped reserves inside us, and made us give one hundred percent of ourselves and really sing.... And he was so persuasive that I often think that if he asked me to sing Micaela, I probably would."

After his illness, Carreras made an astonishing comeback to the operatic stage with triumphant portrayals of the title roles in *Samson et Dalila* in 1991, *Stifellio* in 1993, Loris Ipanov in *Fedora* in 1994, and the title role in Wolf-Ferrari's *Sly* in 1998 in Zurich and Washington in 1999. "At this stage in my career it's only worthwhile singing something new. Singing Alfredo in *La traviata* for the umpteenth time would be boring both for myself and the audience."

Since their first tentative effort at the Terme di Caracalla in Rome in 1990, he, Placido Domingo, and Luciano Pavarotti have performed in fourteen "Three Tenors" concerts worldwide. The fees were several million Deutchmarks per tenor for each of the German concerts in 1998–part of which, in Carreras's case at least, went to his leukemia foundation.

Dreams that remain unfulfilled are singing the title role in *Manon Lescaut*, trying his hand at such lighter Wagnerian roles as the lead in *Lohengrin* and, if that proved successful, Walther von Stolzing in *Die Meistersinger von Nürnberg*. "And," he added during one of our conversations in the mid-eighties, "a really crazy thing that would have thrilled me beyond words would have been to sing Siegmund. Just to feel the joy of singing Act I of *Die Walküre* instead of listening to others doing so would have been worth the risk of losing my voice!"

GLOSSARY

bel canto: term associated with singing in the eighteenth and early nineteenth centuries when a beautiful vocal performance was more important than the dramatic (from the Italian meaning beautiful singing).

corona (also called fermata): a pause on a held note (from the Italian meaning stop or pause).

covering: singing a note with a closed throat, (i.e., allowing the larynx to float downwards rather than upwards).

forte: term applying to volume meaning loud.

fortissimo: term applying to volume meaning very loud.

heldentenor: heroic tenor specializing in the Wagnerian repertoire.

legato: from the Italian verb the smooth passage from on note to another (from the Italian meaning to bind or to tie), as opposed to *staccato*.

mezza voce: denotes singing softly, but not as softly as *piano*. A special way of singing as if under the breath, referring not only to the amount of volume but to a different quality from that when singing full voice (from the Italian meaning half voice).

passagio: the notes E, F, and G, which lie between the head and chest registers.

pianissimo: term applying to volume meaning very soft.

piano: term applying to volume meaning soft.

portamento: a practice by which singers slide from one note to another without a break (from the Italian verb meaning to carry).

register: term used to denote a certain area or vocal range (e.g., chest, middle, or head).

rubato: a way of performing without adhering strictly to musical time (from the Italian meaning stolen time).

short voice: a voice that doesn't stretch to the high notes at the top of the register.

tenore leggero: light lyric, referring to extreme facility at the top of the register, plus considerable agility

tenore lirico: lyric tenor.

tenore lirico-spinto: or lyric tenor leaning towards the dramatic (from the Italian verb *spingere*, meaning to push).

tenore robusto: dramatic tenor.

tessitura: term used to designate the average pitch of an aria or role. A part can be taxing despite the absence of especially high or low notes due to the prevailing *tessitura* (from the Italian meaning texture).

verismo: the opposite of *bel canto*, *verismo* (from the Italian meaning realism) refers to the movement in which drama is as important as beautiful singing. It is applied to the works of Italian composers after Verdi, including Puccini, Mascagni, Leoncavallo, Zandonai, and Giordano. When used as an adjective, *veristic* means realistic and is applied to the way in which the works of these composers are sung–i.e., more freely and less precisely than those of composers such as Mozart.

SELECTED DISCOGRAPHY

With thanks to Malcolm Walker of Gramophone Publications UK, and Charles Rodier and Richard Bradburn of EMI Classics UK.

Enrico **CARUSO**
Milan Recordings (1901-1904). EMI CDH 761046 2
Complete Recordings (1902-1921).
RCA GD60495
(12 discs)
Caruso in Song.
RCA 74321 41199-2

Beniamino **GIGLI**
Umberto Giordano, *Andrea Chenier*. Arkadia 2CD78012
Giacomo Puccini, *La bohème*. Arkadia 2CD78099
Opera Arias.
EMI CDH 761051 2
Complete Victor Recordings (1926-28).
Romophone 82004-2
Complete Victor Recordings (1929-32).
Romophone 82005-2
Opera Arias (1926-51).
RCA GD8781

Tito **SCHIPA**
Gaetano Donizetti, *Don Pasquale*. Arkadia 2CD78017
Opera Arias. EMI CDH 763200 2
Opera Arias, volume 1.
Preiser 89160
Opera Arias, volume 2.
Preiser 89171

Lauritz **MELCHIOR**
Richard Wagner, *Die Walküre*, acts I and II.
Danacord DACOCCD317/8
Electrola and HMV (1928-31). Danacord DACOCCD315/6
Legendary Interpretations: Siegfried (1927-31). Danacord DACOCCD319/21
Melchior Sings Wagner.
EMI CDH 769894 2

Richard **TAUBER**
Operetta Arias.
EMI CDH 769787 2
Opera Arias.
EMI CDH 764029 2
Opera and Lieder Recital.
Preiser 89144

Jussi **BJÖRLING**
Ruggero Leoncavallo,
I pagliacci.
EMI CDH 566778 2
Giacomo Puccini, *La bohème.*
EMI 556236 2
Opera Arias.
Decca 443 930-2DM
Opera Heroes.
EMI CDM 566807 2
Studio Recordings (1930-59).
CMS 566306 2
Duets and Arias.
RCA GD87799

Giuseppe **DI STEFANO**
Giacomo Puccini, *Tosca.*
EMI CDS 556304 2
Giussepe Verdi, *Rigoletto.*
EMI CDS 556327 2
Gaetano Donizetti,
L'elisir d'amore.
Decca 443 542-2LF2
Opera Arias and Songs.
Testament SBT1096
Opera Arias and Songs.
EMI CDM 763105 2
Canzoni e Romanze Italiane.
Decca 417 794-2DM

Carlo **BERGONZI**
Giacomo Puccini, *La bohème.*
Decca 448 725-2DF2
Giussepe Verdi, *La traviata.*
Decca 411 877-2DM2
Ruggero Leoncavallo,
I pagliacci. DG 449
727-2GOR
Giuseppe Verdi,
La forza del destino.
EMI CMS 764646 2
Italian Songs. Sony
SMK60785

Alfredo **KRAUS**
Giuseppe Verdi, *Rigoletto.*
RCA GD86506
Charles Gounod,
Roméo et Juliette.
EMI CDS 747365 8
Jules Massenet, *Manon.*
EMI CDS 749610 2
Giuseppe Verdi, *La traviata.*
EMI CDS 747538 8
Gaetano Donizetti,
Lucia di Lammermoor.
EMI CDS 747905 8
Opera Heroes: Alfredo Kraus.
EMI CDM 566534

Placido **DOMINGO**
Giuseppe Verdi, *Otello.*
DG 439 805-2GH2
Jacques Offenbach,
Les contes d'Hoffmann.
Decca 417 363-2DH2
Giuseppe Verdi, *Don Carlo.*
EMI CDS 747701 8
Opera Heroes:
Placido Domingo.
EMI CDM 566532 2
Domingo Sings Caruso.
RCA 09026 61356-2
Romanzas de Zarzuelas.
EMI CDC 749148 2
The Three Tenors: Rome 1990.
Decca 430 433-2DH

Mario **DEL MONACO**
Giuseppe Verdi, *Otello.*
Decca 411 618-2DH2
Umberto Giordano,
Andrea Chenier.
Decca 425 407-2DM2
Giacomo Puccini,
La fanciulla del West.
Decca 421 595-2DM2
Opera Arias.
Decca 440 407-2DM
*HMV Milan Recordings
(1948-52).* Testament
SBT1039

Franco **CORELLI**
Georges Bizet, *Carmen.*
RCA GD86199
Giacomo Puccini, *Turandot.*
EMI CMS 769327 2
Umberto Giordano,
Andrea Chenier.
EMI CMS 565287 2
Opera Heroes.
EMI CDM 566533 2

Nicolai **GEDDA**
Hector Berlioz, *Benvenuto
Cellini.* Philips 416 955-2PH3
Johann Strauss II,
Die Fledermaus.
EMI CMS5 566223 2
Gioachino Rossini,
Guillaume Tell.
EMI CMS 769951 2
Opera Heroes: Nicolai Gedda.
EMI CDM 566535 2
*Les introuvables de Nicolai
Gedda.* EMI CDS 556568 2

Luciano **PAVAROTTI**
Gaetano Donizetti,
La fille du régiment.
Decca 414 520-2DH2
Giacomo Puccini, *La bohème.*
Decca 421 049-2DH2
Vincenzo Bellini, *I Puritani.*
Decca 417 588-2DH3
Pietro Mascagni, *L'amico
Fritz.* EMI CDS 747905 8
The Ultimate Collection.
Decca 458 000-2DH2
The Three Tenors: Rome 1990.
Decca 430 433-2DH

José **CARRERAS**
Giuseppe Verdi, *Il corsaro.*
Philips 426 118-2PM2
Giuseppe Verdi,
Un ballo in maschera.
Philips 426 560-2PM2
Gaetano Donizetti,
Lucia di Lammermoor. Philips
*Zarzuelas: The Passion of
Spain.* Erato 4509-95789-2
Opera Heroes: José Carreras.
EMI CDM 566536 2
Opera Arias.
Philips 426 643-2PSL
The Three Tenors: Rome 1990.
Decca 430 433-2DH

victory, and the applause of all Memphis!
To return to you, my sweet Aida, decked with the victor's laurels, to say, "I fought, I won for you!"

Heavenly Aida, divine form, mystic garland of light and flowers, you are the queen of my thought, you are the splendour of my life.
That I might bring you once more the blue skies, the soft breezes of your native land,
a royal crown to deck your brow, a royal throne for you, in the sun!
Oh, heavenly Aida, divine form, mystic halo of light and flowers, you are the queen, etc.
9. (P) 1951 EMI Record Ltd
DRM (P) 1994 Testament Records

Giuseppe DI STEFANO

Giuseppe Verdi: *Rigoletto*–"*La donna è mobile*." In Act IV the libertine Duke of Mantua is about to seduce the professional whore Maddalena, sister of Sparafucile, the hired killer who owns the tavern in which the duke has taken refuge from a raging storm. He is in one of his many girl-chasing disguises, and sings playfully of woman's fickleness. Gilda, the innocent daughter of his court jester, Rigoletto, has been taken to the inn by her father to discover the real identity and intentions of the "student" who seduced and captured her heart. She watches the whole scene in hiding before she offers her life in place of the Duke's, who her father had paid Sparafucile to kill.

DUCA
La donna è mobile
qual piuma al vento,
muta d'accento
e di pensiero.
Sempre un amabile
leggiadro viso,
in pianto o in riso
è menzognero.
La donna è mobile, ecc.
È sempre misero
chi a lei s'affida,
chi le confida
mal cauto il core!
Pur mai non sentesi
felice appieno
chi su quel seno
non liba amor!
La donna è mobile, ecc.

DUKE
Women are as fickle
as feathers in the wind,
simple in speech,
and simple in mind.
Always the loveable,
sweet, laughing face,
but laughing or crying,
the face is false for sure.
Women are as fickle, etc.
If you rely on her
you will regret it,
and if you trust her
you are undone!
Yet none can call himself
fully contented

who has not tasted
love in her arms!
Women are as fickle, etc.
10. Translation: Dale McAdoo
© EMI (US) Ltd, 1956
DRM (P) 1997 EMI Records Ltd

Franco CORELLI

Giuseppe Verdi: *Il trovatore*–"*Di quella pira*." In Act III of this opera, which premiered in Rome in 1853, with a libretto based on a Spanish drama by Gutiérrez, the troubadour Manrico is about to marry his aristocratic love, Leonora, lady-in-waiting to the princess. As he sings of his eternal love for her and ecstasy in saving her from the hands of his rival, the Count di Luna (in reality his brother, though neither knows this), he is interrupted and told his supposed mother, the gypsy Azucena, has been captured by the count and will soon be burned at the stake. He abandons Leonora and rushes to her rescue, "or at least, hasten to die with you."

Di quella pira, l'orrendo foco
tutte le fibre m'arse, avvampò!
Empî, spegnetela, o ch'io fra poco
col sangue vostro la spegnerò!
Era già figlio prima d'amarti,
non può frenarmi il tuo martir...
Madre infelice, corro a salvarti,
o teco almeno corro a morir!
Di quella pira, ecc.

The horrible blaze of that pyre burns, enflames all of my being!
Monsters, put it out; or very quickly
I'll put it out with your blood!
Before I loved you, I was yet her son;
your suffering cannot restrain me...
Unhappy mother, I hasten to save you,
or at least, hasten to die with you!
The horrible blaze, etc.
11. (P) 1965 EMI Record Ltd
DRM (P) 1990 EMI Records Ltd

Giacomo Puccini: *Turandot*–"*Nessun dorma*." In Puccini's last, unfinished opera (which was completed after his death by his pupil Alfano and premiered in 1926), an unknown foreign prince is the first to correctly answer the three riddles that the heartless Princess Turandot, the resolutely single daughter of the Emperor of China, poses to every prospective suitor-the reward for failure being death by beheading. But too proud to be her husband by force, Calaf has, in turn, set her the riddle of discovering his identity by dawn. If she does, he will release her from her oath to marry him and will face his death. All night the people of Peking are forced to stay awake to try to discover the answer. The unknown suitor, the Tartar Prince Calaf, certain of victory, takes up their cry of "no one must sleep."

IL PRINCIPE IGNOTO
Nessun dorma!
Nessun dorma...
Tu pure, o Principessa,
nella tua fredda stanza
guardi le stelle che tremano
d'amore e di speranza!
Ma il mio mistero è chiuso in me,
il nome mio nessun saprà!
No, no, sulla tua bocca lo dirò
quando la luce splenderà!
Ed il mio bacio scioglierà il silenzio
che ti fa mia!
Dilegua, o notte!...
tramontate, stelle!
All'alba vincerò!
Vincerò! Vincerò!
© Riccordi & Co.

THE UNKNOWN PRINCE
No one must sleep!
No one must sleep...
You, too, o Princess,
in your cold room
look at the stars, that tremble
with love and with hope!
But my mystery is shut within me;
no one will know my name!
No, I will say it on your mouth
when the daylight shines!
And my kiss will break the silence
that makes you mine!
Vanish, o night!
Set, you stars!
At dawn I will win!
I will win! I will win!
12. Translation: William Weaver
© G. Ricordi & Co
(P) 1966 EMI Record Ltd
DRM (P) 1988 EMI Records Ltd

Carlo BERGONZI

Giacomo Puccini: *Madama Butterfly*–"*Bimba dagli occhi*." In Act I of *Madama Butterfly*, set in Japan and premiered in 1904, Pinkerton, an American naval officer, is enchanted by the fifteen-year-old Japanese geisha girl, Cio-Cio-San, and, despite the warnings of the American Consul Sharpless, goes through a wedding ceremony with her, at which time she dedicates herself to him body and soul. After she has been denounced by her family for embracing Christianity to be his "real, American wife," the two are left together and sing a rapturous duet in which he praises her enchanting beauty and grace.

PINKERTON
Bimba dagli occhi pieni di malia
ora sei tutta mia.
Sei tutta vestita di giglio.
Mi piace la treccia tua bruna
fra candidi veli.

BUTTERFLY
Somiglio la dea della luna,
la piccola dea della luna
che scende la notte
dal ponte del ciel.

PINKERTON
E affascina i cuori...

BUTTERFLY
...E li prende, e li avvolge

in un bianco mantel.
E via se li reca
negli alti reami.

PINKERTON
Ma intanto finor non m'hai detto,
ancor non m'hai detto che m'ami.
Le sa quella dea le parole
che appagan gli ardenti desir?

BUTTERFLY
Le sa. Forse dirle non vuole
per tema d'averne a morir,
per tema d'averne a morir!

PINKERTON
Stolta paura,
l'amor non uccide,
ma dà vita, e sorride
per gioie celestiali
come ora fa
nei tuoi lunghi occhi ovali.

PINKERTON
Dear child, with eyes full of witchery,
now you are all mine.
You're dressed all in lily-white.
I love your dark tresses
amid the white of your veils.

BUTTERFLY
I am like the moon-goddess,
the little goddess of the moon,
who comes down at night
from the bridge of heaven.

PINKERTON
And captivates all hearts...

BUTTERFLY
...and takes them and folds them
in a white cloak.
And carries them away
to the higher regions.

PINKERTON
But meanwhile, you haven't told me yet,
you haven't told me you love me.
Does that goddess know the words
that satisfy burning desire?

BUTTERFLY
She does. Maybe she's unwilling
to say them for fear of dying of it,
for fear of dying of it!

PINKERTON
Foolish fear –
love does not kill,
but gives life and smiles
for heavenly joy,
as it does now
in your almond eyes.
13. With Renata Scotto
(P) 1966 EMI Record Ltd
DRM (P) 1986 EMI Records Ltd

Giacomo Puccini: *Madama Butterfly*–"*Addio, fiorito asil*." In Act II Pinkerton, recalled to America, bids farewell to the idyllic hideout, surrounded by cherry blossoms, that has been his love nest with Butterfly. She vows she will wait for him forever. But he returns more than two years later with an American wife, only to discover that Butterfly, who has been waiting for him day and night, has given birth

to their son, whom Pinkerton now offers to adopt and take back to America. She accepts, bids her child farewell, and commits hara-kiri.

PINKERTON
Addio, fiorito asil
di letizia e d'amor...
Sempre il mite suo sembiante
con strazio atroce vedrò.

SHARPLESS
Ma or quel cor sincero
presago è già...Vel dissi, ecc.

PINKERTON
Addio, fiorito asil...
Non reggo al tuo squallor...
Fuggo, fuggo...son vil!

SHARPLESS
Andate, il triste vero apprenderà.

PINKERTON
Farewell, flowery refuge
of happiness and love...
Her sweet face will haunt me ever,
torturing me agonizingly.

SHARPLESS
But by now the faithful heart
maybe half suspects. I told you,
etc.

PINKERTON
Farewell, flowery refuge...
I can't bear your desolation...
I must fly! I'm beneath contempt!

SHARPLESS
Go, she will learn the sad truth.
14. With Rolando Panerai
(P) 1966 EMI Record Ltd
DRM (P) 1986 EMI Records Ltd

Nicolai GEDDA

Charles Gounod: *Faust*–"*Salut, demeure chaste et pure*." In Gounod's opera, based on Goethe's *Faust* and premiered in 1859, the philosopher Dr. Faust has struck a pact with the Devil, Méphistophélès, according to which he is given back his youth in exchange for his soul after death. A young man once again, he meets the beautiful and innocent Marguerite, whom he seduces. In this aria, he sings of her home as a pure and sacred paradise, fit for an angel. (Marguerite later kills her mother and is condemned to death.)

FAUST
Salut ! demeure chaste et pure, où se devine
la présence d'une âme innocente et divine !
Que de richesse en cette pauvreté !
En ce réduit, que de félicité !
Ô nature, c'est là que tu la fis si belle !
C'est là que cette enfant a dormi sous ton aile,
a grandi sous tes yeux !
Là que, de ton haleine enveloppant son âme,
tu fis avec amour épanouir la femme

en cet ange des cieux!
C'est là... oui... C'est là!
Salut! demeure chaste et pure, etc.

FAUST
Hail, chaste and pure dwelling
where one can feel
the presence of an innocent and
holy soul.
What wealth in this very poverty!
What bliss in this humble cottage!
O Nature, this is where you cre-
ated her beauty!
This is where the maid slept
beneath your wing,
grew up under your gaze!
Here, too, breathing into her soul,
you lovingly turned this angel of
heaven
into a fresh-blooming woman.
This is the place...yes, here it is!
Hail, chaste and pure dwelling,
etc.

 15. Translation: B. Vierne
 (P) 1959 EMI Record Ltd
 DRM (P) 1989 EMI Records Ltd

Adolphe Adam: *Le Postillon de
Longjumeau, "Mes amis, écoutez-moi".*
Adam was born, worked and died in
Paris, although he spent some time
in London after the July Revolution
of 1830 made conditions in Paris
uncongenial. Although his father
was a well-know musician, Adolphe
did not consider music as a career
until encouraged by Ferdinand
Hérold (of *Zampa* fame). He went
on to turn out an enormous num-
ber of tuneful stage works, most of
which are now forgotten, though
the ballet *Giselle* still holds the stage.
Le Postillon de Longjumeau has a
frothy plot revolving around a
coachman who is heard singing at
his wedding reception by a talent
scout from Paris. Leaving his bride
on the spot, he goes off, becomes a
famous tenor, so it is appropriate
that the number he is singing when
he is "discovered", telling the story
of the eponymous *Postillon*, includes
a string of top Ds imitating a
posthorn. It is a favorite showpiece
of any tenor who can sing it, and
some who can't. Nicolai Gedda is
one of those for whom the song
might have been especially written.

CHAPELOU
Mes amis, écoutez l'histoire
d'un jeune et galant postillon.
C'est véridique, on peut me croire,
et connu de tout le canton.
Quand il passait dans un village
tout le beau sexe était ravi,
et le cœur de la plus sauvage
galopait en croupe avec lui ;
Ah ! ah ! ah ! qu'il était beau !
le postillon de longjumeau !

Mainte dame de haut parage,
en l'absence de son mari,
parfois se mettait en voyage
pour être conduite par lui.
Aux procédés toujours fidèle
on savait qu'adroit postillon
s'il versait parfois une belle
ce n'était que sur le gazon !
Ah ! ah ! ah ! etc.

Mais pour conduire un équipage
voilà qu'un soir il est parti ;
depuis ce temps dans un village
on n'entend plus parler de lui.
mais ne déplorez pas sa perte
car de l'hymen suivant la loi
la reine d'une île déserte
de ses sujets l'a nommé roi.
Ah ! ah ! ah! etc.

CHAPELOU
My friends, listen to the tale
of a young and gallant postillon.
It is true, believe me,
and known the province through-
out.
Whenever he entered a village
all the fair sex was enraptured,
and the heart of the wildest one
galloped along with him.
Ah ! how handsome he was!
The postillon of Longjumeau!

Many a lady of high degree,
while her husband was away,
sometimes set out on a journey
so as to be driven by him.
To the niceties always true, one
knew that, skilful postillon,
it was only on the grass!
Ah! how handsome, etc.

But to drive a carriage,
lo, one evening he went out;
since that time in the village
no-one has heard anything of him.
But do not lament his loss
for, following the law of marriage,
the queen of a desert island
of her subjects named him king.
Ah! how handsome, etc.

 16. (P) 1962 EMI France
 DRM (P) 1997 EMI France

Alfredo **KRAUS**

Jules Massenet: *Werther-"Tout mon
ame... Pourquoi me réveiller?"* In
Massenet's four-act opera, based
on Goethe's *Die Leiden des jun-
gen Werthers* and premiered in
Vienna in 1892, the poet Werther
is passionately in love with Char-
lotte, engaged to his friend Albert,
whom she marries to fulfill her
dying mother's wish. Having at
first done the decent thing and
left town, Werther then returns
against his better judgment. He
sings her his translation of a poem
by Ossian that mirrors his own
feelings and state of mind. Char-
lotte's resolve is weakened and,
unable to hide her feelings any
longer, confesses that she loves
him. Yet duty binds her to her hus-
band and she urges Werther to
leave again. But upon hearing
from Albert that he has asked for
his pistols, she rushes to him only
to find that he has shot himself
and is dying from his wounds.

Toute mon âme est là !
(lisant)
" Pourquoi me réveiller, ô souffle
du Printemps ?
Pourquoi me réveiller ?
Sur mon front, je sens tes caresses,
et pourtant bien proche est le
temps

des orages et des tristesses !
Pourquoi me réveiller, ô souffle du
Printemps ?
Demain, dans le vallon, viendra le
voyageur,
se souvenant de ma gloire pre-
mière.
Et ses yeux, vainement, cher-
cheront ma splendeur :
ils ne trouveront plus que deuil et
que misère ! "
Hélas ! Pourquoi me réveiller, ô
souffle du Printemps ?

My whole soul is there!
(reading)
"Why awaken me, o breath of
spring?
Why awaken me?
On my brow I feel thy caresses,
and yet close at hand is the time
of storms and sorrows!
Why awaken me, o breath of spring?
Tomorrow, into the valley, will
come the traveller,
remembering my former glory.
And vainly will his eyes seek my
splendour:
they will find only misery and
grief!"
Alas! Why awaken me, o breath of
spring?

 17. Translation:
 © Joseph Allen, 1969
 (P) 1979 EMI Record Ltd
 DRM (P) 1987 EMI Records Ltd

Luciano **PAVAROTTI**

Giuseppe Verdi: *Messa da Requiem–
Ingemisco.* Originally Verdi had
wanted the death of Rossini in
1868 to be marked by a requiem
mass in which Italy's leading com-
posers would each contribute a
part. His own contribution would
be the Libera me. But the plan
failed to materialize and five years
later, in 1873, Verdi composed his
Requiem Mass to mark the death of
the great Italian poet and patriot
Alessandro Manzoni. The *Requiem*
was written for four voices (tenor,
soprano, mezzo soprano, and
bass); the tenor solo *Ingemisco*
forms part of the *Dies Irae* section.

Ingemisco tamquam reus:
Culpa rubet vultus meus:
Supplicanti parce, Deus.

Qui Mariam absolvisti,
Et latronem exaudisti,
Mihi quoque spem dedisti.

Preces meae non sunt dignae;
Sed tu, bonus, fac benigne,
Ne perenni cremer igne.

Inter oves locum praesta,
Et ab haedis me sequestra,
Statuens in parte dextra.

I groan as one guilty,
and my face blushes with guilt;
spare the suppliant, O God.

Thou who didst absolve Mary
[Magdalen]
and hear the prayer of the thief,
hast given me hope too.

My prayers are not worthy,
but Thou, O good one, show
mercy,
lest I burn in everlasting fire.

Give me a place among the sheep,
and separate me from the goats,
placing me on Thy right hand.

 18. (P) 1987 EMI Record Ltd

Pietro Mascagni: *L'amico Fritz-"The
Cherry Duet."* In Mascagni's charm-
ing but seldom performed work
(1891), the wealthy landowner
Fritz, walking through the
orchard, comes across Suzel, the
daughter of one of his tenants,
picking cherries. In these idyllic
surroundings, the determined
bachelor begins to melt, inspired
by the freshness of oncoming
spring and the girl's youth and
innocence.

FRITZ
Suzel, buon dì! D'un gaio rosign-
uolo
la voce mi svegliò.

SUZEL
Che dite mai?
FRITZ
Mi piace come canti.

SUZEL
Oh, signor Fritz...
Canto così come mi vien dal core.

FRITZ
Quei fiori son per me?

SUZEL
Per voi li ho côlti...
Ed oltre i fiori
ho pronta una sorpresa...
FRITZ
Una primizia certo...

SUZEL
Le ciliege.

FRITZ
Ciliege! e son di già mature?

SUZEL
Han della porpora vivo il colore,
son dolci e tenere...

FRITZ (da sé)
Di primavera somiglia a un fiore
fragrante e roseo...

SUZEL
Son pronta a coglierne un maz-
zolino.
Debbo gettarvele?

FRITZ
Gettale subito, bell'augellino.
Le saprò prendere.
(Suzel esce dalla porta dell'orto,
appare in cima alla scala, dall'altra
parte del muro, coglie le ciliege e
le getta a Fritz.)
Fresche scintillano, di brina
ancora
son tutte roride...
Ma è da quell'albero che sull'au-
rora
pispiglia il passero?

SUZEL
Sì, da quell'albero...

FRITZ
Ciò ch'egli dice non sai compren-
dere?

SUZEL
Il lo so intendere...ch'egli è felice,
nel canto mormora:
sui rami floridi ha i suoi piccini...
lieti l'aspettano;
agili scherzano dei bianco-spini,
tra i fiori candidi.

FRITZ
Come ne interpreti bene il lin-
guaggio!

SUZEL
Sembra che parlino.
Sembra salutino coi fior il raggio
dell'aurora.

FRITZ (da sé)
Tutto tace,
eppur tutto al cor mi parla.
Questa pace,
fuor di qui dove trovarla?
Tu sei bella,
o stagion primaverile!
Rinovella
fiori e amor il dolce aprile!
(Suzel rientra dalla porta del-
l'orto,
il grembiulino pieno di ciliege.)

SUZEL
Quale incanto
nel risveglio d'ogni fiore!
Riso o pianto,
tutto è palpito d'amore!
Tutto il prato
d'un tappeto s'è smaltato...
Al Signore
s'alza l'inno da ogni core!

FRITZ
Good morning, Suzel! I was woken up
by the glad song of a nightingale.

SUZEL
What can you mean?

FRITZ
I like your singing.

SUZEL
Oh, Master Fritz...
I sing what comes into my heart.

FRITZ
Are those flowers for me?

SUZEL
I picked them for you...
And, besides the flowers,
I've a surprise for you...

FRITZ
Some early fruit, I'll be bound.

SUZEL
Cherries.

FRITZ
Cherries! Are they ripe already?

SUZEL
They're bright purple,
sweet and tender...

FRITZ (aside)
She is like a spring flower,
fragrant and rosy...

SUZEL
I'm going to pick a handful...
Shall I throw you some down?

FRITZ
Throw them down, my pretty little
bird,
I'll catch them...
(Suzel goes out by the garden
gate, climbs up a ladder on the
other side of the wall, picks some
cherries and throws them down to
Fritz.)
They sparkle with freshness, still
bedewed
with hoar frost...
But is that the tree
where the sparrow twitters at
dawn?

SUZEL
Yes, that's the one...

FRITZ
Do you understand
what he says?

SUZEL
I do...he sings about
how happy he is:
in the flowery branches, his chicks
await him joyfully;
they play nimbly among
the white hawthorn blossoms.

FRITZ
How well you interpret his lan-
guage!

SUZEL
The birds seem to talk.
They seem to greet, as the flowers
do,
the sun's first rays.

FRITZ (aside)
All is silent,
yet it all speaks to my heart.
Where could one find
peace like this elsewhere?
How beautiful you are,
o springtime!
Sweet April renews
flowers and love alike!
(Suzel comes back through the
gate, her apron full of cherries.)

SUZEL
What enchantment lies
in the awakening of each flower!
Laughter or tears,
it all throbs with love!
The whole meadow
is carpeted with colour...
From every heart
a hymn rises to the Lord.
19. (P) 1969 EMI Record Ltd
DRM (P) 1987 EMI Records Ltd

Placido DOMINGO

Giacomo Puccini: *Tosca–"E lucevan le stelle."* In *Tosca*, Puccini's immensely popular opera, premiered in 1900, the painter Cavaradossi is heavily involved in liberal politics, which brings him into a head-on collision with Baron Scarpia, the chief of the repressive Roman police, who also lusts after his lover, the opera diva Floria Tosca. In Act III of the opera, Cavaradossi, who helped hide a fugitive from Scarpia's jail, is under sentence of death in the prison of Castel Sant'Angelo. He sings of his rapturous love affair with Tosca, reminiscing over the details of their tender times together.

CAVARADOSSI
E lucevan le stelle ed olezzava
la terra, stridea l'uscio
dell'orto, e un passo sfiorava la
rena...
Entrava ella, fragrante,
mi cadea fra le braccia...
Oh, dolci baci, o languide carezze,
mentr'io fremente
le belle forme discioglia dai veli!
Svanì per sempre il sogno mio
d'amore...
L'ora è fuggita...
E muoio disperato!
E non ho amato mai tanto la vita!

CAVARADOSSI
And the stars shone and the earth
was perfumed.
The gate to the garden creaked
and a footstep rustled the sand to
the path...
Fragrant, she entered
and fell into my arms...
Oh soft kisses, oh sweet abandon,
as I trembling
unloosed her veils and disclosed
her beauty.
Oh vanished forever is that dream
of love, fled is that hour,
and desperately I die.
And never before have I loved so
much!
20. (P) 1981 EMI Record Ltd

José CARRERAS

Georges Bizet: *Carmen-"La fleur que tu m'avais jetée."* In Bizet's much-loved opera, premiered in 1875, the irresistible gypsy Carmen has bewitched the soldier Don José, who freed her from arrest for wounding another gypsy girl, and was imprisoned for his offense. Freshly released, he seeks out Carmen in the tavern of Lillas Pastia, a smugglers' den, and she, infatuated with him in her turn, tries to lure him to the mountains to join in their carefree smugglers' life. He is torn between his passion for her and his duty as a soldier and, when she taunts him about this, he answers her by singing the "Flower Song," telling of how the thought of her alone sustained him through his days in jail.

JOSÉ
La fleur que tu m'avais jetée,
dans ma prison m'était restée.
Flétrie et sèche, cette fleur
gardait toujours sa douce odeur ;
et pendant des heures entières,
sur mes yeux, fermant mes
paupières,
de cette odeur je m'enivrais
et dans la nuit je te voyais !
Je me prenais à te maudire,
à te détester, à me dire :
pourquoi faut-il que le destin
l'ait mise là sur mon chemin ?
Puis je m'accusais de blasphème,
et je ne sentais en moi-même,
je ne sentais qu'un seul désir,
un seul désir, un seul espoir :
te revoir, ô Carmen, oui, te revoir !

Car tu n'avais eu qu'à paraître,
qu'à jeter un regard sur moi,
pour t'emparer de tout mon être,
ô ma Carmen !
et j'étais une chose à toi !
Carmen, je t'aime !

JOSÉ
The flower that you threw to me
stayed with me in my prison.
Withered and dried up, that
flower
always kept its sweet perfume;
and for hours at a time,
with my eyes closed,
I became drunk with its smell
and in the night I used to see you!
I took to cursing you,
detesting you, asking myself
why did destiny
have to throw her across my path?
Then I accused myself of blas-
phemy,
and felt within myself,
I felt but one desire,
one desire, one hope:
to see you again, Carmen, to see
you again!
For you had only to appear,
only to throw a glance my way,
to take possession of my whole
being,
O my Carmen,
and I was your chattel!
Carmen, I love you!
21. © Alan Gregory, 1964
(P) 1985 EMI Record Ltd

PHOTOGRAPHY CREDITS

Our warm thanks for their assistance in collecting the photographs go to Linda Silverman in Great Britain; John Pennino, Jane L. Poole, and Winnie Klotz at the Metropolitan Opera; and Elena Fumagalli at La Scala.
Sources for the photographs are as follows: Catherine Ashmore: 112, 117 (below left), 121. Susesch Bayat: 116 (below). Beth Bergman: 82 (below; 1977, 1999), 96 (left; 1976, 1999). Christian Brandstätter: 41, 42, 44 (below). Donald Casper/Photostage: 98, 100 (below), 107, 108 (below), 110 (above), 114, 118, 119, 120. Zoë Dominic: 92 (above), 95, 104, 106 (right center). Margot Feiden Galleries/copyright © Al Hirschfeld: 102 (below right). Hulton/Getty: 17 (above), 26, 43, 44 (above), 84 (below). Winnie Klotz/The Metropolitan Opera: 85 (right), 91, 96 (above), 105, 106 (below), 110 (left), 111 (above and below left), 113 (above), 115. Helmut Koller: 106 (above). The Metropolitan Opera: 9, 16, 17 (below), 18, 21, 22, 23 (above), 24 (above), 25, 27, 28, 29, 30 (right), 31, 32-37, 38 (below), 39, 46, 47-51, 54 (below left), 59, 64 (center), 68, 70 (above center), 72, 76, 82 (above), 85 (left), 101, 102 (above), 108 (above). Richard Open/Camera Press: 113 (below). Agostino pallini/Enguerrand:103. Performing Arts Library/Clive Barda: 74, 78 (below right), 80, 86, 92 (below), 93 (right center), 99, 111 (right), 117 (below right).Popperphoto: 23 (below), 38 (above), 40, 45. David Powers: 100 (above). RAI: 54 (above). Reuters/Corbis: 7. Fred Shea: 83. Stage Image: 97. David Stanton: 109 and front cover (Domingo). Teatro alla Scala, Milan, Library: 8, 19, 20, 21; Archives/photographs by E. Piccagliani: 52, 53, 54 (below right), 55, 56, 57, 58, 60, 61, 62, 63, 64 (above and below right), 65, 66, 67, 69, 70 (below right), 71, 73, 75, 77, 78 (above and center), 81, 84 (above), 88, 89, 90 (above), 102 (left center); Archives/photographs by Lilli and Masotti: 79, 87, 93 (above and below), 116 (above).